A GUIDE TO ART

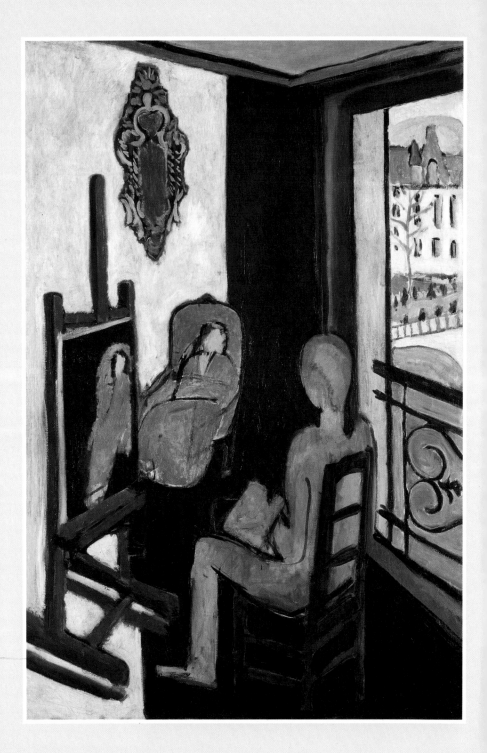

A GUIDE TO ART

Edited by Sandro Sproccati

Harry N. Abrams, Inc., Publishers
New York

Frontispiece: Henri Matisse, The Artist and His Model, *1917, Musée National d'Art Moderne, Paris*

Text by Maria Giovanna Battistini, Vittoria Coen, Elena de Luca, Silvia Evangelisti,
Fabia Farneti, Walter Guadagnini, Paola Jori, Alessandra Rizzi, Antonella Sbrilli,
Loretta Secchi, Sandro Sproccati, Maurizia Torza

Tables by Robert Pasini
Museums chapter by Fabia Farneti

Copyright © 1991 Arnoldo Mondadori Editore S.p.A., Milan
English translation copyright © 1992 Arnoldo Mondadori Editore S.p.A., Milan

Translated from the Italian by
Geoffrey Culverwell, John Gilbert, Judith Landry, Elizabeth Stevenson

Library of Congress Catalog Card Number: 91–77141
ISBN 0–8109–3366–7

Printed and bound in Italy by Arnoldo Mondadori Editore, Verona

CONTENTS

FOREWORD

The study of the visual arts – a vast compendium of knowledge that embraces schools, movements, techniques and concrete objects - is a complex one. Even the most general of terms present problems and are for various reasons often insufficient or inadequate. The very concept of "representation," which should represent the core of "visual expression," is in itself unsatisfactory and can cover everything and nothing at the same time, especially in the modern age. Those who are not experts in the field and are tackling the subject for the first time may feel daunted by its enormity and uncertain about whether to study the history of art as a whole, or to analyze individual works in detail. To look at the development of the visual arts requires an examination of the relationship between art and its political and social context, between artistic production and the marketplace (art collecting, patronage, commissions, etc.), between art and ideology, between art and the establishment. It also involves determining the mutual links and reciprocal influences among artists themselves, the fundamental styles they have created, the subjects and themes treated and the compositional schemes they have favoured. To study particular works means seeing them in terms of recognizable signs and symbols. The aim of this book is to make the overall approach easier by using all these perspectives. It does not eliminate the difficulties we have mentioned, but it is directed towards a public unfamiliar with art and art history.

The history of art is in a process of rapid and continuous change, to the point where, even when it relates to a short or circumscribed period, it cannot safely establish firm parameters. This holds true to an even greater degree in terms of the artistic production of many countries over many centuries, as is the case if we wish to study all of Western art. Nevertheless, for the purposes of our book, we have had to establish a single frame of reference, endeavouring to impose order on the disparate theories and multiplicity of events that have succeeded one another from the fourteenth century to the present day. We have attempted, within the brief span of some 300 pages, to tell the story of an immense structure built from the raw materials of human genius over a period of seven centuries, out of thought and argument and demonstration, out of painstaking experiment and brilliant innovation. The result is a sort of handbook for those in search of a basic but not superficial introduction to the history of art. We have focused our attention on the major historical movements, thus concentrating on the better known artists and their works. The compact dimensions of this book favour its use as a guide, clearly structured for ease of reference. Proportionately more space has been devoted to the last 150 years; this deliberate decision was prompted by the belief that recent happenings

7

will be the least familiar to the reader.

We take the very beginnings of modern art as our starting point. They were laid in the early fourteenth century with the revolutionary achievements of Giotto. By including the 1980s in a review of the later phases, we are also bound to pass judgement on aspects of the contemporary scene. Many academics tend to think that time virtually came to a standstill thirty or forty years before their lifetime on the grounds that the contemporary, by definition, is not yet history and that any description of it cannot help being partial, subjective and provisional. It is with an awareness of these limitations, however, that the authors of the later chapters have set about their task. Their undertaking differs from that of their colleagues, inasmuch as they have to provide a systematic classification of recent events, involving living and young artists, and cycles of work yet to be completed.

The breakdown of the material into chapters follows a logical and familiar scheme. Sometimes the chapters cover obvious spans; at other times they take into account the fact that history is not always linear and can present overlapping or intertwining courses. Dividing history into specific periods can be something of a questionable classification in the twentieth century because of the proliferation of simultaneous and often quite distinct phenomena.

The two-tier structure adopted in the book, which we hope will prove accessible, follows a horizontal–vertical logic: at the bottom of each page of main, "horizontal" text are vertical bands of relevant artists' biographies for easy reference. Boxes highlighting particular areas of interest complement the text, and tables summarizing important events of the period in question provide a further source of reference. The dual approach gives the book flexibility, providing information on two levels, each supplementing the other while remaining distinct and self-contained.

Each chapter thus consists of a historical essay that is compact yet highly informative and a representative selection of illustrations. Together with the essay the illustrations form the substance of each individual chapter and hence, in their sequence, of the entire volume. Complementing the text and pictures are the biographical surveys of the various artists given in each chapter, which offer concise, essential information about their life and work. The highlighted box in each chapter draws particular attention to a related significant theme or question that warrants separate treatment. The synoptic chart conveniently sums up the intricate links between the various strands of history – political, artistic, literary, musical, philosophical, etc., that refer to the period covered in that chapter.

Also included in the book are appendices for further information: a short glossary of specialist terms; a

list of the world's principal art museums and an index of artists.

The structure of the book enables the reader to approach art from many angles, even contrasting ones.

I believe this will enrich the scope of the book and stimulate readers to enhance their interest in art history by further reading and other pursuits.

Sandro Sproccati

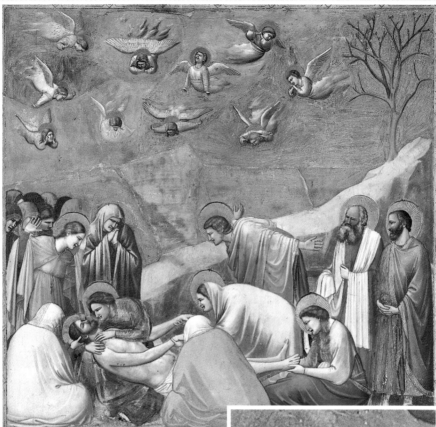

Giotto, The Lamentation, *1303–6, Scrovegni Chapel, Padua. Giotto was commissioned to decorate the walls of Enrico degli Scrovegni's votive chapel, which was built on the remains of the old Roman arena in Padua in expiation of the sins of his usurer father. Dedicated to the Madonna of Charity, the chapel, with Giotto's frescoes, was completed in 1306. Prestige aside, the frescoes were a fundamentally important step in Giotto's artistic development and experimentation with new forms. Colour and plasticity are boldly employed to define the masses in scenes from the life of the Virgin and the life of Christ, which are ranged along the walls in three courses. The diagonal of the rock in the* Lamentation *scene is carried on a three-dimensional plane through the angle of the figures leaning towards the recumbent Christ and converging on a distraught Mary holding her Son in her arms. Pathos and drama are conveyed in the expressions of stunned sorrow on the faces of the bystanders, while repoussoir figures in the immediate foreground carry the spectator inside a scene where linearism has given way to spatial depth.*

1 GIOTTO AND THE FOURTEENTH CENTURY

▲ *Duccio di Buoninsegna,*
Deposition, *panel
from the* Maestà
Altarpiece *1308–11,
Opera Metropolitana
Museum, Siena.*

◄ *Giovanni Pisano,*
Massacre of the
Innocents, *detail,
1302–10, Church of
Sant'Andrea, Pistoia.
Giovanni Pisano's
realistic style here
reaches its fullest
expression.*

The foundations of modern European artistic culture start at the turn of the thirteenth century with the first tentative expressions of a new language whose premise was imitation through the rational eye. With the disappearance of the flat, rigid images of the early Middle Ages came the emergence of a new pictorial art developed from the first experiments in perspective of the Renaissance. This development led to the "Classicism" of the sixteenth century and an art of more or less classical inspiration that endured until it entered into an irreversible crisis at the beginning of our own epoch. The fourteenth century is therefore one of several natural starting points for a study of European art history. In particular we refer to the revolutionary Florentine artist, Giotto, the earliest true interpreter of the Renaissance spirit who turned his back on medieval tradition by reviving the ancient notion of a man-centered universe. From 1290 to 1295, Giotto was able to observe the expressiveness of Cimabue's frescoes in Assisi, and those of the Roman tradition by Jacopo Torriti and Pietro Cavallini. Drawing on these experiences, Giotto evolved a style that was entirely modern, characterized by emotional pathos and powerful, epic forms within a tightly coherent narrative framework. The effect was realistic and totally human.

Aesthetic change had been a matter of philosophical debate already for several decades. The Aristotelian stance of St Thomas Aquinas thus benefited the arts, bringing renewed contact with nature, restoring the power to imitate. Giotto grasped this potential and, without distancing himself entirely from the past, developed a new language of volume, space and realism. This artistic revival does not concern itself only with formal considerations. Bible stories and the lives of saints are "narrated" and described in a manner not unlike the life and environment of the onlooker. Thus, in the fresco cycle of the Upper Church in Assisi, Giotto conveys the "theater" of the Gospels in economical scenes that are true to the event but contemporary in style, achieving this by naturalistic effects, the axonometric presentation of buildings, and rich landscape details.

At Padua, the frescoes in the Scrovegni Chapel show similar expressive qualities and narrative immediacy, solidity of form and a balanced sense of colour (1304–6).

The Miniature

Although Giotto is unmistakably original, the roots of his invention are to be found in the dramatic reliefs of Nicola Pisano and the liveliness of Western European Gothic sculpture in general. It may seem odd in Giotto's case to talk about Gothic antecedents, considering that Siena, not Tuscany, was the first Italian center in the thirteenth century actively to embrace the stylistic sophistication from the north. However, in Florence and especially in Giotto's work, early French Gothic influences can be seen in a new luminosity and use of colour, with contrast having a formal rather than a decorative function. Chiaroscuro is softened or accentuated depending on the intensity of light required, while fantasy becomes subsumed in the drama, for example, the *Lamentation* in the Padua cycle. These plastic and expressive devices are typical of Giotto's development, subsiding only during his Florentine period – the late style of the Bardi

Dante defined miniaturism as "that art which is called illumination in Paris," referring to the luminous surface of the vellum in decorated medieval manuscripts, achieved by the use of gold and silver leaf. Careful application of pure colour on the surrounding background helped to magnify the brilliance of the image. After the Byzantine period, when gold and silver were extensively used, yellow and white gouaches were substituted. This method produced the same brightness of tone but lacked the jewel-like quality of genuine gold and silver. The Latin term "miniatura" is a derivation of "minio," or red, which was the colour traditionally used in monastic scriptoria to illuminate the initial letter. The art of illumination declined when the book replaced the manuscript, and an article which was by necessity available to only a few gave way to the dissemination of the printed word. Above: Christ among the Elders, manuscript on parchment, Turonian Choral MLVII, f.56v., fourteenth century, Biblioteca Capitolare, Verona.

and Peruzzi Chapels in the Basilica of Santa Croce, Florence.

Giotto's development has clear parallels with that of the sculptor Giovanni Pisano, son of Nicola. Both went through a "Classical" phase followed by a period where pathos predominates before returning, in a final phase, to a greater rigidity of form and a correspondingly muted lyricism. Giovanni, however, was apparently aware of the dialectical conflict between northern types and the late Classical/Romanesque traditions of the south, and he was inclined towards the French Gothic model, accentuating its animated spirit. Giotto, on the other hand, belonged stylistically to the Early Christian tradition and never made a complete break with the Latin type, not even in his most expressive work.

During the thirteenth century, three important artists were active in the main cultural centers of Italy: Pietro Cavallini in Rome,

BIOGRAPHIES

♦ **Duccio di Buoninsegna**
(c.1255/1260?–1315/18?). Italian painting of the late thirteenth and early fourteenth centuries is marked by a break with Byzantine conventions by artists such as Duccio, whose livelier images were more in keeping with the new, Gothic spirit. The *Rucellai Madonna* (1285) and the *Madonna with Three Franciscans* (1295) are typical examples, together with Duccio's

greatest work, the *Maestà Alterpiece* in Siena's Opera Metropolitana Museum (1308–11).

♦ **Giotto**
(Vespignano c.1267–Florence 1337). We

first hear of Giotto as an apprentice to Cimabue in the workshop at Assisi where he later returned to paint the fresco cycle in the Upper Church of the Basilica of St Francis.

In 1300 Giotto was active in Rome, Assisi and Florence (*Crucifix* in the Church of Santa Maria Novella). Between 1304 and 1306 he decorated the Scrovegni Chapel in Padua. Back in Florence in 1311, he completed painting the Peruzzi and Bardi Chapels in the Basilica of Santa Croce by 1327. On 12 April 1334 he was appointed architect of Florence Cathedral. He died long before its completion.

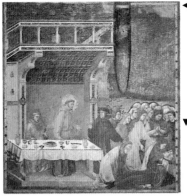

◀ *Giotto, Death of the Knight of Celano, 1298, Upper Church, Basilica of St Francis, Assisi. In the interplay of volume and space, the action is highlighted by accentuated chiaroscuro.*

Cimabue in Florence and, in Siena, Duccio di Buoninsegna (born c.1255/1260), who was founder of the Sienese school. Duccio's

▼ *Simone Martini, Guidoriccio da Fogliano, 1328, Palazzo Pubblico, Siena. This equestrian fresco portrait is in the Sala del Mappamondo.*

early, extensive use of gold background bears witness to his attachment to the Byzantine tradition. Later, the subject matter gains importance; handled in a minutely descriptive manner, it does not lose the exquisite chromatic effects which would subsequently distinguish the work of Duccio's pupils, Simone Martini and the brothers Pietro and Ambrogio Lorenzetti. In a literary context,

where Giovanni Pisano and Giotto might find themselves in the company of Dante, Simone Martini's lyricism can be equated with the courtly cadences of a Petrarch sonnet.

Simone Martini's early style is a combination of French influences and echoes of the eastern tradition which had made inroads into the heterogeneous Sienese culture. After his Sienese

debut, Simone became court painter to the Angevin rulers of Naples. Exposed to the sophisticated ways of French court life, Simone nurtured an elegant *dolce stil nuovo* manner before undertaking commissions executed in a more dramatic vein, partially approaching the realism of Giovanni Pisano and Giotto. Although fascinated by Giotto's strong artistic temperament, Simone did not

♦ **Giovanni da Milano** (fl.1346–69). A Milanese painter influenced by Giotto and his followers, at the same time receptive to French ideas. Giovanni da Milano's works include the *Prato Polyptych* and the frescoes of the Rinuccini Chapel in the Basilica of Santa Croce, Florence.

♦ **Guariento** (Padua c.1338–70). Guariento's style is transitional, combining the effects of

Byzantine culture with the influence of Giotto. He is chiefly remembered for a monumental fresco, *Paradise*, in the Ducal Palace at Venice (1366–68). He formed a school in Padua, which numbered talented artists like Giusto de' Menabuoi and Altichiero among its members.

♦ **Lorenzetti** Ambrogio (Siena c.1319–48). Ambrogio and his brother Pietro, almost certainly the

elder of the two Lorenzettis, worked jointly on several projects though Ambrogio developed a separate career through his knowledge of the Tuscan masters (Duccio, Cimabue, Giotto and Simone Martini). His works include a *Madonna* in Vico l'Abate (1319), frescoes in the Basilica of St Francis (1331) and the "political" frescoes of *Good and Bad Government* in the Palazzo Pubblico at Siena.

♦ **Maso di Banco** (c.1346–92). An important fresco artist and follower of Giotto, Maso decorated the Chapel of San Silvestro in the Basilica of Santa Croce, Florence. Other Giotto disciples include Stefano Fiorentino and the minor though very active Taddeo and Agnolo Gaddi, Bernardo Daddi, the Master of St Mary Magdalen and the Master of Saint Cecilia.

♦ **Martini** Simone (Siena 1284?–Avignon

1. GIOTTO AND THE FOURTEENTH CENTURY

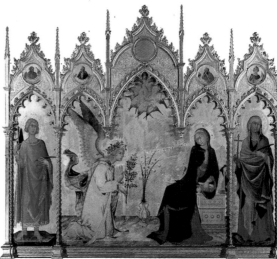

abandon his own, looser, freer compositions that were less concerned with spatial restraints and strict realism. His masterpiece from this period is the frescoed decoration of the Chapel of St Martin in the Basilica of St Francis in Assisi, painted between 1323 and 1326. Later works such as the *Annunciation* of 1333 in Siena Cathedral show a return to the graceful abstractions of Simone's former style.

Among contemporaries of Giotto, the artist who came closest to his ideal was another product of Sienese culture attending the Assisi workshop, Pietro Lorenzetti, whose *Madonna and Child with Saints* in the Lower Church of the Basilica of St Francis clearly shows Giotto's influence. Typical of Pietro's particular blend of Florentine plasticity and Sienese decoration are his representations of the *Burial* and the *Crucifixion*. After the Assisi experience, Pietro broadened his artistic language, seemingly influenced by the flowing colours of Simone Martini. The only other example approaching Pietro's "solemnity" was that of his younger brother and collaborator, Ambrogio Lorenzetti who, while being aware of Pietro's strong temperament, developed an artistic identity of his own.

Niccolò Tegliacci, Bartolo di Fredi and Andrea and Lippo Vanna are minor artists who recognizably emulated or adapted the Lorenzetti style. Elsewhere, a whole crop of schools and individual artists was engaged in imitating the Sienese or Florentine model, with varying degrees of success. One such group, active in the first half of the fourteenth century, modelled itself on Giotto. Members of this group later became known collectively

1344). One of Duccio's most important pupils, Simone Martini imbued refined Gothic themes with a sense of feeling. Active in Siena, Pisa, Assisi, Orvieto and Naples. His works include a famous *Annunciation* (Florence, Uffizi Gallery); the Chapel of St Martin (Lower Church, Basilica of St Francis, Assisi); *St Louis of Toulouse Crowning Robert of Anjou* (Capodimonte, Naples); *Guidoriccio da Fogliano*, 1328 (Palazzo Pubblico, Siena) and a *Maestà* (Palazzo Pubblico, Siena).

♦ **Pietro da Rimini**
(Rimini c.1309–? fl.1333). Prominent locally, Pietro da Rimini painted a *St Francis*, signed 1333, now housed in the Franciscan Monastery of Montottone (Ascoli Piceno). In his late years, he painted the frescoes in the Church of Santa Chiara, Ravenna. Other Rimini artists of the period include the Master of St Augustine, Giovanni Baronzio and Neri da Rimini.

♦ **Pisano** Giovanni (Pisa c.1245/48–Siena 1317?). Italian sculptor whose dramatic style influenced Giotto. He and his father, Nicola, executed several works together. An ivory *Madonna* in Pisa Cathedral is the first example of Giovanni's independent work. The reliefs on the Fontana Maggiore in Perugia were executed jointly (1278); other works include the façade design of Siena Cathedral executed between 1284 and 1296; the pulpit of the Church of Sant'Andrea, Pistoia; the pulpit of Pisa Cathedral executed between 1302 and 1310. The *Madonna of the Girdle* is Giovanni's own work, dating from c.1317.

♦ **Tommaso da Modena** (Modena c.1325/26–d. after 1368). The training of this interesting fresco

14

as the "Giotteschi." Some among them were Giotto's immediate followers; others, like Maso di Banco and Stefano Fiorentino, were sufficiently autonomous to be interesting in their own right.

Tuscan sculpture in the early fourteenth century is mainly noted for the talents of Tino di Camaino, Giovanni Balduccio and Lorenzo Maitani, who transmitted the style of Giovanni Pisano to all corners of Italy. Tino di Camaino's Gothic mannerism in turn influenced minor sculptors like Goro di Gregorio and Giovanni d'Agostino. By the middle of the century, Tuscan sculpture recognized the ascendancy of Florence, where the bronze reliefs of the Baptistry doors had recently been completed by Andrea Pisano, the most important and accomplished sculptor of the day who delicately blended Gothic and classical forms.

Meanwhile, Tuscan painting was developing in the

work of the Orcagna family whose technical prowess made their reputation in the region. The most famous of these artists, Andrea Orcagna, sought to "crystallize" Giotto's plastic vision in a rigid structure of planes and accentuated linearism. His

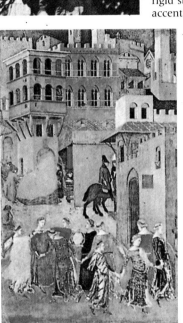

◀ *Ambrogio Lorenzetti,* Good Government, *detail, 1337–39, Palazzo Pubblico, Siena. The fresco is part of a vast political allegory which presents many innovative features, including an admonitory content and an elaborate arrangement of figures. The implicit didacticism and moralism and the problem of portraying such a weighty subject matter cannot, however, detract from the lyricism evident in the purity of line and colour.*

artist took place in Bologna. Here Tommaso was exposed to the Bologna miniaturists and to Vitale da Bologna (q.v.). He was active in the Veneto, particularly in Treviso where he painted a *St Catherine* and a *Madonna with Saints* in the Church of St Catherine (c.1349). Other fresco works in Treviso include the *Illustrious Dominicans,* forty figures of Dominicans executed in 1352 in the Chapter House of San Niccolò. Tommaso also worked in Prague, where he acquired a minor Bohemian following.

♦ **Veneziano** Paolo (Venice 1290?– d. between 1358 and 1362). An artist whose influence was crucial to fourteenth-century Venetian art. Paolo Veneziano's two works, *Death of the Virgin* in Vicenza (1333) and a *St George* in the Church of San Giacomo in Bologna, are good examples of his contrasting styles.

♦ **Vitale da Bologna** (c.1331–c.1369). Though sparsely documented, Vitale had a major impact on Bolognese art. He painted a fresco of *The Last Supper* in the cloister of the Church of San Francesco in Bologna. This was followed by the apse in Pomposa, a *Nativity* in Mezzarata and, in Bologna, a *Life of St Anthony,* a *St George* and a *Madonna* painted on wood. Vitale founded the Bologna school. His circle included Dalmasio, Jacopino di Francesco, Simone dei Crocefissi and Jacopo di Paolo.

◀ *Francesco da Rimini,*
Crucifixion, *Ducal
Palace, Urbino. The
Rimini school is
characterized by the use
of pale pigments and
soft tones.*

▼ *Lorenzo Maitani,* The
Creation of the
Animals, *detail,
Orvieto Cathedral.
Scene from a cycle of
stories from Genesis in
marble relief, begun in
1310.*

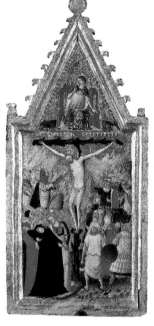

◀ *Master of* The
Triumph of Death,
*1335–40, Camposanto,
Pisa. The fresco has
been recently attributed
to Buffalmacco, an
artist of the Florentine
school. It is of special
interest because of the
curious arrangement of
scenes in a continuous
narrative.*

brothers, Nardo di Cione and
Jacopo, pursued Andrea's
expressive line, modified, in
Nardo's case, by a more
liberal use of colour and, in
Jacopo's, by a vibrant sense
of narrative.

Pisa at this time was be-
coming a polarizing force,
with the anonymous Master
of the *Triumph of Death* prob-
ably among the first fresco
artists to decorate the Cam-
posanto, followed, certainly,
by Andrea Orcagna and An-
tonio Veneziano.

By the late fourteenth cen-
tury Giotto's influence was
receding, maintaining only a
vestigial presence in the
work of Spinello Aretino and
Agnolo Gaddi.

In the first half of the cen-
tury a parallel artistic fer-
ment was in evidence in
Rimini, Bologna, Venice and
Lombardy.

The Rimini school was par-
ticularly active. The archaism
of Giotto and his followers
had made some impact but
not for very long. Siena and
contact with the cool colour
harmonies of the Ravenna
mosaics were major influ-
ences combined with a re-
vival of Pietro Cavallini's
classical type. The most fa-
mous name in the Rimini
school was Pietro da Rimini,
a refined artist capable of
great dramatic intensity and
lyricism.

Bologna enjoyed a more

cosmopolitan culture in
which the skills of miniatur-
ism, imported from France,
were flanked by a lingering
attachment to the Roman-
esque tradition. The scene
livened with the advent of
Vitale da Bologna in the
middle of the fourteenth
century. Vitale founded the
Bologna school, and his style
sprang from a fusion of
Gothic and Tuscan types, re-
peated in the work of his
pupils Jacopino di Francesco,
Simone dei Crocefissi and
Dalmasio.

▼ *Vitale da Bologna, St George and the Dragon, c.1350, Pinacoteca Nazionale, Bologna. The violence of the action causes an unnatural contortion in the horse involving rider and dragon in the* *sudden movement. The princess to the right succinctly completes the scene.*

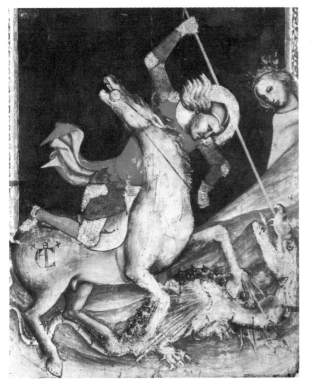

Modenese painting was represented by Barnaba and Tommaso da Modena who produced a linear art of interesting, individual character which in some ways anticipated the style, of several decades later, known as "flamboyant" Gothic. In comparison with other towns, there was little development in Venice, where entrenched Byzantinism discouraged the infiltration of external styles. However, Vitale da Bologna and Tommaso da Modena visited the Friuli and Veneto regions, thus opening the door for the first time to Emilian influences, discernible in a new local interest in strong pigments and sharp colour tones.

At the end of the thirteenth century, Venetian sculpture had been "converted" to a neo-Classicism that was vaguely Pisan in character though still not really liberated from the two-dimensional convention. In the fourteenth century, the De Santis family of stone-carvers were the first who created a blend of Venetian and Tuscan sculpture, while French and Tuscan models were formative influences in the case of two key Venetian sculptors, Pier Paolo and Jacobello delle Masegne.

If sculpture had been visibly susceptible to outside influences, the break from tradition in painting had been slow. The mosaic artists of St Mark's, though not familiar with Giotto and Siena, nonetheless managed to convey a general sort of eclecticism. Paolo Veneziano, a product of the Byzantine tradition, made passing reference

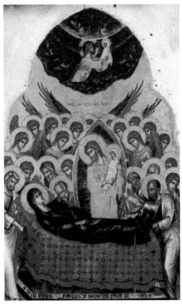

► *Paolo Veneziano, Dormitio Virginis, 1333, Museo Civico, Vicenza. The signed and dated central panel of a triptych formerly in the Church of San Lorenzo. The Byzantine imagery, painted in fourteenth-century Gothic manner, marks a change in Paolo Veneziano's style.*

17

1 GIOTTO AND THE FOURTEENTH CENTURY

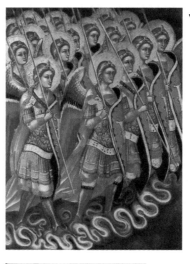

▼ Guariento, The Heavenly Host, c.1345, Museo Civico, Padua. Panel painting which forms part of a vast complex of paintings and decorations executed around 1345, the size and importance of which consolidated Guariento's artistic reputation. Chiaroscuro is employed to portray ranks of angels whose appearance suggests a knowledge of Giottesque plasticism.

▼ Giovanni De' Grassi, Damsels, Biblioteca Civica, Bergamo. Late fourteenth-century pen and wash drawing on parchment. De' Grassi was a miniaturist – as well as sculptor and architect – of delicacy and refinement, whose style combined northern, Franco–Flemish and Bohemian influences.

to Giotto while Lorenzo Veneziano used subtle and refined colours to soften his forms. Other painters, such as Zanino and Niccolò di Pietro, were inspired by northern ideas and reconciled these with influences imported from Bologna. By the end of the fourteenth century, Venice had finally shed her Byzantine past and would soon welcome the International Gothic style. Padua was also an important center for the arts with painters such as Guariento on the scene and the incisive talents of Giusto dei Menabuoi with his rhythmic forms, followed by the worthy Jacobello Alberegno and, at the end of the fourteenth century, by the gifted Veronese artist, Altichiero, founder of the Verona school and conciliator of Giottesque form and International Gothic fantasy.

The lesson of Giotto was not lost on Lombardy. Painters such as Giottino and Giovanni da Milano, who were already disposed to realism, had a concomitant interest in colour not only for its symbolic or plastic functions but as a means of rendering the subject more natural-looking. The most active period of artistic development in Milan involved the building of the Cathedral, with French, German and Italian craftsmen working side by side. The sculpture decoration of the Cathedral was a mammoth project lasting for decades and which saw the rise of the maestri campionesi, a local group of specialist masons and sculptors. These craftsmen were drawn to the bold Tuscan type, which they tempered with touches of realistic humility. Giovannino de' Grassi, a traditional figure among the artists in the Cathedral workshop, abandoned convention for a livelier plasticity, combining his talent for naturalistic design with International Gothic elegance tinged with fantasy. ∎

Simone Martini, St Louis of Toulouse Crowning Robert of Anjou, *Capodimonte Museum, Naples.*

The otherworldliness conveyed by this painting, mainly due to the "mystical" image of the saint, enhances, by contrast, the effect of reality achieved by the almost tangible and life-like profile of the king.

Andrea Pisano, St John in the Desert, *1330–36, south door of the Baptistry, Florence.*

The twenty-eight panels which make up the first bronze doors of the Baptistry consist of scenes of the life of the Baptist, contained in "decorative" quatrefoil frames. Pisano carefully exploits the available space in designs which show French Gothic influence, executed with "classical" sturdiness and vigour.

Altichiero, The Martyrdom of St George, *detail, 1384.*

The fresco shows St George about to be beheaded, surrounded by figures whose outline is echoed by that of the raised landscape behind.

Great Jubilee of the Church Model Parliament	Battle of Bannockburn Death of Philip the Fair	Hundred Years War begun by Edward III	Spread of the Black Death Battle of Poitiers	Peasants' Revolt Start of the Great Schism	House of Lancaster replaces House of Plantagenet Battle of Kossovo
Universities of Rome and Padua Marco Polo: *Il Milione*	Clare College, Cambridge Exeter College, Oxford	First use of naval artillery	Universities of Paris, Vienna, Cracow; Pembroke College, Cambridge.	Guy de Chauliac: *Chirurgia magna* First use of crossbow	Foundation of Winchester College by William of Wykeham
Positive organ with pedal keyboard	Philippe de Vitry: *Ars Nova*	Ghirardellus de Florentia	Guillaume de Machaut: *Notre-Dame Mass*	First popular rhymes about Robin Hood	Landino: motets
Dante: *Vita Nuova* Compagni: *Cronica*	Dante: *Commedia*	Petrarch: *Rime*	Boccaccio: *Decameron* Ranulf Higden: *Polychronicon*	St Catherine of Siena: *Libro della divina dottrina* First English translation of the Bible by John Wycliffe	Chaucer: *The Canterbury Tales* *Fioretti di San Francesco* (Little Flowers of St Francis)
Exeter Cathedral Doge's Palace, Venice	Loggia degli Ossi, Milan Papal Palace, Avignon	School of Rimini Rebuilding of Round Tower, Windsor Castle	Alhambra at Granada	Alcazar of Seville Ulm Cathedral	Palazzo Schifanoia at Ferrara
Giotto: *The Legend of St Francis: Scrovegni Chapel*	**Duccio di Buoninsegna:** *Maestà Altarpiece* **Simone Martini:** *Maestà*	**Andrea Pisano:** Doors of the Baptistry in Florence		**Orcagna:** Tabernacle in Orsanmichele, Florence	**Wilton Diptych**
1292–1310	1311–28	1329–46	1347–64	1365–82	1383–1400

Masaccio, The Rendering of the Tribute Money, 1424–26, detail, Brancacci Chapel, Church of Santa Maria del Carmine, Florence. From the fresco cycle depicting the lives of Saints Peter and Paul, this detail shows the right-hand scene of a three-part narrative painting of the biblical episode of the Tribute Money (Matthew XVII, 24). The manner of the composition – adjoining scenes on a single picture surface – belongs to medieval narrative conventions, yet this particular episode is perhaps the most forward-looking of the cycle. The balanced rhythm of the epic forms is strikingly effective, creating a new sense of drama and realism. Masaccio's stylistic innovations are immediately apparent in the humanity and "mass" of the figures, the effective use of perspective in the background architecture and in the unifying colour.

2 THE EARLY RENAISSANCE

At the beginning of the fifteenth century the historical conditions were being created that would eventually shape that vast movement of ideas, opinions and scholarship which we call the Renaissance. In Italy, the prosperity and growth of the major courts – Medici in Florence, Montefeltro in Urbino, Malatesta in Rimini, Este in Ferrara, Visconti followed by Sforza in Milan, and Anjou followed by Aragon in Naples – brought patronage and the desire for splendour and decorum, in both public and private matters, which elevated the arts to a prime place in society. In philosophy, a singular partnership was growing between the spiritual and secular worlds, the former reassessing the profane values of Graeco–Roman culture as not necessarily antithetical to "Christian truth." In science in general, a similar rapprochement was being entertained between esoteric disciplines such as alchemy and astrology and the natural and exact sciences.

A product of the new eclecticism was the revival of the classics, which were copied, revised and, in certain cases, even translated into the vernacular. The image of the intellectual changed: no longer that of a "cleric" in the service of Church propaganda but of a learned "philologist," privy to the secret of that universal and timeless knowledge, which was once the preserve of the Greeks and now was reborn in an equally secular and progressive society. In the previous century Petrarch had been

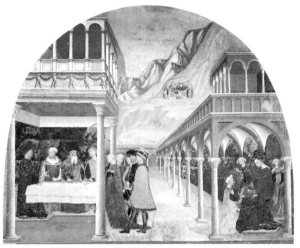

▲ Masolino da Panicale,
The Feast of Herod,
1435, Baptistry,
Castiglione Olona. The
spatial arrangement
here is dominated by a
remarkably realistic
architectural framework
which combines
elegantly with the
Gothic fancy of the
figures.

◄ Lorenzo Ghiberti,
Sacrifice of Isaac,
1401, panel of the
north Baptistry door,
Bargello Museum,
Florence.

the first to espouse the "philological" approach to classical literature and had now become the focus of humanist artists and thinkers such as Lorenzo Ghiberti, Guarino Veronese, Lorenzo Valle, Leon Battista Alberti, and, later, Andrea Mantegna, Enea Silvio Piccolomini (Pius II), Gianfrancesco Pico della Mirandola, Angelo Poliziano and Marsilio Ficino: men who studied ancient texts and Roman monuments for gleanings

about the meaning of life. The climate of renewal saw the arts, too, in search of a new language, one based on scientific principles that would emphasize the centrality of man, who was simultaneously the propounder and the object of all knowledge. Mathematical research became indispensable to the rationalization of architecture and to the three-dimensional projection of the two-dimensional image. Filippo Brunelleschi experimented

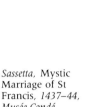

◄ *Masolino and Masaccio,*
Madonna and Child
with St Anne, 1424,
Uffizi Gallery, Florence.

with optical physics and developed a perspective "system" by which he could erect a building to a grand, unified design. Piero della Francesca used the same method to construct a picture, the unity achieved by having a single perspective point usually taken from the eye of the observer, the fundamental metaphor for any cognitive process. In painting and sculpture, from Masaccio and Donatello onwards, an explicit naturalism was aimed at, meaning the gradual mastery of the art of distinguishing between what is "beautiful" and what is "real."

The transition from Gothic to Renaissance art forms was not as swift and straightforward as one might think. Works by the "new men," executed in Florence around 1420, were, on the whole, isolated and there were no corresponding examples in other regions. In Florence itself, at that time, future humanists were still thinking in fourteenth-century terms.

▼ *Sassetta,* Mystic
Marriage of St
Francis, *1437–44,*
Musée Condé,
Chantilly. Sassetta's
art, like Masolino's,
shows the variety of
forms that were
practised during the
early stages of the
Renaissance in terms of
the critical and selective
retention of certain
Gothic types.

One such was the sculptor Lorenzo Ghiberti, who later wrote the influential philosophical treatise *Commentarii* (1447–55). In 1401 Ghiberti won the competition for the reliefs of the second pair of bronze doors of the Baptistry in Florence. The doors have distinct Gothic elements since Ghiberti was conditioned by Andrea Pisano's first bronze doors of fifty years earlier. This shows in the organization of the limited relief field and in the dynamics of the action (note the winning panel *Sacrifice of Isaac*). The work of two other major contemporary sculp-

BIOGRAPHIES

◆ **Alberti** Leon Battista (Genoa 1406– Rome 1472). Florentine by descent, Alberti studied in Padua, Bologna and Rome, receiving a typically humanistic education in philosophy and literature. With these advantages, and a passion for the ancient world, Alberti felt equipped to fulfil the role of "global artist" of the Renaissance: poet, philosopher, scholar, painter, and archaeologist. Alberti

was responsible for some of the finest architecture of the Quattrocento, including the Rucellai Palace in Florence (1447–51), the Tempio Malatestiano in Rimini (1450), and the Church of Sant'Andrea in Mantua (1470 plan). As theoretician and man of letters, Alberti's legacy includes the treatises *De pictura* (1435), *De re aedificatoria* (c.1450) and *De statua*; a play, *Philodoxus*; and various scholarly works.

◆ **Angelico** Fra Guido di Pietro, Fra Giovanni da Fiesole, called (Vicchio, Florence c.1395–Rome 1455). Shortly after his artistic debut Angelico entered the monastery of San Domenico in Fiesole. Though trained in the new style, Angelico evinces first and foremost a deep sense of faith which is reflected in the expressions of gentle piety and in the inventive use of light to convey mysticism.

◆ **Brunelleschi** Filippo (Florence 1377–1446). After early training as a sculptor and goldsmith Brunelleschi entered the competition of 1401 for the second bronze doors of the Florence Baptistry which was won by Ghiberti. In 1402 Brunelleschi made the first of several archaeological visits to Rome in the company of Donatello. Brunelleschi's first major commission was the building of the

among leading sculptors of the early fifteenth century, to the extent that he influenced successive artists from the talented Niccolò dell'Arca, author of an impressive *Pietà* in the Church of Santa Maria della Vita in Bologna (1485) to the likes of Michelangelo. By and large, however, the Gothic style endured, proliferating throughout Europe in the court style known as "International Gothic" whose aristocratic, decorative qualities informed a good deal of Italian painting and sculpture in the first half of the fifteenth century.

In Florence, with the youthful Masaccio at his side, the painter Masolino da Panicale was decorating the walls of the Brancacci Chapel in the Church of Santa Maria del Carmine. Masolino must

tors, Jacopo della Quercia and Nanni di Banco, displays similar Gothic residues, though markedly modern and original tendencies are to be found in Della Quercia's justly celebrated tomb of *Ilaria del Carretto* in Lucca Ca-

thedral (1408), *Fonte Gaia* in Siena (1409–19) and scenes from Genesis in the portal of the Basilica of San Petronio in Bologna (1425–38). Della Quercia's attachment to Gothic plastic values was no obstacle to his position

have been astonished at the power of the hand at work beside him. Even if Masaccio's style is formed on foundations laid by Giotto a hundred years earlier, what distinguishes him from Masolino – an artist whom he

dome of Florence Cathedral, a monumental structure combining Gothic and Renaissance architectural forms (1418). There followed the Churches of San Lorenzo (c.1420) and Santo Spirito (1436), the Hospital of the Innocents and the Pazzi Chapel (c.1430) in the Church of Santa Croce: all key works in the early development of modern European architecture.

♦ **Donatello** Donato di Niccolò di Betto Bardi, called (Florence 1386–1466). Generally considered to be the founder of Renaissance sculpture, Donatello was evidently a fast learner in Lorenzo Ghiberti's workshop, applying principles and solving problems of which his teacher had been only dimly aware. Interested as Donatello was in three-dimensional problems, his art was characterized mainly by "pagan" influences

(the *David* of 1409 in the Bargello Museum is a case in point, as is the *Cantoria* of 1433– 39 in Florence Cathedral). His later style is more expressive, reflecting Renaissance notions of the drama and nobility of life. This spirit can be seen in the forceful equestrian monument to *Gattamelata* in Padua (1446–50); it was similarly displayed in the sculpture for the high altar of the Basilica of St Anthony (now altered) and is

particularly evident in the *Magdalen* in the Florence Baptistry (1453–55).

♦ **Foppa** Vincenzo (Brescia c.1427– c.1575). A contemporary of Piero della Francesca and Mantegna, Vincenzo Foppa, whose early work was in the Gothic idiom, had by 1450 developed a Renaissance language independently of Piero and Mantegna. The frescoes of the *Life of St Peter* of 1466–68 that

International Gothic

Lorenzo Monaco, Adoration of the Magi, 1422, detail, Uffizi Gallery, Florence.

Adoration of the Magi by *Lorenzo Monaco is a typical example of Quattrocento art and culture. The style seems alien to what we think of as belonging to the Renaissance, more akin to fourteenth century notions of narrative and pictorial space. International Gothic is more than the survival of a type of art which has outlived its historical origins: it is the very successful evolution of outmoded forms towards highly sophisticated and refined formal solutions, due in part to the stimulus created by the impact of new ideas on artists who were slow to share them. It is called ''International'' because of the proliferation of an art whose sumptuousness and considerable dignity save it from looking decadent or out of date.*

admired – is precisely what separates the Gothic world from the Renaissance movement: Masolino seeks elegant solutions for his world, achieved with techniques that are essentially decorative in character, whereas Masaccio's vision is dramatic, imbued with a sense of the profane even when the subject is religious. The discovery of the individual being conjoined with the profound and unstinting ''humanity'' of God incarnate, this ''human being'' formed of sorrow and passion, whose dignity is rooted in pain, emotion and feeling, is now the center of a world created for him, dominated by him, of which he is the essence – the essence, too, of Masaccio's art. Thus man is depicted as the ''subject'' (a concept still almost unheard of towards the end of the Middle Ages), meaning that man is in control of his own destiny and above all is the parameter for defining world phenomena. In this scheme of things, nature, too, ac-

quires a new meaning: no longer a ''background'' art, introduced to amaze and delight the eye but a living element to explore and comprehend. It is the dwelling place of the subject. Man and Nature are joined, reflecting each other, reducing all things to one: the macrocosm understood through the microcosm and vice versa – that is the goal of Renaissance art.

Yet, as indicated, Masaccio and a few other precursors were isolated cases in this period of transition and profound change, and no survey of the first half of the Quattrocento can be made without proper reference to the already-mentioned International Gothic style which permeated so much of Italian art of that time. Important exponents of the style include Gentile da Fabriano and Lorenzo Salimbene from the Marches; Antonio Vivarini, Jacopo Bellini, Pisanello and Stefano da Verona in the Veneto; Michelino da Besozzo and Bonifacio

decorate the Portinari Chapel in the Church of Sant'Eustorgio, Milan, and the *Madonna* housed in the Museum of the Castello Sforzesco in Milan are examples of Foppa's refined monumentality and muted tonalities. Foppa is regarded as the founder of the Lombard school.

♦ **Lippi** Filippo (Florence c.1406– Spoleto 1469). As a young Carmelite, Filippo Lippi had the

opportunity of seeing Masaccio at work in the Brancacci Chapel, situated in his own convent church of the Carmine in Florence. In 1456 Lippo abducted a young nun who would bear his artist son, Filippino. Condemned by the Church, Lippo was

later pardoned following the intercession of Cosimo de' Medici. Although the influence of Masaccio was at the core of Lippo's artistry, the *Annunciation* in the Church of San Lorenzo (c.1440) and the frescoes in Prato Cathedral (1452–64)

show the distinctive style of Lippi's maturity.

♦ **Mantegna** Andrea (Isola di Carturo, Padua 1431–Mantua 1506). Mantegna was an apprentice in the Paduan workshop of Francesco Squarcione, in the company of Giovanni Bellini, Tura and Crivelli. His enthusiastic and learned approach to humanism and boldness as an innovator place him high among the

▼ *Donatello*, Judith and Holofernes, *1455–60, Piazza della Signoria, Florence. The first examples of Renaissance sculpture are characterized by heightened expressivity. Here, it is as though*

Donatello's marble has become the "martyred" object, in the angles and hollows of the graphical elements that make up the three-dimensional image.

▼ *Donatello*, Cantoria (Dance of the Putti), *1433–39, Florence Cathedral. Donatello's early and mature styles, preceding the tragic religiosity of his last works, display an exuberant, Dionysian*

world almost pagan in spirit.

Bembo in Lombardy; and Lorenzo Monaco, Sassetta and the Master of the Observance in Tuscany. Pisanello and Sassetta show some affinity with the Renaissance spirit. The weightier Masolino, in his important frescoes in the Baptistry of Castiglione Olona of 1435, shows a familiarity with perspective techniques, and it must be supposed that his collaboration with Masaccio on several occasions had not been a chance one. In 1424 the two achieved a surprising accommodation in the *Madonna and Child with St Anne,* in which differing styles combine and blend with one another. There is no feeling of awkwardness about the bulk of Masaccio's strongly modelled Virgin and the shallowness of Masolino's symbolic background, representing respectively the

prototypical artists of the Renaissance. Mantegna's work is also distinctive in its emphasis on archaeological features. Among his most famous paintings are the foreshortened *Dead Christ* of 1480 in the Brera Art Gallery, Milan, and the wall decorations in the *Camera degli Sposi* in the Ducal Palace, Mantua. The Mantuan decorations are among the most interesting examples of Quattrocento art.

♦ **Masaccio** Tommaso di ser Giovanni di Mone Cassai, called (San Giovanni Valdarno 1401–Rome 1428). Masaccio was a painter of seminal importance to the Renaissance movement. His career began in Florence, working as Masolino's young partner on the frescoes in the Brancacci Chapel in the Church of the Carmine (1424–26). These show the immense innovative power of this artist

whose brief career was nothing short of meteoric. Other master works include the *Pisa Polyptych* of 1426 and the fresco *The Trinity* in Santa Maria Novella, Florence.

♦ **Masolino da Panicale** Tommaso di Cristoforo Fini, called (Panicale in Valdarno 1383–1440). Considerably older than Masaccio, Masolino's standing was obscured by his young partner's genius in spite of the

interesting position he holds in the transition from Gothic to Renaissance art. The frescoes of the *Life of St John the Baptist* in the Baptistry of Castiglione Olona (1435), one of the important works in the development of Lombard art, demonstrate that Masolino was far more modern in outlook than is suggested by his fresco work in the Brancacci Chapel.

♦ **Tura** Cosimo (Ferrara c.1430–95).

25

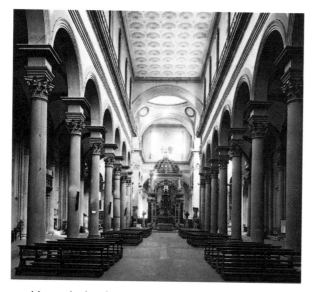

▼ *Filippo Brunelleschi,* Basilica of Santo Spirito, *interior, c.1436 plan, Florence. Applying the rules of perspective in architecture demands a rational analysis of three-dimensional* space, so that the end result can be "measured" entirely with the eye and not seem out of scale.

earthly and the heavenly mysteries: two orders, two styles. The features of Mary and Jesus carry hints of the dramatic expressiveness which would be developed in Donatello's late sculpture, for example, the *Magdalen* of 1453–55 and the *Judith* of 1455, or the exuberantly modelled putti in his *Cantoria* of 1434–39. Masaccio achieves these effects by the innovative use of chiaroscuro as a modelling tool. He also demonstrates a feeling for anatomical proportions through his knowledge of Roman statues as well as a feeling for spatial harmony, the agreeable disposition of the solid image in its surroundings. Similar considerations lie at the heart of Brunelleschi's architecture, from the traditional cupola of Florence Cathedral to the Hospital of the Innocents, the Pazzi Chapel and the magnificent Basilicas of San Lorenzo and Santo Spirito – buildings which perfectly balance the architectural and functional elements, not because of some general aesthetic sense ar-

The court-centered art of Ferrara, or the Ferrara school, was founded by Tura, an extraordinary artist whose early work shows the influence of Donatello's Paduan subjects. Tura's peculiar style results from attempts to reconcile his humanistic sensibility with late Gothic techniques. The effect is quite bizarre, but Tura's ability to paint subjects that are epic and intimate at the same time is nonetheless fascinating and can be appreciated in his two masterpieces, the great *Organ Shutters of St George* in the Cathedral Museum, Ferrara (1469) and the *Roverella Altarpiece* of 1470–74.

♦ **Uccello** Paolo, Paolo di Dono, called (Pratovecchio 1397– Florence 1475). One of the precursors of "scientific" perspective, Uccello's reputation rests on his visionary genius coupled with a formidable technical knowledge. His passion for experimenting with new geometrical ideas gives his work a rather clinical, stylized quality; however, this is often tempered by narrative sensitivity and skilled foreshortening, as in *St George* in the National Gallery, London.

▼ *Leon Battista Alberti,*
Tempio Malatestiano,
*façade, 1450, Rimini.
Sigismondo Pandolfo
Malatesta commissioned
the refacing of the
Gothic Church of San
Francesco, Rimini.
Although the new*
*façade was never
finished, it shows the
humanistic and classical
cast of Alberti's
intellect. The existing
building is unique for
its unabashed mingling
of Christian and pagan
elements. This is not*
*just true of the
architecture but also of
the interior sculpture
decorations by Agostino
di Duccio.*

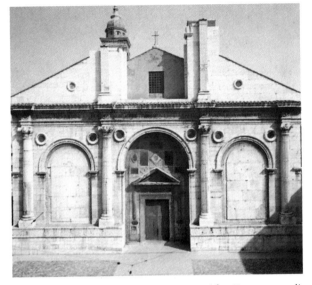

rived at intuitively but as a result of the rational use of geometrical proportions observed from an ideal point.

The oblong of the traditional basilical plan is also the basic form used in the architecture of Leon Battista Alberti. Alberti's buildings tend to be more "archaeological" than Brunelleschi's. The façade design of the Tempio Malatestiano in Rimini erected in 1450 is a careful imitation of the front of the Arch of Constantine in Rome.

Later, with Francesco di Giorgio Martini and Luciano Laurana, author of the Ducal Palace in Urbino, Alberti transformed the rectangular module of the early Renaissance with his theory of architecture based on a complex system of circles.

Brunelleschi was the first to develop Alberti's ideas for an artificial perspective system based on the vanishing point. He pioneered the "linear perspective" which was a means of unifying visible

space, thereby creating the illusion of reality, and was famous for his experiments with small models and mirrors. Paolo Uccello's obsessive researches led to Vasari's comment that he was so preoccupied with his experiments that he forgot to attend to his conjugal duties. Ultimately, however, it was Piero della Francesca who in the middle of the fifteenth century produced the first fully developed theoretical system based on Albertian

▶ *Paolo Uccello, Rout of
San Romano. The
Unseating of
Bernardino della
Ciarda, 1456, Uffizi
Gallery, Florence. The
battle of San Romano is
the subject of three
panel decorations now
split up and found in
three European
museums. Their interest
lies in the experimental
handling of linear
perspective.*

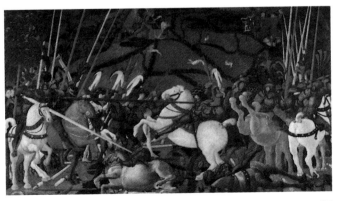

▼ *Fra Angelico,* Last
Judgement, *1432–35,
Museum of San Marco,
Florence. The
compositional
arrangement of this
youthful work and the
majority of the
iconographic solutions*
*(the ring of angels, the
''stewing'' sinners) are
clearly of Gothic origin
though there are hints
of the great artist and
innovator to come.*

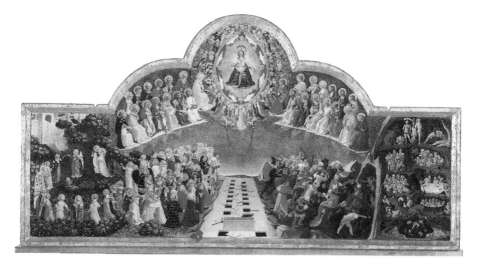

ideas. Paolo Uccello's interest in perspective solutions appears to undermine the aesthetic result. In orthogonal arrangements such as found in the *Rout of San Romano* in the Uffizi Gallery, the organization of the foreground elements at right angles is intended to highlight the importance of the vanishing point, while the background is seemingly left to its own devices so that the effect, as a whole, is curiously distorted. The Dominican friar, Fra Angelico, was a superb colourist with a gift for imaginative tension. While versed in contemporary perspective techniques, Angelico appears mainly concerned with the effects of light. In *The Last Judgement* at the Museum of San Marco, Florence, radiant light becomes the true focus of the scene; the radiance is divinely inspired, it is not sunlight, a concept that distinguishes the pious and gifted Angelico from the more secular positions of Renaissance art. Angelico's contemporary, Fra Filippo

Lippi, was a pupil of Masaccio. Lippi emulated and ''sweetened'' Masaccio's calm dignity while the vigorous Andrea del Castagno startled the art world with his anticipations of Piero della Francesca. Filippo Lippi, Andrea del Castagno and Domenico Veneziano were equally conversant and skilled in the use and development of the new techniques, though none was truly an inventor. Similarly in sculpture Luca della Robbia was important as a developer rather than inventor while Agostino di Duccio, Antonio Rossellino and Desiderio da Settignano were the most competent among Donatello's followers.

The Renaissance reached the northern parts of Italy around 1450. The young Andrea Mantegna and Giovanni Bellini shared the same artistic interests and were related by marriage. The presence of Donatello in Padua during the 1450s was a strong influence. His now dismembered altarpiece for the Basilica of

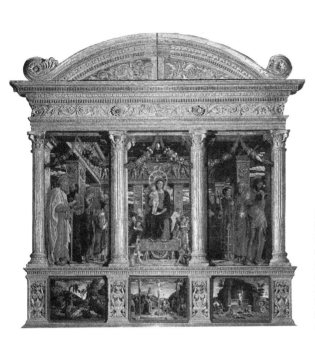

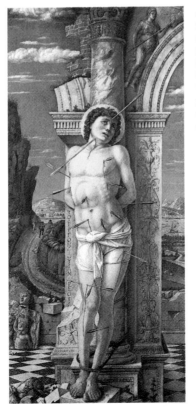

◄ *Filippo Lippi,*
Tarquinia Madonna,
*1437, Palazzo
Barberini, Rome. An
important early work
which shows the
influence of Lippi's
teacher Masaccio.
Within an extremely
concentrated framework
Lippi has created a
spatial structure in
which modelling and
perspective take
precedence over subject
matter.*

► *Andrea Mantegna,*
Martyrdom of St
Sebastian, *1459–60,
Kunsthistorisches
Museum, Vienna. St
Sebastian must have
been a fascinating
theme for Mantegna in
that he was able to
depict the classical male
nude and the world of
antiquity at the same
time.*

Sant'Antonio was an impor-
tant "training ground" for
the young avant-garde artists
of the Veneto and corner-
stone of the new art in the
north of Italy. Donatello's in-
fluence on Mantegna shows
in the heightened expres-
sivity of the frescoes in the
Ovetari Chapel in Padua of
1452–53, and in the *San Zeno
Altarpiece* of 1458 in Verona,
though subsequent studies of
classical findings fuelled still
further Mantegna's striving
for sculptural solutions. Man-
tegna loved the classical
world, which he mytholo-
gized into a sort of lost para-
dise; that, and his skill as a
draughtsman, resulted in a
style in which sophisticated
modelling and bold perspec-
tives are mixed with an al-
most excessive Gothic-like
linearism. The *St Sebastian,*
1480, now in the Louvre,
shows Mantegna's love of
antiquity; genuine archae-
ological remains feature in a
narrative scene with a strong
sense of history.

Giovanni Bellini was a dif-
ferent character of a more
tractable disposition, prefer-
ring from the start the
subtleties of colour, the soft-
ness of contour and the
psychology of faces and ex-
pressions. It was only when
he met Piero della Francesca
around 1470 that Giovanni
Bellini reached full artistic

29

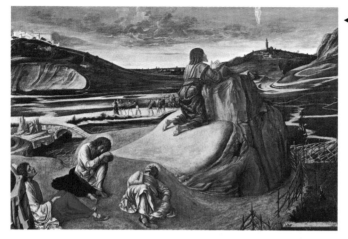

◀ *Giovanni Bellini*, The Agony in the Garden, *1459, National Gallery, London. The younger Bellini and Mantegna were stylistically close though Bellini was inclined towards a more lyrical approach. This work already hints at his future development in the direction of poetical solutions through the use of light and colour.*

maturity. In 1459 he painted *The Agony in the Garden* which is a fine lyrical example of the already considerable gifts of the founder of the Venetian school.

Other innovative artists active in the Italian north at that time were Vincenzo Foppa in Milan, Cosimo Tura in Ferrara and Carlo Crivelli first in Venice and then in the Marches. These artists were watching as northern European trends were spreading south through wars and commercial links with Italy. They created microstructures out of borrowed detail from the International Gothic style. The pursuit of the traditional did not, however, deter them from embracing every new Florentine trend that they could recognize as such. Indeed, the way that these artists constructed space was every bit as advanced in conception as the example of their Florentine peers: more intuitive and less rigorous, perhaps, but just as effective, as Foppa's *Crucifixion* of 1454 shows; or Tura's *Primavera*, in which the

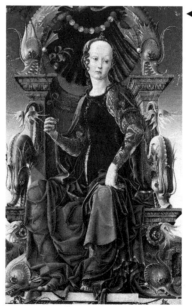

◀ *Cosimo Tura*, Primavera, *1460–63, National Gallery, London. Tura's world is a mixture of archaic detail and new techniques. He excelled in the "art of contradiction" and therein lies his fascination for us today. For example, in this allegorical representation, whose symbolism seems to have some connection with alchemy, what immediately catches the eye is the contrast between the gentle expression of the goddess and the curiously spiky, almost "metallic" furnishings of her throne.*

mythological goddess – perfectly constructed within a three-dimensional plane – seems like an etching in her sharply draped robes, spiky throne and a shell devoid of vestigial Christian symbolism. Painted around 1460–63, perhaps for Duke Borso d'Este, this picture, with its air of paganism (described by Roberto Longhi as fearsome and sharp as an effigy of Borneo) is one of the most telling statements of the Renaissance in that it openly represents a subject laden with esoteric allusion, executed by means of rational observation. ∎

Filippo Brunelleschi,
Sacrifice of Issac, *1401,
Bargello Museum, Florence.*

*Brunelleschi submitted this
design for the second bronze
doors of the Baptistry in Florence
(Ghiberti submitted the winning
entry). It shows how, at this
stage, Brunelleschi still belonged
to the Gothic cultural
mainstream. Only twenty years
later was he broaching new
frontiers.*

Fra Angelico,
Tabernacle of the Linaiuoli
(Linaiuoli Madonna), *1433,
Museum of San Marco, Florence.*

*This is a transitional work
belonging to the period when
Angelico was beginning to
discard his youthful Gothic style
for the Renaissance inspiration
that characterized his mature
style.*

Carlo Crivelli, Madonna
della Passione, *1460,
Castelvecchio Museum, Verona.*

*The style in Crivelli's early
works, completed before 1475, is
light and graceful, providing one
of the most appealing and
enchantingly poetic moments of
the Italian Renaissance.*

Persecution of the Lollards	Battle of Agincourt	Coronation of Henry VI	Henry VI crowned King of France	Henry VI marries Margaret of Anjou	End of Hundred Years War
Union of Poland and Lithuania	Treaty of Troyes		Joan of Arc burned at the stake	Alfonso of Aragon enters Naples	Turks capture Constantinople
Rinio: *Liber de simplicibus*	Toscanelli: calculations for the dome of Florence Cathedral	Lincoln College, Oxford	Cabral discovers the Azores	King's College, Cambridge	Maso Finiguerra's use of niello contributes towards the development of engravings
University of Turin	University of St Andrews	Development of woodcuts	Universities of Poitiers and Caen	Discovery of Cape Verde	
First mention of dulcimer	Johannes Ciconia: *De proportionibus musicae*	Guillaume Dufay at Rimini, then Turin and Bologna		Gilles de Binchois and Guillaume Dufay at Mons	Death of John Dunstable
Lino Salutati: *Laudatio florentinae urbis*	Leonardo Bruni: *Historiarum florentini populi*	Thomas Walsingham: *Historia Anglicana*	Alberti: *De pictura*	Bracciolini: *De varietate fortunae*	Giovanni Pontano: *Amorum libri*
	Thomas Occleve: *De regimine principum*		Vergerio: *De ingenuis moribus et liberalibus studiis*	Lorenzo Valla: *De Elegantiae linguae latinae*	
Competition for the door of the Baptistry in Florence	Competition for the dome of Florence Cathedral	Completion of the cloisters at Norwich Cathedral	Cardinal Bessarion in Florence	Vatican Library	Neo-Platonist academy in Florence
	Temple of Heaven, Peking		Foundation of Laurentian Library in Florence		Enea Silvio Piccolomini elected Pope
Della Quercia: *Tomb of Ilaria del Carretto* in Lucca Cathedral	**Nanni di Banco:** *Four Crowned Saints* in Orsanmichele, Florence	**Masolino and Masaccio:** Brancacci Chapel, Florence	**Paolo Uccello:** *Giovanni Acuto*	**Andrea del Castagno:** *Last Supper*	**Ghiberti:** *Porta del Paradiso* in the Baptistry, Florence
Donatello: *David*	**Brunelleschi:** *Hospital of the Innocents, Florence*	**Gentile da Fabriano:** *Adoration of the Magi*	**Fra Angelico:** Convent of San Marco, Florence	**Fra Angelico:** Niccolina Chapel	**Paolo Uccello:** *Rout of San Romano*
1400–10	1411–20	1421–30	1431–40	1441–50	1451–60

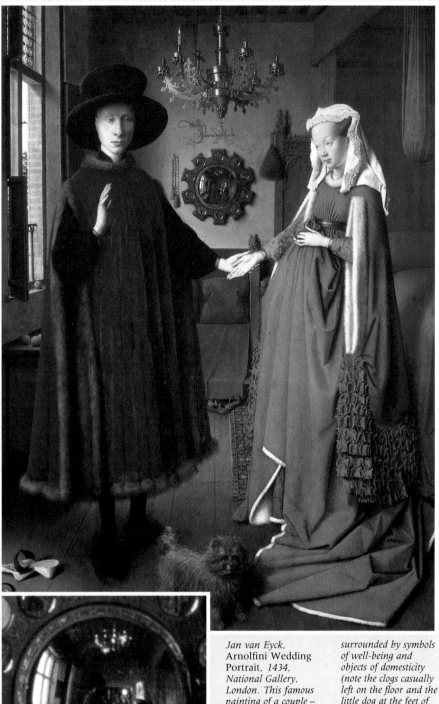

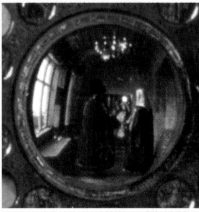

Jan van Eyck, Arnolfini Wedding Portrait, *1434, National Gallery, London. This famous painting of a couple – signed and dated on the wall above the mirror – is thought to be the first ''bourgeois'' portrait in the history of art. The Tuscan merchant Giovanni Arnolfini is pictured with his wife at his home in Bruges,* surrounded by symbols of well-being and objects of domesticity (note the clogs casually left on the floor and the little dog at the feet of his masters). The image is constructed with a ''scientific'' understanding and clarity of vision which is as impressive as any of the most significant Italian works of the period.

3 THE RENAISSANCE IN NORTHERN EUROPE

The historical phenomenon which we refer to today as the Renaissance was by no means confined to Italy. Any study of the Renaissance must also take into account the revolutionary contribution made by German and French humanists to science and philosophy, as well as the major innovations that took place in the arts in Northern Europe.

Throughout the fifteenth century new forms in painting appeared that were largely unaffected by southern influences. Flemish art is the most significant example of this, with the development of a pictorial tradition based on linear perspective and chiaroscuro modelling, the same techniques that had vitalized the Italian art of this period. Yet there is no evidence to suggest that these events were connected as a result of the proliferation of Tuscan types. What happened in the North was rather the result of an autonomous movement that had evolved internally, from precedents that had had some contact with Italian art through commercial and economic links (Florentine banks had agents in Bruges and Ghent) but had not been crucially influenced by it. Jan van Eyck, founder of the Flemish school, was active in Ghent at the same time as Masaccio was in Florence and executed his great altarpiece for the Cathedral of St Bavon in Ghent between 1426 and 1432. The Ghent Altarpiece is to Netherlandish art what the Brancacci Chapel frescoes are to Italian painting. Later trends in

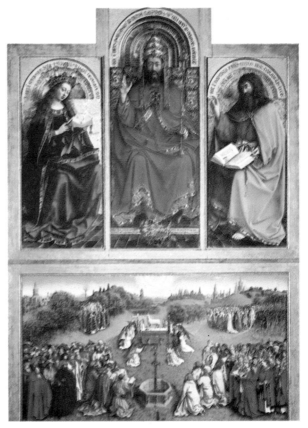

▲ *Jan and Hubert van Eyck,* Adoration of the Lamb, *1426–32, polyptych, St Bavon Cathedral, Ghent. The twelve sections that make up the altarpiece* *in Ghent Cathedral are as important to Flemish painting as the Brancacci Chapel in Florence is to Italian art history.*

fifteenth-century painting originated in the attention to atmosphere, in the spatial and natural harmonies and in the warm glow of the colours of Van Eyck's masterpiece, whose influence was widespread, extending, for example, to late-fifteenth-century Venetian art. The main panel of the altarpiece, the *Adoration of the Lamb*, painted in conjunction with

Hubert van Eyck, Jan's brother, has as its central vanishing point a theological symbol. The atmosphere in this panel contrasts with the secular tones of the figures in the outside wings. The vanishing point coincides with the symbol of the dove; the main compositional elements – the four human processions at the four cardinal points and the Lamb on the

des significations symboliques et théologiques très éloignées des aspects « profanes » prisés des Toscans : le point de fuite coïncide avec la colombe divine et l'ensemble de la composition (avec les quatre cortèges humains aux quatre points cardinaux et l'agneau au centre sur le maître-autel) obéit à l'ordre supérieur établi par la présence du Saint-Esprit. Dans les parties du polyptyque exécutées par Jan, par exemple, les figures d'Adam et Ève, le sentiment profond de la condition de l'homme typique de Masaccio est rendu avec une superbe évidence par la parfaite sensualité en clair-obscur des visages et des expressions, même s'il est médité, cependant, dans un langage différent, moins dramatique, plus esthétique, que celui des figures de la chapelle Brancacci.

La culture gothique concourt, certes, à l'élaboration du style de Van Eyck. Sa sensibilité se

Les peintres flamands du XVᵉ siècle utilisent une technique nouvelle, appropriée à ce soin du détail, caractéristique la plus spectaculaire de leur œuvre : ils mélangent les terres et les couleurs avec de l'huile au lieu d'eau. Ils suppriment ainsi, sur la surface peinte, tout risque de « transparence » excessive (au sens physique comme métaphorique) et obtiennent l'éclat dur et glissant d'une couleur presque minérale, émaillée, dense et compacte. La peinture à l'huile sur toile, encore inconnue dans le reste du monde, permet ainsi d'allier l'extrême précision de la touche la plus légère aux dégradés chromatiques et aux clairs-obscurs d'un raffinement suprême. Dans la Nativité du Triptyque Portinari (Offices, Florence), exécutée par Hugo Van der Goes entre 1475 et 1477, opacité et riche splendeur coexistent dans une gamme tonale froidement contrôlée, qui répond bien à l'exigence de modeler les corps non pas de façon abstraite, mais à partir de la lumière qui les caresse.

nourrit simultanément de l'héritage du Trecento et des techniques les plus modernes (comme la peinture à l'huile) et lui donne un amour presque obsessionnel du détail, de la micro-narration. On décèle une certaine complaisance dans une telle vocation de miniaturiste ; d'ailleurs, à l'évidence, aux Pays-Bas, la valeur d'un artiste dépend également de son habileté à exécuter, un à un, tous les poils de la barbe d'Adam, toute l'orographie de rides et boutons du visage infiniment « tourmenté » d'un certain prélat (la *Vierge du chanoine Van der Paele,* 1436), ou le minuscule reflet dans le miroir lointain du marchand *Arnolfini et sa femme,* avec les scénettes encore plus petites sur le cadre circulaire. Dans ce tableau (comme peut-être jamais encore) apparaît le point fort de la peinture flamande : cette grandiose capacité dans le portrait et la description, la vérité

LES PROTAGONISTES

◆ **Fouquet,** Jean (Tours vers 1425-vers 1480). Miniaturiste remarquable, il se rend en Italie entre 1444 et 1447, où il rencontre Fra Angelico et Domenico Veneziano. Il illustre vers 1450 le *Livre d'heures d'Étienne Chevalier.* De ses tableaux, il faut citer la *Vierge entourée d'anges* d'Anvers, le *Portrait de Charles VII, roi de France* au Louvre.

◆ **Froment,** Nicolas (Uzès vers 1435-Avignon vers 1483). Son nom est lié au triptyque du *Buisson ardent* (1475) consacré à l'épisode biblique, et conservé dans la cathédrale d'Aix-en-Provence.

Dans cette œuvre, l'une des plus belles du siècle, sont présents la description très méticuleuse des Flamands et le sens si chaleureux de la nature qui caractérise l'art italien.

◆ **Lochner,** Stephan (Meersburg vers 1410-Cologne 1451). Par son interprétation lyrique et persuasive des styles du gothique international, il se situe parmi les plus fins interprètes de la peinture allemande du XVᵉ siècle.

◆ **Maître de Flémalle,** généralement identifié à un certain Robert Campin (actif entre 1410 et 1440 environ). L'absence totale

▼ *Rogier Van der Weyden, Déposition de Croix, vers 1435, musée du Prado, Madrid. Intensité dramatique, élégance graphique, équilibre de l'espace et des volumes, habileté descriptive sont sans* doute les principales caractéristiques de la peinture de Van der Weyden, peut-être moins révolutionnaire que celle de Van Eyck, mais tout aussi capable d'atteindre la perfection.

sans limite d'un style qui cherche, au-delà de tout compromis, à rendre la réalité absolue, et la relativise en la situant dans la dimension espace-temps qui lui appartient, comme dans une coquille qui en garantit l'authenticité. De là provient la science de la construction de Rogier Van der Weyden, indéniablement influencé par Van Eyck, son goût pour les effets d'atmosphère, son art merveilleux de disposer chaque objet à sa place dans une atmosphère unique, comme dans l'*Adoration des bergers* de Berlin.

On peut alors se demander quels sont les précédents formels à la révolution de Van Eyck et de Van der Weyden, les racines d'une telle culture visuelle. Il faut évoquer une troisième figure remarquable de la région, un peintre plus âgé : le Maître de Flémalle, resté longtemps sous-estimé, et qu'il faut probablement identifier à Robert Campin. Son rapport avec

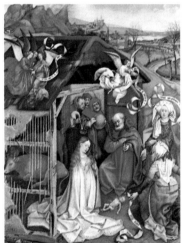

Maître de Flémalle, Nativité, vers 1425, musée des Beaux-Arts, Dijon. En dehors des bergers qui apparaissent à la fenêtre de la cabane, prototypes d'une longue série iconographique, d'autres détails sont remarquables : les anges portant des banderoles, la grille de roseaux qui laisse entrevoir le bœuf, la silhouette de dos d'une pieuse femme et, au centre, le merveilleux visage de Marie.

d'œuvres attestées a longtemps laissé dans l'ombre cette figure de premier plan de l'art flamand. Plus âgé que Van Eyck de presque une génération, le Maître de Flémalle a joué un rôle vraiment irremplaçable dans le passage controversé du gothique à la Renaissance, en proposant une conception plastique d'un concret inédit. Des œuvres comme la *Nativité* de Dijon (vers 1425), la *Vierge à l'écran d'osier* (vers 1430), le *Triptyque de Mérode (1430-1432)* séduisent par un mélange ineffable d'archaïsme monumental et de poésie résolument moderne.

◆ **Maître de Moulins** (actif dans la seconde moitié du XVᵉ siècle). Il est le dernier grand peintre français à suivre la leçon des Flamands. Son activité est connue et elle est comprise entre deux chefs-d'œuvre : la *Nativité* d'Autun (1480) et le *Triptyque de Moulins* (entre 1498 et 1500).

◆ **Memling,** Hans (Seligenstadt 1435-1440-Bruges 1494). La synthèse opérée par Memling marque la fin de la première Renaissance aux Pays-Bas. Son œuvre oscille entre un goût archaïsant dérivé de celui de Van der Weyden et sa capacité à moderniser tous les schémas de provenances diverses. Cette capacité est particulièrement visible dans les admirables portraits des dernières années.

◆ **Schongauer,** Martin (Colmar 1453-Brisach 1491). Réputé comme excellent graveur, il est sans doute le plus intéressant peintre alsacien du XVᵉ siècle.

◀ *Limbourg Brothers, miniature from* Les très riches heures du Duc de Berry, *c. 1413–16, Musée Condé, Chantilly. The Duc de Berry's book of hours, in which the culture of the period is depicted with Gothic fantasy and mythological forms, is unquestionably the finest example of manuscript decoration ever produced in the West and one of the highest achievements of the International Gothic style.*

back to this style of painting.

The realism of the Master of Flémalle approaches the monumentality of the great French Gothic sculptor Claus Sluter, a native of Dijon, the capital of Burgundy. Flanders and Burgundy were regarded as a political entity until 1450, and it is therefore conceivable that the seeds of the Flemish style can be found in the startling originality of Sluter. Burgundy, in the heartland of Europe, had an extraordinarily rich culture. It was probably the birthplace of the International Gothic style, as seen in the work of Melchior Broederlam executed around 1400. The Limbourg brothers produced the magnificent book of hours *Les très riches heures du Duc de Berry* (c. 1416). Duc Jean de Berry, who commissioned this masterpiece of illumination, was one of the first great collectors in the modern sense in that his avid pursuit of manuscripts and art objects seems to have had a stimulating influence on the dissemination and cross-fertilization of different European styles. There is no direct evidence of this connection, nor indeed of any links between Flemish, French and German painters before 1420, yet stylistic analogies sometimes coincided so neatly that one must assume that such links existed and that cultivated patrons like the duke were the conduit.

Earlier trends of the realistic Flemish type are also to be found in the German kingdoms of the fourteenth century, in the work of artists like Bertram of Minden, Theodoric of Prague, the Master of the Třeboň Altarpiece and the Master of the Vyšší Brod Altarpiece, while divergent styles were exhibited by later artists of similar caliber, such as Master Francke, Konrad von Soest, Lucas Moser,

the unprecedented naturalism of his works. His style is an irresistible combination of monumental archaism and modern poetic sensibility, amply demonstrated in attributed works like the Dijon *Nativity* (c. 1425), the *Virgin and Child before a Fire-Screen* (c. 1430) and the superb *Mérode Altarpiece* (after 1430).

◆ **Master of Moulins** Active during the second half of the fifteenth century, the Master of Moulins was the last prominent French follower of the Flemish style. His few known works include two masterpieces, a *Nativity* in Autun Cathedral (1480) and the triptych *Madonna with Child and Angels and Donors* (1498/9) in Moulins Cathedral.

◆ **Memlinc** Hans (Seligenstadt 1435/40–Bruges 1494). The refined synthesis evident in Memlinc's work signals the end of the early Renaissance in the Netherlands. His style is a combination of the archaism of Rogier van der Weyden and the skilful restating of themes from different sources. This latter quality is especially true of his magnificent late portraits.

◆ **Schongauer** Martin (Colmar 1455–Breisach 1491). Celebrated for his exquisite engravings, Martin Schongauer is undoubtedly the most interesting Alsatian artist of the fifteenth century, combining skilled draughtsmanship with a keen sense of spatial rhythm and depth.

◆ **Sluter** Claus (Haarlem c. 1340–Dijon 1406). In a time when sculpture was still a stonemason's art, Claus Sluter's marble decorations for the Charterhouse of Champmol (1391–95) stand out for their corporeal monumentality and expressive power and

▼ *Melchior Broederlam,*
Flight into Egypt,
detail, c. 1395, Dijon
Museum. Another of
the fanciful artists active
during the transitional
pre-Renaissance period,
Broederlam, whose
technique was delicate

and emotionally
expressive, was a
considerable influence
on Flemish and
German artists.

◄ *Stephan Lochner,*
Madonna of the Rose
Bower, c. 1440,
Wallraf–Richartz
Museum, Cologne. The
difficulty of reconciling
humanistic realism
with Gothic formulas
resulted in the pretty
elegance of the "soft"
style (or International
Gothic).

▼ *Claus Sluter,* Bust of
Christ, *1396, Musée*
Lapidaire, Dijon.

Stephan Lochner and the Swiss painter Konrad Witz. Active around 1430, Witz is an important northern example of the type corresponding to the Italian formal idiom of the Masaccio years. Although Witz had less impact than the great Italian, his monumentality is exemplified in the fine altarpiece of the *Redemption* (*Heilspiegelaltar*), now dismembered and distributed among

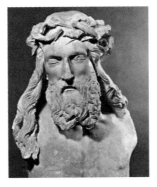

the museums of Basle, Dijon and Berlin.

Monumentality – in the artistic sense, the notion that space is there to be "invaded" by the bulk of the human form – was already present in fourteenth-century Bohemian art, notably in the works of Theodoric of Prague. It reappears, as we have seen, in the art of the Master of Flémalle and Konrad Witz. Thus the

are thought to have been a crucial source of inspiration for the beginnings of the Netherlandish Renaissance.

♦ **Weyden** Rogier van der (Tournai c. 1400–Brussels 1464). One of the founders of the Early Netherlandish school, Van der Weyden, together with his teacher Robert Campin and Jan van Eyck, form a polar influence of categorical importance in the

story of fifteenth-century art. Rogier's combination of detailed observation, expressive warmth and iconographic inventiveness would influence generations to come. Among his most significant works are the *Deposition* (c. 1435) in the Prado, Madrid, the *Last Judgement* (c. 1445–50, Beaune) and the *Seven Sacraments* (c. 1460, Antwerp).

♦ **Witz** Konrad (Rotweil c. 1400–

Basle, before 1446). A Swiss artist well known for his large, impressive altarpieces. Witz's possible connection with Flemish influences and a precocious tendency to use Renaissance forms combine to make him one of the most interesting painters in the history of German art.

3 LE XVᵉ SIÈCLE NORDIQUE

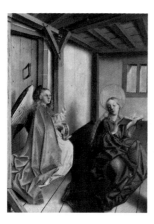

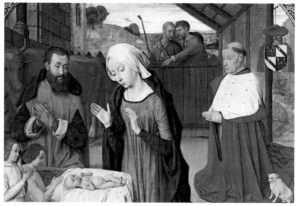

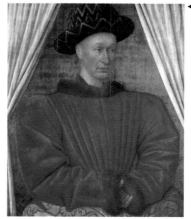

se trouve dans la région subalpine vers 1430, et représente un autre exemple de peintre (incontestablement moins brillant) exploitant les exigences formelles de la Renaissance à l'époque de Masaccio. Son *Retable du Miroir du Salut*, dispersé dans les musées de Bâle, Dijon et Berlin, en est le meilleur exemple.

Un sens prononcé du monumental – une idée donc de l'espace comme de quelque chose qui doit être « agressé » par la figure humaine – était déjà présent chez les peintres de Bohême : les Maîtres Theoderich et Vyssi Brod... Ainsi, nous le retrouvons chez Konrad Witz et le Maître de Flémalle : aux trois sommets, donc, d'un triangle de mille kilomètres de côté ! Et tandis que Stephan Lochner cultive plutôt une « élégance graphique analogue aux styles italiens d'ascendance gothique (Stefano da Verona, Michelino da Besozzo), on distingue chez le Français Jean Fouquet la même adhésion à une conception nouvelle de la description

de l'espace, un espace anthropocentrique. Mais ici, la leçon de Van Eyck est déjà assimilée. La peinture française du Quattrocento subit de façon persistante l'attrait des expériences de Bruges et de Gand, même si l'on fait abstraction des œuvres (nombreuses) exécutées en France, directement attribuables à des peintres flamands, comme l'*Annonciation* d'Aix-en-Provence. Un peintre de premier plan, comme le Maître de Moulins, pousse cette influence jusqu'aux dernières décennies du

siècle, comme on peut le voir dans la *Nativité* d'Autun (vers 1480) ou le triptyque de la *Vierge en gloire* (1498) de la cathédrale de Moulins. Autant de preuves que l'envahissante « mode » italienne est alors presque entièrement ignorée. Un parfait amalgame de styles, entre des suggestions grammaticales flamandes et une large syntaxe toscane, constitue en revanche l'originalité de Nicolas Froment, qui atteint, avec son triptyque du *Buisson ardent* (1475), un autre sommet de la peinture de l'époque.

◀ *Maître de Moulins,*
Nativité, *vers 1480,*
musée Rolin, Autun.
Parmi les œuvres de
jeunesse du maître
anonyme de Moulins,
actif en Bourgogne entre
1480 et 1500, il faut
remarquer ce tableau

aux superbes couleurs
froides ; la composition
est très moderne, avec
le plan d'intersection
très proche du sujet
principal de la scène.

L'ouvrage a été commandé par René d'Anjou pour la cathédrale d'Aix-en-Provence, où il se trouve encore aujourd'hui. La scène principale montre l'interprétation religieuse de l'épisode de la Bible : Moïse est enlevé dans la vision d'un buisson en flammes, au centre duquel apparaît la Vierge avec l'Enfant. Nombreux sont les éléments « italiens » : la douceur du paysage, l'ample souffle de la composition, la conception générale de la scène. Cependant, l'ensemble des choix iconographiques de même que l'utilisation symbolique de la perspective (la Vierge est aussi grande que Moïse et l'ange qui se trouvent au premier plan) déplacent l'accent vers cette expression fantastique et onirique, incomparable, qui constitue la prérogative de l'art nordique. Sans doute par sa puissance plastique (évidente, par exemple, dans l'*Annonciation* de Witz vers 1434), et surtout par son impérieuse spiritualité, cette peinture exerce souvent une fascination comparable à celle des expériences surréalistes, fantasmagoriques ou visionnaires. D'un style proche de Froment, Enguerrand Charonton est l'auteur d'un incroyable tableau mystique, le *Couronnement de la Vierge* (1453-1454), où la Trinité est représentée à travers l'image tout à fait spéculaire du Père et du Fils, identiques et opposés. Est également attribuée à Charonton la célèbre *Pietà d'Avignon*, aujourd'hui au Louvre. Mais ce mélange de styles

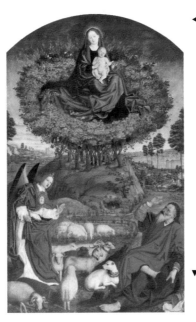

◀ *Nicolas Froment,*
Le Buisson ardent,
1475, cathédrale
Saint-Sauveur,
Aix-en-Provence. Selon
la Bible, Moïse eut un
jour la vision d'un
buisson ardent, parfois
interprétée comme un
signe prophétique du
Christ. Le tableau de
Froment traduit à la
lettre l'image, place
la Vierge et l'Enfant
au centre du buisson,
transforme la scène en
« conversation sacrée »,
où la perspective est
le moteur ambigu
d'hallucinations
mystiques.

▼ *Enguerrand*
Charonton, Pietà
d'Avignon, *vers 1450,*
Louvre, Paris.

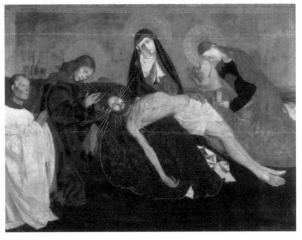

mentionné plus haut est un phénomène existant en Italie après 1470. Davantage que Hugo Van der Goes (qui peint en 1475-1477 le *Triptyque Portinari* pour un agent des Médicis à Bruges), Hans Memling peut constituer pour les Italiens le point d'appui pour la fusion des « deux Renaissances ». Antonello de Messine, en effet, en tiendra compte, de même que Giovanni Bellini et les Vénitiens suivants. Déjà, l'œuvre de Memling n'est plus qu'un effort de synthèse prolongé, une tentative d'assimilation de la diffi-

▼ *Hans Memlinc,*
Adoration of the
Magi, c. 1480,
polyptych, Prado,
Madrid. In the central
panel the adoration
scene is set out
horizontally, recalling
the compositional

technique of Rogier van
der Weyden, whose
influence can also be
seen in the descriptive
material of the
characters.

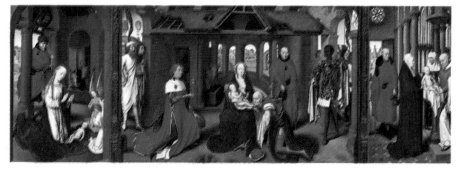

tured in his only authenti-
cated work, *Madonna of the*
Rose Bower, dated 1473,
painted for the Church of St
Martin in Colmar. The young
mother with her long golden
tresses and enveloping red
robe, seated in a garden para-
dise of roses and finches,
seems innocently unaware of
the heavy burden which has
fallen, literally, upon her,
emphasized by the solid-
looking space, like a lump of
stone, circling the Virgin's
head and the oversized
crown being lowered upon
this space by two almost
playful angels. The gentle

subversion implicit in this
witty metaphor indicates the
true measure of an artistic
climate which was con-
stantly dogged by suppres-
sion and cultural idleness. ■

▶ *Martin Schongauer,*
Madonna of the Rose
Bower, *1473, Saint*
Martin, Colmar. The
hortus conclusus
(paradise garden) is the
northern equivalent of
Italy's sacra
conversazione. *It*
represents an
imaginary, symbolic
space, Eden-like, apart
from the real world, a
blissful, dream-like
setting in which the
mystery of divine
incarnation takes place.

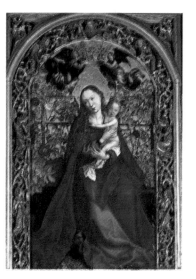

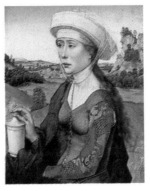

Michael Pacher, Saints Augustine and Gregory, *1482–83, Alte Pinakothek, Munich.*

The two saints are part of the Altarpiece of the Church Fathers, painted for the Tyrolean monastery of Novacella a few years after the St Wolfgang altarpiece. In both altarpieces, Pacher applies his knowledge of Italian perspective techniques to the Northern stylistic preference for highly wrought draughtsmanship and colour.

Rogier van der Weyden, Magdalen, *detail from the Braque Triptych, c. 1452, Louvre, Paris.*

This portrait of a young woman in fifteenth-century dress is one of the most remarkable artistic legacies of the period. The inner psychology of the young woman, even more than the iconographic significance of the jar she holds, conveys the religious sub-text of this worldly image.

Lucas Moser, Magdalen Altar, *detail, 1431, Pfarrkirche, Tiefenbronn.*

The physical subdivisions of this large altarpiece do not detract from the Renaissance element of spatial unity, which is defined by the use of perspective and is especially effective when the wings are closed.

House of Lancaster Burning of John Huss	Capture of Rouen Council of Basle	Albert II, founder of the Hapsburg dynasty End of the Hundred Years War	Marriage of Ferdinand of Aragon and Isabella of Castile	End of the Wars of the Roses House of Tudor	Union of France and Brittany
K. von Eichstatt: *Bellifortis*			Regiomontanus supervises printing of Ptolemy's *Almagest*	Chuquet: *Triparty en la science du nombre*	Columbus reaches the West Indies
	Dufay cantor at Cambrai	Joannes Okeghem in Paris	Josquin Des Prés in Milan	Jacob Obrecht chapel master at Utrecht, Bruges and Antwerp	Earliest reference to sackbut
Vergerio: *De ingenuis moribus et liberalibus studiis*	John Lydgate: *Siege of Thebes*	John Capgrave: *Liber de illustribus Henricis*	Villon: *Le Testament* Death of Thomas à Kempis	First dated book printed in England by Caxton	Johannes Reuchlin: *Henno* Brant: *Ship of Fools*
Brussels Town Hall	Master of the Upper Rhine: *Garden of Paradise*	King's College Chapel, Cambridge	Antwerp Bourse	Cathedral of the Assumption, Moscow	Knebworth House
Limbourg Brothers: *Les très riches heures*	Master of Flémalle: *Mérode Altarpiece* Van Eyck: *Ghent Altarpiece*	Fouquet: *Melun Diptych* Enguerrand Charonton: *Coronation of the Virgin*	Van der Weyden: *Polyptych of the Seven Sacraments*	Memlinc: *Mystic Marriage of Catherine of Siena* Justus of Ghent: *Institution of the Eucharist* Van der Goes: *Portinari Altarpiece*	Dürer: *Adoration of the Trinity* Master of Moulins: *Moulins Triptych*
1400–18	1419–36	1437–54	1455–72	1473–90	1491–1508

41

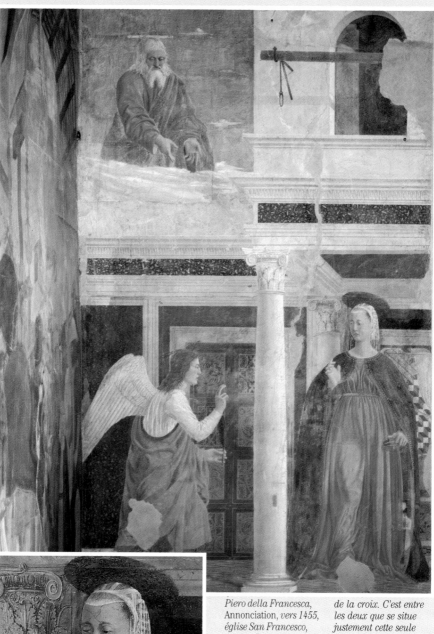

Piero della Francesca,
Annonciation, vers 1455,
église San Francesco,
Arezzo. Parmi l'ensemble
de fresques d'Arezzo
inspirées de la Légende
dorée de Jacques de
Voragine, l'Annonciation
est le pivot thématique
entre l'histoire précédant
et succédant à la légende
de la « vraie croix ».
La première partie
du cycle rapporte les
origines du bois sacré,
tandis que la seconde
raconte les aventures
relatives à la découverte
de la croix. C'est entre
les deux que se situe
justement cette seule
évocation du sacrifice
du Christ, symbolisée par
l'Annonciation. Piero
della Francesca souligne
donc l'importance de cet
épisode par une facture
élémentaire mais
qui se révèle très
puissante, basée sur
une distribution en
quatre de l'espace, tout
à fait inhabituelle
dans la représentation
contemporaine de ce
thème.

4 L'ART DE LA PERSPECTIVE

La deuxième innovation capitale de la Renaissance italienne coïncide avec l'apparition de Piero della Francesca, un des artistes les plus complets et les plus fascinants du Quattrocento. L'impulsion novatrice de sa peinture se diffuse tout d'abord en Ombrie (vers le milieu du siècle), puis en Toscane et dans les Marches, avant d'atteindre progressivement toute la péninsule. C'est grâce à son influence que sera partout admise la *codification* du système de la perspective : de moyen technique, issu de l'intuition imitative, il se fait élaboration scientifique rigoureuse, devenant la « méthode » par excellence, c'est-à-dire le langage de base de la culture plastique occidentale, jusqu'à l'avènement du cubisme et autres avant-gardes. En effet, les règles principales que Piero della Francesca applique dans ses œuvres sont exactement celles sur lesquelles se fondera, quelques siècles plus tard, la photographie : vision monoculaire, immobilité du spectateur, statisme de l'objet observé, centrage du point focal dans le champ visuel, distribution perpendiculaire du plan de représentation par rapport à l'axe visuel (c'est-à-dire par rapport à la ligne qui relie le spectateur à l'objet représenté). Pourtant, Piero della Francesca est davantage un excellent utilisateur de ce moyen qu'un pionnier dans son élaboration. Alors qu'il réalise, entre 1445 et 1465, le

▲ Piero della Francesca, La Flagellation du Christ, vers 1455, Galerie nationale des Marches, Urbino.

◄ Piero della Francesca, Retable de Brera, 1472-1474, pinacothèque de Brera, Milan. Achevé par un élève, ce retable est une des œuvres les plus intéressantes du peintre de Borgo San Sepolcro. On peut remarquer le symbole néoplatonicien de la coquille (Marie, la mer, la mère, la naissance), d'où descend l'œuf mystique (le Christ, l'origine, l'univers).

Baptême du Christ (National Gallery, Londres) et le *Polyptyque de la Miséricorde* de Borgo San Sepolcro, plus de vingt années se sont déjà écoulées depuis les premières expériences de Brunelleschi et de Paolo Uccello à Florence, et, surtout, le texte de Leon Battista Alberti, *De pictura* (1435), est déjà célèbre. L'axiome auquel se tient scrupuleusement Piero della Francesca (auteur d'un traité fondamental, *De prospectiva pingendi*) est que la construction de l'espace ne peut finalement s'établir qu'à partir de lignes disposées selon trois possibilités : parallèles à la base du tableau, parallèles à sa hauteur, convergentes vers le « point de fuite ».

La Flagellation du Christ d'Urbino, réalisée vers 1455, illustre bien cette disposition

the crucial point to which the eye is attracted, at the very center of the work, to the left of the man wielding the whip, and each quantity is determined by fixed mathematical values. The colonnade, for example, divides the space into two sections based on the principle of the so-called golden section, whereby the whole is to the largest part as the largest is to the smallest part, which Piero regarded as a sure guarantee of harmonious beauty. The painting's Classical setting is also significant, since the discovery of geometrically harmonious proportions was attributed to the ancients, which gave it a feeling of authority.

The rigidity of the scientific vision introduced by the painter was, however, tempered by the unifying force of light, which he regarded as an active element, capable of giving life to the almost abstract shapes of his compositions. This formula was probably inherited from his first teacher, Domenico Ve-

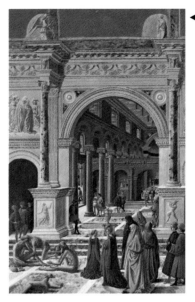

◀ *The Master of the Tavole Barberini, Presentation of the Virgin in the Temple, c. 1475, Museum of Fine Arts, Boston. Classic examples of the influence wielded by Piero della Francesca in Italy, the so-called "Barberini Panels," both of which are now in American museums, display settings derived from the architecture of Alberti and reconstructed in strict compliance with the rules of perspective amid Renaissance festoons, bas reliefs and other decorative elements.*

neziano, an artist whose origins so far remain unknown; it is intended to express the simultaneous presence of perspective precision and rich tonal values, meaning the relationship between light and shade. The feeling of solemn, ceremonial cadence, exuded by works such as *Resurrection*,

the *Madonna del Parto* and the *Brera Madonna*, can thus be viewed as nothing more than the inevitable consequence of the mathematical approach with which Piero tackled the problem of the visual. The *Annunciation* at Arezzo, for example, which is part of the *Story of the True Cross* cycle, is based on four

BIOGRAPHIES

◆ **Antonello da Messina** Antonello di Antonio, called (Messina c. 1430–1479). He trained in Naples at the workshop of Colantonio, where he came into contact with Flemish painting. A familiarity with Piero della Francesca's work enabled him to achieve that synthesis between Nordic realism and the Italian sense of space which characterizes all his paintings: from *Jerome in his Study* to his *Annunciation* in the

museum in Palermo, and from his *San Gregorio Polyptych* to his *San Cassiano Altarpiece,* and his Antwerp *Crucifixion.*

◆ **Bellini** Giovanni (Venice c. 1432–1516). Born into a family of painters (his father, Jacopo, and his brother, Gentile, were artists of considerable importance), he was initially influenced by his brother-in-law Andrea Mantegna. In around 1470 he abandoned this style in

favour of his own chromatic-perspective language, based on the example set by Piero and Antonello. Finally, thanks to the presence of his own followers, he again succeeded in updating his style and giving his art a sixteenth-century dimension.

◆ **Botticelli** Sandro Filipepi, called (Florence 1445–1510). Formally inspired by Filippo Lippi, Botticelli's language had no ideological

precedents. Drawing on aesthetic concepts formulated by the sophisticated neo-Platonist circle of Lorenzo de' Medici, his art tended to reflect the abstract, allegorical symbolism of the "ideal world" rather than portraying the phenomena of the natural one.

◆ **Carpaccio** Vittore (Venice c. 1460–1526). Although dating mainly from the sixteenth century, Carpaccio's painting

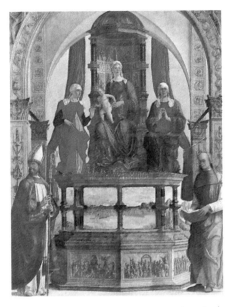

equal rectangles, created by the particular conformation of the architecture. Each figure (the Madonna, the angel, God the Father) occupies its own space within the scene and stands out against the background like a statue. The frozen, staring immobility of the figures, the way in which their poses are almost photo-graphically captured, the light that envelops their surroundings like a solid sheath: all these elements conspire to block the image and project it into an abstract dimension of an enclosed, eternal life. But this work also reveals the symbolic force of Piero's method: the event of the incarnation, confirmed by the position of God's hands, represents a stasis in the unfolding of the story, an insurmountable caesura between what will be and what has gone before, the abolition of time as a mark of continuity and progress. Piero, however, was explicit: for him perspective is the reflection of the harmony that rules creation. It is the product of a superior, divine rationality that sanctifies the

concourt à bloquer l'image et à lui donner une dimension abstraite, de vie retenue, d'immortalité. Mais, ici, la méthode révèle aussi sa valeur symbolique : l'événement de l'incarnation, ratifié par la position « en giron » des mains de Dieu, représente une *stase* dans le cours de l'histoire, l'inexorable césure entre un avant et un après, l'abolition du temps comme continuité et progression. L'artiste est d'ailleurs explicite : la perspective est pour lui le reflet de l'harmonie qui régit le créé, elle est le produit d'une rationalité supérieure et divine qui consacre l'accord parfait entre l'homme et la nature.

L'exemple de Piero della Francesca porte presque immédiatement ses fruits : en Ombrie, la *Vie de Saint Bernardin* du jeune Pérugin ; à Florence, les suggestifs et mystérieux panneaux *Barberini*, les œuvres tardives d'Andrea del Castagno et celles de

La théorie de la perspective

*Léonard de Vinci, étude de perspective pour l'*Adoration des Mages, *1480, Offices, Cabinet des dessins et des estampes, Florence. Dans* De pictura *(1435), Leon Battista Alberti explique : « Là où je dois peindre, j'inscris un rectangle aussi grand que je veux, censé être une fenêtre ouverte par laquelle j'observe ce qui y sera peint. » L'artifice pictural consiste donc à créer sur une surface opaque l'illusion d'un lieu à trois dimensions qui rende très symboliquement cette surface transparente, en l'assimilant à une « fenêtre ouverte ». Cette définition fait de la projection géométrique la condition de la « vérité » du tableau, et elle est étroitement liée aux sept types de mouvement répertoriés dans le même traité : « Toute chose qui se déplace depuis un lieu peut prendre sept directions : vers le haut (un) ; vers le bas (deux) ; vers la droite (trois) ; vers la gauche (quatre) ; en profondeur, se déplaçant d'ici, ou d'ici venant là ; la septième effectuant un mouvement circulaire. Ce sont là tous les mouvements que je désire reproduire en peinture. »*

Giovanni di Francesco ; dans les Marches, les tableaux de Girolamo et de Giovanni de Camerino. Mais ce n'est pas sur une courte distance que doit en être mesurée la portée. Rapidement, les régions les plus lointaines en sont enrichies, ce qui montre toute sa capacité de persuasion. A Ferrare, la sensibilité déjà « Renaissance » de Cosme Tura se conjugue avec la sagesse « architecturale » de Piero della Francesca (qui séjourne à la cour d'Este vers 1450), pour donner naissance au grand art de Francesco del Cossa et, plus tard, d'Ercole de' Roberti. Les fresques des *Mois* du palais Schifanoia, réalisées en 1469-1470, sont l'une des plus hautes expressions de la culture de la Renaissance, pas seulement du point de vue pictural, car la base philosophique qui les sous-tend institue une sorte de « somme » des connaissances de l'époque. Les compartiments relatifs aux

◆ **Lippi,** Filippino (Prato 1457 - Florence 1504). Il reprend de son père, Filippo, des aspects thématiques qui, dans plus d'un cas, le rapprochent de Botticelli. Ses œuvres évitent cependant la préciosité et la cérébralité de celles de Botticelli, offrant une expressivité formelle plus directe.

◆ **Piero della Francesca** (Borgo San Sepolcro vers 1416-1492). En 1439, il étudie à Florence auprès de Domenico Veneziano, mais il a également pour grandes références culturelles Masaccio, Fra Angelico et Leon Battista Alberti. Les idées de ce dernier le conduiront à la perfection géométrique de *La Flagellation du Christ*. Vers 1450, il est à Ferrare, puis il travaille à Urbino pour Federico di Montefeltro. Son œuvre maîtresse est le cycle de fresques de l'*Histoire de la vraie Croix*, qu'il exécute en l'église San Francesco d'Arezzo. Après le *Retable de Brera* (1472-1474), il abandonne la peinture pour se consacrer entièrement aux seules études de théorie artistique et mathématique, souvent en collaboration avec le savant Luca Pacioli.

◆ **Piero di Cosimo,** Piero di Lorenzo, dit (Florence 1461-1521). Les origines et l'activité de ce peintre aux

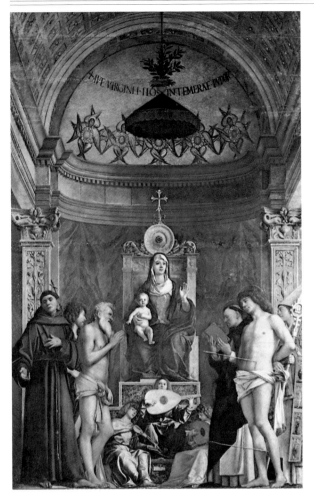

cratie de cour, des fêtes sur la place publique (la célèbre course du *palio*), aux réunions galantes dans de splendides jardins. L'ensemble a des significations occultes qui renvoient aux cycles de la terre et, donc, à des interprétations astrologiques et ésotériques. Cossa superpose son répertoire stylistique personnel, fait de rigueur linéaire et d'émaux cristallins, à l'artifice de Piero della Francesca, en en retenant surtout l'aspect de « machine optique » universelle. A travers cette lentille, foyer diurne de la raison, regarde également le « visionnaire » Ercole de' Roberti, très jeune et génial auteur, à Schifanoia, du mois de *Septembre* et, plus tard, d'œuvres fascinantes comme la *Pala Portuense* (1481) et la *Pietà* de Liverpool (1482). Le modèle de la « conversation sacrée » (Vierge sur un trône au centre, les saints disposés symétriquement à ses côtés) se répand

mois de *Mars* et *Avril*, exécutés par Cossa, nous offrent un panorama unique de la vie dans la société italienne du Quattrocento : du travail des ouvriers et des agriculteurs (tissage, émondage...) aux divertissements oisifs de l'aristo-

inventions épiques très suggestives sont mal connues. Pour l'originalité des thèmes et pour le style, nous citerons les deux séries de grands tableaux « archéologiques » des *Légendes de l'humanité primitive* (1490-1495) et des *Mésaventures de Silène* (1499-1515).

◆ **Roberti,** Ercole de' (Ferrare vers 1450-1496). Formé à partir des œuvres de Tura

et de Cossa, il participe en 1470 à la décoration à fresques du palais Schifanoia (mois de *Septembre*). Il travaille ensuite à Bologne et exécute en 1481 la « *Pala* » Portuense à Ravenne ; c'est le fruit d'une synthèse des expériences ferraraise, vénitienne et de l'enseignement de Piero della Francesca.

◆ **Rossellino,** Bernardo (Settignano 1409 - Florence 1464).

Disciple d'Alberti et frère du sculpteur Antonio, son nom est lié aux travaux d'urbanisme de la ville de Pienza, entrepris en 1459 sur une décision du pape Pie II.

◆ **Verrocchio,** Andrea di Francesco di Cione, dit (Florence 1435 - Venise 1488). Orfèvre et sculpteur aux intérêts multiples, il dirige un atelier florissant à l'époque de Laurent le Magnifique.

Parmi ses élèves les plus célèbres figurent Pérugin, Lorenzo di Credi et Léonard de Vinci.

▼ Antonello da Messina,
San Cassiano
Altarpiece, *1475–76,
Kunsthistorisches
Museum, Vienna. This
was part of a painting
made for the Venetian
Church of San
Cassiano.*

▼ *Vittore Carpaccio*, St
▼ George Killing the
Dragon, *c. 1505,
Church of San Giorgio
degli Schiavoni, Venice.*

1470, when he painted his *Coronation of the Virgin*, now in the museum at Pesaro. The rigid, angular, classical taste of Mantegna, which Bellini had accepted with reservations, was now a distant memory as his painting evolved towards that happy blend of atmosphere and tone which characterized the *sacre conversazioni* of his maturity, such as the *San Giobbe Altarpiece* (1487) and the *San Zaccaria Altarpiece* (1505). The other encounter that was of fundamental importance to this artist, as original as he was receptive, occurred

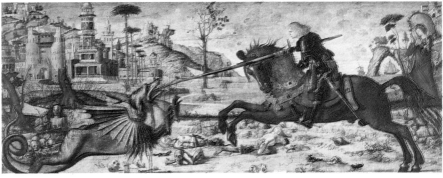

in 1475, when Antonello da Messina executed a work for the Church of San Cassiano in Venice. The *San Cassiano Altarpiece* represents a happy marriage between the geometrical precision of Piero della Francesca and the atmospheric realism of the Flemish, whose works Antonello had studied carefully in Sicily and Naples, where these artists were both known and appreciated. The painting marked the first use of a triangular layout for the *sacra conversazione*, achieved by raising the enthroned figure of the Madonna. But,

most important of all, it made use of mellow, homogeneous colours, based on precise tonal harmony, of a sort that also appear in his *Annunciation* in Palermo and his *Self-Portrait* in London. This harmony seems to take into account the density of the air, treating light as an element of physical fluidity that swirls around objects.

Filtered through the chromatism of Bellini, Antonello's innovations had a profound effect on the work of later Venetian artists, among them such outstanding talents as Vittore Carpac-

cio, Cima da Conegliano and Bartolomeo Montagna. But as well as the Venetian thread, which stretches as far as Titian and Lotto, we should also mention, however briefly, the tradition established by Piero della Francesca at Urbino, at the court of Federico di Montefeltro. Here, in 1466, Luciano Laurana began work on the impressive complex of the Ducal Palace, a project on which he was later replaced, in 1472, by Francesco di Giorgio Martini. Piero's influence on these architects, who were also heirs to the

▼ Luciano Laurana, Ducal Palace, 1466–72, Ducal Palace, Urbino. The façade flanked by two small towers and the three-tier marble loggia are definitely the work of Laurana.

▼ Bernardo Rossellino,
▼ View of the main square at Pienza, with the Cathedral and Palazzo Piccolomini. When Enea Silvio Piccolomini, who became Pope under the name of Pius II,

decided to employ an architect to renew the layout of his hometown, he was fulfilling one of the utopian ideals of the Renaissance: the city as a rational prolongation of the individual.

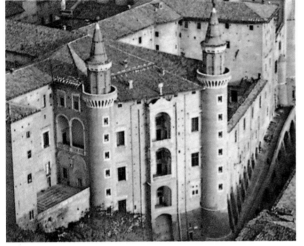

Piero, whereas Melozzo was a direct pupil of his at Urbino. In 1484 he initiated the *sotto in sù* (literally "from below upwards") style of perspective in the dome of the Cappella del Tesoro (also called the Sacristy of St Mark) at Loreto, which was to provide a vital reference point for Correggio and for ceiling decorators during the centuries to come.

In the field of sculpture, application of the golden rule governing the harmonious portrayal of perspective space was much less widespread. It can, however, be

▼ Melozzo da Forlì, Dome of St Mark's Sacristy, 1477, Basilica della Santa Casa, Loreto. This work predates the Cappella del Tesoro at Loreto, also by the same artist,

by seven years, the works of Correggio at Parma by forty-five years, and the baroque church ceilings of Rome by two hundred years.

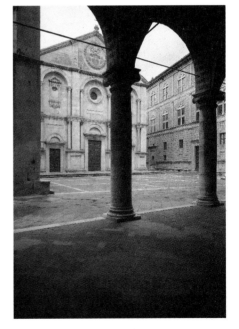

tradition of Alberti, can be clearly seen, as it can on the work carried out by Bernardo Rossellino at Pienza, the city on whose embellishment the humanist Enea Silvio Piccolomini (Pope Pius II) had embarked in 1459. Luca

Signorelli and Melozzo da Forlì also derived inspiration, albeit in different ways, from the works and theories of the painter from Borgo San Sepolcro. Signorelli, like Pietro Perugino, was not a fully fledged follower of

detected in the portrait sculptures of Francesco Laurana (brother of Luciano) and, to a certain extent, in the marble decorations of the oratory of St Bernardino at Perugia (1457–61), carved by Agostino di Duccio. Andrea

▼ *Andrea Verrocchio,* Incredulity of St Thomas, *c. 1483, Orsanmichele, Florence. The artist's Classical taste and great plastic strength were tempered by his faithfulness to traditional Florentine linearism, even, as in this work, in the presence of Piero della Francesca's "clear solar rule."*

Verrocchio, who was linked directly to Donatello, took it into account when working on figures in the round. It is true, however, that in Florence there was a strong reactionary faction, or at least one that was relatively immune to the influences we have mentioned. This tendency revolved around the neo-Platonism of Marsilio Ficino and Pico della Mirandola, whose circle of philosophers, artists and literati enjoyed the generous patronage of their sovereign, Lorenzo de' Medici (Lorenzo the Magnificent), himself a poet and man of vast learning. In painting this cultural core, overtly hostile to naturalism, reached superlative heights in the works of

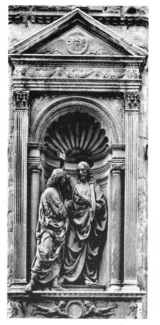

foremost a symbol of the soul purified by baptism, the superior beauty of divinity reflected in the spiritual component of every human being. The naked Venus becomes a symbol of untouched beauty: the shell, from which Greek myth says she was born, is the same device associated by painters with the Virgin in countless religious works of the period.

In the homeland of the early Renaissance of Donatello and Masaccio a very strong domestic tradition acted as a block to more recent innovations. And so, whereas in the Po valley Piero's message spread rapidly (breaking through into France with Nicolas Froment and into Germany

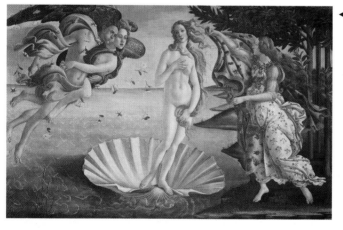

◄ *Botticelli,* Birth of Venus, *c. 1482, Uffizi Gallery, Florence. Although a fascinating example of the Renaissance revival of pagan themes, this well-known painting highlights their allegorical (and therefore Christian) usage, as advocated by Florentine neo-Platonism.*

Sandro Botticelli. The mystical tension, which Ficino cloaked in a reinterpretation of ancient texts (Plato, Pythagoras, Plotinus), manifested itself in Botticelli's paintings as an iconographical return to Classical paganism, giving rise to such complex allegories as *Primavera*

(1478) and the *Birth of Venus* (c. 1482). He was able to show a female nude without either placing it in an infernal vision or condemning it as an object of lust, precisely because, in the ambivalent signification that typifies neo-Platonist allegory, emerging from the waters is first and

with Michael Pacher), the main milestones in the development of Florentine art, which culminated in the early works of Leonardo da Vinci, are Filippino Lippi, Sandro Botticelli, Domenico Ghirlandaio, Antonio del Pollaiuolo and Andrea Verrocchio. The idea that draw-

▼ *Filippino Lippi*, Virgin and Child with St Jerome and St Dominic, *National Gallery, London. The works of Filippino Lippi, Botticelli and Piero di Cosimo provide ample proof of the way* in which Florentine painting went its own way as far as the structural philosophy of Piero della Francesca was concerned.

▼ *Botticelli,* Nativity, *1501, National Gallery, London. Its anti-naturalist tone, the symbolic presence of various choirs of angels and the disturbing perspective inversion make this work an* astounding product of neo-medieval art. It also reflects Botticelli's interest in the spiritual, in symbols and in abstract concepts.

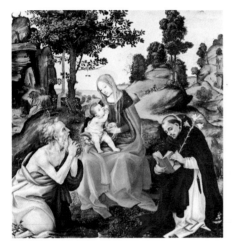

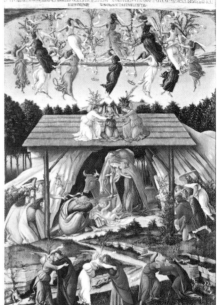

▼ *Piero di Cosimo,* Hunting Scene, c. *1490, Metropolitan Museum, New York. Piero di Cosimo's imaginative genius was drawn to tales about* primitive man, probably inspired by his reading of Vitruvius.

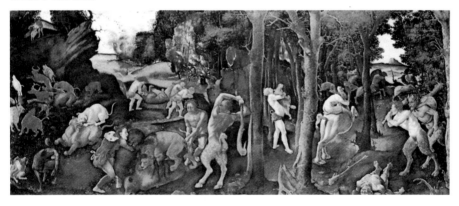

ing was the key element of composition, in comparison with which colour was merely an addition, is little more than a clumsy over-simplification used to explain the development of Tuscan art. And yet it also contains an element of truth. It was his interest in graphic skills that led Ghirlandaio to an overtly decorative style of painting. Filippino Lippi, on the other hand, arrived at a style of formal distortion that intentionally transgressed the spirit of correct proportion and anticipated the Mannerist excesses of Pontormo and Bronzino, as, for example, in his *Apparition of the Virgin to St Bernard* (1486), in which the elongation of the principal figures recalls that found in the almost monochrome paintings of Pollaiuolo (*Rape of Deianira*, c. 1470). The latter represents the very antithesis of the "clear solar rule": the figures struggle dramatically against a space that seems alien and unable to contain them. The tension of the line, which is either curved or broken and has a rhythmical, albeit de-

▼ *Antonio del Pollaiuolo,* Hercules and Antaeus, *c. 1460, Uffizi Gallery, Florence. This tiny panel (16 × 9 cm [6¼ × 3¾ in]) can be linked, on the one hand, to a lost cycle depicting the Labours of* Hercules, *executed by the artist in around 1460 for Piero de' Medici, and, on the other, to the contemporary bronze group of the same name in the Bargello Museum in Florence.*

cidedly syncopated quality, banishes any feeling of measured tranquillity from the pictorial space. It makes us realize how it was possible, in Florence, for an artist as cultured and technically gifted as Botticelli to reject the most elementary rules of perspective in his *Nativity* of 1501.

A mood of relative confusion prevailed in Tuscan art around the beginning of the sixteenth century. It produced almost reactionary works like the painting mentioned above, as well as such decidedly "modern" creations as the formidable synthesis achieved by Leonardo within the context of humanistic knowledge. The restless figure of Piero di Cosimo, whom Giorgio Vasari describes as "a very lofty spirit," "very abstracted," who "differed in tastes from the other pupils," fits very well into this setting. His painting wavered between the example set by Filippino Lippi (at least in its early phase) and the cult of mythological allegory favoured by Botticelli. Compared to Botticelli, however, Piero di Cosimo is a far less straightforward figure, in that he displayed a sort of negativism in his interpretations of Classical texts. He rejected the positive, didactic serenity of earlier masters, preferring to emphasize the darker, more dramatic side of ancient mythology, which he saw as a contradictory documentation of man's origins (*Vulcan and Eolus*, c. 1490; *The Misfortunes of Silenus*, 1505–07). And even when he turned to portraiture he did so in a subtly intriguing way, adding

▼ *Piero di Cosimo,* Simonetta Vespucci, *Musée Condé, Chantilly. The date of this work is unknown, as are its real origins. The inscription referring to the Florentine lady is apocryphal, having been added by a member of the Vespucci family at a later date. The subject of the portrait is, in all probability, either legendary (Cleopatra) or mythical, as is shown by the snake around her neck and the naked breasts, which would otherwise have been inadmissible.*

inappropriate, mainly sinister, symbolic significances (*Simonetta Vespucci*, Musée Condé, Chantilly). His art proclaimed a crisis affecting not so much the subjects that he portrayed as the era in which he lived: the culmination, but also the final stage, of the Italian Renaissance. ■

Antonello da Messina, Annunciation, 1470–73, Alte Pinakothek, Munich.

Piero della Francesca, Baptism of Christ, 1448–50, National Gallery, London.

The baptismal scene is portrayed in a beautiful landscape setting, amid an aura of hieratical immobility, its rhythm set (as in a Byzantine ''series'') by the different postures of the figures and heightened by the meditative beauty of the faces of Christ, St John and the three young angelic philosophers.

Although less famous than the Palermo Annunciation, *this very tender picture of a young woman displays all Antonello's skills as a portrait painter, as well as highlighting its different components: the descriptive powers of the Flemish (particularly Hans Memlinc), the structural skills of Piero della Francesca, and the delicate feeling of ''atmospheric'' colour displayed by Giovanni Bellini and the Venetian painters.*

Cima da Conegliano, Madonna with the Orange Tree, *c. 1495, Gallerie dell'Accademia, Venice.*

In the development of Venetian painting Cima da Conegliano and Bartolomeo Montagna provide the most interesting applications of the taste first introduced by Giovanni Bellini, motivated by the beauty of the countryside and a highly sophisticated use of colour.

Kingdom of the Two Sicilies Council of Florence	End of the Hundred Years War Enea Silvio Piccolomini elected Pope	Lorenzo the Magnificent and Giuliano de' Medici lords of Florence House of York	Murder of Henry VI War between Venice and the Turks	End of the Wars of the Roses Venetians capture Cyprus	Death of Lorenzo the Magnificent Spain conquers Granada
Alberti: *Ludi matematici; De re aedificatoria*	World Map of Fra Mauro	Filarete: *Trattato d'Architettura*	Capitoline Museum, Rome Printing introduced to Spain	Bartholomew Diaz rounds Cape of Good Hope Printed edition of Galen	Vasco da Gama reaches India
Dufay in Italy	Joannes Okeghem in Paris		Des Prés in Milan	De Pareja's *Treatise on Music* printed in Bologna	Obrecht in Ferrara Des Prés in Rome
Valla: *De Elegantiae linguae latinae*	Pontano: *Amorum libri*	Villon: *Ballade des pendus*	Caxton's printing press set up at Westminster	Malory's *Morte d'Arthur* printed	François Rabelais born
Cathedral of San Lorenzo, Perugia	Palazzo Rucellai and Palazzo Medici, Florence	Laurana: Ducal Palace, Urbino	Antonello da Messina active in Venice	F. di Giorgio Martini: Santa Maria delle Grazie, Cortona	Bramante: Santa Maria delle Grazie, Milan
Donatello: *Altare del Santo* **Fra Angelico:** *Cappella Niccolina*	**Piero della Francesca:** *Story of the True Cross*	**Pollaiuolo:** *Portrait of a Young Lady*	**Mantegna:** *Camera degli Sposi, Mantua* **Botticelli:** *Primavera*	**Botticelli:** *Birth of Venus* **Leonardo:** *Virgin of the Rocks*	**Leonardo:** *Last Supper* **Carpaccio:** *Stories of St Ursula*
1440–50	1451–60	1461–70	1471–80	1481–90	1491–1500

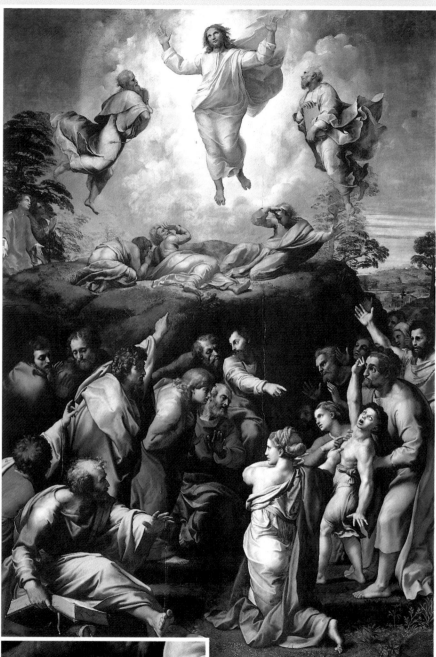

Raphael, Transfiguration, 1518–20, Pinacoteca Vaticana, Rome. The courtly style of Raphael's final phase is based on rhetorical emphasis of the content and on the harmonious balance of shapes. The precise distribution of chromatic masses, of light and shade and of balance and counterbalance creates a mood of sublime visual restraint and gives his paintings a sense of calm and returns them to that cold, impassive perfection that represents the Classical ideal.

5 THE HIGH RENAISSANCE

A t the end of the fifteenth century the city of Milan assumed a role of primary importance in Italian art. The situation in Lombardy was dominated by two figures, Donato Bramante and Leonardo da Vinci. Both were natives of central Italy and took full advantage of the flourishing cultural life at the courts of the Gonzagas and the Sforzas. Bramante started out in Urbino, in the learned circle of Piero della Francesca and the Laurana brothers, but a stay in Mantua gave him firsthand experience of the works of Mantegna and, even more importantly, those of Leon Battista Alberti, whose spiritual mantle he assumed. From 1477 he conducted monumental experiments in the lands of Ludovico il Moro, Duke of Milan, combining the devices of perspective illusion with a powerful structural technique. Rather than in painting his genius expressed itself in such architectural works as the Church

◀ *Leonardo da Vinci, Virgin of the Rocks, 1483–85, Louvre, Paris. Atmospheric perspective was introduced by Leonardo during the final twenty years of the fifteenth century.*

▼ *Leonardo da Vinci, Last Supper, 1495–98, Santa Maria delle Grazie, Milan. A highly skilled practitioner of representational technique, Leonardo found convincing solutions to the problems posed by the subject's setting and by the architectural location of the fresco.*

of Santa Maria presso San Satiro in Milan (c. 1480–90), whose interior displays a majestic sense of space achieved within very modest dimensions. Use of perspective allowed him, among other things, to create the illusion of a deep apse where the building's urban location did not allow for one. While Bra-

mante was erecting the presbytery of the Church of Santa Maria delle Grazie, Milan, Leonardo was painting his *Last Supper* (1495–98) in its refectory. With this fresco the artist–scientist, who had grown up in Florence among the pupils of Andrea Verrocchio and close to Pollaiuolo and Botticelli, created one of

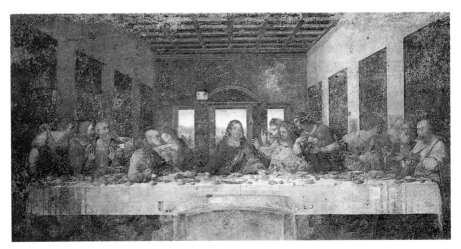

the finest examples of Renaissance representational art: for its composition he revived a famous layout (Andrea del Castagno's *Last Supper* for Sant'Apollonia in Florence, 1448), but he breathed new life into it by breaking down the spatial barriers and giving the figures an extraordinary feeling of psychological depth. In order to understand the radical nature of Leonardo's style we should also examine another painting from his early Milanese period, which ended in 1499 with the fall of Ludovico il Moro: *Virgin of the Rocks* (1483–85). In this work the *sfumato* technique achieved perfection in the portrayal of atmospheric effects, while at the same time successfully linking delicate drawing with carefully balanced proportions, qualities that would also appear in the works of his maturity (*Mona Lisa* or *La Gioconda*, 1503; *The Virgin and St Anne*, 1508–10). Leonardo left a whole host of imitators in Milan, but

In architecture, sixteenth-century Classicism followed a rather tortuous path: there are signs of it in Bramante's Tempietto of San Pietro in Montorio (begun in 1502), in the architectonic oeuvre of Raphael and in the works of the Florentine Sangallo family and the Venetian Lombardo family. It was not until later, however, that it reached full maturity in the works of Jacopo Sansovino and, above all, Andrea Palladio. The former, Tuscan by birth but Venetian by adoption, was responsible, after 1537, for altering the layout of St Mark's Square in Venice by introducing the Libreria Marciana and the Loggia del Campanile. The latter, a native of Padua and one of the most gifted town planners of all time, between 1540 and 1550 erected a number of palaces and public buildings in Vicenza, several churches in Venice and large numbers of villas in the Venetian hinterland. His Villa Capra, known as La Rotonda, is the most typical example of the Palladian revival of Greek and Roman models: four ''temple'' pronaoses, complete with colonnades and pediments, give the central core of the building a sense of harmonious unity and at the same time open it up on to the surrounding countryside, reflecting Palladio's attempt to achieve a perfect fusion between architecture and environment.

among the most interesting sixteenth-century Lombard artists are Bramantino (Bartolomeo Suardi, whose adopted name reflects his allegiance to Bramante) and the leaders of the Brescia school: Romanino, Moretto and Savoldi, all of whom reflect to some degree, on one hand, the Venetian tradition and, on the other, their local roots (Foppa and Bergognone).

Leonardo then moved to Florence, which, at the beginning of the new century, was also playing host to Raphael and Michelangelo. For a few years the Tuscan city relived the glories of its golden age, even though it was soon obliged to relinquish its role of cultural capital to Rome, where Michelangelo and Raphael were summoned in 1508 by Pope Julian II. The next decade was of crucial importance in that it represents the final phase of the Italian Renaissance. Although we cannot legitimately maintain the existence of an evolutionary

BIOGRAPHIES

♦ **Bramante** Donato di Pascuccio di Antonio, called (Pesaro 1444–Rome 1514). Active as a painter in Bergamo from 1477, he created his first architectural works in Milan shortly afterwards. Like all the greatest Renaissance artists, Bramante was versatile and inquisitive, an expert theorist and a courageous innovator. After the death of Ludovico il Moro (1499) he moved to Rome, where he was able to study the city's Classical ruins and, among other things, create a powerful, centrally based plan for St Peter's Basilica.

♦ **Correggio** Antonio Allegri, called (Correggio 1489–1534). He spent his whole life in the town of his birth, apart from a number of trips to Parma, where, between 1519 and 1530, he completed three important fresco cycles. Little is known of his training, but there can be no doubt that his painting owes a certain amount to Mantegna, Lorenzo Costa, Leonardo, Giorgione and Raphael.

♦ **Dürer** Albrecht (Nuremberg 1471–1528). He gained solid ground as a graphic artist while working in the studio of Wilhelm

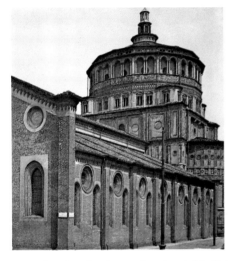

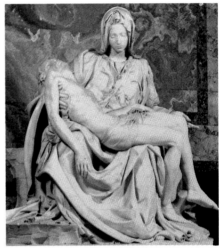

principle whereby the work of these two artists may be regarded as the final phase of a process first initiated by Giotto, it cannot be denied that the humanistic theory of art did indeed come of age during the period in question. Michelangelo consolidated the stylistic elements he had formulated in his early sculptures (*Madonna of the Steps* in Florence, 1491, the figures for the *Arch of St*

Dominic in Bologna, 1495, his *Pietà* of 1499 and his *David* of 1501–4) and also his early paintings (the *Tondo Doni* of 1504–6). In this way he was able to create, between 1508 and 1512, the frescoes on the ceiling of the Sistine Chapel, described by Chastel as "the highest achievement of Florentine linear design." In terms of precedents, it is possible to speak of a revival of the more dramatic aspects

of Masaccio's painting; in direct contrast, therefore, with the delicate graphic elegance of Botticelli or the calm and solemn airiness of Piero della Francesca. In his various portrayals of *Sibyls* and *Prophets*, as well as in his *Genesis* scenes, the artist used a two-dimensional language to interpret a strongly plastic ideal, to achieve a sculptural "hold" on the visual, carefully avoiding the *sfumato*

Pleydenwurff. Journeys to Switzerland and Italy, between 1490 and 1494, allowed him to expand his cultural horizons, and in 1495 he opened a workshop in Nuremberg, gaining considerable fame as an engraver and woodcut artist. In the meantime his paintings revealed a genius for synthesizing a wide variety of different stylistic elements in a European rather than purely German dimension. In 1505 he

was back in Venice, surrounded by admiring local artists. In 1512 he entered the service of Maximilian I and, after the latter's death, in 1520 he entered the service of Charles V.

♦ **Leonardo da Vinci** (Vinci, Florence, 1452–Amboise 1519). In 1469 he entered the workshop of Andrea Verrocchio, where he immediately developed great technical abilities. From 1482 he was in Milan, at the court of

Ludovico il Moro, where he painted his first masterpieces. He also began broadening his range of interests to include natural sciences, astronomy and physics. In 1499 he left Milan, subsequently working for Cesare Borgia as a military engineer, and in 1503 he returned to Florence, the scene of his second creative phase. In the years from 1510 up until his death he devoted himself with increasing vigour to scientific

studies and was only sporadically involved in painting.

♦ **Lotto** Lorenzo (Venice c. 1480–Loreto 1556). His early beginnings lay in Treviso and the Marches, in works that already revealed his estrangement from the linear fullness of Venetian Classicism in favour of a more restrained style of painting, almost Northern European in inspiration. Between 1513 and 1525 he

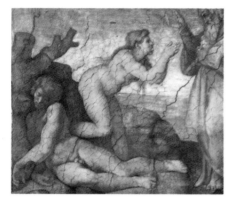

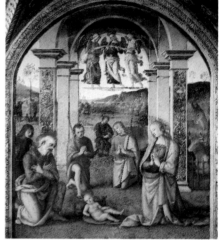

◄ *Michelangelo*, Birth of Eve, *1509–10, Sistine Chapel, Vatican Palace, Rome. His frescoes depicting subjects from Genesis gave Michelangelo the chance to give full rein to his visual and plastic genius. He reinvented the iconography of the subjects on the basis of his own, highly personal interpretation of the "concept" of humanity.*

technique of Leonardo and using chiaroscuro solely as a means of intensifying the expressive power of volume.

Raphael's approach, although complementary to Leonardo's, was completely different. In his work the sculptural element is almost totally lacking, but his exceptional mastery of drawing allowed him to achieve a perfect sense of balance between the different components. The *Transfiguration* (1518–20), one of his last masterpieces, shows clearly how every detail and every figure plays its part in the structure of the composition, with the individual masses of colour also acting as building blocks, so that the work is effectively based on a harmonious interplay of point and counterpoint, on an *assemblage* of focal interstices that function both as formal and as narrative elements. Within this structure, the turmoil of events calms down in a sort of synthetic serenity, a sublime, stylistic peace that had already appeared in his *Deposition* of 1507. It is this ability to match the psychological characteristics of the *narrative* with the physical reality of the *technique* that made Raphael such a unique figure in the eyes of future generations, ranging from his early followers (Andrea del Sarto, Giulio Romano, Perin del Vaga) to sixteenth-century academics and his admirers

lived in Bergamo and in the Lombard countryside before returning to Venice, where he made a final bid to establish himself in that city. It was, however, his contacts with the small towns of the Marches that continued to provide him with work until 1554, when he decided to enter the monastery of the Santa Casa in Loreto as a lay brother.

◆ **Michelangelo Buonarroti** (Caprese 1475–Rome 1564).

After completing his classical studies he overcame family opposition and entered the workshop of Domenico Ghirlandaio. This was followed by a brief period away from Florence for political reasons and his return to the city in 1501. He accepted Pope Julius II's invitation to go to Rome where, from 1508 onwards, he spent most of his career (Sistine Chapel, St Peter's Basilica, etc.). He then returned to Florence, where he worked on the architectural extensions of the church of San Lorenzo, finally settling in Rome for good in 1534. His later works include the fresco of the *Universal Judgement*, the final statues for the tomb of Julius II, the paintings in the Pauline Chapel and the Rondanini Pietà.

◆ **Palladio** Andrea di Pietro della Gondola, called (Padua 1508–Maser, Treviso, 1580). He moved at a very early age to Vicenza, where he met the humanist Gian Giorgio Trevisano, who entrusted him with the building of his house and gave him invaluable spiritual guidance. In 1550 he began rebuilding the Basilica or Palazzo della Regione, after which he came into contact with Daniele Barbaro, thanks to whom he obtained commissions from the Venetian aristocracy for dozens of country villas. In 1570 he was

▼ *Raphael, School of Athens, 1508–11, Vatican Palace, Rome. The dispute between the three greatest Greek philosophers seems to encapsulate the great dichotomy of Renaissance culture: on the one hand the rational pragmatism of Aristotle, on the other the mystical spiritualism of Plato with, in the middle, Classical painting as the supreme attempt at synthesis.*

◀ *Piero Perugino, Nativity, 1498–1500, Collegio del Cambio, Perugia. The paintings in the Audience Hall of the Exchange, although far removed from Raphael's universal pronouncements, represent the most illustrious forerunners of pictorial Classicism in central Italy.*

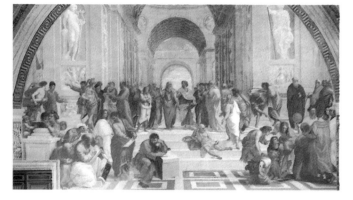

of the Romantic era. Between 1508 and 1514 he completed the decoration of the Vatican *Stanze*, part of the vast Roman building project on which Michelangelo and Bramante also worked. There are also certain precise analogies to be drawn between the pictorial style of Raphael and the architectural style of Bramante (Tempietto of San Pietro in Montorio, 1502–10). Apart from their common origins in the region of Urbino, which are not without significance, the two artists seem to agree on the exemplary value of Greek and Roman art. More specifically, the direct references to the Classical world, clearly visible in Bramante, in Raphael's works are indicative of the achievement of a "modern classicism," in other words a modern style as definitive and exemplary as that practised by the Greeks.

The Classicism of Raphael represents the final, and perhaps the richest and most complex, product of the retrospective tendency favoured by Italian humanism throughout the fifteenth century. The relationship with the Greek world began with direct, didactic reproduction and culminated in the achievement of complete aesthetic assimilation. Between 1510 and 1525, before Mannerism sounded its death knell, the ideology of an eternal, immutable beauty, directly inspired by the civilization of Antiquity in its capacity as the reflection of a superior order, encouraged other attempts: for example, Andrea del Sarto's

appointed official architect of the Venetian Republic. His final masterpiece was the Teatro Olimpico, inspired by the theaters of ancient Greece.

◆ **Raphael** Raffaello Sanzio, called (Urbino 1483–Rome 1520). Son of the painter Giovanni Santi, within the space of only twenty years he had established himself as a highly talented artist. He made a lasting impression on every

place he visited: Città di Castello until 1504, Florence and Perugia from 1504 to 1508, and Rome from 1508 until his death. His painting, whose fame spread like wildfire throughout the Italian peninsula, perfectly exemplifies the sense of balance achieved by Renaissance art.

◆ **Titian** Tiziano Vecellio, called (Pieve di Cadore c. 1490– Venice 1576). The greatest Venetian painter of the

sixteenth century, he started as a pupil of Giorgione before 1510. His career is generally divided into three stylistic periods: the tonal Classicism of his youth (1510–30), his triumphal, Mannerist phase (1530–50) and the dramatic expressionism of his old age (1550–70). During this time his fame gradually grew throughout Europe, and his patrons included the dukes of Mantua, Ferrara and Urbino, Pope Paul III

and the Emperors Charles V and Philip II.

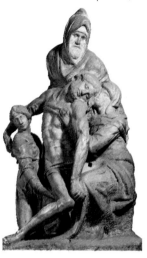

▼ Michelangelo, Pietà, c. 1550, Cathedral, Florence. This work represents one of the greatest sculptural achievements of all time, both in the poetic strength of its composition, in which it is still possible to detect the marble block from which it grew, and in the expressive distortion of the figures, a skilful foretaste of the tragic mystery of death.

cycle of paintings depicting the *Life of the Virgin* (c. 1514), the sculptures executed by Michelangelo for the tomb of Pope Julian II (including his famous *Moses*) and the final paintings of Fra Bartolommeo.

Classicism had another vitally important center at Venice, which, at the beginning of the century, saw the emergence of Giorgione da Castelfranco, a figure as highly prized by his contemporaries as he is poorly documented. The works now attributed to this artist, who may have been a pupil of Giovanni Bellini, but who was definitely the master of Titian, include *Tempest* and *Three Philosophers*. These works reveal the hand of a great and very independent artist, who cannot be typecast in the role as a link between the two greatest Venetian painters. His style exploited Bellini's use of colour, the Umbrian-Flemish syntax of Antonello da Messina, the *sfumato* of Leonardo and even the best elements of Perugino's art, as is shown by one of his early works, the *Castelfranco Madonna*. Giorgione continued the research into tonal harmony, first begun more than twenty years earlier, and introduced at least two surprising innovations: from a technical point of view, he abolished drawing from the painting process (in the words of Vasari, he painted "without making drawings previously, believing this to be the true method of procedure"), and, from the point of view of content, he made landscape the main subject of his oeuvre, as in the *Tempest* mentioned above.

When Giorgione died in 1510 Titian was roughly twenty years old, and there are still some paintings (the most famous of which is the *Concert* in the Louvre) whose attribution is disputed between the two artists. Titian's early beginnings undoubtedly represent a logical continuation of Giorgione's work, even though some critics have pointed out that the joyous colours and tonal perfection of the former do not appear in works attributable to the latter. The splendid symphony of colours achieved by Titian in almost

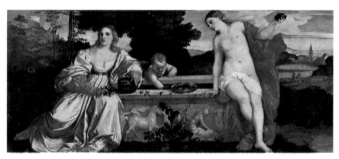

◀ Titian, Sacred and Profane Love, 1514, Galleria Borghese, Rome. Sacred love is naked, as faith is and as man's soul should be before God; profane love is richly clothed in the transient robes of contemporary fashion.

◀ Titian, Flaying of Marsyas, c. 1575, Zámek Kroměříž, Czechoslovakia. Among the most extraordinary works of Titian's old age, modelled by the fingers of the almost blind artist, this cruel and bloody fable denotes the end of utopias: it speaks to us of an artist god foolishly challenged and an uncultured subject brutally punished.

all his early compositions (from *Sacred and Profane Love* of 1514 to the *Assumption of the Virgin* of 1518; from *The Three Ages of Man* of 1515 to the *Pesaro Madonna* of 1526) exploits the same laws of harmony that now form part of the common heritage of Italian art, but he also introduced a "musical" quality typical of Venetian culture.

The culture of the period is also reflected in the choice of subject, even though it is true that in Titian's works pagan mythology provides material

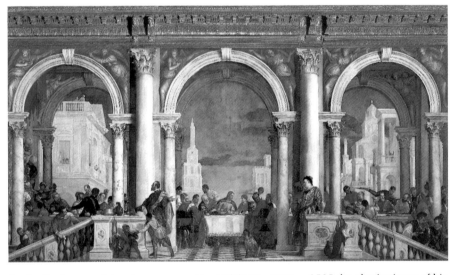

for the final successful metaphors of the spiritual equilibrium achieved by Renaissance man (for example, the two Venuses of *Sacred and Profane Love*). His style developed at the same rate as the quality of the messages conveyed, a feature that received further confirmation many years later, when Titian, by now an old man, intentionally dissolved his brushwork into a shapeless chromatic substance that seems to anticipate Rembrandt or even Monet, and he did this in works whose dramatic effect is carried through to their content, in which mythology is manipulated so as to reflect the hopelessness of a society racked by conflict and insecurity (*Death of Actaeon*, 1565–70, *Flaying of Marsyas*, 1570–75). In this context it is worth remembering that Michelangelo followed an almost parallel course. After 1525 the plastic vigour of his drawing, the formal solidity of his inventions, both sculpted and painted, and the bold defiance of his youth gave way to a mood of desperation, almost of mental and physical fatigue: with his *Slaves* in the Accademia in Florence, *Last Judgement* in the Sistine Chapel (1537–41), frescoes in the Pauline Chapel (1542–50) and *Pietà* in Florence Cathedral (c. 1550).

◀ *Correggio,* Nativity (Night), *1529–30, Gemäldegalerie, Dresden. After Piero della Francesca's fifteenth-century* Dream of Constantine, *this painting by Correggio represents one of the rare Renaissance attempts at portraying a nocturnal scene; hence the traditional nickname for his Dresden painting of the Adoration of the Shepherds.*

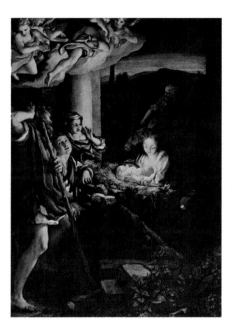

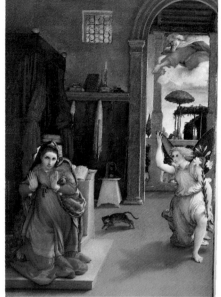

In the Veneto region, Classicism was similarly prolonged by the rich, triumphal painting of Paolo Veronese, which sometimes displays an almost provocative quality in the way that religious subjects are set in surroundings of theatrical grandeur and secular opulence. And yet the stimulus provided by the art of Bellini and Antonello was still capable of producing alternatives to the courtly language of Titian and Veronese: Lorenzo Lotto, for example, specialized in narrative paintings of intimate, melancholic scenes with a delightfully anti-rhetorical quality. His life was marked by a long, voluntary exile in Lombardy and the Marches, in pursuit of patrons uninfluenced by the dominant Titianesque style. The *St Dominic Polyptych* (1508), the frescoes at Trescore Balneario (1524) and his versions of the *sacra conversazione* at Bergamo and in various churches in the Marches are works of unusual emotional intensity, endowed with a strongly lyrical quality. They avoid the dominance of chromatic harmony in favour of contrast and the measured revelation of tonal differences. Lotto sided with the poor and the oppressed, with those for whom the world was a place of small miracles, of intense personal wonderment, like that on the face of an almost child-like Virgin, in the Recanati *Annunciation* of 1527, who reacts by turning away, while

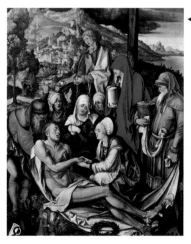

◀ *Albrecht Dürer,* Lamentation on the Dead Christ, *c. 1500, Alte Pinakothek, Munich. This work in a way represents a compendium of sixteenth-century Northern European art. And yet, while its details recall the great masters of early German Classicism, albeit with elements of Gothic refinement, the structure of the composition already displays an almost Mannerist quality.*

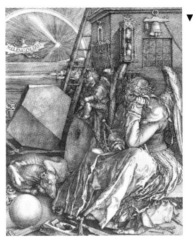

the cat shows its own lack of enthusiasm for unexpected supernatural visitations by running off in terror.

An adroit and skilful blend of the styles of Leonardo, Giorgione, Raphael and Emilian artists of the late fifteenth century produced the highly original paintings of Antonio Allegri da Correggio, who created his greatest works in Parma: the *Camera di San Paolo* (1519) and his *Assumption of the Virgin* (1526–30) on the dome of the cathedral. The most fascinating aspect of this Emilian artist's work is the rich variety of its structural solutions and perspective angles and the exuberant richness of its colour, all of them characteristics that take Correggio out of his time, making him a forerunner of the Baroque. Another Emilian artist worthy of mention is Dosso Dossi, the principal exponent of the Ferrara school, whose mythological paintings are worthy of inclusion among the greatest expressions of sixteenth-century philosophical thinking.

The flowering of the Renaissance coincided with its spread beyond the borders of the Italian peninsula. Germany, in particular, produced artists of great historical importance and undoubted technical merit. Albrecht Dürer was the complete intellectual, who matched his creative activities with theoretical research, publishing a treatise on anatomy and a manual on perspective layout. There can be no doubt that his painting owes a great debt to his experiences in Italy during his dif-

ferent visits to Venice, but it also reveals signs of a strong artistic personality, modelled on the synthesis of different influences: apart from the Venetians, the Flemish and later Michael Pacher and Martin Schongauer. In his early watercolours Dürer adopted an approach to landscape that was unique in its day: romantic visions of the Alps and the woods of Bavaria, lakes, towns and castles, glimpses of the wonderful views that would later

▼ *Dosso Dossi,* Jove and
Virtue, *c. 1530,*
Kunsthistorisches
Museum, Vienna. Zeus-
Jove, the first painter, is
shown intently painting
a landscape and has
already completed three
butterflies. One of the
Virtues is trying to
recall him to profane,
more worthwhile
duties, but Hermes-
Mercury, the practical
spirit, is entranced by
the magic of art and
imposes a religious,
hermetic silence on the
woman making this
inopportune request.

act as the backgrounds to his sacred paintings (*Lamentation on the Dead Christ*, Munich, 1500; *Feast of the Rose Garlands*, Prague, 1506; *Adoration of the Trinity*, Vienna, 1511). As well as being a highly skilled portraitist, Dürer was also a brilliant engraver: one thinks of his etching *Melancolia I* (1514), in which he encapsulated, in a sophisticated allegory, much of the learning of his day, bequeathing a "document" of inestimable importance in

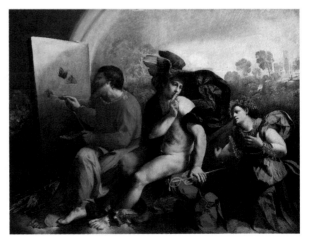

▼ *Albrecht Altdorfer,* Battle of Darius at Issus, *Alte Pinakothek, Munich. The surreal immensity of the space portrayed, the pulsating mass of soldiers, the encampments, forts and town, the light on the mountains and between the clouds, the expanses of sea and land: all these elements contribute towards the sense of panic and cosmic poetry exuded by this vast aerial view.*

the form of a mysterious and thought-provoking image.

Another area of German art is represented by the surprising spatial compositions of the Bavarian Albrecht Altdorfer, a man endowed with excellent technique and an innovative, restless curiosity. These qualities are taken to the extreme in his two almost hallucinatory paintings in the Pinakothek in Munich (*Birth of the Virgin*, c. 1520, and the *Battle of Darius at Issus*, 1529). In the latter the viewer's gaze is led across seas and inlets, over distant coasts, mountains and immense stretches of land and water until it finally captures the curving surface of the earth at a horizon transfigured by a dream-like sunset. Another of the high points of sixteenth-century painting is represented by Hans Holbein the Younger's picture of *The Ambassadors* (1533), in which pride in humanism, a full awareness of its nature and a conviction in the rightness of its achievements are all thrown into doubt by the very act that proclaims them. At the feet of the two dignitaries, beneath the emblems of the various branches of knowledge, the monstrous effigy of a distorted skull, recognizable by taking a slanting look at the painting, reminds the living that everything passes, even the rational clarities of the most enlightened age, and that death is, in the final event, the only certainty of life. ■

◄ *Hans Holbein the Younger,* The Ambassadors, *1533, National Gallery, London. The unidentifiable object in the foreground is in fact the distorted perspective of a skull. On walking to the right the skull takes shape until it can be clearly seen from the extreme right of the painting.*

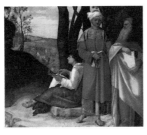

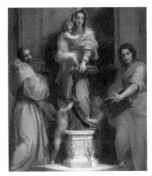

Michelangelo, Madonna of the Steps, *detail, 1491, Casa Buonarroti, Florence.*

Together with the Battle of the Centaurs *(1492), this work attests to the precocious talent of the sixteen-year-old artist. It is interesting to note the completely graphic treatment of the bas relief, with no sculptural plasticity or even chiaroscuro illusion. Michelangelo's eclecticism is anticipated in the work's Platonic-idealist element.*

Giorgione, Three Philosophers, *detail, 1505–10, Kunsthistorisches Museum, Vienna.*

The subject of this allegorical painting may be linked to the moralistic representation of the three ages of man. The hypothesis of the philosophers does, however, involve a daring form of cultural syncretism (undoubtedly possible in a learned humanist such as Giorgione), which gives the same weight, together with as many symbols of universal knowledge, to the Greek thinker, the Oriental scholar and the Renaissance scientist.

Andrea del Sarto, Madonna of the Harpies, *1517, Uffizi Gallery, Florence.*

Sarto offered his own interpretation of Classicism, marked by a mature and highly sophisticated approach to imagery that today fails to arouse the same enthusiasm as Lotto, Titian, Correggio, Giorgione, Raphael and Michelangelo, but nevertheless possesses very original and worthwhile qualities.

Treaty of Tordesillas Jews expelled from Spain	Savonarola burnt at the stake French capture Milan and Genoa	Julius II elected Pope Queen Isabella of Castile dies	Coronation of Henry VIII	Luther's 95 theses of 1517 Cardinal Wolsey becomes Chancellor of England	Field of the Cloth of Gold Battle of Pavia
Printed edition of *Tractatus de virtutibus herbarum*	Circumnavigation of Africa	Christ's College, Cambridge First book printed in Scotland	Pacioli: *De divina proportione*	Voyages of Magellan	Commines: *Mémoires*
Des Prés in Rome Okeghem in Paris	Obrecht in Ferrara	Mandolin and viola da gamba	First harpsichord	Costanzo Festa in Rome	Villaert at Ferrara
Brant: *Ship of Fools*	Vicente: *Monólogo do Vaqueiro*	Bembo: *Gli Asolani* Ariosto: *Commedie*	Erasmus: *Encomium moriae* Machiavelli: *The Prince*	Sir Thomas More: *Utopia* Ariosto: *Orlando Furioso*	Sachs: *Die Wittembergisch Nachtigalle* John Major: *De historia gentis scotorum . . .*
Columbus' first voyage across Atlantic	Holyrood House, Edinburgh	Giorgione working in Venice Columbus dies	Michelangelo and Raphael in Rome	Leonardo at the court of François I	Lefèvre d'Etaples translates the New Testament into French Luther translates the Bible into German
Michelangelo: *Madonna of the Steps*	**Leonardo:** *Last Supper* **Michelangelo:** *Pietà*	**Dürer:** *Feast of the Rose Garlands* **Leonardo:** *Mona Lisa* **Michelangelo:** *David*	**Michelangelo:** Sistine Chapel **Raphael:** Vatican *Stanze* **Grünewald:** *Isenheim Altarpiece*	**Raphael:** *Transfiguration* **Titian:** *Assumption of the Virgin*	**Correggio:** Dome of Parma Cathedral
1490–96	1497–1502	1503–08	1509–14	1515–20	1521–26

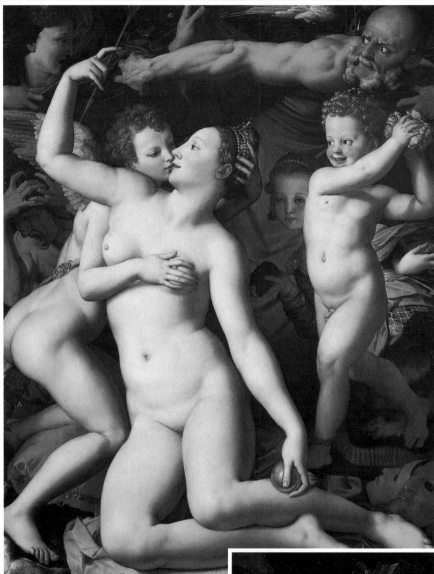

Bronzino, Cupid, Time and Folly, *c. 1546, National Gallery, London. This work, which may be read as a series of coded symbols, has been variously interpreted as the triumph of Venus, an allegory of pleasure, the victory of time over love, and lust unmasked. It is almost certainly this work to which Vasari refers as a painting of "singular beauty" sent to François I in France that depicted a "naked Venus with a Cupid kissing her." With its pale, opalescent surfaces and dark background tones, this perfect amalgam of Classical and literary references comprises the Mannerist principles of draughtsmanship, form and colour.*

6 MANNERISM

The definition of Mannerism is normally applied to the figurative experiences of a few generations of artists, who, during the second decade of the sixteenth century, at a time when the Renaissance had achieved ultimate perfection, developed a style that imparted a bizarre, fantastical and highly imaginative quality to the models established by the great masters.

The term Mannerism, which is very widely used, is in itself somewhat controversial. From the seventeenth century right up until the beginning of the twentieth it was synonymous with unnaturalness, with a cold, cerebral quality and sterile virtuosity. Critics then gradually revised their opinion and Mannerism came to be particularly appreciated at times when people's awareness of living through a period of social and cultural crisis made them identify with similar situations in the past.

The first signs of a break in classic Renaissance equilibrium, which was characterized by an idealized, measured harmony, appeared in Tuscany. In Florence, Pontormo and Rosso Fiorentino, artists in the workshop of Andrea del Sarto, were the first exponents of what has been described as the experimental phase of Mannerism. It was certainly the most instinctive and also the bravest for the way in which it ran contrary to prevailing custom. The frequency with which many of the first Mannerist works were rejected by those who

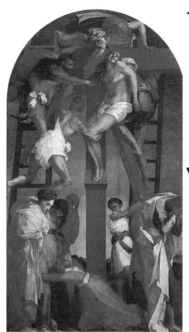

◀ *Rosso Fiorentino, Deposition, c. 1521, Pinacoteca Civica, Volterra. Rosso's absorption of Northern influences, clearly visible in this work, anticipates his openness to a cosmopolitan style of art that would later find practical application at Fontainebleau.*

▼ *Bronzino, Portrait of Lucrezia Panciatichi, c. 1540, Uffizi Gallery, Florence. The artist has taken everything into account, from the costume of the figure right down to the smallest detail, in expressing the dignity of a social role in transcendental terms. This feature confers a remote, rarefied mood to the portrait.*

had commissioned them and the dismay caused by their visual style give an idea of the new figurative language's revolutionary impact. They scandalized traditionalists but completely won over all those who, sensing they reflected the anxieties of a new era, were encouraged to carry out their own experiments. Young Florentine painters had been greatly influenced by their studies of Leonardo and Michelangelo's preparatory cartoons for two frescoes portraying battle scenes in the Palazzo Vecchio. Michelangelo's cartoon for the *Battle of Cascina* was actually destroyed by the retracings made of them.

One of the first artists to imitate Michelangelo in his own way was the Spaniard Alonso Berruguete, whose nonconformism encouraged Rosso and Pontormo to break free from convention. Rosso's *Deposition* is an explicit and open declaration of dissent in the face of tradition, and its allusions

to Dürer hint provocatively at the possibility of other sources of expression and other technical devices. Its composition is based on contradictory planes, on improbable equivalences and dazzling flashes of light, with each figure having its own rhythm, balanced somewhere between the frenetic and the sluggish.

The aggressive intellectualism of Rosso, who soon left Florence for Rome and then Rome for Fontainebleau, was matched by the manic introversion of Pontormo. Everything that Vasari wrote about Pontormo and everything that he says about himself in his diary encourages the image of an antisocial, cantankerous artist. In fact, Pontormo was almost unique in his awareness of the parlous nature of his times. Almost a prisoner of his own creative fury, this highly talented draughtsman and portraitist worked only in Tuscany. A few years after Rosso's *Deposition* in Volterra, Pontormo

Mannerist portraits always convey more than they show. It is this characteristic that makes them stand out within the context of sixteenth-century painting. The artist's desire to penetrate the essence of the subject in order to grant the sitter an ideal historical commemoration, combined with the need to preserve a recognizable physical likeness and a sense of psychological verisimilitude, means that the images have many different levels of meaning. The portrait becomes so emotionally charged that it transmits a feeling of vague unease to the onlooker. An example of how Mannerist painters also knew how to make use of visual tricks in order to achieve a bewildering effect is represented by Parmigianino's Self-Portrait in a Convex Mirror. *Painted on a circular wooden panel, it mimics the image that a convex mirror would give of the artist, and obliges the viewer to accept the hand, which appears misshapen and disproportionate in the painting, as a logical and elegant consequence of the reflection.*

tackled the same subject and created a synthesis of his own suffering talent, displaying an astonishing technique and creating a disconcertingly fascinating effect. The subject is composed of insubstantial colour barely controlled by its own contours, while an unreal light eternalizes a single moment of total desperation.

Still in Tuscany, but earlier than Pontormo and Rosso and far from the turmoil of Florence, a city torn between republicanism and restoration, the Sienese painter and sculptor Domenico Beccafumi translated the language of Leonardo and Raphael in Mannerist terms, giving fantastical expression to ideas derived from Florentine Classicism and also to the innovative disquiet of the new generation.

In Florence, it was left to Bronzino, Pontormo's only pupil and court painter to the Medici, to impart an extraordinary degree of formal perfection to one of the most important characteristics of

BIOGRAPHIES

◆ **Beccafumi**
Domenico (Valdibiena, Siena c. 1486–Siena 1551). Active in around 1515. His earliest works reveal a Classical layout but over the years his restless brushwork developed a laboriously formal style of great structural complexity.

◆ **Bronzino** Agnolo di Cosimo, called (Florence 1503–72). A pupil and assistant of Pontormo, he worked at Pesaro and Florence,

where he spent most of his life. He worked in the service of Cosimo I de' Medici and, in 1545, began the decoration of Eleanor of Toledo's chapel in the Palazzo Vecchio.

◆ **Cellini** Benvenuto (Florence 1500–71). A sculptor, goldsmith and engraver, he is also well known for his memoirs. Banished from Florence in 1516, he spent time in Bologna, Pisa and Rome. Once back in his native city, he was

forced to escape again. In Rome he enjoyed the protection of Clement VII and took part in the defense of the city in 1527. He subsequently worked in France, at the court of François I.

◆ **El Greco**
Domenikos Theotokopoulos, called (Crete 1541–Toledo 1614). He worked in Venice with Titian and was strongly influenced by Tintoretto. He visited Rome and finally

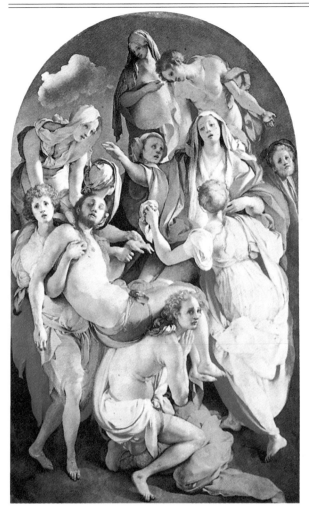

◄ *Pontormo*, Deposition, *c. 1526–28, Santa Felicità, Florence. This work was executed as part of the decoration for the chapel acquired by Ludovico Capponi in 1525.*

work turns to ice in Bronzino: Lucrezia's gaze is remote not so much because it is disdainful but because it is somewhere else; and whereas in *Lady in Red* the skin is cold, in this work it is the very blood that is frozen.

Florentine Mannerism later became gradually codified along academically eclectic lines by artists responding to the demands of the Medici court, while Vasari and Salviati, Macchietti and Cavalori, Poppi, Naldini and Zucchi also adopted stylistic elements from International Mannerism with great finesse. Francesco I's *Studiolo* in Florence's Palazzo Vecchio represents the synthesis of a cultural moment that was in perfect harmony with the mood of the day. In the regions of Emilia and the Veneto, the need for renewal and expressive freedom, which in Florence and Rome were first defined and then academically codified, opened new chapters in the history of Mannerism that were destined to have a

Mannerism: the refined and detached elegance of pure abstract thought. A comparison between Pontormo's *Lady in Red* and Bronzino's *Portrait of Lucrezia Panciatichi* shows how the vibrancy running through the master's

settled in Toledo, Spain.

◆ **Fontainebleau** School of. An artistic center established by François I on his return to France after the defeat at Pavia. Many Italians were summoned to Fontainebleau, starting with Rosso Fiorentino. Other artists included Luca Penni, Primaticcio, Niccolò dell'Abbate, Cellini, Vignola and Serlio.

◆ **Giambologna** Jean de Boulogne, called (Douai 1529–Florence 1608). A Flemish, Italianate sculptor, he worked mainly for the Medici. He experimented with different techniques, eventually concentrating on works of a religious nature.

◆ **Giulio Romano** Giulio di Pietro, called (Rome 1499–Mantua 1546). A pupil and assistant of Raphael, after whose death he

completed the decoration of the Vatican frescoes. He moved to Mantua, where he worked as an architect for the Gonzaga family.

◆ **Niccolò dell'Abbate** (Modena c. 1509–Fontainebleau? 1571). He studied the art of Parmigianino in Bologna and later worked at Fontainebleau. There are frescoes by him in the Palazzo Poggi and Palazzo Torfanini in Bologna.

◆ **Parmigianino** Francesco Mazzola, called (Parma 1503–Casalmaggiore 1540). He developed alongside Correggio and worked in Parma, Rome and Bologna. After the Sack of Rome, he drew on the work of Raphael and Michelangelo to produce precious, non-naturalistic paintings. Prints of his drawings were widespread.

◆ **Pontormo** Jacopo Carrucci, called (Pontormo, Empoli,

◀ *Tintoretto*, Discovery of the Body of St Mark, *Pinacoteca di Brera, Milan. This work displays an overwhelming degree of creativity and a dazzling comprehension of Mannerism.*

▼ *Michelangelo, entrance hall of the Laurentian Library, begun in 1524, Florence.*

decisive influence on artistic sensibilities during the second half of the sixteenth century in both Italy and Europe. It influenced the formal choices of Parmigianino, the adventurous, chivalrous themes of Primaticcio and Niccolò dell'Abbate, the atmospheric magic of Lelio Orsi and the joyful, exuberantly Michelangelesque style of Pellegrino Tibaldi, as well as the composite genius of Tintoretto and the metaphysical tendency of Luca Cambiaso.

The most recent studies of Mannerism have identified its origins in Rome rather than in Florence, in around the 1530s. Failure to see Mannerism as a symbol of moral or artistic crisis is to deny that it represents a break with the Renaissance and to suggest that it was a logical development of the latter, with specific characteristics of aristocratic elegance and a taste for refinement and artifice. Thus the most apposite definition for the Florentine phase between 1515 and 1525 is either "anti-Classical experimentalism" or "early Mannerism." In fact, Rome, which had suffered great upheavals and difficulties during the reigns of Pope Julian II and Leo X, under Clement

1494–Florence 1556). A pupil of Andrea del Sarto, he was influenced by Michelangelo and was also familiar with the engravings of Dürer.

◆ **Primaticcio** Francesco (Bologna 1504–Paris 1570). He worked with Giulio Romano in Mantua and, after the death of Rosso Fiorentino, was summoned to Fontainebleau, where he became chief court artist. He created innumerable frescoes (many no longer extant) and stucco decorations.

◆ **Rosso Fiorentino** Giovanni Battista di Jacopo, called (Florence 1495–Fontainebleau 1540). After working in Florence with Andrea del Sarto and Pontormo, he went to Rome and later became the official painter to François I at Fontainebleau.

◆ **Salviati** Francesco de' Rossi, called (Florence 1510–Rome 1563). A friend and follower of Vasari, he worked in Rome, Venice and Florence. His work is an excellent example of the profane tendency of Mannerism. Between 1540 and 1550 the formal devices he employed in his work came to influence the artists working on the Oratory of San Giovanni Decollato in Rome.

◆ **Spranger** Bartholomaeus (Antwerp 1546–Prague 1611). He worked in Paris and in Italy and was court painter in Vienna and Prague.

◆ **Tibaldi** Pellegrino (Puria in Valsolda 1527–Milan 1596). A sculptor and architect, as well as a painter, he worked in Bologna, Rome, Ancona and Lombardy. He took part in the decoration of El Escorial in Spain.

VII became a unique hive of cultural activity as a result of the arrival in the city of artists from every direction, attracted not only by the very real prospect of work, but also by the opportunity to exchange ideas and experiences. The Sack of Rome, which had such a profound effect on Italy that 1527 has come to be regarded as the year that marked the end of the Renaissance, led to the dispersal of most of the city's artists and hence also the dissemination of Mannerist culture throughout Europe.

Every artist took with him, as well as a knowledge of the art of Michelangelo and Raphael, an already acclaimed ability to elaborate on these masters' stylistic repertoire in a highly original way and so, in turn, create schools of their own. Of Raphael's followers, Sansovino and Serlio went to Venice, Perin del Vaga to Genoa, Polidoro da Caravaggio to Naples, Parmigianino to Bologna and Parma, and Rosso Fiorentino to Arezzo and Venice and then to France. Giulio Romano en-

joyed an extraordinarily large following thanks to his vast repertoire of inventions that signalled a further development in Mannerism, first with his frescoes in the Sala di Costantino in the Vatican and later with all the works of architecture and painting he created in Mantua. Against a background of brilliant literary and archaeological erudition, Giulio interpreted Classical Antiquity, drawing on the austere and tragic grandeur of Michelangelo and laying particular emphasis on the element of wonder and amazement. The irrepressible vitality, the extraordinary optical and psychological effects and the creative power of the Classical allusions in the frescoes of the Palazzo del Tè in Mantua illustrate this most clearly. A similar revival of Antiquity occurs in the work of Polidoro da Caravaggio, who adorned the façades of palaces with martial scenes, and Perin del Vaga, who refined the graphic skills of his Florentine training with a formal

♦ **Tintoretto** Jacopo Robusti, called (Venice 1518–94). A pupil of Titian, he was influenced by Michelangelesque Mannerism. In his work draughtsmanship, form and colour are taken to the extreme limits of expressiveness, thanks to his highly individual treatment of light and movement. He influenced El Greco.

♦ **Vasari** Giorgio (Arezzo 1511–

Florence 1574). An architect and art historian, as well as a painter, he worked in Florence and, more especially, in Rome, where he founded the Academy of Drawing (1561). He worked on the decoration of the Palazzo Vecchio in Florence (Salone dei Cinquecento and Studiolo of Francesco I de' Medici). His principal contribution to the history of art is the work *Lives of the Great Artists* (1550 and 1568) where, among

other things, he defines the characteristics of Mannerism.

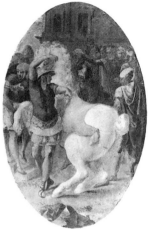

◀ *Domenico Beccafumi, Birth of the Virgin, 1531–36, Pinacoteca, Siena. The light of daytime and nighttime together rescues the figures from the shadow and enhances the illusion of depth.*

finesse derived from the stucco decoration and grotesques of subterranean Rome that had been unearthed by archaeologists. Rome had accepted the demands of Tuscan Mannerism in an atmosphere of cultural turmoil and then exploited them for major commissions.

Parmigianino's oeuvre almost represents a compendium of Italian Mannerism. Correggio, Michelangelo and Raphael were decisive formative influences, while Rosso, Perin del Vaga and Giulio Romano played a vital role in the final development of his art. This does not, however, explain the extraordinary originality of his output, in which distortions, exaggerations and sinuous meanderings combine to create a sense of graceful refinement and an unaffected elegance whose naturalness is at once persuasive and yet at the same time improbable.

It was Parmigianino who was responsible for the mark made on French painting by Niccolò dell'Abbate and Primaticcio. By proclaiming that man is the measure of himself, unlike the Renaissance principle whereby man is the measure of all things, Mannerism contained the seeds of its own downfall, since no model can repeat itself endlessly without exhausting itself. When in 1564, the year of Michelangelo's death, Andrea Gilio wrote his *Dialogues*, he was drawing up an indictment of the "mannered" quality of Italian art and providing the theoretical reasons for its demise. Rome had recently witnessed the completion of such great works as the deco-

ration of the Sala Paolina in the Castello Sant'Angelo by Perin del Vaga, the frescoes for the Oratorio di San Giovanni Decollato by Francesco Salviati and Jacopino del Conte and, also by Salviati, the frescoes in the Palazzo Ricci-Sacchetti and the Palazzo Farnese. At the time, Mannerism was already feeling the effects of the Counter-Reformation and had become weighed down by the academic rigidity of its final stage, which was marked by a substantial tempering of its language and by the grandiose rhetoric of vast residential projects.

One of the most salient features of Mannerism was the circulation of its ideas. Once the legitimacy of the imitation had been not just established, but raised to the level of the accepted norm, the outcome was a stale reworking of acquired knowledge. The borrowed idea became the raw material that would be transformed into a new artistic product which, although often of undeniable originality, had a composition that, to a greater or lesser extent, invariably betrayed signs of its original inspiration. The diffusion of engravings and prints (particularly the graphic work of Dürer and Lucas van Leyden in Italy and that of Parmigianino throughout Europe) meant that new ideas spread with extraordinary speed. The course of history flowed fast in the sixteenth century and its current carried men and ideas to distant lands.

Information on Mannerism and its techniques was also transmitted by those European artists who, in their search for the Rome of

◀ *Benvenuto Cellini,*
Nymph, 1542, Louvre,
Paris. In its
overwhelming emphasis
on decorative criteria
this work attests to the
School of
Fontainebleau's perfect
adherence to formal
choice.

▼ *Giorgio Vasari, Studiolo*
of Francesco I, 1570–
72, Palazzo Vecchio,
Florence. Conceived and
decorated like a casket,
this room represents the
synthesis of Tuscan Late
Mannerism.

◀ *Primaticcio,* Alexander
and Bucephalus, *c.*
1541–45, bedroom of
the Duchesse
d'Etampes,
Fontainebleau. After
the death of Rosso
Fiorentino, control over
the works at
Fontainebleau passed
into the hands of
Primaticcio, who, with
the assistance of other
Italian artists, imposed
a repertoire of
decorative models that
became common to all
contemporary French
artists.

◀ *Giambologna,* Rape of
the Sabine Women,
1583, Loggia dei Lanzi,
Florence. In this work
the space is brought to
life by two contrasting
forces entwined in a
double spiral: one
assists the dis-
entanglement of the
girl, while the other
coils around and brings
the base to a full stop.

Classical Antiquity and the masters of the Renaissance, discovered the great progenitors of Mannerism. El Greco visited Italy, as did Heemskerck, the "Michelangelo of the North," and also Wtewael, Pieter de Witte, Sustris, Spranger and Heintz. By the 1530s Italian Mannerism in all its most refined variants was becoming familiar throughout Europe, where it combined with local traditions to give rise to so-called International Mannerism, meaning forms of art that were paradoxically linked by the fact that they were all different, but uniformly marked by a sense of the bizarre, by distortion, ambiguity, intellectualism, elegance and contrivance. It particularly appealed to the courts of Europe because of its finesse, its wealth of cultured references, its playful sensuality, its interplay of symbols and allusions and its ability to surprise. France provided the Italians who had been summoned there with a chance to display their exceptional versatility and show how adaptable Mannerist formulas could be in meeting the requirements of commissions. Rosso, Primaticcio, Luca Penni and Niccolò dell'Abbate, Salviati, Serlio and Cellini founded the School of Fontainebleau, inventing a style that matched the needs of its environment so closely that it came to be adopted by the French as their own and was raised almost to the level of a decorative philosophy. Mannerism spread and made converts in France, the Low Countries, Bavaria, Spain and Prague. By feeding on itself, however, it became academic and stilted, the reflection of a reflection, a compulsion to shock at any cost; no longer the reaction to a feeling of discontent, but itself a feeling of visual discontent, carried to a point of exhausted and frenzied

▼ *School of
Fontainebleau,*
Gabrielle d'Estrée
and the Duchesse de
Villars, *c. 1594,
Louvre, Paris.*

▼ *Bartholomaeus*
▼ *Spranger,* Last
Judgement *(detail),
1567, Galleria
Sabauda, Turin. The
Flemish artist Spranger
fell under the spell of
Italian Mannerism.*

sophistication. Whatever the formal developments of Mannerist art over the decades, at their basis lay a constant dissatisfaction with the heritage of Renaissance Classicism.

It was Michelangelo who established the premise for a renewal in sculpture, later taken up in Tuscany by Baccio Bandinelli and Ammannati. The main exponents of the refined culture of the mid sixteenth century were Cellini and Primaticcio, who gave plastic form to the fluid formal harmony of Parmigianino and gained a wide following among Italian and foreign artists. One of the most outstanding of these was Giambologna, who succeeded in achieving something at which Cellini had been only partly successful: visual multilaterality. It is again to Michelangelo that one must turn when dealing with Mannerist architecture, granted that the ideas he had already applied to his sculpture, achieved through the mediation of his pictorial language, were also highly relevant to architecture. It is significant that one of the prototypes of the genre, the entrance hall of the Laurentian Library in Florence, was conceived with a sculptor's logic and using the license of overturning the functional roles of the traditional elements and of the space itself: a broken tympanum, pillars that do not support, brackets that bear no load, blind windows and steps that seem to melt downwards. Then there are the eccentricities of Giulio Romano, whose triglyphs in the Palazzo del Tè slip at intervals, making the architrave appear unstable, and the monsters in the Palazzo Zuccari in Rome, whose open jaws form windows. There are also the ambiguous volumes in Vasari's Loggia for the Uffizi Gallery, the monotonous repetitiveness of the rustication in Ammannati's courtyard in the Pitti Palace, and the follies at Bomarzo, which veer between enchantment and fear, all of them elements intended to shock and provoke. ∎

Francesco Salviati, David Dancing before the Ark, *c. 1553, Palazzo Ricci-Sacchetti, Rome.*

Parmigianino, Madonna with the Long Neck, *c. 1535, Uffizi Gallery, Florence.*

The subtle alteration of classic shapes and a complex, esoteric symbolism, both prominent features of Early Mannerism, represent Parmigianino's response to the High Renaissance's ideal of perfection.

The technical skill and inventiveness that characterize the frescoes in the Palazzo Ricci-Sacchetti are the outcome of experiences developed first in Rome, then in northern Italy and later in Florence. It was here that Salviati's decorative devices (trompe l'oeil cornices, fake tapestries, swags, etc.) received their warmest welcome as part of the Grand Duke's plans.

El Greco, The Resurrection, *1605–10, Prado, Madrid.*

The disconcerting novelty of El Greco's style reveals links with the painting of Tintoretto and thus with the Mannerist experience.

Excommunication of Luther Sack of Rome	Act of Supremacy and suppression of the monasteries in England	Council of Trent Death of Henry VIII	Death of Mary Tudor Coronation of Elizabeth I	Mary Queen of Scots in Scotland	Battle of Lepanto Low Countries' fight for independence
	Paracelsus: *Chirurgia magna*	Copernicus: *De revolutionibus orbium coelestium*	Georgius Agricola: *De re metallica*	Falloppio: *Observationes anatomicae*	Tycho Brahe: *De nova stella*
Villaert choirmaster of St Mark's	Verdelot: 1st and 2nd book of madrigals	Glareanus: *Dodecachordon*	Palestrina: *Mass of Pope Marcellus*	Oratorios of St Philip Neri	William Byrd: *Cantiones Sacrae*
More: *Dialogue Concerning Heresies* Luther: *De servo arbitrio*	Calvin: *Christianae religionis Institutio* Rabelais: *Gargantua et Pantagruel*	Ronsard: *Odes* Vasari: *Lives*	Geo Wickram: *Der Goldfaden* Autobiography of Cellini	Vignola: *Regola delli 5 ordini di architettura* Palladio: *4 libri dell' architettura*	Montaigne: *Essais*
Joseph Kotter: the rifle Château of Azay le Rideau	Château of Chambord Completion of Hampton Court Palace	School of Fontainebleau Escorial, Madrid	Uffizi Gallery, Florence Palazzo Chiericati, Vicenza	Longleat House rebuilt Rugby	Bullant: *Rules of Architecture*
Lucas van Leyden: *Last Judgement* **Sebastiano del Piombo:** *Pietà*	**Parmigianino:** *Madonna with the Long Neck* **Holbein:** *The Ambassadors*	**Cellini:** *Perseus* **Primaticcio:** *Ulysses and Penelope*	**Tibaldi:** *Stories of the Odyssey* **Salviati:** *Deposition*	**Pieter Bruegel the Elder:** *Hunters in the Snow* **Titian:** *Tarquinius and Lucretia*	**Veronese:** *Venice Crowned Queen of the Sea*
1520–30	1531–40	1541–50	1551–60	1561–70	1571–80

Federico Barocci, Madonna of the People, 1579, Uffizi Gallery, Florence. This altarpiece clearly shows the ideology of the Counter Reformation where the problem of sacred works was concerned. This work is, in fact, a sort of "popular text," with a very simplified sense of space, completely in keeping with the threefold dictates concerning devotionalism, clarity and verisimilitude.

7 REFORMATION AND COUNTER REFORMATION

During the course of the sixteenth century, at a time when Classicism and Mannerism were producing their finest artistic achievements, Europe underwent the traumatic upheaval of the Protestant Reformation, which threw the Roman Catholic Church into disarray by bringing its central role into question. Where devotional images were concerned, the art of the Counter Reformation, which developed during the second part of the sixteenth century, represented a response to this very serious problem, which had first begun to surface during the late Middle Ages when various attempts at reform were made from both inside and outside the Church.

In 1517 Martin Luther, by nailing his ninety-five "theses" to the door of Wittenberg Cathedral, openly displayed his own criticism of the Church in Rome; in particular, he denounced the sale of indulgences, which he regarded as a money-making device to further the Imperial policies of Pope Julius II, whose vast projects (the greatest of which was St Peter's in Rome, to which Luther referred in no fewer than three of his theses) required vast expenditure. He was equally critical of the elements making up the ritual apparatus of the Catholic Church: the pilgrimages, the churches, the holy hierarchy and the sacred images. In brief, the rulers of the Church were accused of behaviour that deviated in every respect from the basic essentials of the Faith. What resulted was the phenomenon of Lutheran iconoclasm, which was linked to a campaign for the reformation of the priesthood and for the preaching of the Gospel in the vernacular, so that every member of the congregation could achieve "divine grace" without the need for intermediaries.

Despite its iconoclastic tendencies, the Reformation did, however, introduce its own new forms of artistic expression. The printed book,

◄ Lucas Cranach the Elder, Crucifixion, c.1503, Alte Pinakothek, Munich. A secular and strongly "humanizing" spirit permeates this painting, in which the cross seems to pierce the air weighed down by gloomy clouds. Christ's Passion becomes a drama of nature, a cosmic suffering that may be without redemption.

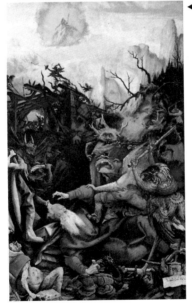

◄ Matthias Grünewald, Temptations of St Anthony (Isenheim Altarpiece), 1512–16, Musée d'Unterlinden, Colmar, France. This painting was destined for the convent-hospital run by the Hospitallers of St Anthony, which housed sufferers from diseases such as syphilis and epilepsy. It seems therefore as though the work also had a thaumaturgical value, which would explain the eagerness with which the painter depicted physical deformities and a variety of medical symptoms.

for example, became an important weapon for the Protestants because of its capacity to exploit images as instruments of both propaganda and education. German printers, following a tradition already firmly established in Northern Europe, illustrated *Bibliae Pauperum* with simple yet effective plates, in keeping with the spirit of Lutheranism, while the technique of engraving, which reached extraordinary levels of perfection with Albrecht Dürer, now became widely used throughout Europe. In Germany an important reformist propaganda role was played by Lucas Cranach the Elder, who, together with Hans Holbein the Elder, radically altered iconographical convention. In Cranach's *Crucifixion* of 1503, the foreshortened Christ, the tormented swirl of the drapery and the sharply melancholic landscape (echoing and underlining the pathos of the main scene) are elements that were to be adopted by other,

non-Nordic schools of painting. The artist was clearly striving to reach beyond the rhetoric of Catholic imagery and introduce an element of expressionistic and highly dramatic emotionalism, similar to that which characterizes the breathtaking painting of Matthias Grünewald. In the *Isenheim Altarpiece* (now in Colmar, France), which Grünewald completed between 1512

and 1516, the artist has given full rein to this expressionistic element, imbuing the painting's harsh sense of realism with a feeling of visionary mysticism.

Both artists worked for Archbishop Albert of Brandenburg, but this did not prevent Cranach from being a close friend of Luther's or Grünewald from being banished from the archbishop's court on suspicion of having

◀ *Matthias Grünewald, Crucifixion, 1523–25, Staatliche Kunsthalle, Karlsruhe. Grünewald scaled extraordinary heights of emotional intensity and tragic feeling in this work, which portrays the culmination of Christ's suffering, the final, most crucial event of his life on earth and the true meaning of the Christian faith.*

BIOGRAPHIES

♦ **Aspertini** Amico (Bologna 1474–1552). After early experiences in the classicist circle of Lorenzo Costa and Francesco Francia, he travelled to Florence where he studied the art of Filippino Lippi and possibly Piero di Cosimo. From his earliest works his painting veered, with often strange overtones, between Northern references and original invention, a combination that makes him a unique

figure in the history of the Italian Renaissance.

♦ **Barocci** Federico (Urbino c.1535–1612). During a stay in Rome he achieved great success with his frescoes for the *casino* (country retreat) of Pius IV. Returning to Urbino he pursued his own very refined formal style, often sending works to Rome. His compositions, with their strong sense of movement, make him

an original painter, set apart somewhat from his contemporaries.

♦ **Bosch** Hieronymus, Jeroen van Aeken (c.1450–1516). The lack of biographical information makes it hard to establish the stylistic origins of Bosch's work, but his oeuvre is one of the most astonishing of all time. Every sort of theory (esoteric, sociological, psychoanalytical, mystical and even pharmacological) has

been advanced to explain the stunning and scarcely human imagination shown in works such as the *Garden of Earthly Delights*, the *Temptation of St Anthony*, the *Ship of Fools* and many others.

♦ **Bruegel** Pieter, called the Elder (Breda? 1528/30–Brussels 1569). As a young man he travelled extensively in Italy. The earliest documentation of his activity as an artist

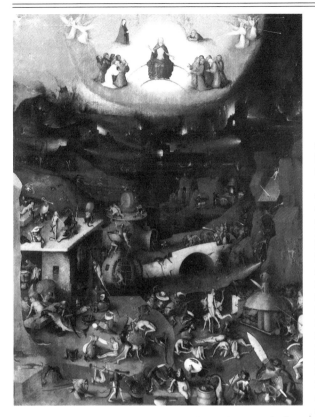

of the man betrayed by his followers, under his cry of despair.

In Flanders, during the early years of the century, an extraordinarily imaginative artist named Hieronymus Bosch painted works seething with neo-medieval symbolism. Their subjects, such as temptation, sin, redemption, punishment, mankind's and society's vices, reflect and interpret the pressing moral concerns of the new mysticism. The same sort of poetry reappears, two generations later, in the quiet tones of Pieter Bruegel the Elder. Ancient proverbs, parables and the world of the countryside and of peasant festivities provided him with a metaphorical starting point for his exposure of the transient, less acceptable aspects of life.

The sense of conflict and disquiet that was a particular feature of Northern European art encouraged a great adherence to reality. Its "lay" dimension in particular found an echo in certain

sympathies and contacts with the Protestant movement and the peasant revolt. The whole revolutionary mood of the day is captured in Grünewald's work: his fantastic fervour, his fiercely descriptive vein, both tragic and populist, and his refined, almost grotesque medievalism (visible in the Colmar panel depicting the *Tempta-* *tions of St Anthony*) make him a unique figure in the history of art. In his various *Crucifixions* (in Basle, Karlsruhe, Washington, D.C. and also in the *Isenheim Altarpiece*) the modern drama proclaimed by the Reformation is reflected in the age-old drama of the Passion: the crosses groan under Christ's martyred body, under the weight

dates from 1553, although he displays few signs of Italian influence. His most important achievement, from the art historical point of view, is that he gave great dignity to "genre painting," which was to become a typical feature of seventeenth-century Dutch and Flemish painting.

♦ **Carracci** Ludovico (Bologna 1555–1619). A pupil of Prospero Fontana, he was one of the founders, together

with his cousins Annibale and Agostino, of the Accademia dei Desiderosi (1582), later to become the Accademia degli Incamminati (1590). Ludovico's painting, characterized by layouts of elegant and naturalistic simplicity, enjoyed widespread popularity and became a key reference point for seventeenth-century art.

♦ **Cranach** Lucas the Elder (Kronach,

Franconia, 1472–Weimar 1553). After an apprenticeship in the workshop of his father, Hans, he moved to Vienna in 1501. His work in that city (*Penitent St Jerome* of 1502, and *Crucifixion* of 1503) paved the way for the development of the Danube School. In 1505 he settled in Wittenberg, where his painting took on a less dramatic tone, closer in feel to courtly art.

♦ **Crespi** Giovanni Battista, called "il

Cerano" (Cerano, Novara, 1567–Milan 1632). The finest Lombard painter from the time of Federico Borromeo, he represents, together with the Procaccini family, Morazzone and, later, Tanzio da Varallo and Francesco del Cairo, the last major expression of the Counter Reformation in Italy.

♦ **Grünewald** Matthias, Neithardt Gothardt, called (Würzburg c. 1480–

sixteenth-century Lombard artists, who distanced themselves from all bombast and aristocratic pretension, using their works to express an intimate faithfulness to earthly things, to the dignity of labour and everyday life. It is this quality which links the naturalistic dimension of Romanino and Moretto da Brescia to the luministic lyricism of Giovanni Girolamo Savoldo and the unaffected realism of Vincenzo Campi and Giovanni Battista Moroni, while a similar process can be seen in the brilliant formal and iconographical innovations of Lorenzo Lotto. Similar examples reveal a new way of portraying sacred subjects, this time anticipating some of the qualities of the Counter Reformation. This is true because, if nothing else, they are clear, devout and modest images, with an intensely religious feeling, bereft of any of the glitter that might detract from their spiritual message.

The reverberations of the religious battles were soon

In Ludovico Carracci's Annunciation *(1585) the problems of religious painting are fully and exhaustively developed. The naturalness of everyday life is recalled in a work dealing with a sacred subject: the event is placed in a strongly defined space, almost fifteenth century in feel, while the house of the Virgin, modest and austere in its colouring, is portrayed within the "perspective box," and the Annunciation, quiet and human, is whispered between the Virgin and the angel (both of whom are very young) as though it were a private conversation. This treatment makes it easier for us to feel involved in the scene; it presents us with a story that is both accessible and moving. Decorum, clarity, verisimilitude and an ability to stimulate piety and reflection: the painting fulfils every aspect of the three requirements in a formally irreproachable way. The artist was aware that his work would be seen by young visitors to the Oratory of San Gregorio in Bologna and it is very likely that he bore this in mind.*

felt in Italy, when large numbers of refugees started arriving in the far north of the country and in Venice. This phenomenon manifested itself in the form of a number of heretical movements, all of them with roots in Northern Europe. Evangelists, Anabaptists and various sympathizers of the *devotio moderna* provided tangible proof of a new spiritual disquiet, aggravated by war and by the collapse of ancient values. Art, to all appearances homogenous, began to reflect a reaction against the richness of Roman culture. In Bologna, Amico Aspertini presented an anti-Classical style that rejected the influence of Raphael. The tortured modes of early Mannerism and the references to Northern culture in his work reflect a very different sensibility and an approach to life and belief that is anything but canonical. Aspertini's *Pietà* (1519) is closer to Grünewald than to the mainstream of Italian Renaissance art.

Halle 1528). The greatest exponent of so-called "Nordic expressionism," he probably trained in the circle of Holbein the Elder, later working at the court of the Archbishop of Mainz from 1511 to 1526. From 1512 until 1515, however, he was in Alsace painting his most famous masterpiece, the winged *Isenheim Altarpiece*. In 1525 he embraced Protestantism and, in keeping with the iconoclastic precepts of Lutheranism, he gave up painting.

♦ **Moretto da Brescia** Alessandro Bonvicino, called (Brescia 1498–1554).

His Lombard training, in close proximity to Romanino and Girolamo Savoldo, soon absorbed influences from Venice (Titian, Lotto) and Tuscany (the Florentine Mannerists). A fine portrait painter, his greatest work is the cycle of paintings for the Chapel of the Sacrament in San Giovanni Evangelista, Brescia, which clearly reveals his religious and doctrinal commitment.

♦ **Pulzone** Scipione, called "il Gaetano" (Gaeta c.1550–Rome 1598). He became famous as a portrait painter in Rome at a very early age. After

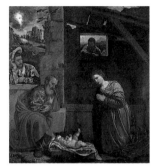

In order to counteract its loss of power, in 1545 the Roman Catholic Church convened the Council of Trent, which ended in 1563. In its twenty-fifth session (3 December 1563) the Council issued a decree relating to images, which defined the approach to be taken to sacred art and its application. This marked the beginning of

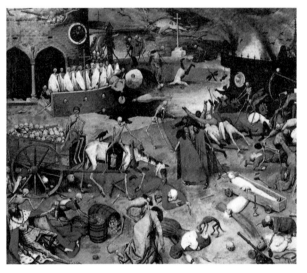

the Counter Reformation. In Italy, however, the mood of Mannerism was certainly not in tune with the three rigid requirements of "clarity, verisimilitude and devotionalism." The assimilation of these three elements by artists was a slow and gradual process.

In Rome artists in the final stages of Mannerism were obliged to reconcile themselves to some extent with the complications of the new papal dictates. But attempts at stylistic intermingling or slavish respect for ecclesiastical guidelines very rarely produced any artistic revival. A typical case of this is the decoration of the oratory of Santa Lucia del Gonfalone, completed between 1573 and 1575. The most important artist working on this project was Federico Zuccari, head of the Accademia di San Luca (St Luke's Academy). He was the champion of Roman art during this period and practitioner of the "regulated mixture" required by the Counter Refor-

meeting the Jesuit Giuseppe Valeriano he collaborated on the decoration of the Chiesa del Gesù, in which he showed himself to be an efficient interpreter of the precepts laid down by the Council of Trent.

◆ **Savoldo** Giovanni Girolamo (Brescia c.1480–Venice? after 1548). He was probably a pupil of Vincenzo Foppa, whose naturalistic and popular quality he inherited, whereas he followed Titian's example in creating his own technical repertoire. His art was highly individualistic, founded on great formal ability and a remarkable narrative gift. In works such as the *Magdalene* (National Gallery, London) his painting clearly anticipates the style of Caravaggio.

◆ **Zuccari** Federico (Urbino 1543–Ancona 1609). Very famous during his lifetime and much in demand for his decorative work, he occupies an important place in the history of art because of his treatise on aesthetics published in 1607, *L'idea de' scultori, pittori e architetti* (The Idea of Sculptors, Painters and Architects).

▼ Giovanni Battista
Moroni, The Tailor,
1570, National Gallery,
London. This painting
represents a new style of
portraiture that
combines Flemish
influences with respect
for Counter-
Reformation
"decorum." The skill
and industry of the
tailor are conveyed in a
way that lays great
stress on the human
psychology of the man
and his daily chores.

▼ Vincenzo Campi, The
Ricotta Eaters, Musée
des Beaux Arts, Lyons.
This Cremonese painter
drew inspiration from
some of the Northern
European paintings
sent to Italy by
Alessandro Farnese,
governor of the Low
Countries, the majority
of which were small-
scale works portraying
secular subjects. The
painting celebrates the
worship of commerce
and money, as well as
warning against the
hidden moral dangers
of such behaviour.

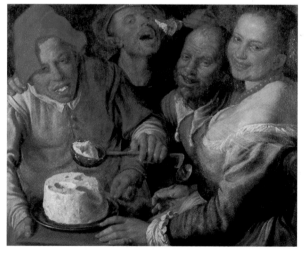

as on the "visualization" of
mystical subjects. Basing his
work on these suggestions,
Pulzone created a pictorial
formula that was indepen-
dent of contemporary fashion
and which resulted in his
paring his work down to its
essential elements.

Rejecting fixed formulas,
however convincing, and so
placing himself at the op-
posite end of the spectrum to
Pulzone, Federico Barocci
created paintings that were
enlivened by the idea of
movement and vitality. His
formal dynamism, evi-
denced, for example, in his
*Presentation of the Virgin in the
Temple* and his paintings
for the cathedral in Urbino,
is aimed at achieving a
more immediate expression
of their narrative content.
Barocci's work mirrors many
of the ideas expressed by the
Oratorians of St Philip Neri,
whose idea of "joyful grace,"
of beauty seen as a projection
of divine love, he undoub-
tedly shared. His emotive,
liquid style of painting is
ideally suited to the creation
of spectacular effects of light,
colour and vibration, as well
as providing a highly effec-
tive means of conveying vi-
sions of ecstasy. He was,
moreover, one of the most
important figures of his gen-
eration, endowed in certain
respects with a feeling that
was already baroque, a pre-
cursor of the freest develop-
ments of sixteenth-century
language.

In the same context men-
tion should be made of an-
other very distinguished
painter, Jacopo Bassano, who
was only partly involved in
the Counter-Reformation
movement. Starting with the

mation (that is to say,
respecting orthodox iconog-
raphy through simple, ac-
cessible art). But nowadays
we remember him for his
strict theoretical work rather
than for his creative efforts,
which were not always so
successful. Another painter
worth mentioning, who was
equally in tune with his
times, is Scipione Pulzone. A
talented portrait painter, he

derived great inspiration
from his contacts with the
highly influential Society of
Jesus, founded in 1539. The
Jesuits were one of the main
instruments of the Counter
Reformation, partly because
their founder, St Ignatius
Loyola, had given precise
instructions in his *Spiritual
Exercises* on the procedures
to be followed in individual
religious experience as well

▼ *Moretto*, Christ and
the Angel, *1550,
Pinacoteca Tosio-
Martinengo, Brescia.
This painting radiates a
disconcertingly
innovative quality, both
in its composition and
its livid colouring. It*

*provides eloquent
testimony to the intense
inner turmoil
experienced by Moretto
when faced with the
religious problems of his
day.*

▼ *Federico Barocci*, Rest
on the Flight into
Egypt, *1570,
Pinacoteca Vaticana,
Rome.*

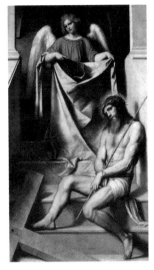

▼ *Jacopo Bassano,
Adoration of the
Magi, 1559–61,
Kunsthistorisches
Museum, Vienna. This
work occupies an
important position
within the artist's
oeuvre in that it
exemplifies his refined
(and at the same time
naturalistic) language.*

most populist version of Ve-
netian naturalism (derived
from Bellini and Lotto), he
graduated to a highly per-
sonal style of Mannerism,
different from that practised
by Tintoretto, until finally,
in works such as the *Baptism
of St Lucilla* (c. 1570), he de-
cisively anticipated the ex-
pressive tendencies of the
seventeenth century.

There were also other ap-
proaches adopted to sacred
art towards the end of
the century. In Bologna,
Bartolomeo Passarotti com-
bined portraits with still
lifes, sometimes translating
Counter-Reformation ''ver-
isimilitude'' into raw realism.
Also in Bologna, Cardinal
Paleotti became an active
promoter of the directives
promulgated by the Council
of Trent and in 1582 he pub-
lished a *Discourse on Sacred
and Profane Images*. One en-
thusiastic and masterly in-
terpreter of the cardinal's
advice, as well as of the artis-
tic strictures imposed by the
Church, was Ludovico Car-

racci. Together with his
cousins Agostino and Anni-
bale, he showed an aware-
ness of the need to restore
naturalness to painting;
guided by his own sense of
devotion, which allowed him
to express mysticism and
profound reflection in an
accessible artistic language,
he dealt with truly human
subjects that reveal his
own faith. In addition, the

spatiality introduced by
Ludovico projects a sense of
openness, luminosity and
involvement, as in his *Con-
version of St Paul*, a work
structured so as to create a
feeling of visual immediacy,
in which this biblical episode
becomes a physical, me-
teorological incident, all-
embracing and embraced
within its circular space, or
his *Annunciation* (c. 1585), in

7 REFORMATION AND COUNTER REFORMATION

phase of this "movement," in which Giovanni Crespi, Morazzone and the Procaccini family were prominent figures, was an extreme consequence of the Counter Reformation: one thinks of the ideological impact of the paintings dealing with the *Life of the Blessed Carlo Borromeo* created for Milan Cathedral (1610). The second phase, on the other hand, with Tanzio da Varallo, Daniele Crespi and Francesco del Cairo, displays early signs of Caravaggesque influence, even though it attempted to reconcile the latter with earlier styles. It should also be pointed out that in many regions of Italy the survival, on a religious level, of the Counter-Reformation mood acted as a partial antidote to the new seventeenth-century "poisons" (Caravaggio in particular) and prevented a real historical break between the two centuries. ∎

which authenticity and decorum achieve a perfect balance of tension and purity.

The role played by Paleotti in Bologna was filled in Milan by first Carlo Borromeo and later his cousin Federico, both of them cardinals and both of them ardent supporters of the Council of Trent. To Federico Borromeo must go the credit for having made an important contribution, between the end of the sixteenth century and the beginning of the seventeenth, to the cultural development of his city, where he founded a number of academies and encouraged the formation of an important circle of artists. The first

◀ *Giulio Cesare Procaccini, San Carlo Borromeo in Glory, 1610, Milan Cathedral. The artist's compact composition is enlivened by small putti, a light-hearted element used in all his works.*

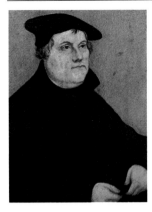

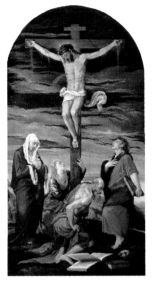

Lucas Cranach, Portrait of Martin Luther, *1533, Uffizi Gallery, Florence.*

The lack of any naturalistic background concentrates our attention on the face of the sitter and enhances the severity of his expression.

Jacopo Bassano, Crucifixion, *1562–63, Museo Civico, Treviso.*

This altarpiece shows early signs of the cold light that characterizes Bassano's final period.

Giovanni Crespi, San Carlo Borromeo Renounces the Princedom of Oria in Order to Give the Proceeds to the Poor, *1603, Milan Cathedral.*

A fully-fledged Counter-Reformation work, this painting celebrates the new champions of the Church and the didactic iconography preached by them.

Luther's 95 theses of 1517 Coronation of François I	Diet of Worms English Reformation	Peace of Augsburg Council of Trent	St Bartholomew's Day Massacre Holy League	Independence of the Low Countries Spanish Armada	Edict of Nantes House of Stuart
Pomponazzi: *De naturalium effectuum . . .* Achillini: *Osservazioni anatomiche*	Copernicus: *De revolutionibus orbium coelestium* Vesalius: *De humani corporis fabrica*	Nostradamus: *Centuries* Falloppio: *Observationes anatomicae*	Jean Bodin: *De la république*	Edinburgh University Galileo's pendulum	Kepler: *Mysterium cosmographicum* Galileo: *Sidereus nuncius*
Death of Des Prés Birth of Roland de Lassus	First German chorales	Gabrieli at Munich and then Venice Spread of the violin	Gabrieli: *Sacrae cantiones* Palestrina: *Missa brevis*	Oratorio of St Philip Neri Marenzio: *Madrigals*	Gesualdo da Venosa: Fourth book of madrigals
Melanchthon: *Confessio Augustana*	Calvin: *Christianae religionis Institutio*	Book of Common Prayer	More: *Dialogue of Comfort against Tribulacyon*	Spenser: *Faerie Queene*	Shakespeare: *Merchant of Venice*
St Ignatius Loyola: *Exercitia spiritualia*	Foundation of the Society of Jesus	Academy of Geneva	*Index Librorum Prohibitorum*	John of the Cross: *Cántico espiritual*	James VI: *Basilikon Doron*
Moretto: *Coronation of the Virgin* **Grünewald:** *Isenheim Altar*	**Michelangelo:** *Cappella Paolina*	**Salviati:** *Deposition* **Bassano:** *Adoration of the Magi*	**Barocci:** *Deposition* **Zuccari:** *Flagellation*	**L. Carracci:** *Conversion of St Paul* **Pulzone:** *Holy Family*	**El Greco:** *Assumption of the Virgin*
1515–31	1532–47	1548–63	1564–79	1580–95	1596–1611

Diego Velázquez, Las Meninas, 1656, Prado Museum, Madrid. This painting is a theater of mirrors and perspective interplay. At the center of the composition stands the Infanta Margarita, surrounded, and partly watched, by her little court, just as she is being watched by us. She, on the other hand, is watching her parents, whom we can see in the pale reflection of the mirror in the background. The position is further complicated by the presence of the artist, who has portrayed himself watching his subjects: Philip IV and Marianna of Austria. The work revolves around several subjects, each of which relates to another one and involves the spectators within it, leaving us disorientated and bewitched by this contrived ''baroque'' illusion.

8 THE BAROQUE

There is controversy regarding the origins of the word "baroque." In Portuguese it is synonymous with irregularity, while in Spanish (*barrueco*) it indicates a pearl of uneven shape, one that is not perfectly round. The term, first used by jewellers, has thus become the adjective to describe a style of refined, precious and extravagant art: an art of the witty and the unexpected. The innovative and imaginative spirit of the baroque revolution swept through Europe during the seventeenth century, at a time when the Spanish empire was in decline, when the concept of nationality was beginning to grow and when the discoveries of the "new science," exemplified by men such as Kepler and Galileo, were radically altering man's concept of the universe. With the downfall of biblical geocentricism, the human dimension came face to face with the vision of infinity, the macrocosm of Giordano Bruno, which introduced revolutionary new philosophical concepts. The crisis in conscience provoked by the Protestant Reformation represented a further deterrent for the transformation of the man–universe relationship: baroque culture marked the beginning of a new perception of the incommensurable "divine design" and a new religious mythology.

At the beginning of the seventeenth century Rome was the meeting point for a wide variety of different artistic expressions, as well as being the seat of Papal government and the place from

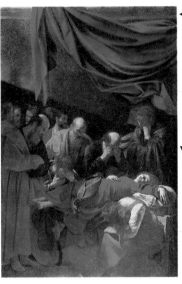

◀ *Caravaggio,* The Death of the Virgin, *1605, Louvre, Paris. Although dealing with a "holy" death, this painting is pervaded by an intensely observed realism and a very human feeling of dejection in the face of an unfathomable event.*

▼ *Caravaggio,* The Conversion of St Paul, *1600–1, Santa Maria del Popolo, Rome. The saint is transfixed by the vision and the action is frozen, as if in a photographic frame, by the work's radically new iconographical characteristics.*

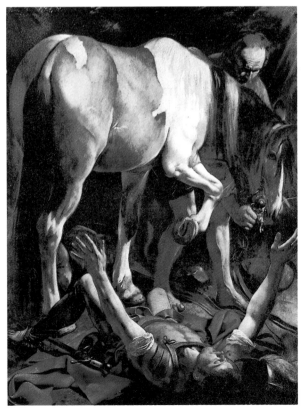

The Enveloping Space

which the Church exported the restoration of its power and its image. At a time when the oratorians of St Philip Neri and the Jesuits represented the main propaganda instruments for the reaffirmation of the Counter Reformation church, Michelangelo Merisi, called Caravaggio, was working in Rome. A protégé of Cardinal Francesco Maria del Monte, thanks to whom he obtained the commission to paint his series of canvases in San Luigi dei Francesi (1599–1602), Caravaggio was well aware of the new cultural developments that were affecting every area of human knowledge, and they aroused a strong interest in him in the "intrinsic nature of things." This new thinking was grafted onto his own Lombard education (influenced by the naturalism of Savoldo and Moroni, Lotto and Campi) and led to his distancing himself from the iconographical orthodoxy anticipated in the theoretical treaties of the day in favour

The baroque doctrine of psychological involvement finds full expression in the Cornaro Chapel of Santa Maria della Vittoria, Rome, created between 1644 and 1652 by Gian Lorenzo Bernini. The entire spatial arrangement revolves around the sculptural group portraying The Ecstasy of St Theresa, *which seeks to express the inexpressibility of a mystical event through a series of formal devices. The saint is shown fainting, overcome by physical exhaustion and collapsed on a floating cloud from which she seems about to slide, while an angel pierces her ambiguously with arrows of love. The sculpture is set among brilliantly coloured marbles, frescoes and gold stucco decoration. The wings of this "stage set" are provided by members of the Cornaro family, who watch the miracle like spectators in boxes at the theater. The modern admirer thus becomes part of the fiction and grasps the divine universality of the event, sensing its simultaneous presence in both real and illusory space.*

of a rigorously close and penetrating observation of reality, an approach that resulted in his initiation of the most radical artistic revolution since the Renaissance. Everything in Caravaggio's painting – the raking light, the vital moment, nature, whether alive or dead – is captured without any value judgement. The artist's gaze rests on things, running over them and penetrating them, without any thoughts of formal convention. The good and the bad appear like faces of the same medal, a single pretext for plumbing the deepest recesses of reality. Take, for example, his *Death of the Virgin* (1605), which conveys the true essence of this very human drama, with all its feelings of loss and grief and its real sense of defeat: an irreversible destiny, whose immediacy the bowed head of the Magdalene portrays without any element of consolation.

It is not surprising that Caravaggio's new aesthetic soon attracted a number of

BIOGRAPHIES

♦ **Bernini** Gian Lorenzo (Naples 1598–Rome 1680). Sculptor, architect, town planner and painter. One of the founders of the baroque movement, from 1624 onwards he was in close contact with the papal authorities, for whom he worked almost without interruption throughout his life. His irrepressible and multifarious activities, as well as his large number of commissions, made his

workshop one of the centers of seventeenth-century Roman culture. The mark that he made on Rome's appearance can still be seen today.

♦ **Borromini** Francesco Castelli, called (Bissone,

Switzerland 1599–Rome 1667). His long apprenticeship as a marble-carver in the employ of Carlo Maderno ended only with the latter's death in 1634. He subsequently gained great fame as an architect, obtaining

such prestigious commissions as the rebuilding of San Giovanni in Laterano and the building of the Collegio di Propaganda Fide. In these and various other works he revealed himself to be, together with Bernini, the greatest exponent of baroque architecture.

♦ **Caravaggio** Michelangelo Merisi, called (Milan 1571–Porto Ercole, Grosseto, 1610). After an early apprenticeship in

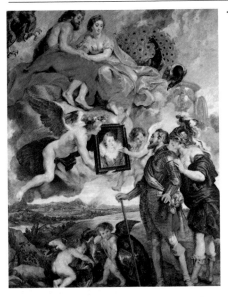

followers. A similar quality can be detected in the art of the Lorraine-born Georges de La Tour, a Cartesian spirit moved by deeply reflective religious feelings. He created works in which the suspension of time and motionless, carefully gauged structures express a sense of intensely meditative dialogue. Although belonging to the seventeenth century, the Caravaggisti, as his followers were known, were exponents of an intolerant and tormented generation, alienated from the love of mental complications that is typical of baroque sensibilities. The style and aesthetic they borrowed from the master, caravaggismo, flourished, one moment emulating Caravaggio's essential characteristics, the next merely displaying the external, purely technical features of his art. The movement was well represented by such painters as Orazio Gentileschi, Carlo Saraceni, the Franco-Italian Valentin de Boulogne, the Dutchman Gerrit van

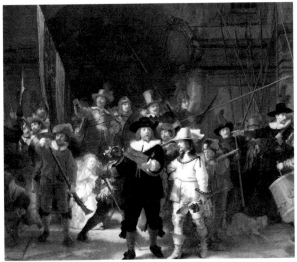

Lombardy, he moved to Rome in 1590, where he gained a reputation as a painter of secular subjects. Towards the end of the century he obtained commissions for a number of church altarpieces, but the scandal aroused by the realism of his works, and particularly by his turbulent life, forced him into an exile that took him the whole length of Italy. Pursued by the Roman authorities for having killed a gambling rival,

he was in Naples in 1606, in Malta in 1608, then in Sicily, in Messina and Palermo, and then back again in Naples. He died while trying to re-enter Rome in 1610.

◆ **Carracci** Annibale (Bologna 1560–Rome 1609). As a very young man in Bologna he joined the Accademia dei Desiderosi, making his mark with works possessing a strong popular feeling. Between 1595 and 1602 he completed the

decoration of the Palazzo Farnese in Rome, a work rightly regarded as his masterpiece, in which he very convincingly anticipated the stylistic elements and spatial sensibilities of the baroque.

◆ **Guercino** Giovanni Francesco Barbieri, called (Cento 1591–Bologna 1666). He completed his artistic training in northern Italian cultural circles, where he came into contact with the

Carracci family. In 1621 Pope Gregory XV summoned him to Rome, where he created a number of important works. After returning to Bologna, his art tended towards a mood of calm devotionalism.

◆ **Pietro da Cortona** Pietro Berrettini, called (Cortona 1596–Rome 1669). His move to Rome at an early age was of fundamental importance to him since it enabled him to study the classicism of

▼ *Rembrandt van Rijn,*
Doctor Tulp's
Anatomy Lesson,
1632. Mauritshuis, The
Hague. This painting
provides a disturbingly
realistic vehicle for a
celebration of the
famous anatomist and

his profession, in
keeping with the
Puritan Protestant
tastes of the
burgomasters,
merchants and "craft
guilds."

Honthorst and others. While Caravaggio was creating his paintings for the churches of San Luigi dei Francesi and Santa Maria del Popolo, the Flemish artist Peter Paul Rubens was working in Rome. For Duke Vincenzo I Gonzaga he acquired Caravaggio's *Death of the Virgin,* which had been rejected by its commissioners because of the scandal surrounding the artist's choice of model: a young drowned girl. An ardent admirer of Italian painting, Rubens was an experimental artist of great culture and refinement, who endowed his works with a strongly modelled quality and a feeling of richness and sensuality that make him one of the greatest baroque artists. Of the subjects most popular and widespread in his homeland, Rubens particularly favoured portrai-ture, a genre which was very elegantly developed by his compatriot Anthony van Dyck, but whose greatest exponent was Frans Hals. The latter painted mainly members of the emerging classes, such as burgomasters, merchants and craftsmen, who saw group portraits as an acknowledgement of their newly acquired social status.

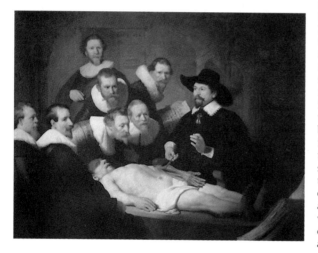

Examples of group portraits also occur in the work of the greatest Dutch artist of the century, Rembrandt van Rijn, who painted such works as *Doctor Tulp's Anatomy Lesson* (1632) and *The Night Watch* (1642). His style seems able to reconcile Caravaggio (albeit interpreted in a highly personal way) with certain aspects of the baroque. However, he goes far beyond the usual portraits, landscapes and tavern scenes of Dutch painting to create works of extraordinary spiritual depth, almost like private stories, which gradually became increasingly personal and inaccessible with the passing

Raphael and the baroque art of Annibale Carracci and Gian Lorenzo Bernini. The fruits of this research can be seen in the many works he executed for Pope Urban VIII.

♦ **Poussin** Nicolas (Les Andelys 1594–Rome 1665). The greatest representative of seventeenth-century classicism, he pursued his retrospective interest in the ancient world in Rome, where he was also able to study Raphael. These influences enabled him to link nature and history, myth and society, language and ideology in works of impressive formal perfection.

♦ **Rembrandt** Harmenszoon van Rijn (Leyden 1606–Amsterdam 1669). Although a miller's son, he attended Latin school and then university. His mastery of engraving and painting brought him fame at an early age, but the financial difficulties to which he fell victim led him far from the mainstream of contemporary taste and lost him the patronage he had acquired in his youth. He ended his career virtually alone and unknown.

♦ **Reni** Guido (Bologna 1575–1642). A pupil of Denijs Calvaert, he completed his training in the academy run by the Carracci. Between 1601 and 1613 he worked in Rome; he then returned to Bologna, by which time he was already acclaimed as the inventor of a style that was destined to enjoy widespread popularity right up until the Romantic era and beyond.

♦ **Rubens** Peter Paul (Siegen 1577–Antwerp 1640). After working for a few years in Antwerp, he travelled to Italy and entered the service of the Duke of Mantua, where he had the

▼ *Diego Velázquez,*
Christ in the House
of Martha, *1619–20,*
National Gallery,
London. The religious
scene, framed in the
small window, acts as a
means of illustrating
the "vision" that the

woman in the
foreground is having of
this episode from the
Gospels.

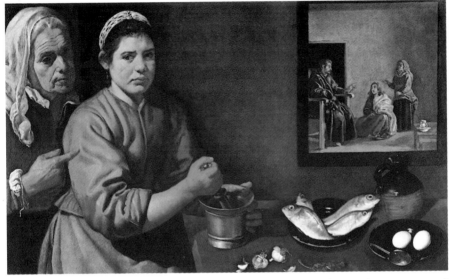

of the years. In Rembrandt's later works the emphasis on the actual painting material becomes so intense that, like a lingering gloom, it scarcely lets the subject emerge, turning the latter more and more into a pretext.

Caravaggio's influence can be detected in the "Spanish colony" of southern Italy even more than it can in the north. José de Ribera was bewitched by the work of the Lombard artist, who was active in Naples in 1606: he noted the latter's *chiaroscuro* effects and pushed the bounds of realism into the realms of raw narrative. Philip IV of Spain's favourite painter, Diego Velázquez, also spent some time in Naples, staying as a guest of Ribera. His artistic development was influenced by the relationship, economic as well as cultural, that linked Spain and Flanders. In his *Christ in the House of Martha* (1619–20) the layout of the painting is Flemish, with its very effective device of the scene beyond the window (almost like a painting within

chance to study Mannerist and Renaissance works. In 1609 he returned home as court painter to the Spanish governors of the Low Countries. His very extensive output is characterized by an evocative sense of technical and rhetorical fluency.

♦ **Velázquez** Diego Rodriguez de Silva y (Seville 1599–Madrid 1660). In 1624 he was created court painter to Philip IV and in 1629–30 made his first journey to Italy, where he was able to gain first-hand experience of Caravaggio and the sixteenth-century Venetian painters. An excellent and highly talented portraitist with a very incisive and inventive eye (*Las Meninas, Las Hilanderas*), he received a number of honours during his lifetime, including (after 1649) being made responsible for the acquisition of works of art on behalf of the Spanish crown.

♦ **Vermeer** Jan (Delft 1632–75). The scant information on Vermeer's life contrasts with the posthumous glory enjoyed by his art. Modern critics have attributed some forty paintings to him, of which only sixteen are signed and only two dated. Given the high quality of his acknowledged works, this factor has contributed to the creation of a real mythology around his name, which has been further enhanced by the role assigned him by Marcel Proust in the famous passage describing the death of Swann in *A la Recherche du Temps Perdu.*

▼ *Annibale Carracci,* Polyphemus and Galatea, *1597–1604, Palazzo Farnese, Rome. The study of nature, antiquity and the work of Raphael and Michelangelo is translated by Carracci* *into a fluent, grandiose style that became a landmark for later artists.*

a painting), but the influence of Caravaggio is present in the extremely realistic physical portrayal of the figures and their expressions. And yet the way in which the maid forms part of this evangelical scene is perfectly in keeping with the writings of St Ignatius Loyola: she is witness to it because everyone has the chance to "see" through the eyes of their soul. In the paintings of Velázquez there is a sort of obsession with space, which is conceived as a principle of confusion and not of rational

▼ *Andrea Pozzo,* Allegory of the Missionary Work of the Jesuits, *1691–94, Sant'Ignazio, Rome. This work is a distillation of earlier experiments in perspective painting, which are here contained within a strict, architectonic "frame" that has been broadened out of all proportion.*

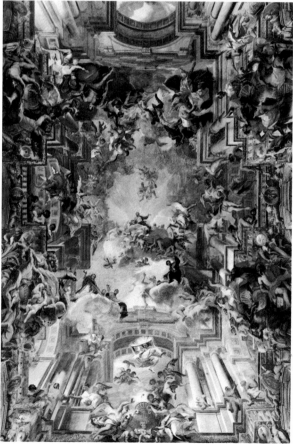

certainty. It is not the spatialism of the Renaissance that interests him, despite the realism of his works, but rather, as in his famous *Las Meninas*, a scenographic portrayal, baroque in its way, a theater of mirrors and illusions in which the beholder is also the observed.

The taste for still lifes achieved brilliant results in Spain with the absorbed objectivism of Francisco de Zurbarán, another very talented interpreter of Caravaggio's artistic language. This style reached some areas of Italy in a diluted form, filtered through the neo-Renaissance models provided by protagonists of the Counter Reformation. In Bologna, in as early as 1590, the Emilian artists Annibale, Agostino and Ludovico Carracci had founded the Accademia degli Incamminati, whose programme concentrated on life study and drawing as the indispensable premise for all creative action. In his grandiose decoration of the Galleria of the Palazzo Farnese in Rome, Annibale was inspired

▼ *Guido Reni,* Aurora,
*c.1612–14, Palazzo
Rospigliosi-Pallavicini,
Rome. This painting
portrays a courtly scene,
a figurative subject
derived from the
Renaissance, and harks
back to Annibale*

*Carracci's decoration of
the Galleria Farnese.
The spirit of liveliness,
typical of Northern art,
is matched by the clear
classicism of Roman
artists.*

▶ *Gian Lorenzo Bernini,*
Fontana dei Quattro
Fiumi *(Fountain of the
Four Rivers), detail,
1648–51, Piazza
Navona, Rome. Bernini
has drawn attention to
the center of the* piazza
*in a theatrical way,
with the rocks providing
the setting for allegories
of the four parts of the
world, and also, at the
foot of the Cross, the
rivers of paradise. At
the center stands an
obelisk crowned by a
dove, symbol not only of
Pope Innocent X, but
also of the Holy Ghost.*

stimulated by his old links
with Ludovico Carracci, his
master, and by his own very
real feelings of devotion.
Through a complex formal
search for balance, purity
and rhythm, Reni exalted
form and suspended action,
creating truly archetypal rep-
resentations that were end-
lessly repeated after him.

It was also by following
this direction that art gradu-
ally took on more and more
of the characteristics of the
baroque. The innovations of
the Palazzo Farnese made it
easier to define the concept
of "infinite space": repre-
senting the vastness and
grandeur of the divine design
meant rediscovering the link
between the human and
heavenly worlds. The idea of
infinity, a concept which has
always frightened mankind
and been synonymous with
the loss of man's central role,
is revived as something emo-
tional, spectacular and in-
toxicating. Artists present an
involving image of nature
and eternity, one that is both
alluring and powerfully per-
suasive. Guercino's fresco of

by the examples of Raphael
and Michelangelo. The theme
of love is resolved against a
background of free, classical
tones, the composition is
divided into squares, either
in the sixteenth-century
manner or by means of new,
natural solutions. Annibale

had a number of Emilian fol-
lowers in Rome: artists such
as Francesco Albani and
Domenichino and, later,
Guido Reni, Giovanni Lan-
franco and Guercino. After
returning to Bologna, Guido
Reni became increasingly in-
volved in sacred subjects,

◄ *Pietro da Cortona,
 façade of Santa Maria
 della Pace, 1656–57,
 Rome.*

▼ *Francesco Borromini,
 dome of San Carlo alle
 Quattro Fontane,
 1638–41, Rome.*

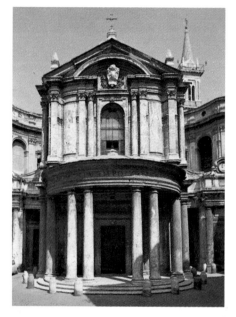

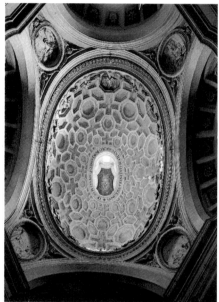

Aurora (1621) in the Casino Ludovisi marked the fall of the first architectonic barriers restricting the painter's vision. Soon afterwards, the ceilings of church and houses became filled with representations of the eternal and the boundless. In the dome of Sant'Andrea della Valle in Rome (1621–27) Giovanni Lanfranco celebrated the new Catholic mythology with a swirling kaleidoscope that emotionally overwhelms all those who see it. On the ceiling of the Palazzo Barberini (1633–39) Pietro da Cortona created a seething mass of figures and events, transforming the perspective technique from an instrument for dominating reason into a device for overturning the senses. The Jesuit Andrea Pozzo, creator of the extraordinary ceiling of Sant'Ignazio in Rome (1691–94), gave a theoretical explanation of his prodigious

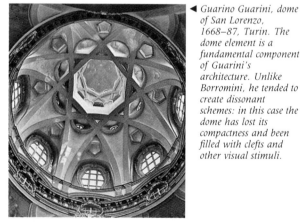

◄ *Guarino Guarini, dome of San Lorenzo, 1668–87, Turin. The dome element is a fundamental component of Guarini's architecture. Unlike Borromini, he tended to create dissonant schemes: in this case the dome has lost its compactness and been filled with clefts and other visual stimuli.*

achievements in a treatise on the new representation of illusion. Together with Luca Giordano and Pietro da Cortona, he was responsible for the most extensive application of the idea of *aesthetic vision* introduced by St Ignatius Loyola.

The ideal of an enveloping art, both communicative and spectacular, was magnifi-

cently ˙ developed by the creative genius of Gian Lorenzo Bernini. His sculpture is an assemblage of evocative shapes, dynamic and sensual, in which the most isticated techniques are brought into play to achieve an art that is at the same time both incisive and lyrical, both popular and aristocratic, and which makes aesthetics syn-

▼ *Giuseppe Zimbalo,
façade of the Chiesa del
Rosario, begun in
1691, Lecce.*

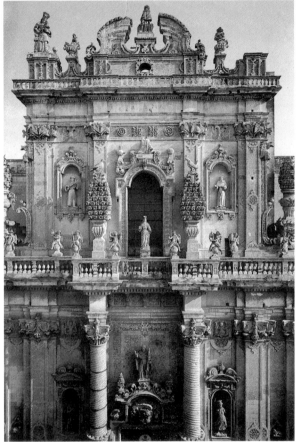

onymous with enchantment. In Rome, capital of the world and also birthplace and cradle of the Church, Bernini altered the layout of the city with a stage-designer's eye, creating perspective series, vast open spaces for traffic, triumphal fountains (the Fontana del Tritone and the Fontana dei Quattro Fiumi) and, above all, squares: the Piazza del Popolo, whose three roads leading off it create an unparalleled visual effect, and the Piazza San Pietro (St Peter's Square), inscribed within colonnades that act as a functional enclosure for liturgical purposes, but, even more importantly, symbolize the Church's universality and its maternal embrace.

If Bernini was a formidable town-planner and a brilliant designer of buildings (one has only to think of his Church of Sant'Andrea al Quirinale), the most radical and revolutionary baroque architecture is to be found in the work of Francesco Borromini, in his churches of Sant'Ivo alla Sapienza and San Carlo alle Quattro Fontane. Here, geometrical complexity, dominated by elliptical and spiral modules, becomes a symptom of disquiet and bewilderment: it proclaims the dynamic vortex to be the beginning and end of a sight line that coils in on itself, no longer capable of finding secure points of reference. The emotional power with which Bernini invests sculpture is in Borromini entrusted to the rhythmical contraction and expansion of architectural structures. The expressive quality of the work thus coincides with the distortion of vision. But, as is also the case in Turin with similar constructions by the architect Guarino Guarini (San Lorenzo and the dome of the Chapel of the Holy Shroud), this distortion is compensated for by the joyfulness of a boundless fantasy, an unwonted freedom and an art that proclaims its sacred creative fervour from every nook and cranny. Changes also occur within the urban context, where architecture takes on a new meaning: façades are no longer thought purely as the bounds of an internal space, but are sinuously broken up by means of a mixture of curvilinear forms that embrace the external space and become involved with it. This new formal language spread throughout Europe, ranging from the flamboyant baroque architecture of Lecce to the gloomy, symbolist buildings of Prague, to name but two of the most outstanding examples.

But, as we have already seen, this world of extravagance contained within it a dialectic antithesis, classicism, with which it coexisted

▼ *Nicolas Poussin,*
Autumn, 1660–64,
Louvre, Paris. In this
allegorical work
Classical art is recalled
in the broad, serene
conception of the

landscape and the very
carefully calculated
composition.

▼ *Jan Vermeer, View of*
Delft, 1658–60,
Mauritshuis, The
Hague. The novelty of
this painting lies in the
great precision with
which the atmospheric
conditions are
portrayed, at a precise
moment of the day that
is also indicated on the
face of the clock.

in a state of academic, but hardly dramatic, conflict. The classicist theory, initially formulated by Giovanni Battista Agucchi (a close friend of Domenichino) and later adopted by Giovanni Bellori, enjoyed a great following. Its adherents included artists such as the Frenchman Nicolas Poussin, who used mythology as a source of subjects containing innate moral tension. His style of painting revived the golden serenity of Raphael – the very antithesis of Michelangelo, Mannerism and the baroque – and yet he made it compatible with the ideological demands of the seventeenth century. Other staunch champions of classicism, besides Poussin, included Andrea Sacchi, Alessandro Algardi and François Duquesnoy, for whom the ideal aesthetic continued to be that proposed by the ancient Greeks and Romans.

Probably the most interesting example of anti-baroque formalism, however, is to be found not in Italy, but in Holland. From the window of his house in Delft, Jan Vermeer recorded a secular and Protestant spiritual panorama that represents the main historical antidote to Roman Catholic culture. When his glance, at the same time both profane and mystical, penetrates the studies of musicians and astronomers, the private workshops of lacemakers and the comfortable interiors of high-born young ladies, it evokes not the dramas of the century's religious crises, but rather the rhythmical cadences of the life enjoyed by a self-satisfied society proud of its values. ■

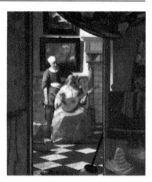

Jan Vermeer, The Love Letter, *1667, Rijksmuseum, Amsterdam.*

A specialist in interior scenes such as this, created with great technical skill and poetic sensitivity, the artist records the rhythms of life with an analytical spirit that was very original for its time, a characteristic that also provided him with an opportunity for achieving outstanding results on the level of pure artistic ''language.''

Guercino, Aurora, *detail, 1621, Villa Ludovisi, Rome.*

The sharp perspective foreshortening marks a key stage in the development of decorative baroque ceilings, which now began to open out into ever broader and more breathtaking vistas.

Francesco Borromini, *Sant'Ivo alla Sapienza: lantern of the dome, 1642–50, Collegio della Sapienza, Rome.*

*The spiral of the lantern is probably emblematic of its location (*sapienza *means knowledge), a bold symbol of the mind and its formative processes.*

Henri IV King of France	Outbreak of Thirty Years' War	Rise of Richelieu in France	Peace of Westphalia	Great Fire of London	William of Orange becomes King of England
			Execution of Charles I	Peace of Nijmegen	
John Smith founds Jamestown, Virginia	Dutch found settlement, later New Amsterdam	English Civil War			
Galileo: *Sidereus nuncius*	Kepler: *Harmonice mundi*	Galileo: *Dialogo sopra i due massimi sistemi*	Harvey: *De generatione animalium*	Newton: *New Theory about Light and Colours*	Newton: theory of gravity
Kepler: *Mysterium cosmographicum*	Kepler: *Tabulae Rudolphinae*	Foundation of Harvard University	Christian Huygens: Pendulum clock	Boyle's Law	
Peri: *Euridice*	Gibbons: Madrigals	Monteverdi: *Incoronazione di Poppea*	Cavalli in Venice	Lully: *Cadmus et Hermione*	Scarlatti in Naples
Monteverdi: *Orfeo*	Landi: *La morte di Orfeo*		Carissimi in Rome	Scarlatti: *Gli Equivoci nell'Amore*	Purcell: *Dido and Aeneas*
Ben Jonson: *Volpone*	Bacon: *Novum Organum*	Corneille: *Le Cid*	Hobbes: *Leviathan*	Milton: *Paradise Lost*	Locke: *Essay Concerning Human Understanding*
Marlowe: *Dr Faustus*	Marino: *L'Adone*	Descartes: *Discours de la méthode*		Pascal: *Pensées*	
East India Company founded	Collegium Musicum, Prague	Académie Française	Royal Society, London	Royal Academy of Science, Paris	Academy of Science, Berlin
A. Carracci: Palazzo Farnese frescoes	**Van Dyck:** *Self-Portrait*	**Pietro da Cortona:** *Triumph of Divine Providence*	**Bernini:** Cornaro Chapel	**Borromini:** San Carlo alle Quattro Fontane	**Fischer von Erlach:** Schönbrunn Palace, Vienna
Caravaggio: *Conversion of St Paul*	**Bernini:** *Apollo and Daphne*	**Rembrandt:** *Night Watch*	**Velázquez:** *Las Meninas*	**Ruisdael:** *The Jewish Cemetery*	
1592–1610	1611–28	1629–46	1647–64	1665–82	1683–1700

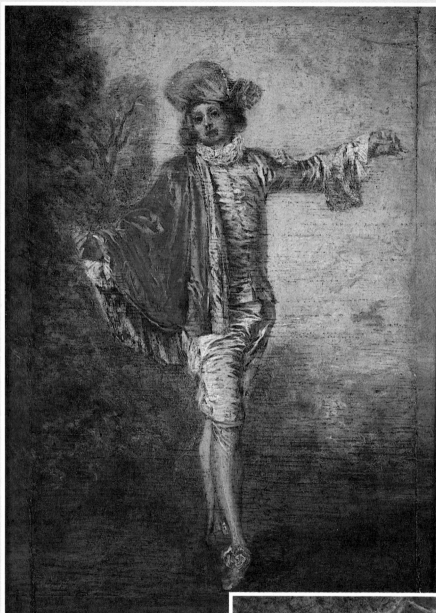

Jean-Antoine Watteau,
L'Indifférente, *1716,*
Louvre, Paris. This
painting, the title of
which is not Watteau's,
but derives from an
engraving of 1729,
shows a ''diabolo''
player. L'Indifférente
is also the title of a story
by Marcel Proust, who
dedicated a poetic
composition to Watteau
(it forms part of his
Portraits de Peintres
et de Musiciens), *in*
which he sums up the
characteristics of the
artist's painting, which
mirrored a twilight
world, with all its
grace, its loves and its
masks.

9 THE EIGHTEENTH CENTURY

The eighteenth century saw a gradual erosion of the absolutist, aristocratic world that had dominated Europe for hundreds of years, determining its political forms and customs, its philosophical thinking and its aesthetics. Thanks to the enlightened movement of the *philosophes*, new personalities began to make their mark, together with new ideas, such as that of citizen and *bourgeois*, reason and nature, freedom and the search for happiness, which were destined to alter decisively the course of history. In fact, the second half of the eighteenth century saw the outbreak of the American War of Independence (1776), which sanctioned the independence and right to self-determination of the British colonies on the other side of the Atlantic, and later the French Revolution (1789), when the execution of the king and the abolition of centuries-old feudal privileges also acted as a symbolic milestone marking the beginning of the modern world.

During the first part of the century art found itself reflecting the lifestyle of the aristocracy, adorning their palaces and their theaters, their salons and their parks in a style known as "rococo." The term comes from the French word *rocaille* (rockwork), indicating a type of decoration that was used particularly for the embellishment of grottoes and pavilions and was based on shell shapes and other naturalistic elements. The new style found its strongest representation in interiors filled

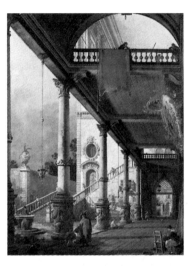

▶ *Canaletto, Architectural Capriccio, 1765, Gallerie dell' Accademia, Venice. This work dates from the final years of the artist's life. Having returned from his stay in England, he was admitted to the academy in Venice in 1763, only five years before his death.*

▼ *Giambattista Tiepolo, Thetis Comforting Achilles, 1757, Villa Valmarana, Vicenza.*

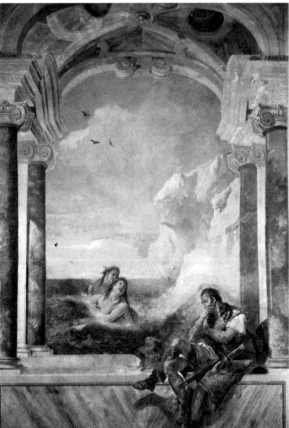

▼ *Jean Honoré
Fragonard*, La Belle
Serveuse, *1760–70,
National Museum,
Stockholm. The artist,
whose work belongs to
the final phase of the
rococo, adopted subjects
(eroticism, games,
intimate and luxuriant*

*poses) and a style
characterized by
sinuously curving lines
and hazy, pastel
shades. As with
Boucher's, Fragonard's
intimate scenes are
sometimes set in the
boudoir, the rococo
room par excellence.*

of books on decoration (J.-A. Meissonier's *Livre d'Ornament*) and to travelling artists and craftsmen, cabinet makers and theatrical designers.

As in the baroque era, painting retained its place on ceilings and staircases, creating an illusion of greater architectural space, but in a more light-hearted and ephemeral vein. The solemn allegories of the seventeenth century gave way to pastoral visions of Arcadia, to the kingdom of Venus and Pan and to sensual and erotic scenes that glorified the pleasure seeking of a social class on the threshold of decline.

with furniture whose sinuous lines were thought the best means of expressing sensual beauty, mirrors (as seen in the Amalienburg pavilion in the Palace of Nymphenburg near Munich), tapestries and particularly in porcelain, now no longer imported from China thanks to the discovery of the formula by the German J.F. Böttger, but produced in the famous factories of Meissen and Nym-phenburg, Capodimonte and Sèvres.

The center for the spread of the rococo movement was the France of Louis XV and the regent Philippe of Orléans, who moved the court from the Palace of Versailles to Paris, dividing it up between a number of different salons and private residences. From France the rococo style radiated outwards to central Europe and Italy, thanks to the diffusion

One subject that was particularly popular in painting was that of the *fête galante*, an eighteenth-century variant of the rustic concert and the *jardin d'amour*, whose greatest exponent was Jean-Antoine Watteau. In these scenes ladies and their escorts join together in games and minuets and attend concerts and plays, dressed like the protagonists of a pastoral

BIOGRAPHIES

◆ **Bellotto** Bernardo (Venice 1720–Warsaw 1780). A pupil of his uncle, Canaletto, he worked in numerous cities in Italy and elsewhere (Dresden, Munich, Warsaw), which he depicted in vast and minutely detailed views, in both paintings and engravings.

◆ **Boucher** François (Paris 1703–70). Influenced by Watteau, he studied in Italy in 1727. Among his decorative schemes

were the Hôtel de Soubise and the Châteaus of Crécy and Bellevue. He was director of the Gobelins tapestry works and also created models for the Sèvres porcelain factory. His paintings include *Female Nude* and *Diana at Rest*.

◆ **Boullée** Etienne-Louis (Paris 1728–99). Professor of architecture at the *Ecoles Centrales*, Boullée constructed few buildings, primarily in

the Classical taste. His radical influence lay in the unrealized projects that provide the illustrations in his treatise *Architecture, Essai sur l'Art*.

◆ **Canaletto** Giovanni Antonio Canal, called (Venice 1697–1768). Initially a stage designer and then a painter of views, Canaletto recorded his native city in broad, luminous compositions (*St Mark's Square, The Grand Canal at San Vio,*

The Regatta Seen from the Ca'Foscari). Well known and popular among the English, he moved to London in 1746, where he lived for ten years (*View of Eton and the Chapel*).

◆ **Canova** Antonio (Possagno 1757–Venice 1822). He came into contact with Neo-Classicism in Rome, where he arrived in 1779. He created funerary monuments, portraits (Pauline Bonaparte Borghese as Venus) and figures

◄ *Thomas Gainsborough,* William and Elizabeth Hallet *or* The Morning Walk, *1785, National Gallery, London. The perfect fusion of figures and setting was a great feature of English eighteenth-century art.*

▼ *John Trumbull,* The Declaration of Independence, *1818, Yale University Art Gallery, New Haven, Conn. The painting shows, among others, Benjamin Franklin and Thomas Jefferson.*

and portraits and sketches of landscapes.

In the meantime, the ideas of the Enlightenment were advancing: between 1751 and 1777 the volumes of Denis Diderot and Jean d'Alembert's *Encyclopédie* were published and the values of experience and reason became prized, while the domain of literature, newspapers and art widened to include the middle classes and intellectuals from different social strata.

In the wake of the Enlightenment's re-evaluation of human skills and faculties, new importance began to be given to the genre of realistic views, in which numerous artists specialized with the help of the "camera obscura," an instrument based on lenses and mirrors that reflected the outside world and enabled artists to follow its contours exactly. Masters of this genre of precision painting, and also of the imaginary views known as *capriccios*, included the Venetians Giovanni Canaletto and

mythology. In his painting *Enseigne de Gersaint* Watteau pinpoints another part of eighteenth-century life: an art dealer's shop. In numerous canvases he also portrayed domestic interiors, with female figures shown either dressing or undressing in settings that gave rise to a style of painting filled with hazy, fugitive tints, executed by means of swift, sensitive brush strokes. Other exponents of French painting worked along similar lines, artists such as François Boucher, a protégé of Madame de Pompadour and director of the Gobelins tapestry factory, and Jean-Honoré Fragonard, himself the author of *fêtes galantes*, erotic and domestic scenes,

derived from Classical mythology (the *Three Graces* and *Cupid and Psyche*), in which he strove to attain the ideal of beauty, in the sense of "beauty according to reason," which was an essential element of the eighteenth-century aesthetic.

♦ **David** Jacques-Louis (Paris 1748–Brussels 1825). He encountered Classical culture and Neo-Classicism in Rome, which he visited for the first time in 1775. His pre-Revolutionary works include the *Oath of the Horatii,* the *Death of Socrates* (1787) and his portrait of *The Chemist Lavoisier and his Wife* (1788), while his *Death of Marat* and *Triumph of the French People* were central works of the Revolutionary era. After the Terror he painted *The Sabine Women* and in 1800 he painted Napoleon, whom he glorified as General, First Consul and then Emperor.

♦ **Fragonard** Jean-Honoré (Grasse 1732–Paris 1806). Influenced by Jean-Baptiste Chardin and Boucher, he went twice to Italy, where he copied Italian subjects on commission for the Abbé de Saint-Non, to whom he presented a collection of engravings. His most memorable works include *The Stolen Shift* and the *Gardens of the Villa d'Este.*

♦ **Gainsborough** Thomas (Sudbury 1727–London 1788). As he was attracted mainly by landscape subjects, he painted his numerous commissions as open-air portraits. They reveal his taste for the picturesque and for the natural qualities of air and light.

♦ **Guardi** Francesco (Venice 1712–93). Born into a family of Venetian painters, he concentrated particularly on views (*vedute*). He replaced documentary realism

Bernardo Bellotto, who were in great demand throughout Europe, and also Francesco Guardi, who replaced their photographic realism with a more emotive concept of the subject and a more rapid, less clinical technique. Attention to the customs of society, an interest in entertainment, and a taste for involved criticism are other characteristics of eighteenth-century painting taken up, in different ways, by artists such as Giovanni Domenico Tiepolo (son of Giambattista Tiepolo) and William Hogarth, Pietro Longhi and Thomas Gainsborough.

Towards the middle of the century, discoveries made by archaeologists at Pompeii and Herculaneum and in Athens and Rome brought about a reappraisal of ancient art. The Greek, Etruscan, Roman and also Egyptian finds were catalogued, then historically and stylistically analyzed. Archaeology in the modern sense of the word was born, while, at the same time, disciplines such as art history and aesthetics developed their own methodologies.

This is how many eighteenth-century artists, eager to dispense with rococo forms, came to see ancient art and the values linked to the Classical civilizations in general as inspirational models for both life and art. The thematic repertoire of both painting and sculpture changed once again: Venus and Pan were now replaced by the heroes of Roman history and by images taken from ancient vases and reliefs, which provided a more suitable vehicle for reflecting the moral ethos of the ascendant middle classes. Neo-Classicism spread throughout Europe as proof of art's desire to participate in the social changes, the new moral standards, the rise of revolution and the new ideas of beauty.

Europe was not the only area in which this new artistic vernacular took hold: the American colonies, in their search for independence, felt

At the root of the Neo-Classical style lay the theoretical works of the German Johann Joachim Winckelmann (On the Imitation of Greek Works, 1755, and History of Ancient Art, 1764), in which he affirmed the need to imitate Classical art and defined the aesthetic characteristics of Greek sculpture ("noble simplicity, quiet grandeur"). Among those who responded to this invitation to imitate the ancients were Antonio Canova and Jacques-Louis David, who searched among Classical models for images that his contemporaries could interpret as a mirror of their own situation. Neo-Classicism represents yet another stage in the perennial dialogue between Western culture and the language of Antiquity, from medieval revivals to the Renaissance to the nineteenth century, particularly with Ingres (above: La Source, 1856, Musée d'Orsay, Paris) and the monumental revivals of Classical architecture during the 1830s.

with a fantastic interpretation of places that gives an almost dream-like quality to his paintings, which are executed in swift, dappled brush strokes.

♦ **Hogarth** William (London 1697–1764). In paintings and engravings he portrayed typical characters from contemporary English society with all the complexity and insight found in novels of the day. His moralistic series include *Harlot's Progress*, *Rake's Progress* and *Marriage à la Mode*. He wrote a treatise entitled *The Analysis of Beauty* (1753).

♦ **Ingres** Jean-Auguste-Dominique (Montauban 1780–Paris 1867). He studied at Toulouse Academy and was a pupil of David in Paris. He lived for a long time in Italy, where he was able to derive maximum benefit from direct contact with the paintings of Renaissance masters. His works include a portrait of *Napoleon on the Imperial Throne*, *Oedipus and the Sphinx*, *The Dream of Ossian*, *La grande Odalisque* and the *Apotheosis of Homer*.

♦ **Longhi** Pietro, Falca, called (Venice 1702–85). A genre painter, he specialized

Antonio Canova, Cupid and Psyche, 1787–93, Louvre, Paris. The subject of this famous sculptural group is almost a staple of Neo-Classical iconography.

that Neo-Classical forms were the best means of expressing the new values, many of which had never been visualized before. The official buildings of the state (courthouses, capitols, museums), as well as private houses, were based on the architecture of Greek temples, complete with pediments, porticoes and colonnades, on whose capitals the Classical acanthus was

◀ *François Boucher, Birth (or Triumph) of Venus, 1740, National Museum, Stockholm. In this painting Boucher celebrates Venus as queen of rococo mythology.*

replaced by tobacco or maize leaves.

Equally, in France the painter Jacques-Louis David sometimes used a Classical language to express the values of Jacobinism (in *Oath of the Horatii* and *Brutus*) or to pass judgement on the progress of the revolution

mainly in scenes of aristocratic and middle-class Venetian life.

♦ **Tiepolo** Giambattista (Venice 1696–Madrid 1770). He executed important fresco decorations that mark the transition from the baroque illusionistic tradition to a new style, tinged with irony and an awareness of pictorial artifice. Among his greatest works are his frescoes in the Archbishop's Palace,

Udine (1726–28), his *Stories of Anthony and Cleopatra* (Palazzo Labia, Venice), the ceiling and walls of the *Kaisersaal* and the ceiling of the grand staircase in the *Residenz* at Würzburg, the ceiling of the Church of La Pietà, Venice, and the frescoes in the Villa Valmarana near Vicenza (1757). He spent his final years in Madrid, in the service of Charles III, where he decorated the Royal Palace. He was also author of a number of

canvases, drawings and etchings.

♦ **Watteau** Jean-Antoine (Valenciennes 1684–Paris 1721). His greatest works include *L'Indifférente, Love Disarmed, La Toilette* and *Fêtes Vénetiennes*, in which the characters, situations and style of rococo painting dominate.

▼ Jean-Auguste-
Dominique Ingres, The
Dream of Ossian,
1813, Musée Ingres,
Montauban. This
painting blends the
polished, statue-like
style typical of Ingres
with a decidedly
romantic subject, that of
the legendary bard
Ossian and his
"rediscovered" songs,
which had in fact been
invented by the
Scotsman James
Macpherson between
1760 and 1765.

▼ Giambattista Piranesi,
View of the Temples
of Paestum, 1778,
etching. The Neo-
Classical spirit was fired
by the remains of the
ancient world
unearthed by
archaeologists and
publicized throughout
Europe by collections of
engravings. The
excavations carried out
were recorded in the
works of many artists.

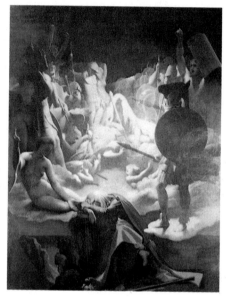

▶ Etienne-Louis Boullée,
Project for a
Monument to
Newton, 1780–90,
Bibliothèque Nationale,
Paris. Newton was a
real cult figure for
members of the
Enlightenment, and
Boullée dedicated this
plan for a combined
temple, cenotaph and
monument to him. It
was conceived in the
form of a giant sphere,
symbolic of the
universe, the stars and
their cosmic movements.

(The Sabine Women), while at
other times he stayed within
his own day, not resorting to
any archaic devices in por-
traying the Oath of the Tennis
Court and the Coronation of
Napoleon.

But the greatest interpret-
er of the Neo-Classical aes-
thetic in painting was Jean-
Auguste-Dominique Ingres,
who drew inspiration from
the great masters of the High
Renaissance, in particular
Raphael, whose ideological
and stylistic characteristics
he reinterpreted in a highly
personal way. The extraor-
dinary formal perfection of
his paintings was due to his
remarkable draughtsman-
ship and skilful structuring of
image, combined with an
equally outstanding clarity
of vision. And yet Ingres'
oeuvre belongs to the nine-
teenth century and, in some
respects, it reflects Romantic
sensibilities: one thinks of
The Dream of Ossian (1813), in
the Musée Ingres, Mon-
tauban, whose visionary
boldness makes it compa-
rable to certain paintings by
Francisco Goya, William
Blake and Henry Fuseli.

The closing decades of the
eighteenth century saw a
process of formal simplifica-
tion and a search for the es-
sential affecting every area of
art from the sculpture of An-
tonio Canova and Bertel
Thorvaldsen, the visionary
architecture of Etienne-Louis
Boullée to the graphic work
of John Flaxman, furniture
and the applied arts. The
result was a spare, sober style
that provided the right setting
for a new world, no longer
peopled by courtiers but by
citizens. ∎

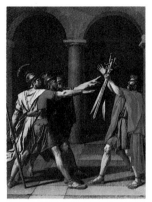

William Hogarth, The Visit to the Quack Doctor, *(detail)*, *from the series* Marriage à la Mode, *1745, National Gallery, London.*

Jean-Antoine Watteau, Enseigne de Gersaint, *(detail)*, *1720, Schloss Charlottenburg, Berlin.*

After painting countless scenes of parks and gardens, theater entertainments and panels filled with grotesques and arabesques destined for the adornment of Parisian houses, Watteau here changed the setting of his figures, fixing it in a real place, an art dealer's shop, where portrayals of life are exchanged and compared.

Hogarth created a series of paintings, later made into engravings, in which he censured ''modern morality.'' From the point of view of composition, the device of a series allows for a novel-like presentation, filled with information as varied as the nature and life of society. The moral judgement tends to reflect the complexity of the new, eighteenth-century system of values and ethics.

Jacques-Louis David, Oath of the Horatii, *(detail)*, *1784– 85, Louvre, Paris.*

In this manifesto of French Neo-Classicism, David invited his fellow Frenchmen to swear fealty to the ethical values (discipline, self-sacrifice and the rejection of luxury) that were to overthrow the ancien régime. To achieve this he chose an episode from Roman history and gave it clear form; the sentiments, subjects and shapes of rococo art have been completely superseded.

War of Spanish Succession	George I, first Hanoverian King of England	War of the Austrian Succession	Seven Years' War	American War of Independence	George Washington first US President
Union of England and Scotland		French found Louisiana			French Revolution
Newcomen: first steam engine	Gabriel Fahrenheit: mercury thermometer	John Kay: flying-shuttle loom	Linnaeus: *Species Plantarum*	Adam Smith: *The Wealth of Nations*	Lavoisier: *Traité élémentaire de chimie*
Bartolommeo designs the first piano	Bach: *Brandenburg Concertos*	Handel: *Messiah*	Noverre: *Lettres sur la danse*	Paisello: *Il barbiere di Siviglia*	Mozart: operas and symphonies
	Rameau: *Traité de l'harmonie*	Pergolesi: *La serva padrona*	Gluck: *Orpheus and Eurydice*	Gluck: *Alcestis*	Haydn: *The Creation*
Berkeley: *Principles of Human Knowledge*	Leibniz: *La Monadologie*	Hume: *Treatise on Human Nature*	Diderot and D'Alembert: *Encyclopédie*	Goethe: *Die Leiden des Jungen Werthers*	Casanova: *Memoirs*
Locke: *Some thoughts concerning Education*	Jonathan Swift: *Gulliver's Travels*	Voltaire: *Lettres philosophiques sur les Anglais*	Winckelmann: *On the Imitation of Greek Works*	Kant: *Critique of Pure Reason* (1st ed.)	Boswell: *The Life of Samuel Johnson*
	Montesquieu: *Lettres persanes*				de Sade: *Justine*
Wren completes rebuilding of St Paul's	Belvedere Palace, Vienna	Rastrelli court architect at St Petersburg	Robert Adam remodels interior of Syon House	Quarenghi architect at St Petersburg	Discovery of Rosetta Stone
Rigaud: *Portrait of Louis XIV*	**Watteau:** *Embarkation for the Island of Cythera*	**Boucher:** *Birth of Venus*	**Tiepolo:** decoration of the *Residenz* at Würzburg	**Fragonard:** *Fête à Saint-Cloud*	**Canova:** *Cupid and Psyche*
		Reynolds: *Eliot Family Group*		**Guardi:** *View of the Piazzetta*	**Gainsborough:** *The Morning Walk*
1692–1710	1711–28	1729–46	1747–64	1765–82	1783–1800

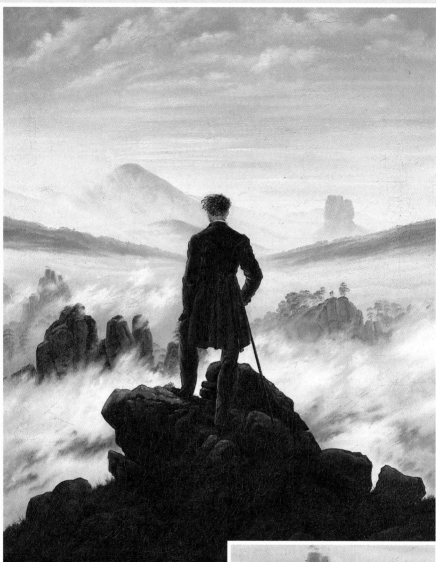

Caspar David Friedrich, Journey above the Clouds, *1818, Kunsthalle, Hamburg. Throughout his life Friedrich observed and drew the natural environment of northern Germany, the countryside around Dresden, the Baltic coast and the mountainous landscape of Saxony, a glimpse of which can be seen in this painting. He did not, however, stop at the straightforward portrayal of nature, but overlaid it with a secondary meaning, expressed through symbols (the figure with its back to us, the clouds, the mists, the horizon) and through colour and structural composition. The man pictured here is like a symbol of the Romantic experience of nature: alone, on a peak, he looks towards the unattainable and what he sees is both an external reality and a projection of his own self.*

10 ROMANTICISM

In 1846 Baudelaire wrote: "Anyone who speaks of Romanticism speaks of modern art, that is to say, intimacy, spirituality, colour, an aspiration for infinity, expressed by all the means at the disposal of the arts." By that time the themes of the Romantic movement had already been established and they are indeed the ones that make up modern art. We must go back to the beginning of the nineteenth century to witness the birth and spread of Romanticism, always bearing in mind that this term, like many other art-historical terms, is only a blanket definition used to describe artists and situations that differ from one another but share the same new cultural mood, sensibilities and historical panorama.

During the nineteenth century artists no longer had specific clients: they found themselves working for themselves, creating works on their own initiative that might or might not find a buyer. The era of exhibitions and "journalistic" art criticism had arrived; the public discussed styles and fashions, looking for reading matter and art that would excite their imagination and their sense of fantasy. And so the traditional subjects of painting (gods and nymphs, allegories of abstract concepts, Bible stories and events from ancient history) gave way to the artist's inner vision, to what excited him in the present as well as in the historical past, in myth as well as in his natural surroundings, in the real and the imaginary, in dreams and flights of fancy. Historically, it was the era of

the Napoleonic adventure, which ended with the Restoration, the years of nationalist upheaval in the states of Germany and Italy, of war between the Greeks and Turks and of the first manifestations of class conflict in Europe, while the Americans, only recently independent, were searching for a national identity of their own in both politics and art.

In painting, subject and feeling became the most important elements, just as they were in Kant's and Schelling's philosophy of nature and of the individual, in the poetry of Goethe, Foscolo and Leopardi and in the music of Schubert and Beethoven. Germany was the first country to witness this new interiorized aesthetic, which saw art as a means of reaching to the heart of creation and gaining contact with the infinity of nature through a feeling of the sublime. The echoes of this thinking carried from the realms of philosophy and poetry (Novalis) into the painting of Caspar David Friedrich and Philipp

▲ *Thomas Cole*, The Hunt. The Moon and Fires at Night, *c.1828, Thyssen-Bornemisza Collection, Lugano. Cole was the founder of American landscape painting. In this picture he depicts nature beyond this earthly Paradise, impervious and sublime.*

▼ *Philipp Otto Runge, Night, 1803, Kunsthalle, Hamburg. This drawing belongs to the* Times of the Day *cycle.*

▼ *John Constable, Weymouth Bay, c.1824, National Gallery, London. Constable was a Romantic naturalist representing natural phenomena in all their variety and detail.*

▶ *Théodore Géricault, The Raft of the Medusa, 1818–19, Louvre, Paris. Géricault's work reveals the disintegration of all the values of the Revolution and the Napoleonic era.*

most say his soul, towards the grandeur of the natural landscape and from that moment on becomes a part of it: he is lost in a sublime environment of elemental power and grandeur, in other words the divine plan, the unfathomable thinking of God. Confronted with such magnificence, man is at one and the same time both destroyed and strengthened, subdued but yet enlightened by the intimate grace of his own "participation."

In England, too, nature became the focus of interest for the public and for artists, ranging from John Constable, who investigated the substance and form of sky and countryside, to Joseph Turner, who used light as a means of transforming what he saw before him, and John Martin, who employed lofty mountain landscapes as a setting for subjects taken from Byron's poems or Nordic myths.

The case of Turner merits particular attention. In his works the fusion of subject

Otto Runge, two Northern European artists who rejected the traditional voyage to Italy and the equally traditional Classicist subjects in order to paint only nature and its effects on their emotions. These men were among the earliest exponents of modern landscape painting as a respected genre capable of expressing, better than any other, certain aspects of nineteenth-century man's sensibilities.

Friedrich was undoubtedly one of the century's greatest artists: his works combine a technique which was, to say the least, outstanding with an ability to project onto the painted image extraordinarily evocative reflections on man and nature. His *Journey above the Clouds* (1818) in Hamburg's Kunsthalle can be seen as a veritable "manifesto" of Romanticism. The solitary figure of a man directs his gaze, one could al-

BIOGRAPHIES

♦ **Blake** William (London 1757–1827). A poet, painter and engraver, he illustrated his own books and strove to translate into images the great visionary strength of his poetic inspiration, thereby contributing to that renewal of human sensibilities which typifies Romanticism.

♦ **Church** Frederic E. (Hartford, Conn., 1826–New York 1900). A pupil of Cole, he extended the range of subjects in American

landscape painting, with the *Andes of Ecuador* (1855), *Icebergs* and *Aurora Borealis* (1860) and *Cotopaxi* (1862).

♦ **Cole** Thomas (Bolton-le-Moors, England, 1801– Catskill, NY, 1848). He painted numerous landscapes in the Hudson River valley and earned fame as founder of the Hudson River School. He also specialized in allegorical and symbolic landscapes,

such as those in his *Journey of Life* series (1840).

♦ **Constable** John (East Bergholt, Suffolk, 1776–London 1837). After studying the great Dutch and French masters of landscape painting, he evolved his own style, paying great attention to mood and atmosphere, and often returned to the same subject, such as Salisbury Cathedral and the Stour valley.

♦ **Delacroix** Eugène (Charenton-Saint-Maurice 1798–Paris 1863). During his long career he tackled literary subjects (Dante, Byron), subjects from contemporary history (*Massacre at Chios*, 1824; *Liberty Leading the People*, 1831) and allegories. He kept a diary (*Journal*) between 1822 and 1824 and from 1847 until his death.

♦ **Friedrich** Caspar David (Greifswald

Turner arrives at that identification of space with light which he had sensed and researched during his long years as an artist, in the thousands of drawings and watercolours in which he experimented with chromatic juxtaposition and technique, in his lectures on perspective at the Royal Academy, and in his oil painting, which rejected the conventional portrayal of identifiable landscapes and laid the foundations for a new form of vision "through great masses of light and shade."

In America, too, young painters realized that their local natural environment provided the best means for constructing an identity of their own, distinct from the European tradition. The result was the portrayal of the majestic grandeur of Niagara Falls or the imagined and visionary depiction of the primordial world found in the works of Thomas Cole, the principal painter of the Hudson River School.

As well as the modern

and nature is taken to a point where the figurative image dissolves, since, in his poetic style, the "emotive penetration" of the landscape brings with it the loss of all rational and cognitive certainty. In his later watercolours, now in London's Tate Gallery, the natural dimension seems to melt in the warmth of a shimmering, discoloured light. The feeling of an irrevocable loss of self overcomes all phenomenal objectivity and the pictorial effect thus created anticipates the results achieved by twentieth-century "informal" art. In his mature work

1774–Dresden 1840). Born in Pomerania, he studied at the Academy in Copenhagen and then moved to Dresden. His most notable works include *Monk by the Sea* (1808–10), *Abbey in the Oak-Grove* (1809–10), *White Cliffs of Rügen* (1818) and *The Shipwreck of the "Hope" in the Ice* (1822).

◆ **Fuseli** Henry (Zürich 1741–London 1825). After studying theology in Switzerland, he moved to London, where he changed his name from Johann Heinrich Füssli. Linked to the pre-Romantic *Sturm und Drang* movement, he painted the *Oath on the Rütli* (1780). He translated his love of great poets (Homer, Dante, Shakespeare, Milton) into images.

◆ **Géricault** Théodore (Rouen 1791–Paris 1824). He knew many veterans of the French Revolution and the Napoleonic Wars and painted a number of military subjects. He also painted horses (*Capture of the Wild Horse*, 1817), execution victims and the insane. He visited England and Italy.

◆ **Goya** Francisco (Fuendetodos, Saragossa, 1746–Bordeaux 1828). As court painter (*Family of Charles IV*, 1800) he created numerous cartoons for the royal tapestry works. As well as oil paintings, he did engravings (*Los Caprichos*, 1799; the *Disasters of War*, 1810) and frescoes in his country house, the so-called "black paintings," now displayed in the Prado.

◆ **Hayez** Francesco (Venice 1791–Milan 1882). He painted portraits of Cavour, d'Azeglio, Rossini, Manzoni and others, as well as numerous subjects from medieval history containing hidden patriotic messages (*Sicilian Vespers*, 1821–22).

myth of "subjective" nature, the Romantic repertoire also saw the introduction of "interior" images. Modern artists painted what they felt, extending their search to include the innermost areas of the self, the world of dreams, the fantastic, the subconscious and the unreality that seeps through the real world. This was the case with Henry Fuseli, who painted *The Nightmare* (showing a sleeping woman and the dream figure oppressing her) and free interpretations of scenes from Shakespeare, the *Nibelungenlied* and the biblical poems of Milton, in which he displayed a high degree of formal inventiveness. The most visionary component of the Romantic movement, the fascination with the fantastic and the unreal also embraces the literary genre known as the Gothic novel (M. G. Lewis, E. T. A. Hoffmann). A full-blown example of this is provided by the poetry and painting of William Blake, which is characterized by a strong

Francesco Hayez, The Kiss *(1859), Pinacoteca di Brera, Milan. For a variety of reasons, throughout "Romantic" Europe the return to classic values was matched by the phenomenon of the Gothic revival. Whether out of a taste for the romantic and the bizarre or because the Middle Ages were the cradle of the nations of Europe and the guardian of the spirit of true religion, new buildings were erected and old ones restored in the medieval style in England (Augustus Pugin, exterior refurbishment of the Houses of Parliament in London), in France (Eugène-Emmanuel Viollet-le-Duc, restoration of the cathedrals of Amiens, Reims, Chartres and Notre-Dame in Paris), and in Germany (works and projects by Karl Friedrich Schinkel, completion of Cologne Cathedral). In paintings the Middle Ages, evoked in costumes and settings, were often used to conceal patriotic and nationalistic messages, as in the painting illustrated here.*

vein of dreamy mysticism.

A similar attitude can be detected in the paintings, frescoes and etchings of Francisco Goya, who, while depicting what he saw (scenes of war or courtship, people fighting or playing), distorted his subject and revealed its hidden side, using the artist's materials in an expressive rather than descriptive way, by means of contrasting, undefined areas with no outline.

In France, where Neo-Classical culture had been particularly strong, and also an integral part of the Revolution, there was a similar process of formal modification, with Théodore Géricault painting the gruesome heads of execution victims and the remains in slaughterhouses and drawing inspiration from contemporary disasters (the wreck of the raft of the Medusa, during which there were incidents of cannibalism) to express his existential condition and his sympathy towards social outcasts, slaves, the poor and the

◆ **Martin** John (Haydon Bridge, Hexham, 1789–Douglas, Isle of Man, 1854). He painted visionary landscapes and scenes from the Bible and Milton. His works include *The Flood* (1828) and *The Great Day of His Wrath* (1852).

◆ **Minardi** Tommaso (Faenza 1787–Rome 1871). In 1813 he painted *Self Portrait in the Garret*, which symbolizes the social condition of the

Romantic artist. In 1834 he signed the *purismo* manifesto, which preached a style of painting of great linear purity inspired by fifteenth-century Italian art.

◆ **Nazarenes** In 1809 a group of artists opposed to the Vienna Academy, and led by Friedrich Overbeck and Franz Pforr, formed the Fraternity of St Luke, which was

inspired by religious and patriotic principles. The following year, the painters in the group (Peter Cornelius, Philipp Veit, Wilhelm von Schadow, J. Fürlich, J. Koch) settled in Rome. Their Roman works include the frescoes for the Casa Bartholdy and the Casino Massimo (1819–30), which depict scenes taken from the *Divine Comedy, La gerusalemme Liberata* and *Orlando Furioso.*

◀ Henry Fuseli, The Nightmare, 1790–91, Goethemuseum, Frankfurt-am-Main. With this work, based on Mannerist models, the artist paved the way for the modern painting of the subconscious, portraying the subject (the recumbent woman) and the cause of her nightmare (the incubus and the horse). A reproduction of this painting hung on the walls of Freud's study in Vienna.

◀ Johann Friedrich Overbeck, Italy and Germany, 1811–28, Bayerische Staatsgemäldegalerie, Munich. For all those nineteenth-century Nordic artists who, following in Goethe's footsteps, yearned for Italy, this painting is a sort of manifesto. It juxtaposes the Gothic Germany of Dürer with the Italy of Renaissance purity.

▲ Eugène Delacroix, Women of Algiers, 1834, Louvre, Paris. It was Baudelaire, in his writings on Romantic art, who drew attention to Delacroix's oeuvre, which reverberates with the colour of "Oriental landscapes and interiors" that was to prove so popular in French painting until Matisse.

mentally disturbed, of whom he created a whole gallery of portraits. Eugène Delacroix expressed other aspects of the Romantic personality: a sense of taking part in contemporary events (his *Liberty Leading the People*, painted in 1831, recalled the Revolution of 1830) and the lure of the exotic, as witnessed by the diary and sketchbooks

◆ **Runge** Philipp Otto (Wolgast 1777– Hamburg 1810). After studying in Copenhagen, he spent some time in Dresden before settling in Hamburg. He was the author of theoretical writings on Romantic art and the theory of colour (*Farbenkugel*). His works include the drawings *Times of the Day* (1803) and the paintings *Morning* (1808) and *The Nightingale's Lesson*.

◆ **Turner** Joseph Mallord William (London 1775–1851). He began his career as a watercolourist and topographical artist, illustrating the places that he visited during his travels in Europe. He gradually modified his style, distancing himself from the representational portrayal of nature. His works include *Hannibal Crossing the Alps* (1812) and *Burning of the Houses of Parliament* (1835).

from his travels in North Africa and by works characterized by a bold, innovative use of colour.

Another element of the Romantic world was a fascination with the Middle Ages, which were seen as an era of pure religious feeling, in direct contrast to pagan Antiquity and contemporary materialism. It is this which explains the neo-Gothic mood in novels, plays, architecture and the figurative arts. One group of Nordic painters, known as The Nazarenes, founded a sort of

fraternity in Rome in 1810 whose members proposed to live their lives in accordance with the original principles of Catholicism and revive the stylistic purity of Dürer and the Italian artists of the fifteenth century. The Nazarenes also embraced patriotic subjects linked to German nationalist feelings. The development of other similar groups during the course of the century confirms the conscious desire of artists to withdraw from the world. The Italian Romantics (ranging from Antonio Fontanesi to Francesco Hayez and Tommaso Minardi) became involved in similar themes: the countryside, the isolation of the artist, the Risorgimento movement and the feelings of the individual. ∎

Tommaso Minardi, Self Portrait in the Garret *(detail), 1813, Uffizi Gallery, Florence.*

This picture portrays the young nineteenth-century artist's sense of disquiet: having abandoned Classical models and broken the link with society, he is searching for his own path.

John Martin, Manfred on the Jungfrau *(detail), 1837, City Museum and Art Gallery, Birmingham, England.*

The hero of Byron's Manfred *takes man's desire for awareness and experience to the limit, engaging in a Titanic struggle with the spirits of the cosmos, the forces of nature and his own self amid the romantic setting of the Jungfrau.*

Frederic E. Church, Niagara Falls *(detail), 1857, Corcoran Gallery of Art, Washington D.C.*

Church interpreted the adventurousness and frontier spirit of American culture, travelling as far afield as South Africa and Labrador and committing to canvas the landscapes and natural phenomena that he encountered, ranging from icebergs to volcanos and the Northern Lights.

Battle of Austerlitz Napoleon in Madrid	Congress of Vienna Battle of Waterloo	Monroe Doctrine	Abolition of slavery in British colonies	February Revolution in Paris	Crimean War
Volta: invention of the battery	Stephenson: first steam locomotive	Wöhler: first synthesis of an organic compound	Daguerre: first photographic device	Galle: discovery of the planet Neptune	Suez Canal: work begins
Beethoven: 23 piano sonatas	Rossini: *The Barber of Seville*	Weber: *Der Freischütz*	Berlioz: *Symphonie Fantastique*	Chopin: *Sonata op. 58*	Wagner: *Lohengrin*
Goethe: *Faust* (Part I)	Hegel: *Science of Logic*	Shelley: *Prometheus Unbound*	Poe: *Tales of the Grotesque and Arabesque*	Kierkegaard: *Either/Or*	Baudelaire: *Les Fleurs du Mal*
Spread of the Empire style Emergence of the neo-Gothic	Canova: *Pauline Borghese* Opening of the Prado Museum in Madrid	Corot: first examples of painting *en plein air*	Affirmation of Realism Arc de Triomphe in Paris	Birth of the Pre-Raphaelite Brotherhood	Eclecticism in architecture
Runge: *Night* Constable: *Borrowdale*	Friedrich: *Journey above the Clouds* Goya: *Execution of the Rebels on 3rd May 1808*	Cole: *The Hunt* Martin: *The Flood*	Delacroix: *Women of Algiers*	Turner: *Rain, Steam, Speed* Cole: *Journey of Life*	Hayez: *The Kiss*
1800–10	1811–20	1821–30	1831–40	1841–50	1851–60

Gustave Courbet, The Painter's Studio, *detail, 1855, Musée d'Orsay, Paris. Delacroix was an admirer of this painting, which he described as a ''singular work.'' Although it enters the realms of allegory, it succeeds in remaining firmly anchored to a realistic form of expression. In it*

Courbet has depicted all the figures, both real and symbolic, who contributed to his awareness as man and artist, ranging from the poet Baudelaire to the Irish beggarwoman, from the art-lover to the shepherd boy from Franche-Comté rapturously watching the artist as he paints their common homeland.

11 NINETEENTH-CENTURY REALISM

Between 1830 and 1870 a unitary thread ran through French culture that became interwoven with the political and social events, scientific discoveries and the new morals and customs. The consolidation of the industrial economy meant that financial capital gained the upper hand at the expense of the landowners, preventing the birth of the proletariat and stifling class awareness; revolutions paved the way for democratic ideas and signalled the irreversible involvement of the common man in politics.

Against this background nineteenth-century Realism differs from the earlier art forms based on verisimilitude, emerging as a historically identifiable movement. French Realism enjoyed its greatest flowering in the wake of the Revolution of 1848 and then matured during the period of disillusionment represented by the Second Empire, but its foundations were laid by the Revolution of 1830, when Louis Philippe placed the monarchy at the service of a bourgeoisie that became an increasingly dominant force in French politics.

This led to a break between artists and the ruling class that expressed itself in two different ways. It determined the highly active political involvement of artists such as Honoré Daumier, who chose lithography as his main means of expression and served the anti-monarchist struggle by creating illustrations for "La Caricature," the legendary republican publication founded by Charles

▲ Honoré Daumier, La Rue Transnonain, lithograph, 1834, Bibliothèque Nationale, Paris.

◀ Honoré Daumier, The Washerwoman, 1863, Musée d'Orsay, Paris. A constant feature of Daumier's art is his interest in the human condition, linked both to the repressive ferocity of the régime and the hardships of everyday life.

Philippon in 1830. Up until 1835 the pages of this review contained the often savage cartoons which Daumier used to convey his moral message: *Gargantua* and *La Rue Transnonain* are direct heirs to the tradition of Goya. Lithography, Daumier's favourite medium, provided him with such an exceptionally consistent means of artistic expression that it dwarfs his equally extraordinary activities as a painter. The subjects of his paintings, although less polemic than those of his lithographs, are also drawn from daily life, but their nervous and abbreviated style, far removed from that which characterizes the great Realist paintings of Millet and Courbet, shows his desire to capture the essential features of a figure or scene without dissipating the image's expressive force in details.

There was another group of artists, by contrast, who sought to achieve a kind of

escape from the reality of urban life and its accompanying political involvement. They gathered at different times, but in particularly large numbers around 1849, at Barbizon in the Forest of Fontainebleau, where they theorized a style of landscape painting *en plein air* and sought contact with nature, every one of whose manifestations they analyzed and every one of whose innermost secrets they investigated. Nature as portrayed by the Barbizon painters, although it sometimes possessed an unearthly quality (particularly in the works of Théodore Rousseau, the group's most illustrious member), is more often familiar and accessible, and therefore far removed from Romantic mythologizing. It was no mere coincidence that the greatest inspiration for these artists were the paintings by Constable, who in the 1824 Salon had profoundly affected the French Romantics with his "truthfulness," which had encour-

The birth of photography is traditionally believed to date from 1839, the year in which Louis Daguerre announced the invention of the daguerrotype, thus concluding the twenty-year-long experiments of Joseph N. Niepce; Hippolyte Bayard created images on silver chloride paper; Henry Fox Talbot perfected his own method of reproduction on paper, which, by anticipating the use of negatives, paved the way for photography's role as a means of mass communication. The relationship between the new medium and art was a close one but with time the relationship between the two mediums took a different turn. Being capable of registering only one of the countless visible aspects of reality, photography could not give artists that impartiality which had originally been expected of it; it therefore ceased to be regarded as a tool of art and took on the status of an independent form of expression, becoming the best interpreter of that interest in the mundane which was one of the basic tenets of Realism. Above: Nadar, Portrait of Baudelaire, c.1863

aged them to take a naturalistic direction. The process thus initiated was to continue through and beyond the Barbizon experiment, especially at the hands of François Daubigny, who from the late 1850s was able to broaden the scope of his work by painting what he saw from on board his small boat on the Seine. Another artist with links to the Barbizon School was Jean-Baptiste-Camille Corot, who followed in the footsteps of the Realist painters, a generation his junior, but without identifying himself completely with their ideas. A solitary figure, impossible to classify under any trend or movement, he evolved a highly personal and spontaneous language, charged with emotion and expression. Landscape painting was of fundamental importance to him and he devoted himself unceasingly to it, not only at Barbizon, but also in the Seine valley, on the Channel coast and in Italy, a country to which he was

BIOGRAPHIES

♦ **Bingham** George Caleb (Virginia 1811–Kansas City, Missouri 1879). After training in America he lived in Europe from 1856 until 1859, at a time when Realism was already firmly established. Rather than showing the social stirrings of Europe, his painting reflects a conscious feeling of pride in belonging to a peaceful, democratic nation and a desire to portray it in a simple, unrhetorical style. This is the mood that pervades his most successful paintings, which record daily life along the Missouri River.

♦ **Corot** Jean-Baptiste-Camille (Paris 1796–1875). He attended the Académie Suisse, where he received a classical education accompanied by excursions to paint the countryside. He made three very important journeys to Italy as part of a nomadic life that took him to the French provinces, Switzerland, Holland and England. His work is characterized by the rigorous distinction between his official works, which belong to the tradition of classical landscape painting in the manner of Poussin, and the studies that he did

attracted by his Classical training.

These two apparently divergent trends share the main characteristic of the Realist movement: an interest in contemporaneity. For all these artists, the faithful representation of observed reality was the only way of giving form to a genuine expressive need. The two stages of this process, observation and representation, were also affected by the new perceptive theories and social interests and the new concept of history. Paintings, hitherto the domain of exceptional characters and idealized or imagined landscapes, now began to depict townscapes, farming communities and ordinary people going about their daily lives. With Jean-François Millet peasants entered French painting, no longer as evocations of a world of simplicity and innocence, but as real people, in all their physical energy and social strength. In the 1848 Salon, which the Revolution had opened to all French

"from life," which Corot regarded as exercises and almost always refused to exhibit. The first group contains the paintings that brought him his success, while the second group contains works that reveal a stronger link with the search for "modern" means of expression: not only the innumerable landscapes, but also the portraits, which reflect the influence of photography.

◆ **Courbet** Gustave (Ornans 1819–Tour-de-Peilz 1877). The son of well-to-do farmers, he moved to Paris in 1839, where he attended the Académie Suisse. He made periodic visits to his native Franche-Comté. Following his trip to Holland in 1847, which was of fundamental importance in familiarizing him with the works of Hals and Rembrandt, he travelled frequently to Belgium, Germany and

Switzerland. The most crucial events in Courbet's life were his contacts with Charles Baudelaire, Pierre Proudhon, to whom he owed his socialist ideals, and Alfred Bruyas, who was his patron. Although not an active participant in the Revolution of 1848, he was fully committed to the 1871 Commune. When this fell he was accused of being one of those responsible for the destruction of the Vendôme column and

imprisoned for six months, then sentenced to pay for the rebuilding of the Napoleonic monument. In 1873 he fled to Switzerland, where he remained until his death.

◆ **Daumier** Honoré (Marseilles 1808–Valmondois 1879). Taken as a child to Paris, he became an errand-boy for a lawyer and then clerk in a bookshop before being able to devote himself to art, when he

117

▼ *Jean-Baptiste-Camille Corot*, The Bridge at Nantes, *1868–70, Louvre, Paris. As a fellow traveller of the Realists, Corot searched for a true-to-life style of representation, which he achieved by linking atmosphere and volume and by creating a harmonious range of luminous greys, using a technique that was to meet with the approval of the Impressionists.*

at times apparently tinged with mannered humanitarianism, generally displays a perfect balance between sentiment and involvement. In works such as *The Gleaners* (1857) and *The Angelus* (1859), composition, rhythm and colour form what could be called a "classic" combination.

A very different role within the Realist movement was played by Gustave Courbet, although the more severe Millet was a major influence on him. Courbet's

artists, Millet exhibited *The Winnower*, a painting that provides a fine representation of the key elements of the Realist mood. Ideologically speaking, Millet was certainly a republican and a democrat, but his commitment was expressed on a moral rather than political level, particularly following his move to Barbizon, where he was uniquely successful at combining the life of the peasantry with an art of great austerity. This art, although

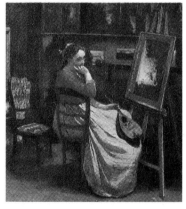

◀ *Jean-Baptiste-Camille Corot*, The Studio, *1870, Musée des Beaux-Arts, Lyons. Realism stripped portraits of any sense of celebrative solemnity and took them into the more congenial area of human investigation. In Corot's portraiture the extreme sobriety of the image is matched by a very high level of expressive intensity.*

studied old paintings and attended lessons at the Académie Suisse. Charles Ramelet taught him the technique of lithography, thanks to which he was able to contribute to the satirical journals "La Silhouette," "La Caricature" and, from 1833, "Charivari," entrusting his message to such purely invented characters as Ratapoil and Proudhomme. He executed so many thousands of

lithographs that he ruined his eyesight, partly in an attempt to rescue himself from the poverty that dogged him throughout his life. He visited Barbizon and was also a friend of Rousseau and Millet, but his painting, to which he came late in life (after 1848), concentrated not on landscape, but on humanity, the same subject that inspired the forty-five sculptures he created during the 1830s,

thirty-seven of which have survived.

♦ **Fattori** Giovanni (Livorno 1825–Berlin 1905). After studying in Livorno and Florence in a traditional environment and after early beginnings in the field of historical painting, his representations of military life and Risorgimento battlefields brought him within the orbit of the subjects and modes of European Realism.

After joining the Macchiaioli movement, whose most authoritative exponent he became, he devoted himself to domestic and rural subjects, preferably taken from the Tuscan countryside, which he rendered in broad, flat sweeps of intense colour, always striving to remain faithful to reality and far removed from any rhetoric.

♦ **Leibl** Wilhelm (Cologne 1844–

▼ *Jean-François Millet,*
The Gleaners, 1857,
Musée d'Orsay, Paris.
In the simple poses and
humble actions of
fieldhands Millet
acknowledged and
revealed a mood of
solemn austerity,

endowing rural subjects
not with a light, idyllic
touch, but with the full
gravity of historical
painting.

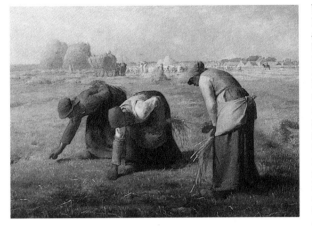

commitment to the politico-ideological aspect of Realism was total and he is very important for the part he played in the critical debate that gave rise to the Realist style. The principal theoretician was the writer Jules-François Husson, known as "Champfleury," author of the essay *Le réalisme*, published in 1857. But the constructive phase of "Realist theory" had begun ten years earlier, taking advantage of contributions from artists and writers, scientists and economists, journalists and philosophers, whose ideas, debated during frequent meetings at the Andler brasserie in Paris, betray a culture that was torn between acceptance of an unrenounceable Romantic heritage and the need to overcome it. This mood had its effect on the development of Courbet, who divided his time in Paris between painting lessons and visits to the Louvre, where he admired works by seventeenth-century French, Spanish and Dutch artists, and periodic forays into the countryside around Barbizon. In his landscapes, his portraits and, above all, his first self-portraits in a long series that was to span his entire career, he used a language of great immediacy and strove to establish a feeling of emotional involvement, a sense of contact with nature that was derived from Romanticism. But his interest in the reality of the visible, rather than in its powers of evocation, is symptomatic of a rejection of the idea that the irrational rules supreme and that the fantastic is more important than the concrete, both of which beliefs lie at the heart of the Romantic ideal.

The Romantic artist to whom Courbet owed his greatest debt was undoubtedly Géricault, whose influence can be detected in *Funeral at Ornans*, painted in 1850. Here Courbet has completed his early experiments and created a work that

Würzburg 1900). While a pupil of the Academy in Munich he met Courbet and in 1869 followed him to Paris, where his art immediately veered towards the Realist. On his return to Germany he adopted a very precise style of painting and showed a growing interest in the world of the peasantry, which he depicted with an observant eye.

◆ **Millet** Jean-François (Gruchy 1814–Barbizon 1875).

A childhood spent in the fields did not prevent him receiving a good artistic education, based on the study of old paintings, as well as an early debut in Paris. After a difficult start, Millet found his own style by reconsidering the peasant world of his youth in the light of Revolutionary experience. The outcome was works such as *The Winnower* and *The Sower*. After meeting Rousseau and moving to Barbizon in

1849, Millet's commitment softened and he turned to more peaceful rustic subjects.

◆ **Rousseau** Théodore (Paris 1812–Barbizon 1867). A leading light of the school of Fontainebleau, he went to Barbizon in 1836. He took his experiences from among the mountains of the Jura to a place where a group of artists was already gathered and which,

from that moment on, became an obligatory stopping-off point for anyone interested in a "sincere" style of landscape painting. For Corot, Courbet, Millet and Daumier, their time at Fontainebleau was of varying degrees of importance, whereas for Rousseau and other painters such as Jules Dupré, Virgile Diaz, Constant Troyon and Rosa Bonheur, it was crucial for both their art and their inspiration.

▼ *Gustave Courbet, Funeral at Ornans, 1850, Musée d'Orsay, Paris. Distancing himself from his Romantic origins, Courbet sensed that in the mid-nineteenth century aristic truth* *was to be found in the reality of everyday life. He therefore reserved the full dignity of painting for ordinary events in the life of the rural provinces or the petite bourgeoisie of the cities.*

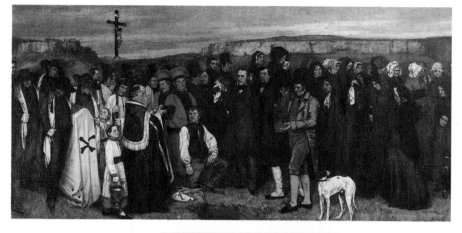

seems to correspond with the new interests pinpointed by the Revolution. He has chosen very large dimensions and the dignified genre of historical painting to depict a commonplace theme, in which the subject of death, so often celebrated by the Romantics with a feeling of deep sentimental involvement, has been brought back into the realms of everyday "normality" and contained emotion. The composition, with its skilful balance of rhythmical solemnity, and the portrayal of the figures (each of which, whether dog or priest, has been accorded the same degree of attention) shows how Courbet had learned the lesson of the great paintings of Hals and Rembrandt in order to give form and body to long-considered ideas. From that moment on, Courbet's painting concentrated on the bare facts, with no displays of sentiment and no concern for decorative qualities, using a style that often proved displeasing to the conformist sensibilities of his contemporaries.

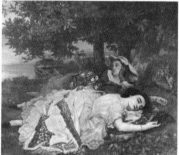

◄ *Gustave Courbet,* Girls on the Banks of the Seine, *detail, 1857, Petit Palais, Paris.*

Paradoxically, the apotheosis of Realism occurred at a time when the reactionary reflex following the downfall of the republican revolution and the coup d'état of 1851 was at its height. At the Universal Exhibition of 1855, intended to celebrate the glories of the empire, Courbet saw some of his works rejected because they offended middle-class respectabilities. As a result he set up a wooden pavilion, the Pavillon du Réalisme, in which he assembled the most important of his works, thus emphasizing for the first time the central nature of the problem of artistic independence. It is significant that the most outstanding work

in this exhibition was *L'Atelier,* the painting in which Courbet provided a synthesis of the theories and passions that had inspired his art since 1848 and which echoes *Funeral at Ornans* in its size, the simplicity of its composition and its underlying mood of emotional restraint.

The scene at the second Universal Exhibition in Paris in 1867 was very different. Courbet again set up his own pavilion, but this time he was no longer by himself and the young Manet was among those who followed his example. In the intervening twelve years Courbet had suffered at the hands of both the public and the authorities, but he had also had

▼ *Wilhelm Leibl,* Three
Women in Church,
*1878–81, Kunsthalle,
Hamburg. In his
frequent portrayals of
German peasant life,
carefully executed with
a very observant eye,
Leibl echoed the*
*teachings of Courbet
and the compositional
inspiration of
photographic technique.*

▼ *George Caleb Bingham,*
Fur Traders
Descending the
Missouri, *1845,
Metropolitan Museum
of Art, New York. The
most successful of
Bingham's paintings
are those depicting life
along the river, which
show how the spirit of
American Realism had
roots that were
independent of
European history. Here
everyday happenings
are interwoven with the
events that created a
nation, while the
narrative tone,
although simple and
understated, sometimes
achieves a feeling of
great solemnity.*

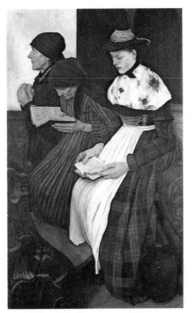

and the marine painters
Boudin and Jongkind, who
were to inspire Monet. In
1859 Courbet had joined
Boudin at Honfleur, and
from 1866 until 1871, the
year which marked the onset
of his early decline, he took
to making increasingly fre-
quent visits to the Normandy
coast, devoting himself al-
most completely to land-
scapes, particularly marine
ones.

Outside France, Realism
expressed itself in a way that
was neither as original nor as
meaningful. German Real-
ism took mainly the most ob-
vious route of portraits and
landscapes, and even though
Adolf Menzel, who ended up
submitting to the limitations
of genre painting, revealed a
familiarity with Constable in
Munich, the real cradle of
German Realism, Wilhelm
Leibl adhered strictly to the
teachings of Courbet.

In the United States, Real-
ism did not take the form of
an organic movement, but
it found a fertile breeding-
ground in a culture that
naturally favoured sponta-
neity and regarded its own
national identity as one
of its greatest assets. From
the artists of the Hudson
River School to such genre
painters as George Caleb
Bingham and Edward Hicks,
American Realism, the heir
to Benjamin West and John
Singleton Copley, developed
amid majestic landscapes and
scenes of colonial life, trans-
forming accounts of every-
day events into a national
epic. The innate American
tendency towards Realism is
also reflected to a certain
degree in the painting of
James Whistler, who visited

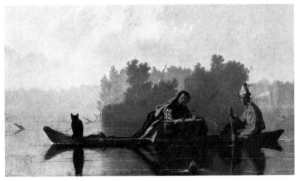

many successes, and al-
though he consistently pur-
sued his aesthetic and civil
ideas (the same ones that led
slowly to the 1871 Com-
mune), his art had lost the
vital spark of the 1850s. Im-
pressionism had already
been born, and although in
its earliest stages it was influ-
enced by Realism, it soon
modified the latter's orienta-
tion. In as early as 1857 one
of Courbet's masterpieces,
Girls on the Banks of the Seine,
seems to signal an about-
turn, both in its subject, de-
rived not from agrarian
working-class reality but
from the urban petite bour-
geoisie that was to inspire
Manet and Degas, and also in
its treatment of air and light,
which indicates the transfor-
mation of Realist sensibilities
into "naturalism." This is the
direction indicated by the
theorist of Realism's second
phase, Jules-Antoine Castag-
nary, as well as by Daubigny

121

▼ *James McNeill Whistler,* Portrait of the Artist's Mother, *1871, Musée d'Orsay, Paris. The American tradition and the influence of Courbet are immediately detectable in this portrait by Whistler, which also contains echoes of the seventeenth-century Dutch art that attracted the Realists, together with a taste for Japanese prints.*

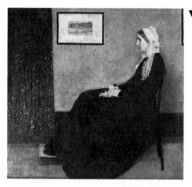

Europe at a very early age where he was influenced by Courbet, but later branched out in other directions, finally ending up with the two-dimensionalism of Art Nouveau.

In Russia and the Slav countries Realism took on a characteristically humanitarian aspect, giving expression to a vast repertoire of social subjects. Unsupported

▼ *Giovanni Fattori,* The Rotonda of Palmieri, *1866, Galleria d'Arte Moderna, Florence. Fattori's main anti-academic innovation lay in juxtaposing splashes of colour on bare panels, without any concern for outline or chiaroscuro, but with the sole aim of reproducing the "impression" of truth.*

by any real artistic debate, however, it is of interest for the way in which it expressed national interests rather than for the excellence of its results.

Any discussion of Realism in Italy will revolve around the Tuscan Macchiaioli movement, although mention should also be made of the artists of the School of Posillipo and the painters of the Romagna countryside. All of these groups were dedicated to "open-air" painting, often in watercolours and bearing the mark of lessons learned from northern European landscape artists.

Just like the French Realists, whose works they had seen at the Universal Exhibition of 1855, the Macchiaioli had a precise programme of adherence to the truth and they were profoundly aware of the link between art and life. Almost all of them supported the Risorgimento, the movement for the unification of Italy, and equated freedom in art with the freedom of their country. The 1860s saw the most important Macchiaioli works, by Giovanni Fattori, Silvestro Lega and by the younger Telemaco Signorini, Odoardo Borrani and Giuseppe Abbati, which were executed

with no thought for academic design, often on small panels, in which even the new formal elements take on a strong "democratic" flavour. ∎

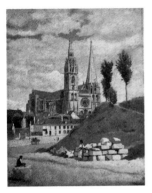

Jean-François Millet, The Angelus, *detail, 1858–59, Musée d'Orsay, Paris.*

This painting contains the key elements of the Realist style: the humble subject portrayed with genuine impartiality, the everyday language bereft of any formal embellishments, the monumentality of the figures, matching the heroic dignity that workers were gradually acquiring in the mind of the public, and the carefully controlled feelings, symbolizing emotional involvement with events of the day.

Silvestro Lega, The Visit, *detail, 1868, Galleria Nazionale d'Arte Moderna, Rome.*

The final phases of Realism coincided in France with a growing interest in the vibrancy of light and the transparency of colours as the Impressionist mood gradually asserted itself. With the Italian Macchiaioli, however, there was a fusion of naturalistic and lyrically inspired elements with a solidly classical layout.

Jean-Baptiste-Camille Corot, Chartres Cathedral, 1830, Louvre, Paris.

The early stages of Realism reveal a debt to Corot's views, which contain no picturesque or topographical additions. Enveloped by the elements, France's most important historical monument is observed without rhetoric, reflecting the simplicity of life in the town around it.

Texas becomes 28th State Queen Victoria	Revolutions of 1848 Irish Potato Famine	Second Empire in France Crimean War	Treaty of Paris Battle of Harper's Ferry	Abolition of serfdom in Russia Abolition of slavery in United States	Opening of Suez Canal Purchase of Alaska
William Morse: magnetic telegraph James Joule: first law of thermodynamics	Foucault: speed of light Sobrero: nitro-glycerine	First double-decker omnibus Wells Fargo founded	Pasteur: discovery of micro-organisms Darwin: *On the Origin of Species*	Huxley: *Man's Place in Nature* World's first underground railway in London	Clerk-Maxwell: electro-magnetic theory of light
Verdi: *Nabucco* Wagner: *Tannhaüser*	Liszt musical director at Weimar	Verdi: *Rigoletto, Il Trovatore, La Traviata*	Gounod: *Faust* Offenbach: *Orpheus in the Underworld*	Bizet: *The Pearl Fishers* Wagner: *Tristan and Isolde*	Brahms: *German Requiem* Mussorgsky: *Boris Godunov*
Proudhon: *What Is Property?* Dumas: *The Three Musketeers*	Marx and Engels: *Manifesto of the Communist Party* Dickens: *David Copperfield*	Melville: *Moby Dick* Tolstoy: *Tales from Sebastopol*	Flaubert: *Madame Bovary* Baudelaire: *Les Fleurs du Mal*	Hugo: *Les Misérables* Turgenev: *Fathers and Sons* Dostoyevsky: *The Insulted and the Injured*	Verlaine: *Poèmes saturniens* Goncourt: *Germinie Lacerteux*
Barbizon School	Pre-Raphaelite Brotherhood	Haussmann's plan for Paris	Champfleury: *Le réalisme*	Karl Marx founds *First International* in London	Ibsen: *Brand*
Bingham: *Fur Traders Descending the Missouri*	Courbet: *Funeral at Ornans* Daumier: *Ecce Homo*	Rousseau: *Effet d'orage* Courbet: *The Painter's Studio*	Millet: *The Angelus* Degas: *Bellelli Family*	Daumier: *The Washerwoman* Whistler: *Old Battersea Bridge*	Repin: *The Bargemen* Leibl: *The Young Parisienne*
1840–45	1846–50	1851–55	1856–60	1861–65	1866–70

Claude Monet, Women in the Garden, *1866–67, Musée d'Orsay, Paris. In this picture, the first to be painted entirely in the open air, Monet has tackled one of his favourite subjects, that of the poetry of the garden, the serenity of middle-class holidays. The artist is trying to encapsulate the visual suggestion of a moment of natural reality made up of lights and colours, atmospheric transparency and luminous vibration.*

The natural surroundings and the figures, bathed in a bright, life-like atmosphere, are portrayed using a technique that revels in chromatic values and contrasts in light and shade: the sunlight filters through the leaves and bounces off the folds in the clothing, while light blue and violet shadows shower down on to the open umbrella and reflect on to the face of the seated woman.

12 IMPRESSIONISM

I mpressionism first saw the light of day in Paris in the mid 1860s and was launched officially in 1874, when the photographer Nadar's studio on the Boulevard des Capucines played host to the first collective exhibition by the "Société Anonyme des Artistes peintres, sculpteurs, graveurs." It was the first instance of a group-show run by the participating artists independently of official circles. Thirty-one artists took part in the exhibition, many of whom had little to do with Impressionism, a word that had yet to be invented, and whom the critics referred to by the generic term "naturalists." Their number included Edgar Degas, Claude Monet, Pierre Auguste Renoir, Camille Pissarro, Paul Cézanne, Alfred Sisley, Berthe Morisot and Armand Guillaumin, artists who would later be called "the Impressionists." As so often happens, the identification of these painters as an organically constituted "group" is, in fact, purely arbitrary and acceptable only for purposes of classification. Impressionism did not take the form either of a school or of a close-knit, homogenous group of artists identifying themselves with a clearly formulated theory; the Impressionists never published manifestos or issued proclamations. Rather, Impressionism was a happy meeting of a number of very different artistic personalities sharing similar feelings and the same goal, that of expressing themselves outside the trite and closed environment represented by the officially

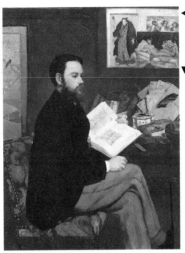

◀ *Edouard Manet, Portrait of Emile Zola, 1868, Musée d'Orsay, Paris.*

▼ *Edouard Manet, Olympia, 1863, Musée d'Orsay, Paris. With no chiaroscuro or modelling, it is left to the painting itself to define shape and volume.*

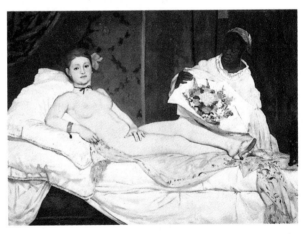

sanctioned art of the public Salons. The latter welcomed only academic painters who had been accepted by the critics and barred the way to those young artists who were experimenting with a new way of painting that was far removed from academic conventions and cold, conceptualistic compositions.

This new style of painting expressed a new "taste," a revolutionary and highly personal way of seeing and depicting the "visible"

in spontaneous, subjective terms, free of literary allusions and "symbolisms" and untrammelled by the rigidly obsolete canons of tradition and the celebratory style of painting so beloved of official French critics of the day. Born of Naturalism and heir to Courbet's style of Realism, Impressionist painting irreversibly changed the traditional artistic structure that had hitherto governed painting. The fundamental basics involved in the rendering of

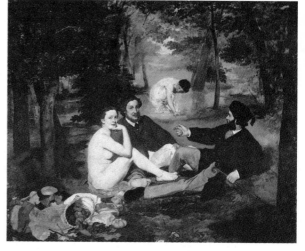

▼ *Edouard Manet*, Le Déjeuner sur l'Herbe, *1863, Musée d'Orsay, Paris. Carrying on the Realism of Courbet and drawing inspiration from everyday life, in this painting Manet laid the foundations of* *Impressionism by almost completely abolishing chiaroscuro and using large areas of flat colour to create stark and daring contrasts.*

visual reality were revolutionized: the faithful representation of nature was now abandoned in favour of the reproduction of sensible and perceptive truth. In fact, the radical change produced by Impressionist painting lay in its alteration of the way in which nature and the outside world were seen and transferred on to canvas with a feeling of immediacy, both sensory and temporal. It sought, in other words, to capture a split second of a constantly moving reality, whose appearance and truth alters with every variation in light. The artist's choice of subject is thus of no relevance: what matters is the way in which this subject is perceived by the painter at that precise moment of light, in that unrepeatable moment of atmospheric, meteorological existence, and portrayed in the picture.

"Treating a theme in terms of tone and not of the subject-matter, that is what distinguishes the Impressionists from other painters,"

wrote Georges Rivière in 1877. One of the century's most thoughtful and intelligent critics, he was trying to emphasize the differences separating the ideas of the new painters from those of the Realists, especially Courbet, who used paintings as a vehicle for social and ethical comment, expressed through a completely faithful reproduction of contemporary reality. But if the Realists

turned mainly to lowly subjects, peopling their paintings with peasants and workers, washerwomen and prostitutes portrayed in the wretchedness of their everyday existence, the Impressionist painters, the very epitome of *peintres de la vie moderne*, preferred to capture the moments of relaxation and enjoyment in these subjects' lives: when the people of Paris took their Sunday

BIOGRAPHIES

♦ **Cézanne** Paul (Aix-en-Provence 1839–1906). He completed his studies in his native city, where he formed a close friendship with Emile Zola that was to last until 1886. In 1862, after moving to Paris, he began attending the Académie Suisse, where he met Renoir, Monet, Sisley and Pissarro, to whom he became particularly close. In 1874 he took part in the first show by the Impressionist

group, exhibiting *La Maison du Pendu*. After the third show with the group, in 1878, he broke with Impressionism and pursued his own researches in solitary isolation to the total bemusement of critics and public alike. In 1882 he left Paris to retire to Aix, where in 1895 he held his first one-man show at the Ambrose Vollard gallery. He died at the age of sixty-seven in the house where he was born.

♦ **Degas** Hilaire Germain Edgar (Paris 1834–1917). Son of a wealthy banker, after finishing high school he attended the school run by Henri Lamothe, a pupil of Ingres, and then graduated to the Ecole des Beaux-Arts. He travelled frequently to Italy, creating copies of Renaissance masterpieces, and, under the influence of Ingres and the Italians, devoted himself to historical and mythological subjects. In 1865 he met Manet

and began to turn his interest to subjects derived from contemporary life which were to become a constant feature of his paintings. He took part in all the shows by the Impressionist group, also taking an active part in their organization. By then he was already suffering from the problems with his sight that were to lead ultimately to almost total blindness. In order to be able to carry on with his art,

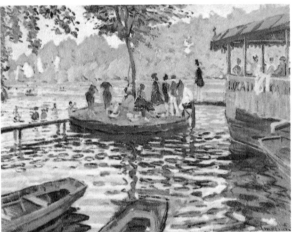

▼ *Claude Monet,* La Grenouillière, *1869, Metropolitan Museum of Art, New York. The sparkle of colours on the troubled surface of the water and the play of reflected light filtered through the foliage were particularly favourite motifs of Monet.*

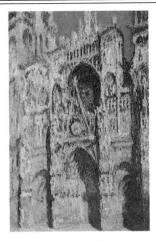

◄ *Claude Monet,* Rouen Cathedral: Full Sunlight, *1894, Musée d'Orsay, Paris. Monet painted the same subject, at different hours of the day in order to study the effects of light.*

atmospheric transparencies, sudden chromatic changes depicted in pure and brilliant colour. Perceived reality is never fixed or immutable, but in a constant state of flux: hence the perceptual ambiguity that appears in Impressionist paintings, in which the synthesis of light and colour makes outlines misty and inconstant, pulverizes shape and continually fragments vision into thousands of shimmering touches of colour.

In order to be able to interpret such an ever-changing reality, the Impressionists were obliged to experiment with radical new techniques, searching for new processes that would more accurately represent natural visual phenomena, in particular sunlight and its infinite vibrations and refractions. Leaving their *ateliers* to paint directly *sur le motif*, in the open air, face to face with nature, with no filter other than that of the sensory and subjective perception of chromatic and luminous values, just as the

afternoon stroll along the Seine, thronging the open-air cafés and restaurants, or walked down streets hung with flags on festival days. Such sights, like the landscapes bathed in sunlight, were only a pretext (the "motif") for capturing a swift and immediate visual suggestion, luminous annotations of a colourful, busy life, painting *en plein air*. In 1859 he went to Paris and attended the Académie Suisse together with Camille Pissarro. He began spending a lot of time with the group of young artists who would shortly form the nucleus of Impressionism, becoming particularly friendly with Renoir. He took part in the first Impressionist show in 1874 and subsequently participated in most of the group's other

he abandoned painting in oils in favour of the more wieldy pastels.

♦ **Manet** Edouard (Paris 1832–83). Born into an upper-middle class family, he studied with one of the most famous academic painters of the day, Thomas Couture, and visited the main European museums, where he copied masterpieces of the past. But it was Spain and its painting that particularly fascinated him, and between 1853 and 1865 he painted a great many pictures with Spanish subjects. His *Le Déjeuner sur l'Herbe* and *Olympia*, both of which were rejected by the Salons of 1863 and 1865, scandalized the critics and the public, who reacted violently against them, but they captured the imagination of the young avant-garde painters, who proclaimed Manet to be their ideal teacher. After his initial disinterest, and despite the fact that he never participated in any of their exhibitions, Manet developed a close relationship with the Impressionists and began painting *en plein air*.

♦ **Monet** Claude (Paris 1840–Giverny 1926). At the age of five he moved with his family to Le Havre, where he studied drawing and, in 1858, met his first teacher, the painter Eugène Boudin, who introduced him to

Light

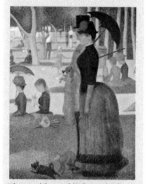

Barbizon painters had already done in the forest of Fontainebleau, the Impressionists realized that sunlight was not a single, homogenous element, but a sum of pure chromatic values. And so they experimented in their pictures with the decomposition of colours, which were no longer mixed on the palette, but applied to the canvas straight from the tube, fragmenting the tones and the brush strokes in order to better represent the vibrations of light. They also realized that, in nature, shadows are not an absence of colour, a uniform darkness, but a different chromatic intensity, with hazy shades of violet. As a result, they banished black as a "non-colour" from their palette and used it as a colour in its own right, like red or blue ("black," said Renoir, "is the prince of colours"). Having abandoned the use of *chiaroscuro*, a quintessentially academic technique, they used only colour to fulfil the task of defining space and

The problem of light, which the Impressionist painters had instinctively and empirically resolved through the use of pure colour and divided brush strokes, was tackled in a systematic way by the young Seurat. He based his painting on the scientific theories of colour and visual perception that had made remarkable progress during the course of the nineteenth century, thanks to the studies of Chevreul, Blanc, Rood and Sutter. Making use of the laws on the simultaneous contrast of colours and the optical decomposition of light, Seurat experimented with a new painting technique based on the systematic separation of brush strokes, which were arranged on the canvas in small touches of pure colour, juxtaposed in accordance with the rules of chromatic complementarity. It was then left to the eye of the observer to make the final synthesis. This "divisionist" technique allowed the painter to obtain a composition in which the exaltation of light was complemented by the constructive and formal values lacking in Impressionist paintings. One of the greatest examples of divisionist art is Seurat's extraordinary painting Sunday Afternoon on the Island of La Grande Jatte *(1885–86).*

the borders between images, which were no longer bounded by outlines.

The purest and most "typical" expression of Impressionism is undoubtedly landscape painting, the genre favoured by Claude Monet, Auguste Renoir, Camille Pissarro and Alfred Sisley. Although the works of the last two artists still created a vision of nature that is in a sense "sentimental," albeit translated into a clearer and more luminous style of painting (one thinks, for example, of the effects of reflected light and the flicker of colours on white snow in Sisley's *Snow at Louveciennes*, 1874, and Pissarro's *Entrance to the Village of Voisins*, 1872), in Monet and Renoir the landscape sparkles with light and colour, with luminous vibrancy and chromatic sensitivity rendered by means of pure painting that captures the instantaneity of vision in a pictorial synthesis. The colours are spread in broad swathes or small touches, either juxtaposed or melting

exhibitions. In old age, after a life of great difficulty and suffering, Monet finally received the recognition and respect due to him.

♦ **Pissarro** Camille (St Thomas, West Indies, 1830–Paris 1903). The strongest influence on him was the painting of Corot, followed shortly by that of Courbet. He took up with the group of artists who met at the Café Guerbois and in 1874 joined in the first Impressionist

exhibition, after which he took part in every showing of the group.

♦ **Renoir** Pierre Auguste (Limoges 1841–Cagnes 1919). Son of a modest

provincial tailor, he moved with his family to Paris, where, in 1862, he began attending Gleyre's studio in the Ecole des Beaux-Arts and met Monet, Sisley and Bazille. He exhibited regularly at the Salons, where he even achieved modest successes, and took part in the first four Impressionist shows, after which he had a disagreement with Degas and no longer participated. In 1881 he travelled to Italy

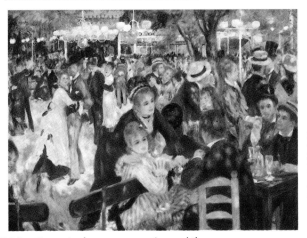

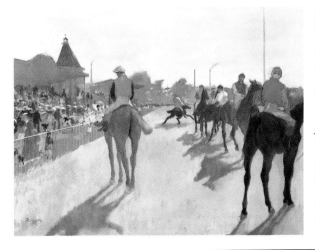

▼ *Edgar Degas,* At the Races, *c.1879, Musée d'Orsay, Paris. The structure of this painting, based on diagonals that create an expanded spatial perspective, and the study of light, in this case full and bright, are typical features of Degas's paintings.*

into one another with no precise technical rules, but freely used to mark the reflections of light on water or among the leaves of the trees, as in *La Grenouillière* (1869) and *Sails at Argenteuil* (1873). Here are two motifs painted by the two painters, together, on the banks of the Seine which may be regarded as the manifesto of Impressionist painting.

Since the early 1860s the Impressionists would have been able to see an early experiment with the innovations that they practised, as well as a new and different way of approaching nature, in the paintings of an extraordinary artist, some years their senior, Edouard Manet. Manet painted the large and "scandalous" canvas, *Le Déjeuner sur l'Herbe*, which dominated the exhibition at the 1863 *Salon des Refusés*, the exhibition of the works refused by the jury of the official Salon. In that picture, as in the famous *Olympia*, painted in the same year and rebuffed with equal

and discovered the painting of Raphael and the frescoes of Pompeii, which exerted a strong influence on his work. At the beginning of the twentieth century he returned to the bright, lively colours of the Impressionist period, albeit with greater solidity of substance.

♦ **Seurat** Georges (Paris 1859–99). After enrolling in the Ecole des Beaux-Arts, he came under the influence of Ingres, Delacroix, Puvis de Chavannes and the new "painters of modern life." After studying scientific treatises on colour and examining the new techniques introduced by the Impressionists he developed his own style of painting, which he himself defined as "chromoluminarism." At the 1884 Salon he exhibited a divisionist work for the first time, *Bathers at Asnières*. Together with Paul Signac he founded the Neo-Impressionist movement, whose members also included Pissarro.

♦ **Sisley** Alfred (Paris 1839–Moret-sur-Loing 1899). Born of English parents, he was sent to London at the age of eighteen to complete a course in commercial studies, but in 1862 he returned to Paris to take up painting. He enrolled in the Ecole des Beaux-Arts, where he met Monet and Renoir, and began accompanying his two friends on open-air painting expeditions, along the banks of the Seine and in the forest of Fontainebleau. The countryside became the favourite subject of his paintings, as it had for Pissarro.

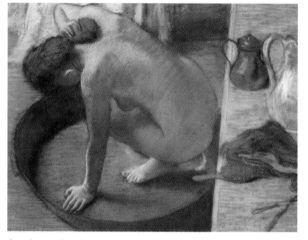

▼ *Edgar Degas*, The Tub, *1886, Musée d'Orsay, Paris. The natural pose of the female body, sinuous and strongly contoured, is captured in this intimate picture. The angle chosen, looking down on the subject, flattens out the image, imparting a two-dimensional quality reminiscent of Japanese prints. The use of pastels creates extraordinary effects of light.*

the intentions of its creator, whose greatest ambition had been to use tradition as the starting-point for his campaign of renewal. Manet had, in fact, been a passionate student of the art of the past and a frequent visitor to the Louvre, where he had admired the work of Titian, Rembrandt, Delacroix and especially the Spaniards Velázquez and Goya, from whom he derived inspiration for his use of colour and also for his synthesis of visual space — although for the latter Manet owed a large debt to the two-dimensional, non-perspective structure of the Japanese prints that were taking Paris by storm at the time. His *Portrait of Emile Zola*, his friend and supporter, represents an official homage to Japanese art.

Japanese prints and the paintings in the Louvre, especially Ingres and the Italians, were the teachers for even Edgar Degas, the most

harshness by the critics and public of the Salons, Manet was presenting a completely new style of painting, albeit classical in its composition (the subject was inspired by, among other things, Titian's *Fête Champêtre* in the Louvre): the progressive abolition of chiaroscuro, half-tones and strong contrasts between pale and dark shades (*Olympia* provides a fine example of this) creates an effect of flattened visual perspective, further enhanced by the broad, flat areas of colour that define the figures, while the flowers are described in swift, free brush strokes that convey the transparency of the atmosphere. The painting was adopted by young avant-garde artists as the banner of anti-academicism, ignoring

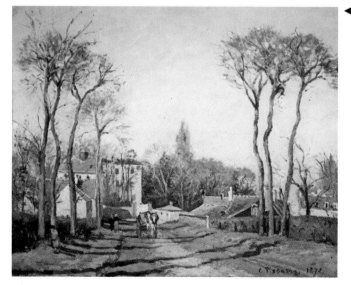

◀ *Camille Pissarro,* Entrance to the Village of Voisins, *1872, Musée d'Orsay, Paris. It was from Corot and Millet that Pissarro inherited his love of the countryside and rural life, simple and humble motifs that he has translated into a gentle and vibrant painting, creating a mood of gentle melancholy. One of his favourite subjects was that of the tree-lined avenue, whose enlarged perspective opens up in a clear, airy vision, while at the same time retaining a certain compositional solidity.*

▼ Henri de Toulouse-Lautrec, Au Moulin Rouge, *1882, The Art Institute of Chicago. Following in the footsteps of Degas, the artist portrayed fin de siècle Paris with an often harsh feel.*

▼ Paul Cézanne, La
▼ Maison du Pendu, *1873, Musée d'Orsay, Paris. This work reveals the influence Pissarro had on Cézanne and his interest in Impressionism. This led him to the use of lighter*

colours in search of a vibrant new luminosity.

independent of the Impressionists. An extraordinary portraitist (his large painting *The Bellelli Family* is a particularly fine example of this), he returned to Paris in 1873 from a trip to New Orleans and was "converted" to modern painting, becoming one of the most active organizers of exhibitions by the Impressionist group. Unlike his friends, Degas remained virtually immune to the lure of nature and the countryside and he also rejected painting *en plein air* (apart from a few rare instances), preferring to use his studio to complete his spatially complex compositions with their unusual perspective slants. Rather than the natural light of the Impressionists, he favoured the artificial light of indoors, the glare of the lamp and the footlights, which he studied not so much as sources of light than as effects of light enabling him to attain that purity of vision which was his greatest concern. Reality, captured as it appears to the eye of the painter, is rendered by Degas with extraordinary psychological insight and technical finesse. He concentrated mainly on the theme of urban life, but not so much happy Sunday gatherings as the daily grind of washerwomen, laundresses and ballerinas involved in long and tiring practise sessions. He examined and portrayed these subjects with almost cruel objectivity, foreshortening them from above or below, freezing them photographically, "stealing" moments of intimacy and breaks in the action, as in *The Rehearsal*

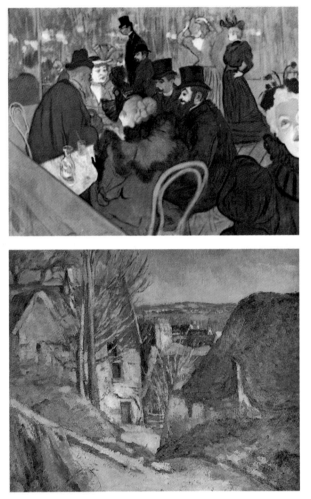

(1877), *The Orchestra of the Opéra* (1869) and *The Dancing Lesson* (1873–75).

Originally a member of the Impressionist movement, Paul Cézanne was a "unique" and independent painter who shared his young colleagues' love of nature and their desire to study it at first hand, as well as their rejection of academic rules and their enthusiasm for that new approach to visual perception. But his researches

very soon branched off on their own as he attempted to give greater solidity and durability to the changing, fragmentary vision of the Impressionists, who captured only the outer appearance of reality. Cézanne felt the need to analyze reality in greater depth, beyond pure appearance, and in his landscapes, as in his still lifes and portraits, he studied the visible even more closely, trying to unveil the principles of

▼ *Paul Cézanne, Les Grandes Baigneuses, 1895–1905, Philadelphia Museum of Art. The relationship between landscape and figures, and the latter's integration with nature, was one of Cézanne's favourite themes.*

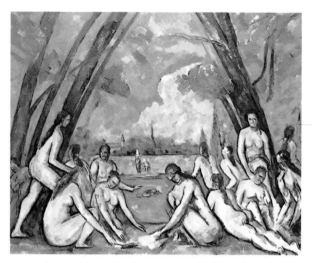

perception and investigating its inner essence. Every cognitive process involves the intervention of thought and mind, and by combining sensation with logic Cézanne sought to recreate the harmony of nature on canvas, weaving a web of "controlled" and "ordered" brush strokes so as to build shapes and not dissolve them like the Impressionists. It was this radically new departure that led into the twentieth century and set the stage for the great avant-garde experience. ∎

▼ *Georges Seurat, La Baignade, 1883–84, National Gallery, London. The painting is executed in small touches of colour, juxtaposed in accordance with the rules of chromatic complementarity, so as to achieve an effect of extraordinary luminosity.*

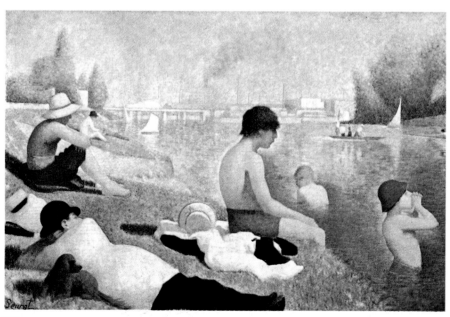

Pierre Auguste Renoir, La Grenouillère, *detail, 1869, National Museum, Stockholm.*

In 1869, and also during succeeding years, Monet and Renoir performed certain basic artistic experiments together, often painting the same subjects. A notable example of this exchange of ideas is the execution by both artists of La Grenouillère *(a suburban location on the Seine) by means of rapid lines and nervous touches that capture the shimmering atmosphere and the movement of the water.*

Claude Monet, Impression: Sunrise, *detail, 1872, Musée Marmottan, Paris.*

It was from the title of this work shown at the first Impressionist exhibition that the journalist Louis Leroy mockingly coined the word "Impressionism," later adopted by the artists themselves. Impression may be defined as a split second of pure and unrepeatable visual sensation made up of light and colour and revived on the canvas through the magic of painting.

Paul Cézanne, The Blue Vase, *1885–87, Musée d'Orsay, Paris.*

During the 1890s Cézanne's palette, based on shades of blue, green and earth tones, gradually became more fluid and more transparent and the brushwork acquired a much stronger structural role. Space, identified by means of a few, essentially vertical and horizontal lines, is defined solely by colour of the light that spreads through the painting as though it were emanating from the objects themselves.

Unification of Italy	Franco-Prussian War	Paris Commune	Japan opens up to the West	Triple Alliance	Kaiser Wilhelm II
American Civil War		Bismarck German Chancellor	Congress of Berlin	Berlin Conference: division of Africa	2nd Socialist International
Jean Henri Dunant founds Red Cross	Mendel: laws of heredity	Universal Postal Union, Berne	Bell: telephone	Sergi: physiological theory of perception	Eastman: Kodak camera
	Monier: reinforced concrete	Schliemann excavates Troy	Edison: phonograph	Swan: artificial silk	Daimler; Benz: motor-car engine
Bizet: *The Pearl Fishers*	Brahms: *German Requiem*	Verdi: *Aida*	Tchaikovsky: *Swan Lake*	Massenet: *Manon*	Strauss: *Don Giovanni*
Wagner: *Tristan and Isolde*	Verdi: *Don Carlos*	Bizet: *Carmen*	Dvorak: *Slavonic Dances*	Brahms: *Symphonies*	Borodin: *Prince Igor*
Baudelaire: *Les Paradis artificiels*	Zola: *Thérèse Raquin*	Mallarmé: *Hérodiade*	Tolstoy: *Anna Karenina*	James: *Portrait of a Lady*	Mallarmé: *Poésies*
Hugo: *Les Misérables*	Dostoyevsky: *Crime and Punishment*	Verne: *Around the World in 80 Days*	Zola: *Nana*	Ibsen: *Ghosts*	Shaw: *Fabian Essays*
Albert Memorial, London	Nihilist Congress, Basle	*Kulturkampf* in Germany	Opening of Wagner Theater, Bayreuth	Universal suffrage in Great Britain	Symbolist manifesto
Manet: *Le Déjeuner sur l'Herbe*	**Monet:** *La Grenouillère*	**Monet:** *Impression: Sunrise*	**Renoir:** *Le Moulin de la Galette*	**Renoir:** *The Two Sisters*	**Seurat:** *Les Poseuses*
Rossetti: *Beata Beatrix*	**Bazille:** *The Artist's Studio*	**Cézanne:** *La Maison du Pendu*	**Sisley:** *Flood at Port Marly*	**Signac:** *The Seine at Asnières*	
1860–65	1866–70	1871–75	1876–80	1881–85	1886–90

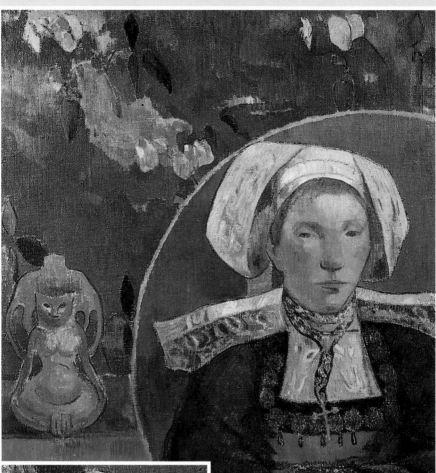

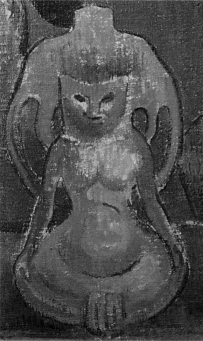

Paul Gauguin, La Belle Angèle, *1889, Musée d'Orsay, Paris. This work summarizes and compares the two ideological mainstays of Gauguin's maturity: the obsessively religious world of the European peasantry, which he had rediscovered in Brittany, and the "savage" world of Polynesian culture (represented here by the idol on the left). The two parts of the equation are separated, so to speak, by a thin line of demarcation, but they are interchangeable. It is worth noting that after 1886 the painter often created works with Polynesian subjects while he was in Europe and also Breton pictures when he was in Tahiti and Oceania.*

13 SYMBOLISM

The particular form of expressive language that dominated European art of the 1880s and 1890s has come to be known by the term "Symbolism." A reaction against naturalism, it was governed by a specific taste, the goal of which was to assert, in literature, painting and music, an incisive vision of the world. Evocatory rather than descriptive, it aimed at capturing and highlighting that deep, mysterious, indistinct and thought-provoking reality known as "inner reality." The most pressing need soon became that of finding suitable stylistic means with which to translate the extraordinary complexity of modern man's spirit, feelings and ideas, a complexity that could of necessity be expressed only via symbols, emblems of its evocative properties, endowed with the sort of mystery and ambivalence that permit a wide variety of different meanings and interpretations. Man crosses "forests of symbols" (Baudelaire), he sees the world as a "forest of signals" (Rilke), whose meaning he must unravel in order to discover the universal in the particular, the invisible in the visible. The symbol is something that exists beyond factual data and also beyond appearances: it is an ambiguous indicator, partly spiritual, partly natural, which allows itself to be perceived, but its perception can be achieved only through the imagination, that invincible creator of analogies, metaphors and associations.

In the field of literature, Symbolism established its

own identity mainly in France (where it appeared in 1886 in the manifesto written by Moréas in *Le Figaro Littéraire*), with the poets Baudelaire, Rimbaud, Mallarmé and Verlaine as its acknowledged spiritual leaders.

It was Huysmans, with his *A Rebours* (Against Nature), a highly polished summary of the Symbolist aesthetic published in 1844, who finally overcame naturalism and proposed new myths in

▲ *Odilon Redon,* Death, *1889, from the album of lithographs* A Gustave Flaubert, *Bibliothèque Nationale, Paris.*

▼ *Gustave Moreau,* Salomé *or* The Apparition, *c.1876, Musée Gustave Moreau, Paris.*

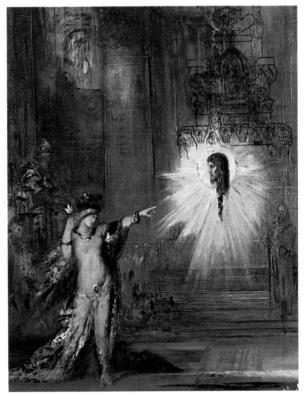

13 SYMBOLISM

painting, displaying an acute perception of the values that were emerging at the time in the field of figurative arts. The protagonist of his book, the aesthetic practitioner Des Esseintes, rejects the Impressionist tradition in favour of the triumvirate of Moreau, Bresdin and Redon, painters capable of making bold, unusual and rarefied choices. Of the three, Odilon Redon certainly represents the most truly modern figure.

Author, in 1879, of the album of lithographs *Dans le Rêve*, the first entirely Symbolist work, Redon introduced the non-finite, the vague, the indistinct into his works: "an uncertainty next to a certainty," as he put it, revelling in the growth of suggestion and mystery. From the natural world he extrapolated the particular, presented as a fragment often isolated in a void, made disquieting by the infinitely tiny (or infinitely large) optical scale on which it was presented. One thinks of an eye or a flower, for example, be-

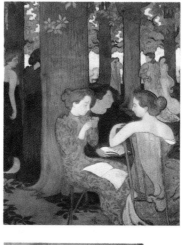

coming animated, sinister protagonists of a different world, a world apart: the world of the supernatural investigated with a scientific eye. At the end of the nineteenth century people no longer believed that science could explain everything, since the confidence engendered by positivism now seemed irredeemably flawed. The Symbolists matched scientific methods with parascientific procedures to such

BIOGRAPHIES

◆ **Beardsley** Aubrey (Brighton 1872–Menton 1898). He belonged to the last generation of Symbolists, which partly explains why his output, predominantly graphics, can be linked directly to Art Nouveau. Beardsley was profoundly influenced by his meetings with William Morris and Oscar Wilde.

◆ **Ensor** James (Ostende 1860–1949). In 1883 he became

involved in his characteristic production of paintings based on "masks," symbols of an existential theater rich in characters and personalities (*The Scandalized Masks*). His most important works include *Christ's Entry into Brussels* (1888), *Astonishment of the Mask* (1889) and *Masks and Death* (1897).

◆ **Gauguin** Paul (Paris 1848–Marquesas Islands 1903). In 1885, tired of

life as a stockbroker and dilettante painter, he deserted his job and his family in the first of a series of escapes to "primitive freedom." In 1887 he travelled to Panama and the Caribbean. In 1888 he was in Brittany with Van Gogh, where he founded the Pont-Aven group and drew inspiration from the archaic religious spirit of the peasantry (*Vision after the Sermon*, 1888). He later moved to Arles in Provence (1890) and then to

Tahiti (1891–93), returning to France in 1894. Finally, still unfulfilled, he settled in Polynesia in 1895, first in Tahiti and then in the Marquesas Islands. Here he appears to have found that "truly spiritual" world he craved and his painting reached its zenith.

◆ **Hodler** Ferdinand (Berne 1853–Geneva 1918). At the end of the 1880s he began to practise a style of Symbolism filled with

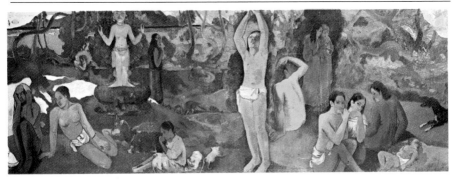

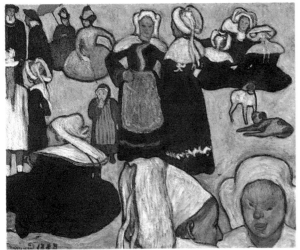

an extent that in their works psychology often degenerates into metaphysics with frequent recourse to spiritualism and the occult. In Symbolism, therefore, it is possible to detect a certain bipolarity, which is the result of this oscillation between naturalism and spiritualism, between scientific and fideistic solutions.

The instantaneous, phenomenal images of the world, full of life, movement and natural light, brought to the fore by Impressionism, now become static and mys-terious: they fade away, frozen in a grid of sparse, essential lines obtained by a process of abstraction (in its literal sense), producing a hypnotic, timeless feeling. The Symbolist image has a quality of infinite timelessness, while a vital, dynamic linear quality, with a strong psychic element, reduces the articulated, anecdotal vision of the world to a two-dimensional screen, which, by the use of synthesis, points to the essence of things and leads to the "noumenon."

Because, contrary to what happened in literature, there was no coherent Symbolist movement in the figurative arts, it is hard either to indicate the exact co-ordinates of the phenomenon or to find any unitary criterion by which to judge the different artists. In fact, there exist such deep formal and stylistic differences among those

literary, often almost mystical, suggestions. During the decade between 1890 and 1900 he produced his finest works (*Night, The Elect, Eurhythmy, Day, The Battle of Nafels*), almost all of which play on the motif of repetition, theory and succession, with implicit echoes of Byzantine art.

♦ **Moreau** Gustave (Paris 1826–98). In 1857 he became friends with Puvis de Chavannes and Degas after meeting them in Italy. His art, however, evolved in a way that has analogies with the former's painting, while consciously ignoring the latter's Impressionist discoveries. As a result, the classicism of his early masterpieces (*Oedipus and the Sphinx*, 1864) gives way to a heavily sensual painting, revolving around the idea of a mystery concealed beneath natural appearances. His works from the 1870s and 1880s are the ones that come closest, at least as far as content is concerned, to full-blown Symbolism.

♦ **Munch** Edvard (Löten 1863–Ekely 1944). He started out as a naturalist painter, dealing mainly in subjects with a socio-political content. In 1896, having forsaken French Impressionist models, he developed a sharper, more radical linear synthesis. Between 1889 and 1892 he travelled through Italy, Germany and France. Strongly anticipating twentieth-century Expressionism, he grasped the importance of linear and chromatic "distortion" as a means of portraying psychic and emotional states. But he very soon progressed from individual psychology to a universal, cosmic psychology, which in many of its aspects puts him on a par with the tragic view of life that appears in the

The Pre-Raphaelites

artists normally defined as "Symbolist" that it sometimes seems almost impossible to group them together under a common heading.

In order to illustrate this statement, let us consider some of the most outstanding, and disparate, artistic personalities of *fin de siècle* Europe, starting with France, where the leader of the "Synthesist-Symbolist" movement, Paul Gauguin, and the young Emile Bernard founded the School of Pont-Aven in Brittany. Here Symbolism was not only an artistic ideal: it became a way of life. This was also the case with the group of artists calling themselves Nabis ("prophets"), who were driven by an initiatory spirit and who imposed on themselves a strict, ethically motivated code of living in scornful reaction to the bland, commonplace existence of the bourgeoisie. Paul Sérusier, Georges Lacombe, Maurice Denis, Paul Ranson and others created exquisite icons, in which nature be-

The Romantic and post-Romantic periods gave rise to some notable anticipations of the Symbolist genre. One example of this phenomenon are the English Pre-Raphaelites (John Everett Millais, William Holman Hunt, Dante Gabriel Rossetti and Edward Burne-Jones), who in 1848 formed themselves into an artistic "brotherhood" aimed at bringing about a return to the great Quattrocento tradition. The ideal of graphic elegance embodied by the painting of the so-called "Tuscan primitives" (Botticelli, Lippi, Ghirlandaio) was rendered with a symbolically melancholic allusiveness and using a refined style based on linear purity that was later also adopted by William Morris and Art Nouveau in general. In Millais' Ophelia (1852, Tate Gallery, London) the Shakespearian subject is laden with allegories, since the contrast between the suicide and the method used (the clear waters of a flower-strewn stream) proclaims death to be unreal, a mere appearance, the herald of future rebirth.

came stylized, imbued with mystical values and elegantly rendered by means of arabesques, curves and the *à plat* technique. The fact of nature, however stylized, was never abolished, like the anecdote, the *fiction symbolique*, the theme. Symbolist painting exploits religious, philosophical and mystical motifs in order to construct a pictorial reality, and it never uses colour and shape as independent elements, even though it did lay the basis for a new expressive language that would later be developed by the twentieth-century avant-garde. Gauguin subsequently rejected what he saw as the corruption of the Old World and moved to Oceania in search of original, primordial purity. He had already arrived at the Symbolist synthesis in his *Vision after the Sermon*, painted in 1888, a work in which he made the final break with his early Impressionist beginnings in favour of creating large, flat areas of colour encased

works of his fellow Norwegian Ibsen.

♦ **Previati** Gaetano (Ferrara 1852–Lavagna, Genoa 1920). His encounter with the Milanese *Scapigliatura* movement weaned him away from ingenuous, rhetorical concepts and encouraged him towards dramatic, modern themes (*Women Smoking Opium*, 1887). *Maternità* (1891) marked his painting's entry into the

dominant Symbolist mode. In 1906 he published a treatise on the technique of Divisionism.

♦ **Redon** Odilon (Bordeaux 1840–Paris 1916). A pupil of Bresdin, in 1879 he

created an early series of lithographs, *Dans Le Rêve*, and in 1882 he illustrated the tales of Edgar Allan Poe. In 1884, at the request of the author Huysmans, he illustrated *A Rebours* (Against Nature). He became a friend of

Stéphane Mallarmé and published his collection *Homage to Goya*. He then devoted himself to painting in pastels and in oils (*The Cyclops*, 1885; *Orpheus*, 1903; *Roger and Angelica*, 1909). His last great work was the decoration of the medieval abbey of Fontfroide (1910).

♦ **Segantini** Giovanni (Arco di Trento 1858–Schafberg, Engadine 1899). He initially favoured a popular,

in strong, dark outlines (cloisonnisme). The example set by his friend Emile Bernard, whose *Breton Peasant Women in a Green Meadow* opened Gauguin's eyes to the advantages of Synthesism and also encouraged him to pursue that path with even more radical determination, was a fundamental influence on him.

His compositions are all based on the interplay of unexpected shapes (somewhat reminiscent of Oriental art), resolved by means of slanting angles and the addition of diagonals intended to remove any illusion of depth. Resisting all analytic-descriptive temptations, Gauguin built up his compositions in layers, with brightly contrasting colours, in order to obtain an icon-like whole.

The works of his Tahitian period, ranging from *Ia Orana Maria* to *Manao tupapao*, show how deeply immersed he became in Polynesian culture. The titles of the works, inscribed directly on to the canvas in the native language, assume a linguistic dignity equal to that of the pictures. They are painted with robust use of the *à plat* technique, in bright, forceful colours, contained within dexterously stylized outlines, but strong enough to form solid, plastic figures. *Whence Do We Come? What Are We? Where Do We*

rural style of naturalism, but in the 1880s he began producing paintings with allegorical themes (*The Two Mothers*, 1889). At the same time his technique developed along the "divisionist" principles of Seurat (*The Fruit of Love*, 1889 and *The Angel of Life*, 1894).

♦ **Van Gogh** Vincent (Groot Zundert 1853– Auvers-sur-Oise 1890). After being a preacher and almost fanatical evangelist, in 1879 he began to devote himself to painting. In 1886 he moved to Paris where he met Gauguin, Bernard and Seurat. His brief life was marked by progressively worsening bouts of mental illness, mirrored in the intense drama of his paintings. In 1888 he settled in Arles, where he was joined by Gauguin, but their friendship, from which they both benefited, was short-lived. In 1890 he moved to Auvers, where he stayed with Doctor Gachet. In the same year, after suffering a number of nervous breakdowns, he committed suicide.

▶ *Edvard Munch,* The
Scream, *1893,
National Gallery, Oslo.
Early intimations of
Expressionism are
clearly perceptible in the
paintings of Munch,
Ensor and Van Gogh.
Munch, in particular,
displayed an anguished
quality that would
appear to be the
antithesis of the ideal of
refined elegance
expressed by "Art
Nouveau" Symbolists
such as Beardsley, and
yet the metaphorical
element in his work is
derived from the same
great ideological source.*

▶ *James Ensor,* Christ's
Entry into Brussels,
*1888, Musée Royal des
Beaux-Arts, Antwerp.
This, the Belgian
painter's most famous
work, was completed in
the same year as
Gauguin's* Vision after
the Sermon. *In both
paintings, and with no
contact between the two
artists, the Symbolist
revival of Christian
themes has the feeling
of a stubborn
condemnation of society.*

Go? is a monumental work with a characteristically Symbolist theme, in which Gauguin has tackled the questions that a despairing humanity has always posed and to which it has found no answers. The title is written, rather like a cartoon caption, in the corner of the canvas, which is filled with people portrayed in an accentuated stylized way and surrounded by a mysterious and magical atmosphere.

Another exceptional figure was Vincent Van Gogh, who, after an initial friendship with Gauguin, parted company with him, both in his lifestyle and in his art. Instead of Gauguin's vast expanses of colour, Van Gogh adopted a pattern of chromatic fragmentation similar to that proposed by Seurat, but using much harsher colours, pulled into coils, swirls and waves that echoed the existential torments and dramas which so marked his psyche. The vibrant, linear repertoire of the Symbolists was ideal for an icon-like portrayal of modern life and it recurs in an incredible variety of different guises in the applied arts, in the finest works of the great Art Nouveau designers, from Horta to Van de Velde, from Guimard to Mackmurdo, from Gallé to Tiffany.

The Norwegian painter Edvard Munch found his symbols within rather than "beyond" reality. It is a crushing, angst-ridden reality, which sometimes seems as though it is about to explode, but is immediately restrained, subdued, curbed by

▼ Jan Toorop, The Three
Wives, 1895, Kröller-
Müller Museum,
Otterlo. The eclecticism
of Toorop, born in Java
of Dutch parents in
1858, provides for the
simultaneous presence
of ideal Symbolic

tensions and
''modernist'' linear
refinements. These
elements, to which must
also be added the
influence of William
Morris, make Toorop
one of the precursors of
Art Nouveau.

▼ Henri ''Le Douanier''
▼ Rousseau, The
Sleeping Gypsy Girl,
1897, Museum of
Modern Art, New York.
Rousseau's evocative
style of painting has
much in common with
the Symbolist spirit.

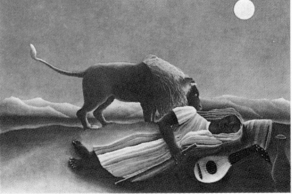

suffocating, pitiless swirls and curves that are like the projections of psychic waves of vibrant intensity, reflections of cosmic oscillations that seem to shake the universe.

In Belgium we find James Ensor, plunged in a Symbolism not aimed at the conquest of sublime and mysterious spaces, but focused on the "human comedy," whose protagonists — profane, mocking and desecrating masks — he brilliantly depicts in a range of shrill, violent colours (Christ's Entry into Brussels, 1888).

The whole of Europe was affected by the Symbolist mood. Significant contributions were made in Holland by Toorop, in Austria and Germany by artists of the Sezession, and in England by Aubrey Beardsley. The latter almost acts as a figurative companion to the literary work of Oscar Wilde, whose Salome he illustrated in 1884. Beardsley chose subjects taken from "absolutely modern" life or, more frequently, symbolic mythologies with a strong erotic content (Beneath the Mountain: Stories of Venus and Tannhäuser), which he tackled with a boldly synthetic spirit and not without a touch of humour. He used an extreme linear style, strengthened by his favourite, graphic technique, and displayed an unashamedly stylized quality that was in tune with the highly sophisticated results being achieved at the time by the designer and illustrator Charles Rennie Mackintosh. Mention should also be made of the architect Antoni Gaudí in Spain and, in Switzerland,

Ferdinand Hodler, whose Night, The Elect, Eurhythmy and Day place him among the most important names of international Symbolism. Hodler never abandoned the anecdotal; instead, he strengthened it by imposing an allegorical role on his figures, which are rhythmically arranged in the foreground, in processions that nullify any perspective differences. The faces of these figures are depicted in a precise, analytical way, while their bodies, elegantly delineated by firm,

modulated outlines, are strongly modelled.

The year 1891, in which Gaetano Previati's Maternità was shown at the first exhibition of the Brera Triennale, is a crucial date for Italian Symbolism. Fiercely attacked because of the radical nature of its subject, but especially because of its technique, the work was passionately defended by the critic Grubicy, a dominant figure in Milanese life at the time. The same exhibition also contained Segantini's canvas of

141

▼ *Giuseppe Pellizza da Volpedo,* The Procession, *1892–95, Museum of Science and Technology, Milan. This Italian artist (known mainly for his painting,* The Fourth Estate, *which enjoyed great political success) represents the synthesis of two different trends: the social realism of the Late Romantic and the "divisionism" of Previati and Segantini.*

The Two Mothers, which was well received by the critics and public. The technique chosen by the Italians was that of Divisionism, but the three great painters of the Italian Symbolist era adapted its brushwork to meet their different requirements: in Previati they were filamentary and trailing in wavy, fluctuating lines, while in Giovanni Segantini

◀ *Giovanni Segantini,* Love at the Fountains of Life, *1896, Galleria d'Arte Moderna, Milan. Of clearly allegorical inspiration, this work is remarkable both for its technique, derived from Seurat, and also for its curious iconographic composition. That world beyond reality which Segantini, like Hodler and Previati, seemed to see in Symbolism, became a cultural fashion rather than a real necessity.*

they were more solid and dot-shaped and in Giuseppe Pellizza da Volpedo they were minute, like fine dust.

At the beginning of the twentieth century, following the critical assimilation of Symbolism, Milan resumed its dominant role, becoming a fertile breeding ground for the new generation of artists, who, with Futurism and its modernistic credo, prepared finally to lay to rest any relics of nineteenth-century ideals. ∎

Pierre Puvis de Chavannes, Hope, *c.1872, Musée d'Orsay, Paris.*

Together with Gustave Moreau, Puvis de Chavannes belongs to that group of artists who, by their categorical rejection of Impressionism, were regarded with sympathy (almost like early fathers) by the young Symbolists. Despite the allegorical, dream-induced and religious motifs, de Chavannes' work does not display the expressive innovations of the Nabis or Gauguin and anticipates only some of the characteristics of the movement to whose growth it contributed.

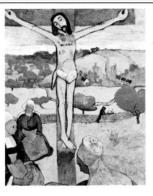

Paul Gauguin, The Yellow Christ, *1889, Albright-Knox Art Gallery, Buffalo.*

This is one of the most successful paintings of the Pont-Aven period. Its most striking feature is the fact that the setting for the Crucifixion is not historical but modern: the Breton peasant women "inhabit" the space occupied by Christ's Passion, as though it were their own existential space.

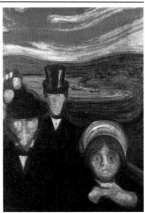

Edvard Munch, Angst, *1893, National Gallery, Oslo.*

The bold new perspective slant, the strongly descriptive schematism, the heavy sensuality of the outlines and the harshness of the colour are all elements of a new artistic language, capable of expressing ideas and feelings through the direct symbolization of the "shapes."

Paris Commune Rome capital of united Italy	Battle of Little Big Horn Queen Victoria proclaimed Empress of India	Triple Alliance Assassination of Tsar Alexander II	William II, German Emperor Brazil proclaimed Republic	Russo-French Alliance	Spanish-American War Hague Conference
Spencer: *Study of Sociology* Hansen: leprosy bacillus	Morgan: *Ancient Society* Berthelot: *Mécanique chimique*	Koch: tuberculosis bacillus Parsons: steam turbine	Klic: rotogravure Eiffel Tower	Röntgen: X-rays Lumière brothers: first cinematographic projection	Marconi: transmission of radio signals Holt: caterpillar tractor
Grieg: *Peer Gynt* Bizet: *Carmen*	Saint-Saëns: *Samson and Delila* Delibes: *Sylvia*	Gilbert and Sullivan: *The Mikado* Metropolitan Opera, New York	Fauré: *Requiem* Satie: *Trois Gymnopédies*	Leoncavallo: *I Pagliacci* Debussy: *Prélude à l'après-midi d'un faune*	Puccini: *Bohème* Sibelius: *Finlandia*
Tennyson: *Lucretius* Rimbaud: *Bateau ivre*	Ibsen: *Doll's House* Strindberg: *The Red Room*	Verlaine: *Sagesse* Mark Twain: *The Prince and the Pauper*	Rimbaud: *Illuminations* Zola: *La bête humaine*	Wilde: *Portrait of Dorian Grey* Maeterlinck: *Pelléas et Mélisande*	Chekhov: *The Seagull* Hardy: *Jude the Obscure*
Trade Unions legalized in England Metropolitan Museum, New York	Sacré Coeur, Paris De Lesseps: Panama Company	Trade Unions legalized in France Arts and Crafts Movement	Van Gogh at Arles School of Pont-Aven	Maison de l'Art Nouveau, Paris Sullivan: Guaranty building, Buffalo, NY	Nabis movement Mackintosh: School of Art, Glasgow
Puvis de Chavannes: *The Carrier Pigeon*	**Böcklin:** *Island of the Dead* **Rodin:** *The Vanquished*	**Redon:** *Homage to Goya* **Sargent:** *Madame Gautreau*	**Hodler:** *Night* **Gauguin:** *Vision after the Sermon*	**Munch:** *The Scream* **Toulouse-Lautrec:** *Les Deux Amis*	**Gauguin:** *Nevermore* **Rousseau:** *The Sleeping Gypsy Girl*
1870–75	1876–80	1881–85	1886–90	1891–95	1896–1900

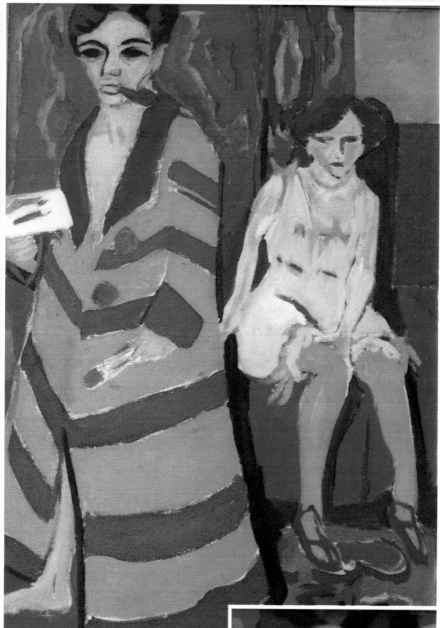

*Ernst Ludwig Kirchner,
Self-Portrait with
Model, c.1907,
Kunsthalle, Hamburg.
The fraught, oppressive
atmosphere in which
the works of* Die
Brücke *are steeped is
an allusion to
existential angst. It is
present even in
paintings that are not
dealing with an* *inherently gloomy
reality but rather are
portraying a genre
subject drawn from
contemporary art: it
shows how
Expressionism regarded
the whole of modern life
as negative, and not
just its more dramatic
manifestations.*

14 EXPRESSIONISM

The most striking aspect of art at the beginning of this century (the period sometimes known as the "historical avant garde") was the tendency of its protagonists to organize themselves into homogeneous groups and movements, that is to say, formations born of precise ideological convergences and based on broadly shared theories concerning the meaning and aims of artistic production. It is almost unnecessary to point out that projects of this sort were formulated in the name of the century's greatest myth, namely an insistent belief in the need for a radical, often destructive, renewal of human psychology and existence. The theoretical framework for the new aesthetic was for the most part laid down in specific proclamations (the so-called "manifestos"), which were required to fulfil a variety of different functions. The main role of these manifestos was to confirm the statutes with which artists had to conform in order to become members of a particular movement, to provide the means with which to combat unbelievers, and, finally, to certify a group's collective identity, thereby allowing its members to identify themselves with it.

There is often a danger, when analyzing Expressionism, of oversimplifying its principles into a kind of schematic shorthand and speaking in terms of an organic and unitary artistic plan rather than a cultural mood that was very widespread during the opening years of the

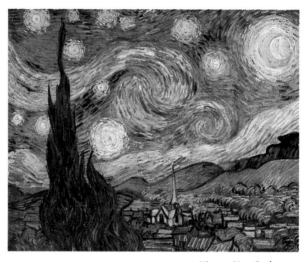

▲ *Vincent Van Gogh,* Starry Night, *1889, Museum of Modern Art, New York.*

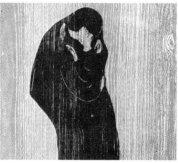

◄ *Edvard Munch,* The Kiss, *woodcut, 1892, City Museum of Fine Arts, Oslo.*

twentieth century. In fact, the movement represents the whole gamut of innovative research during those years, so it is to be seen as a multi-faceted phenomenon based on a number of different experiences and reactions. Between 1900 and 1910 it spread through the German-speaking world, the area where it had first evolved, but other Western European countries soon fell under its influence. It is possible to speak, at best, in terms of a body of loosely linked proposals, a description that certainly applies to the Expressionist group par excellence, *Die Brücke,* founded

in Dresden in 1905, but also to the works of Kokoschka and Schiele in Vienna and of Permeke and Toorop in Holland, as well as the efforts of certain Parisian (Soutine, Rouault, Vlaminck, Modigliani and, before 1908, Picasso) and Slav (Chagall, Kupka) artists and the engravings and canvases of the Norwegian Munch.

Painting was not the only genre affected, however, since Expressionism soon permeated every creative and artistic discipline: from sculpture to architecture, from the graphic arts (whether individually made or mass-produced) to

Expressionist Music

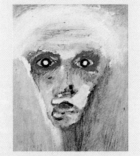

literature and poetry, from music to theater, stagecraft, choreography and even the new but powerful art of cinematography.

The Expressionist mood reflected, above all, the crisis in values with which capitalist Europe found itself having to come to terms. The extraordinary acceleration in technology and production processes, the loss of importance suffered by the agrarian economy in the face of massive financial investments in industry, the upheavals caused by the growth of the cities and by enforced urbanization, the priority given to the needs of consumption over those of saving and the resultant cracks in the social order (with the early beginnings of the "class struggle" in the large cities) were all determinant factors in the historical formation and transmission of Expressionist culture. The very concept of tradition, for centuries a pivotal element, gradually began to crumble in the face of the pressures of "modern-

The main obstacle that twentieth-century music has had to face is the link between European musical procedure and the structures of harmonic consonance. On a very simplistic level, this may be seen as the obligation to see the relationship between notes as being based exclusively on predetermined formulas, the "tonic scales," which establish and perpetuate perceptive habits. Any possible exceptions form part of the internal dialectic of the relationship, in other words they confirm the rule. Gustav Mahler, however, put Brahms' and Wagner's suggestions into practise and intensified the moments of "dissonance" to such a degree that he shook the very foundations of harmonic structure. His ideal followers were the three composers of the so-called Vienna School. To Arnold Schönberg (also the author of such Expressionist paintings as The Red Glance, [1910] and Pierrot Lunaire [1912]) must go the credit for having inaugurated atonal music, in which combinations of isolated sounds achieve their own validity, while Anton Webern, who excelled in the creation of pure and rarefied phonic constellations, carried the search to unimaginable lengths.

ism," which affected social and intellectual life at every level. The sense that history and its specific origins were being rooted out (the feeling of a "loss of tradition") had immediate repercussions on artistic language. The most astute artists and writers, those who were most attuned to the changes under way, accepted this crisis as a necessity, every one of whose consequences they had to exploit. They no longer shut themselves up in the artificial paradise of a nostalgic academy, but turned the instruments of crisis against modern society itself. Although on the one hand they brought their subjects up to date by using whatever the new social dimension decreed, on the other they shattered the classical harmony of the expressive vernacular, searching for their own models outside the European tradition. Particularly in the figurative arts, the avant-garde proposed a return to "primitive" languages, which they saw as

BIOGRAPHIES

♦ **Chagall** Marc (Vitebsk 1887–Saint-Paul-de-Vence 1985). After taking part in the "primitivist" movement in Moscow, he moved to Paris in 1910, where he was able to study the painting of Cézanne, Van Gogh and Gauguin. A friend of Lenin and Lunacharsky, he returned to Russia in 1914 and, after 1917, founded the Constructivist school of Vitebsk. When Malevich managed to

undermine his position, in 1919, Chagall reacted by returning to the ingenuous, fairy-tale

style of his early period. In 1922 he settled in Paris definitively.

♦ **Kirchner** Ernst Ludwig (Aschaffenburg 1880–Davos 1938). His career as a painter developed from his encounters with the anti-Classical art of the old German masters (Grünewald, Dürer, Cranach) and also Japanese prints. Munch, Van Gogh and African sculpture provided him with his next impulse, when in 1905 he founded *Die Brücke* in Dresden. He later participated, from the outside, in the

▼ James Ensor, Self-Portrait with Masks, 1899, Jussiant Collection, Antwerp. Heir to a Flemish tradition ranging from Bosch to Bruegel, from medieval representations of Hell to the moralistic allegories of the seventeenth century, Ensor's art combines its own aims with an element of grotesque irony driven by a strong sense of social condemnation.

▼ Karl Schmidt-Rottluff, Self-Portrait with Monocle, 1910, Staatliche Museen, Berlin. Although the Expressionist ideology began affecting the German avant garde during the final decade of the nineteenth century, it was only after 1905, with the works of the artists of Die Brücke, that the violent, almost "screaming" painting of this important movement came completely to terms with itself and its particular technique.

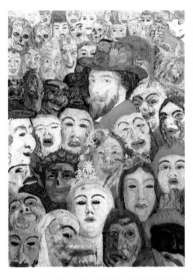

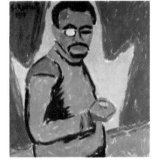

archaic or infantile, but in any case strongly regressive. The subject matter, however, is linked to a strictly contemporary actuality, reflecting the fact that the ultimate goal of the Expressionists was the denunciation of modern civilization and middle-class society. In other words, what appears in their work is an irreconcilable contradiction between "form" as a restoration of out-of-date elements and "meaning" as an immediate political analysis.

For the purposes of comparison, let us consider the theory of art formulated by Filippo Tommaso Marinetti. According to this theorist of Italian Futurism, the great problem of the century is the inadequacy of the literary and pictorial tools handed down by tradition, that is, their failure to do justice to the modern world and their inability to represent contemporary reality. Faced by a decisively dynamic world, symbolized by the mechanized society, artists have at their disposal only means

more efficient vehicles for the direct and highly dramatic expression of the widespread malaise in society.

Expressionist art thus made a choice that involved a deep incongruity, between the language employed and the content sometimes expressed. The image is simplified, deformed and brutalized. It constantly harks back to stylistic devices that are

works of *Der Blaue Reiter*, after which he moved to Switzerland, where he continued to paint in isolation.

♦ **Kokoschka** Oskar (Pöchlarn 1886–Villeneuve 1980). His training took place in the surroundings of the Vienna *Sezession*, where he was closely associated with Klimt. But from 1908, partly as a result of Adolf Loos' influence, he turned his back on Art Nouveau decorativism in favour of the

painting of *Die Brücke*. His style, however, continued to display great originality, in that it drew inspiration from Rembrandt, Austrian baroque art and the Romantic tradition. Between 1910 and 1914 he worked on the Expressionist magazine *Der Sturm* and, at the invitation of Kandinsky, exhibited with *Der Blaue Reiter*.

♦ **Nolde** Emil, pseudonym of "Emil Hansen" (Nolde,

Schleswig-Holstein 1867–Seebüll 1956). After working as a designer in a furniture factory, he was attracted to Symbolism and created paintings that are exemplary for the strong schematic quality of their figures and their high degree of expressiveness. During the same years (1896–1900) he made important study trips to Munich and Paris. In 1906 he joined *Die Brücke* at the invitation of Schmidt-Rottluff but left the group shortly

afterwards. Nolde's artistic maturity, between 1910 and 1920, was accompanied by a number of personal misfortunes that heightened the emotive qualities of his art.

♦ **Pechstein** Max (Zwickau 1881–Berlin 1955). After studying at the Dresden Academy, he sharpened his figurative skills during a trip to Paris. Attracted by all forms

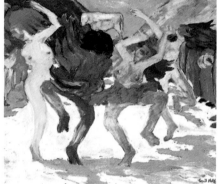

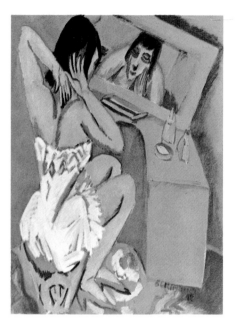

that are anachronistic, because they are static. What, in effect, are perspective and linearity if not the foundations of a contemplative and therefore static tradition? The pictorial image is per se immobile: how can it ever hope to describe the relentless motion that surrounds us? But instead of "modernizing" shapes by making them dynamic, as Futurism did, Expressionism took the opposite course, that of distortion. Another distinctive feature was its rejection of the traditional values that had held sway ever since the Renaissance, but, rather than a step forward, the Expressionists took, so to speak, a step back, towards the culture of "primitive" peoples. The painters of *Die Brücke* dealt with the most negative aspects of contemporary society (prostitution, poverty, exploitation, oppression, suffering and injustice), but

of "primitive" art, he practised a modified form of Expressionism that allowed him to graduate through a number of different groups, such as *Die Brücke* (1905–09), the *Neue Sezession* (1910–12) and *Der Blaue Reiter* (1913–14).

◆ **Permeke** Constant (Antwerp 1886–Jabbeke 1952). The output of his maturity, based on powerful formal simplifications and tragic material structures, dates only

from 1914, when the experience of the war deeply affected his personality.

◆ **Rouault** Georges (Paris 1871–1958). He was the most overtly Expressionist member of the French Fauve movement (whose members included Matisse, Dufy, Marquet and Vlaminck), to which he belonged for a brief period. His painting reflects his passionately held beliefs, both religious

and philosophical. His friendship with the theologian Jacques Maritain, whom he met in 1911, led to his complete rejection of lay subjects.

◆ **Schiele** Egon (Tullin 1890–Vienna 1918). His brief career as a painter was characterized by its mixture of German Expressionism and the art of the Vienna *Sezession*. Although the ideological intent of his work is very different from that of Art

Nouveau, it cannot be denied that the example set by Klimt inspired him in his use of the sharp, nervous line that gives his paintings their dramatic effect.

◆ **Schmidt-Rottluff** Karl (Rottluff 1894–Berlin 1976). Like his early avant-garde colleagues, he studied architecture at the Technische Hochschule in Dresden and it was there that he met Heckel and Kirchner, with whom he

they did so by means of an expressive language that was distorted and deformed, alienated from the co-ordinates of Western culture. In this way they created a visual shock, a feeling of sensory unease, a conflict which transposes their message of distress and tragedy (the great *krisis*) to within the mechanics of expression.

This destruction of the balance derived from classical tradition can already be detected in certain exponents of the Symbolist and Late Romantic era: there is a hint of it in Gauguin's Polynesian paintings, while in the dramatic, feverish works of Van Gogh (such as his famous *Crows in the Wheatfields,* painted in 1890) it finds full expression. And the angst-laden atmosphere that Edvard Munch manages to convey in his pictures, which display many of the devices later exploited by the new generation, is much more than a premonition: the colours are brash and strident, the lines, although anything but broken, are manipulated to create an oppressive and intensely emotional element (*The Kiss,* 1892), while the perspective structure, where it exists, acts not as a means of providing visual certainty, but rather confuses the eye by plunging it in vertiginous depths (*The Scream,* 1893). It was these painters who inspired the young members of *Die Brücke,* who were no less influenced by the Belgian James Ensor and his series of "masks" and "skulls," with which the artist attempted to provide a metaphor for everyday life in a spiritually dead society dominated by lies. Another, lesser influence on them was the sinister fascination of the visions depicted by Arnold Böcklin (*Island of the Dead,* 1880) and his pupil Max Klinger.

The formal innovations introduced by the painting of

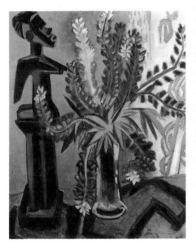

founded *Die Brücke* in 1905. In 1906 he became friends with Nolde. After 1911, partly as a result of a fertile exchange of ideas with Lyonel Feininger, he developed new interests: Cubism, African art and, on a technical level, woodcuts. Like many of his generation, during the 1930s Schmidt-Rottluff endured persecution by the Nazis, who destroyed more than 600 of his paintings.

◆ **Soutine** Chaïm (Smiloviči 1894–Champigny 1943). Born in Lithuania, he moved to Paris in 1911, where he became acquainted with Modigliani and Chagall. His work displays an intensely visionary quality, verging on the crazed, which is reflected in his unrestrained use of blood red and the frightening distortions to which he subjected both portraits and landscapes.

▼ *Oskar Kokoschka*, The Storm, *Kunstmuseum, Basle. The typically German subject of a storm (the* Sturm *of the Romantic artists) is here interpreted in an allegorical key, as a personal turmoil. One* *curious element is the neo-baroque quality of the style, reminiscent of early twentieth-century Viennese artistic circles.*

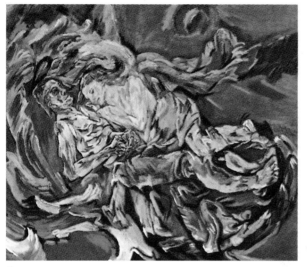

impulse is not just an ordinary negation of the forms of the outside world, but rather the upsetting of the harmonic principles of art. The language does not disappear: it is turned inside out like a glove. In the same way, the dazzling elements of Wiene's, Murnau's and Lang's film sets are turned upside-down, and later on the explosive colours of Chaïm Soutine and Georges Rouault's paintings would be overturned, losing all composure and sobriety.

Die Brücke ("The Bridge") existed between 1905 and 1913. Its earliest inspiration was Ernst Ludwig Kirchner,

the German avant-garde can be summed up in two concepts: violent colour and broken line. The first was obtained by the explosion of a feverishly exaggerated range of colours, while the second was diametrically opposed to the *"Feinheit der Kurve"* (curving elegance) of the *Sezession*. The "scream" unleashed from the picture by the violent colours and broken lines is accompanied by a liberation of the subject's dramatic quality. The formal crisis (the cry of the formation/deformation) was correlated with the social drama to which it alluded. It is noticeable, for example, that the artists of *Die Brücke* seldom directly represent distressing subjects in their painting, but the inherent feeling of tragedy is always there, even when the subject is only a portrait, like Ernst Kirchner's *Woman at the Mirror* (1912), or a landscape, such as Karl Schmidt-Rottluff's *Path through the Wood* (1910), or an episode

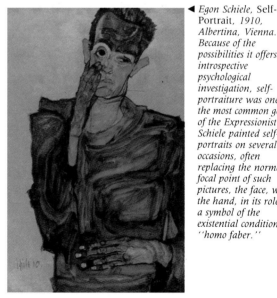

◄ *Egon Schiele*, Self-Portrait, *1910, Albertina, Vienna. Because of the possibilities it offers for introspective psychological investigation, self-portraiture was one of the most common genres of the Expressionist era. Schiele painted self-portraits on several occasions, often replacing the normal focal point of such pictures, the face, with the hand, in its role as a symbol of the existential condition of ''homo faber.''*

from contemporary life, such as *School of Dance* (1912), also by Kirchner. The feeling of tragedy in these paintings is the implicit product of an expressive language taken beyond its limits, a language whose integrity has been damaged. The Expressionist

who worked in close collaboration with his colleagues Erich Heckel, Fritz Bleyl and Karl Schmidt-Rottluff. In his *Chronik der Künstlergruppe Brücke* (Chronicle of *Die Brücke* group) Kirchner stated that "painting is an art which represents a percep-

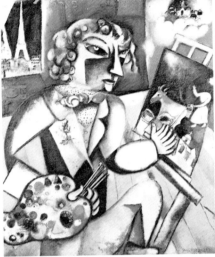

▼ Marc Chagall, Self-Portrait with Seven Fingers, *1912, Stedelijk Museum, Amsterdam. Chagall's work displays an original mixture of almost naïve, primitivist sensibilities* linked to the mood of Russia during the 1910s, and a distorting Fauve *violence, the result of his contacts with French and German art of the same period.*

▼ R. Wiene, frame from The Cabinet of Doctor Caligari, *1920. In the cinema, the youngest of the arts, Expressionism found a fertile breeding ground. It is remarkable how in this classic story of* human emotions the director used a set based on the principle of broken, non-orthogonal lines, a device that heightens the mood of unease.

► Amedeo Modigliani, Red Nude, *1917–18, Mattioli Collection, Milan. Modigliani's works can be linked to the taste for expressive distortion which by 1915 had spread throughout the world. This tendency characterized, albeit in different ways, all contemporary art: here, for example, its goal is to accentuate the lyrical quality of the painting.*

tible phenomenon on a flat surface. The medium of painting is colour, both as line and ground. The painter transforms the perceptible conception of his experience into a work of art. There are no rules for this. Rules for the individual work are formulated during the work." The accent fell on psychological subjectivity and the rejection of rules, or rather the constant breaking of rules that every work, because it is individual and therefore the product of an individual psyche, carries out in relation to earlier works. In 1906 an exceptionally able artist, Emil Nolde, joined *Die Brücke* but after three years he parted company with the group. It was Nolde, however, who took Expressionist painting to its limits: an example of the extent to which this subversion could be taken can be seen in his *Dance round the Golden Calf* (1910). A demonic spirit seems to enter and shake the fabric of the work, the colour disintegrates in fiery clots, in splashes thrown on to the canvas as though by one possessed, the linear framework disappears beneath the frenetic strokes of the painter, while the pagan violence of the subject translates into the abolition of all aesthetic, rational or formal control.

A second phase of the Expressionist avant-garde is

▼ *Constant Permeke*, The Couple, *1923, Musée d'Art Moderne, Brussels. Permeke's solemn and intensely powerful painting, based on the metaphorical use of colour, represents the* Expressionist mood carried beyond the historical boundaries of the movement.

represented by the Russo-Bavarian group *Der Blaue Reiter* (The Blue Rider), whose most outstanding exponents were, between 1910 and 1914, Wassily Kandinsky, Franz Marc, August Macke, Gabrielle Münter, Max Pechstein and Paul Klee. Strictly speaking, with the exception of Pechstein, these painters offered a distinctly unorthodox interpretation of the problem: the anarchic subjectivism of *Die Brücke* was transformed into a lyrically chromatic dimension, the "modern" social themes gave way to an almost nostalgic revival of the purity of nature (in Marc and Macke) or the unrestrained emotion of the abstract surface (in Kandinsky and, in a different way, in Klee). Expressionism thus opened up to influences and developments that, as has already been said, went far beyond individual groups and specific historical dates. Another of its by-products was the work of the *Neue Sachlichkeit* (New Objectivity) movement, which developed in the Weimar Republic after 1920. It should be remembered, however, that probably the most inventive and far-reaching revolution was the one affecting music, which manifested itself in the work of Arnold Schönberg, Anton Webern and Alban Berg (preceded and influenced by the lyric Expressionism of Gustav Mahler). Vienna, where Oskar Kokoschka and Egon Schiele expressed ideas very similar to those of *Die Brücke* in their paintings, was home to the workshop that within the space of a few years was to

▼ *Chaïm Soutine,* Carcass of Beef, *c.1925, Musée des Beaux-Arts, Grenoble. A visionary endowed with an astonishing talent for self-expression, Soutine embodies art at its most rebellious and its most ferociously anti-Establishment. His attachment to the innermost "truth" of things drove him, as it had Van Gogh before him, to a crazed and obsessive observation of nature in all its aspects.*

revolutionize the world of music. The destruction (or more accurately the "destructuring") of the rules of tonality, as practised by Schönberg from 1912, confirms the unique character of an experience that represents an irreplaceable element in the history of twentieth-century culture. ∎

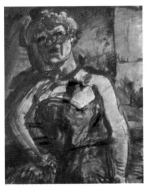

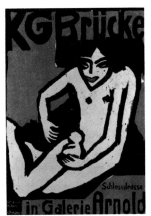

James Ensor, Masks and Death, *1897, Kunstmuseum, Lüttich.*

Georges Rouault, The Drunken Woman, *1905, Musée National d'Art Moderne, Paris.*

Ernst Ludwig Kirchner, *cover for the catalogue of an exhibition by Die Brücke, woodcut, 1910.*

The earliest phase of the Expressionist avant garde, still steeped in Symbolist theory, produced the paintings and ideas of three great artists: the Dutchman Vincent Van Gogh, the Belgian James Ensor and the Norwegian Edvard Munch.

If there really does exist a historical link between the Fauves and the Expressionists, then Rouault is perhaps the painter who best illustrates it. It should, however, be remembered that artists such as Matisse or Dufy had very little to do with the intolerance and political rage of the Germans.

Using the technique of graphics, Kirchner deepened his own expressive language and explored the communicative potential of a dry, schematic and ''scratchy'' line capable of interpreting the expressive immediacy of the most simple ideas.

Dreyfus affair in France First Hague Peace Conference	Theodore Roosevelt becomes President of US Queen Victoria dies	Anglo-French *Entente Cordiale* Russo-Japanese War	Meeting of 1st *Duma* in St Petersburg	Accession of George V Revolution in Portugal	Assassination of Archduke Ferdinand at Sarajevo Panama Canal
Curie: radium	De Vries: *The Mutation Theory*	Russell: *Principles of Mathematics*	Onnes: liquefied helium	Landsteiner: blood groups	Einstein: general theory of relativity
Puccini: *Bohème* Giordano: *Fedora*	Elgar: *Dream of Gerontius* Debussy: *Pelléas et Mélisande*	Puccini: *Madame Butterfly* Strauss: *Salome*	Mahler: *The Symphony of the Thousand*	Schönberg: *Harmonielehre*	Stravinksy: *Rite of Spring* Scriabin: *Prometheus*
Chekhov: plays Rostand: *Cyrano de Bergerac*	Mann: *Buddenbrooks* Gide: *L'Immoraliste*	Jack London: *Call of the Wild* Barrie: *Peter Pan*	Galsworthy: *The Man of Property* Gorky: *Mother*	Stein: *Three Lives* Forster: *Howard's End*	Apollinaire: *Alcools* Proust: *Swann's Way*
Durkheim: *Le Suicide* Veblen: *The Theory of the Leisure Class*	Freud: *The Interpretation of Dreams* Croce: *Estetica*	Weber: *Protestant Ethic and the Spirit of Capitalism*	Frank Lloyd Wright: Unity Temple Start of Cubism in France	Marinetti: *Manifesto del futurismo* *Blaue Reiter* founded	Jung: *Symbols and Transformations of the Libido* Kandinsky: *Concerning the Spiritual in Art*
Ensor: *Self-Portrait* **Gaudí:** Church of Sagrada Familia	**Munch:** *Girls on the Bridge* **Sickert:** *Interior of St Mark's, Venice*	**Rouault:** *The Drunken Woman*	**Nolde:** *Red and Yellow Roses* **Kirchner:** *Self-Portrait with Model*	**Nolde:** *Dance round the Golden Calf* **Utrillo:** *Church at Châtillon*	**Chagall:** *The Newspaper Seller* **Kokoschka:** *The Storm*
1896–99	1900–02	1903–05	1906–08	1909–11	1912–14

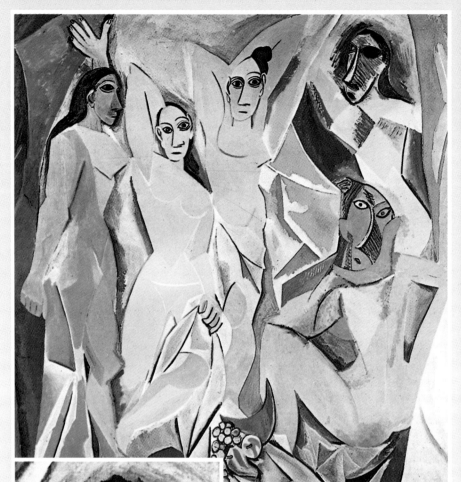

Pablo Picasso, Les Demoiselles d'Avignon, *1907, Museum of Modern Art, New York. Completed shortly before his first meeting with Braque, this painting was the result of much work and many second thoughts. One early version depicted seven figures, five women and two men, one of whom carried a skull in his hand: the picture was therefore a* Vanitas, *a memento mori, because of the reference to death placed next to the female nudes. The latter, for their part, have an erotic significance, as is shown by the painting's first title,* Le bordel philosophique, *which was changed to the present one after the war, while ''Avignon'' refers to a street in the red-light district of Barcelona. On a stylistic level, the work harks back to the nudes of Cézanne, distorted along the lines suggested to Picasso by pre-Christian Iberian sculpture and African art. The detail shows clearly the ''natural'' force exercised by African art on Picasso's language.*

15 CUBISM

ainted in 1907, Picasso's *Les Demoiselles d'Avignon* is "a picture like no other," to quote John Golding, one of the main authorities on Cubism. This is because the faces are distorted like African masks, the bodies are broken up like open sculptures attached to a surface, and because the background is not behind the figures but among them. When faced with the work, we must be prepared to abandon that sense of absolute visual certainty which Western tradition has favoured since the Renaissance and provide ourselves with new techniques of comprehension and interpretation in order to approach it.

During the first decade of the twentieth century, European artistic culture was clearly showing itself to be ready for this change. That same need to multiply the points of view in a work of art, to break language up into segments and to extend the usual range of sound is found in the music of Igor Stravinsky and the prose of James Joyce, Virginia Woolf and Gertrude Stein, herself a friend and biographer of Picasso.

It is customary to regard the Spanish artist, together with the Frenchman Georges Braque, as the founders of Cubism, the movement that occupied the Parisian avant-garde stage from 1907 to 1914 and left an indelible mark not only on those young artists who visited Paris as though it were a living academy, but also on the very concept of modern art as a whole. And yet, although

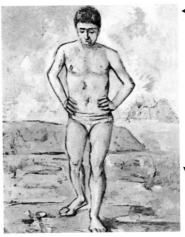

Paul Cézanne, Man Standing with Hands on Hips, *1885–87, Museum of Modern Art, New York. In this work Cézanne imparts a feeling of solidity and volume to a body in space, without resorting to chiaroscuro and the traditional techniques of modelling.*

they were the instigators of Cubism, neither Picasso nor Braque ever called their painting by this name, which was invented by the critics of

Georges Braque, Houses at L'Estaque, *1908, Hermann and Margrit Rupf Foundation, Kunstmuseum, Basle. With landscapes such as this, people began to speak of "cubes," initially with an element of disparagement.*

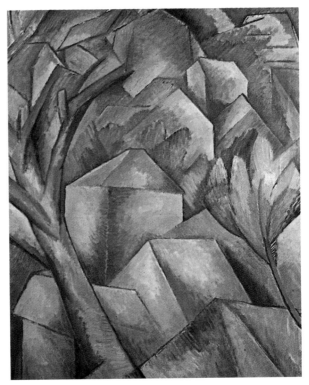

K. Schmidt-Rottluff, Red and Blue Head (Fear), 1917, Brücke-Museum, Berlin.

the day. The description was, however, acknowledged by numerous other artists (some throughout their careers and others for only a brief period): men such as Jean Metzinger and André Lhote, Henri Le Fauconnier and Albert Gleizes, Fernand Léger and Robert Delaunay, who, in exhibitions and publications, each offered his own interpretation of Cubism, as the term spread beyond the frontiers of France.

But how did Picasso and Braque operate? And what is the history of Cubism? In 1907, the year after Cézanne's death, the *Salon d'Automne* played host to a great exhibition of his most important works, in which his teachings stood clearly revealed: not to stop at the impressionist appearance, but to look beyond for their structure and their geometric framework and to see nature in terms of cylindrical, spherical and conical shapes. Cézanne expressed himself in these terms in a famous

"Expressivity, structure and simplicity" were, according to the art historian Ernst Gombrich, the qualities possessed by "primitive" artistic expressions in the eyes of the avant-garde movements. Western culture, with its refined and involved expressive language, used primitive, archaic or regressive shapes in order to revitalize its style. Thanks to Gauguin and his "romantic" escape to Oceania, to Henri "Le Douanier" Rousseau and his magically naïve and regressive inventions, to the Expressionists, who preached the uncontaminated values of the "savage," and also to the Cubists, our conventional ideas of perception were introduced to the expressive language of other cultures, thus enabling our civilization to progress beyond the barriers of classical art.

letter to Emile Bernard, who, despite their different artistic beliefs, was very close to the artist for many years. However, the same correspondence reveals another fact, namely that the Aix-en-Provence painter was also preaching the strictest possible adherence to perceived reality, to nature as it presents itself to the eye: "The painter ought to devote himself completely to the study of nature. . . . All discussions of art are virtually useless. . . . The man of letters expresses himself in abstractions, whereas the painter, by means of design and colour, gives shape and form to his sensations and perceptions." In effect, Cézanne was referring to training the eye to "see" nature, to "understand" it. Although, on the one hand, this process distances the eye from its original impressionist function (it is now the essence of things that it must penetrate, not their surface), on the other, it makes it absurd to try and attribute abstraction-

BIOGRAPHIES

♦ **Archipenko** Alexander (Kiev 1887–New York 1964). Much influenced by the Cubism of Léger, he was a member of the *Section d'Or* group. In 1914 he began creating *assemblages* containing strips of various materials. In 1923 he moved to the United States.

♦ **Braque** Georges (Argenteuil-sur-Seine 1882–Paris 1963). After an Impressionist phase he joined the

Fauves (*The Small Bay at La Ciotat, The Harbour at L'Estaque,* 1906). Together with Picasso, he was the greatest exponent of Cubism. His subjects were mainly still lifes with musical instruments, landscapes, still lifes on a round table (*Guéridons*), fireplaces and the series of

Ateliers (1948–55) and Birds (1955–63).

♦ **Delaunay** Robert (Paris 1885–Montepellier 1941). In 1909 he painted his first *Tour Eiffel*. In 1911 he was invited by Kandinsky to take part in the first *Blaue Reiter* exhibition. In 1912 he created his *Fenêtres* series and in 1913 his

series of *Formes circulaires cosmiques* or *Disques*. Apollinaire defined him as "Orphic," a reference to his involvement in researching the rhythms and meanings of non-representational coloured shapes.

♦ **Delaunay** Sonia Terk (Ukraine 1885–Paris 1979). In 1910 she married Robert Delaunay and took part in his researches into colour and light. In 1913, together with

ist intentions to it or make it responsible for the creation of a conceptual image. And it was this "naturalist" lesson, in tandem with a deeper use of sensory perception, which influenced the early beginnings of Cubism in around 1906–7.

There is one particularly persistent misconception about Cubism which must be corrected: that it represents a substantial rejection of pictorial realism. In fact, in more than one respect, the paintings of Braque and Picasso can be clearly related to the idea of a greater adherence to concrete phenomena, to the exterior dimension of real things. These artists were trying to gain a closer knowledge of nature, not to ignore it, and, according to basic Cubist theory, a closer knowledge of nature required new

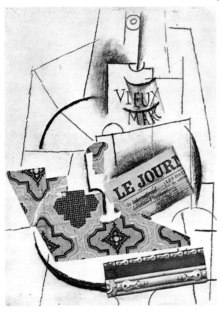 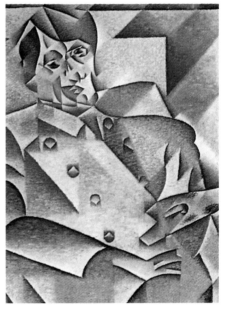

Blaise Cendrars, she created *Prose du Transsibérien et de la petite Jeanne de France*, in which poetic text and illustration converge. She worked on theatrical decoration and designed clothes and tapestries. During the 1930s she turned to abstractionism.

♦ **Duchamp-Villon** Raymond (Damville 1876–Cannes 1918). After being initially influenced by Rodin and Maillol, he joined

the Cubist movement and developed his own powerfully synthetic style (*Horse*, 1914).

♦ **Gleizes** Albert (Paris 1881–Avignon 1953). Together with Jean Metzinger (Nantes 1883–Paris 1956) he wrote the book *Du Cubisme* in 1910. In the same year he took part in the *Section d'Or* group, founded by Jacques Villon, whose members also included André Lhote, Roger de la Fresnaye (Le Mans

1885–Grasse 1925) and Louis Marcoussis (Warsaw 1878–Cusset 1941).

♦ **Gris** Juan, pseudonym of José Victoriano González (Madrid 1887–Boulogne-sur-Seine 1927). He moved to Paris in 1906, where he met Picasso. He joined in Cubist researches, concentrating on the mathematical aspects of formal decomposition; he used collage, inserting

a piece of mirror in *Le Lavabo* (1912). In 1922 he designed scenery and costumes for Diaghilev's *Ballets Russes*.

♦ **Laurens** Henri (Paris 1885–1954). During the Cubist period he created polychrome sculptures, collages and architectural and theatrical projects. In 1925 he abandoned geometrical structures in favour of fuller, more fluid shapes.

▼ Raymond Duchamp-Villon, Horse, 1914, Peggy Guggenheim Collection, Venice. Brother of Marcel Duchamp and Jacques Villon, Duchamp-Villon used plaster and bronze to apply the Cubist interpretation of shapes, first analyzing them and then synthesizing them in new devices, bursting with energy and dynamism, ready to break away. The horse and machinery, sometimes fused together, are among the subjects most frequently dealt with by the artist.

representational elements. It was this that led to an awareness of the arbitrary (and conventional) nature of traditional means of representation. We are not "immobile" in the presence of the objects of reality: we move in space, synthesizing the multiple images provided by the eye. Sight is anything but motionless: it is constantly shifting its range of vision, vibrating like a radar scanner able, through countless trials, to reconstruct distances, volumes, planes, cavities, projections and surfaces.

After his Blue and Rose periods, Picasso learned from Cézanne that the outlines of landscapes and bodies can be broken up and that the hidden, "intuitive" facets of perspective objects can be shown. The idea of painting was changing, trying to breach the historical boundaries of flat illusionism and get closer to things in their entirety. The form of expression that came nearest to conveying the plastic substance of objects was African sculpture, examples of which were already circulating among the Expressionists. Picasso used these models to simplify painting, to reach the internal structures of objects and establish that a picture was not a window on the world, but something which grasps the substance of an object and then restores it, like a totem. This marked the birth of Cubism, whose earliest phase, lasting until roughly 1912, is known as "analytical" because the first operation carried out by Picasso and Braque (who had met in 1907 through the poet Apollinaire) was to analyze and dismantle objects, as though turning them around, so as to be able to unfold their different facets on a two-dimensional surface and depict them from different angles.

The surfaces of the pictures appear initially to be articulated in geometric (cubic) shapes and then by a network of lines on which are inserted the surfaces of the objects and the space, so that we see the front, the profile and the corners at one and the same time. It is both an extreme form of realism and a way of giving a painting the

♦ **Léger** Fernand (Argentan 1881–Paris 1955). After a Fauve period he joined Cubism, to which he gave his own personal interpretation that evolved towards decorativism and the use of primary colours and black and white. The year 1917 was his "mechanical" period, when he created tubular and geometrical shapes. He worked on the sets of films and ballets and also on the mural decorations of the

Palais de la Découverte (1937).

♦ **Lipchitz** Jacques (Druskininkai, Lithuania, 1891–Capri 1973). He went to Paris in 1909. He joined the Cubist movement and created sculptures based on architectonic principles. In 1941 he moved to the United States.

♦ **Picasso** Pablo (Malaga 1881–Mougins 1973). In 1904 he settled in Paris, where his studio, the Bâteau Lavoir, became a mecca for the international avant-garde. After his Blue (1901–4) and Rose (1905) periods, he developed Cubism and from 1916 worked on sets for ballets and plays. He subsequently turned to figurative and monumental, "Neo-Classical" shapes. Between 1925 and 1930 he showed a Surrealist tendency. In 1937 he painted *Guernica*. As well as his paintings, he created a vast number of drawings, prints, ceramics and sculptures.

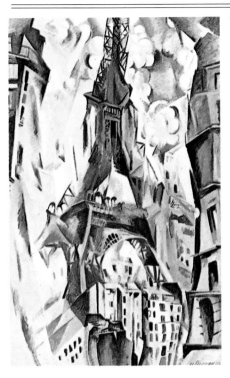

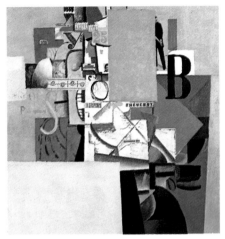

◀ *Robert Delaunay,*
Tour Eiffel, *1910,*
Guggenheim Museum,
New York. Delaunay
has ''dislocated'' the
image, breaking it up
and imparting a feeling
of dynamism to the
picture.

▼ *Kasimir Malevich,*
Woman in front of a
Column of Posters,
1914, Stedelijk
Museum, Amsterdam.
There had been interest
in Cubism in Russia
since 1910.

dimensions of time, succes-
sion and duration. In this
analytical research the works
became hermetic and, in
order to reaffirm their con-
tact with reality, between
1910 and 1911 Braque began
to include painted trompe-
l'oeil details and stamped let-
ters in his works. The pic-
tures thus became objects in
their own right (*tableaux-
objets*), whose aim was not to
trick the eyes, like the veils
and the fruit painted by Zeusi
and Parrasio, but the mind
(*trompe-l'esprit*).

Cubist research deepened
and spread, new names
emerged, such as that of the
Spaniard Juan Gris, and
closer contacts developed
with the *Blaue Reiter* group,
the Italian Futurists and the
Russian avant-garde (the
"Cubo-Futurism" of Kasimir
Malevich and Vladimir Burl-
juk). The year 1912 saw the
invention of collage (the
application of such extra-
neous materials as labels,
pieces of newspaper and
metal, waxed cloth and sand
to the surface of the painting)
and the start of the so-called

▼ *Fernand Léger,* The
Wedding, *1911–12,*
Musée National d'Art
Moderne, Paris. The

modelled shapes and
flat surfaces follow the
''laws of contrasting
colour.''

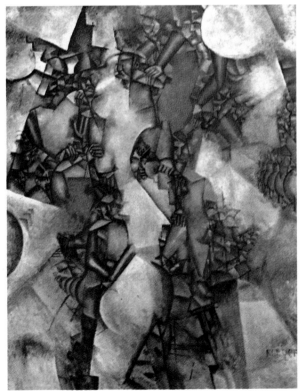

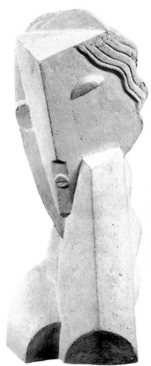

◀ *Henri Laurens,* Head of a Young Girl, *1920, Peggy Guggenheim Collection, Venice. The decomposition of the flat surfaces of an object, the multiple recomposition of its facets, the creation of a new relationship between space and shape and between filled and empty spaces, are all features of this work.*

nand Léger, with his tubular and cylindrical modules. Other artists formed themselves into the *Section d'Or* group (from the geometrical "golden section") in order to investigate the mathematical relationships and evocative potential of shapes: Jacques Villon, Francis Picabia, Marcel Duchamp and Frantisek Kupka. At the outbreak of war Cubism was the collective name for a variety of different forms of research that anticipated future developments in art. Whereas Braque and a great many others were called to the front, Picasso was at hand to occupy the artistic stage, for many years to come, with his unsettling and vital interpretations of shapes and events. ∎

▼ *Marcel Duchamp,* Sad Young Man in a Train, *1911–12, Peggy Guggenheim Collection, Venice. In this painting Duchamp reveals his early adoption of the Cubist idea of decomposition, but interpreted in a dynamic way.*

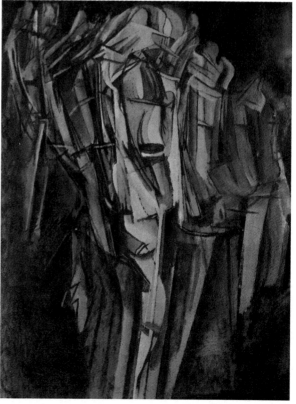

synthetic stage. The aim was no longer to break an object up into its successive parts, but to create an image that would synthesize its essential shapes and material. The picture became more and more an object, a small world complete in itself, appealing to the intellect, proposing a new relationship between truth and falsehood, reality and representation, and paving the way for Dadaism and multi-media art.

Apollinaire coined the term "Orphic Cubism" (from the mythical Orpheus) to refer to artists who were attracted to the investigation of colour and its effects and the rhythms of "abstract" chromatic shapes: figures such as Robert Delaunay and his wife Sonia Terk, and Fer-

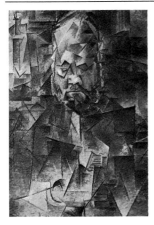

Pablo Picasso, Portrait of Ambroise Vollard, *Pushkin Museum, Moscow.*

The picture, which on first sight appears disconcerting, reveals itself, on closer inspection and with a greater awareness of the principles of analytical Cubism, to be an accurate portrait of the art dealer Vollard, a portrait possessing not only the strength of a photographic likeness, but also a new degree of realism. In the painting the face and the space are broken up and spread out flat at their linear intersections.

Sonia Terk Delaunay, Electrical Prisms, *1914, Musée National d'Art Moderne, Paris.*

The Delaunays' search for the rhythms and internal laws of colour led them away from Cubism and towards a form of lyrical and decorative abstraction. Sonia Terk explained that her painting, like that of her husband, was governed solely by the internal laws of chromatic substance, which were linked intimately to light. In 1913, together with the poet Blaise Cendrars, she created Prose du Transsibérien et de la petite Jeanne de France, *with the text printed vertically and the illustrations based on the simultaneity of chromatic contrasts.*

Alexander Archipenko, Two Vases on a Table, *1918– 20, Musée National d'Art Moderne, Paris.*

A native of Kiev, in 1908 Archipenko moved to Paris, where he became involved in the researches of the avant-garde, and particularly in the work of Léger. He too experimented with objects and space, which he treated as elements correlated by a rhythm and a relationship that differed greatly from traditional perceptions. From 1914 he devoted himself to sculptural paintings and assemblages, made from a mixture of different materials.

Pope Pius X issues his encyclical *Pascendi gregis* against Modernist system	Revolt of Barcelona	*Titanic* sinks on maiden voyage	Outbreak of First World War	Battle of Verdun: 700,000 dead	October Revolution in Russia
International Congress of Psychoanalysis	Peary reaches the North Pole	Casimir Funk identifies the action of vitamins	Bohr: studies of the atom	Einstein: general theory of relativity	Artom: invention of the radiogoniometer
Ravel: *Rhapsodie espagnole*	Schönberg: five pieces for orchestra	R. Strauss: *Der Rosenkavalier*	Jazz becomes popular in the USA	Sibelius: *Fifth Symphony*	Stravinsky: *L'histoire du soldat*
Nietzsche: *Ecce Homo*	Gertrude Stein: *Three Lives*	D.H. Lawrence: *The White Peacock*	Proust: *Swann's Way*	Kafka: *Metamorphosis*	Ungaretti: *Il porto sepolto*
Development of Art Nouveau	Birth of Metaphysics Birth of Abstractionism	Alfred Jarry: the *Pataphysique* theory	Chaplin's first films	Birth of Dada	Birth of Neo-plasticism
Picasso: Les Demoiselles d'Avignon **Braque:** Houses at L'Estaque	**Delaunay:** Tour Eiffel	**Gris:** Homage to Picasso **Leger:** The Wedding	**Picasso:** Bottle of Vieux Marc **Duchamp-Villon:** Le Cheval Majeur	**Gris:** Breakfast	**Laurens:** Still Life **Leger:** The Card Players
1907–08	1909–10	1911–12	1913–14	1915–16	1917–18

Umberto Boccioni, Visioni simultanee (Simultaneous Visions), 1911, Von der Heydt Museum, Wuppertal. Though it already reveals signs of a knowledge and partial reworking of the lessons of Cubism, this painting is one of the most significant examples of the adaptation of Divisionist methods to the concepts of ''simultaneity'' and ''dynamism.'' Indeed the figure is presented simultaneously full-face and in profile, in accordance with one of the theories set forth in the Manifesto of Futurist Painting, according to which figures ''stand still and move, come and go, ricochet on to the road, devoured by a patch of sunlight . . . enduring symbols of universal vibration.'' The houses themselves seem to be dovetailed into one another, fused with the street, trees and passers-by, in a synthesis of time and space expressed through the bright tones and unusual perspectival slant. The resulting impression is one of perpetual becoming, a world in permanent transfiguration, indissolubly linked to the concepts of matter as vital energy.

16 FUTURISM

W hen the Italian writer and poet Filippo Tommaso Marinetti launched the *Futurist Manifesto* from the pages of the Paris newspaper *Le Figaro* in 1909, no Futurist painting or sculpture actually existed. Conditions were right, however, for the creation of such a movement, dictated by the inexorable pace of technological development taking place at the time, by a general sense of cultural void and by a growing desire for cultural renewal that was to embrace the whole social system. Within a few years, starting from agitation for new departures of a literary kind, Marinetti elaborated one of the "prototypes" of the historical avant-garde, the Futurist movement, which brought together several young artists who, like him, were inspired by the determination to "change life," in accordance with the radical watchword formulated by the French poet Rimbaud.

"It is from Italy that we are launching this violent, sweeping, incendiary manifesto of ours on to the world. With it we establish Futurism, because we want to free this land from its stinking gangrene of professors, archaeologists and antiquarians," in the words of one of the key passages of the manifesto, whose polemical stridency, directed in particular at the academic traditionalism and entrenchment of contemporary bourgeois culture, implies a propagandist attitude which was in fact common to all avant-garde movements.

Artists began to feel that a

▲ *Umberto Boccioni, La città che sale (The City Rises), 1910–11, Museum of Modern Art, New York. Originally entitled* Il lavoro (Work), *it is characterized by great urgency of form.*

▼ *Umberto Boccioni, Stati d'animo. Gli addii (States of Mind. Farewells), 1911, Museum of Modern Art, New York. The painting belongs to the first series of* States of Mind.

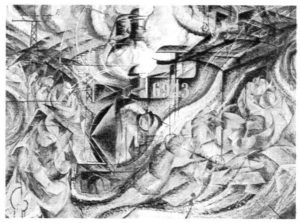

programme of general formal and linguistic renewal was needed, that would be able to express the spirit of a new age. Between 1909 and 1916 more than 50 manifestos were published – of painting, the theater, literature, the dance, cookery, etc. – partly to stress the importance attributed to the manifesto as a means of communication, the favoured vehicle for the spread of new aesthetic and behavioural values. Similarly, the *café-cabaret* was the means chosen to present linguistic experimentation to the public, which thus found itself attending the many, provocative fully-fledged theatrical

performances known as "Futurist performances."

The ideology of the movement, which had its root in the particular relationship between art and life that underlay so much Romantic and post-Romantic thought, thus involved all levels of experience: from art to politics and ethics, based on a conception of existence that was in some ways connected to the thought of Bergson and Nietzsche. More specifically, Marinetti announced the birth of a "new beauty," "the beauty of speed," connected to the myth of the machine and embodied in the hectic life of the industrial metropolis. The concept of dynamism, a key word in this whole cult of motion, is taken up again in the *Manifesto tecnico della pittura futurista* (Technical Manifesto of Futurist Painting), launched in 1910 and signed by Umberto Boccioni, Carlo Carrà, Luigi Russolo, Giacomo Balla and Gino Severini, which stressed that "painters have always shown us objects and

It was in the Russian Empire that Futurism was most widespread, initially defined with the term "Cubofuturism," coined by David Burliuk around 1912. This referred to the collaboration between Cubist painters and Futurist poets, united by the same desire to revitalize the cultural system. It was supported by, among others, Vladimir Majakovsky, Vladimir Tatlin, Kasimir Malevich, Natalia Goncharova, Velimir Khlebnikov and Mikhail Larionov (Illustration: The Cockerel, detail, c.1912, Tretiakov Gallery, Moscow). Italian Futurism also inspired some features of Rayonism, a doctrine conceived between 1912 and 1913 by Larionov and Goncharova, which constituted their first attempt to take painting towards abstraction. Rayonism based its principles on the physical laws of colour and the perception of light. The ray of light is represented on the painting by an explosion of lines of colour. On the eve of war, the various currents of Russian Futurism lost their initial character and, with the coming of Malevich's Suprematism, the protagonists of the avant-garde took other paths.

people placed before us. We shall henceforward put the spectator in the center of the picture."

As far as form was concerned, the Futurists, in their attempt to create effects of mobility and vibration or "dynamic sensation" in their art, had recourse to the principles used by Divisionist Post-Impressionism, with links both to the social realism of Angelo Morbelli and of Giuseppe Pellizza da Volpedo and to the Symbolism of Gaetano Previati. Examples of this are *Rissa in Galleria* (Riot in the Galleria) (1910) or *La Città che sale* (The City Rises) (1910–11) by Boccioni, or the *Funerali dell'anarchico Galli* (Funeral of the Anarchist Galli) (1910) by Carrà, some of the most significant works produced by adapting the Divisionist method to the realities typical of city life at a time of dizzying expansion.

The values of late nineteenth-century figurative culture, both French and Italian, were made known to

BIOGRAPHIES

♦ **Balla** Giacomo (Turin 1871–Rome 1958). He studied music and soon began to paint. In 1900 he left Rome to visit Paris, where he became acquainted with Post-Impressionist painting. He was also particularly influenced by Italian Divisionism and an interest in photography, which inspired him to adopt very personal compositional angles (*La pazza*, The Mad Woman, 1905). In

1912 he began his Futurist-inspired studies for the *Compenetrazioni iridescenti* (Iridescent Interpenetrations) whose triangular

chromatic forms still reflected Symbolist values. In his synthetic representations of the trajectories of motor cars and swallows (1913), movement is

rendered in terms of abstraction, though the original figurative starting points are retained. In 1915 he produced the *Manifesto for the Futurist Reconstruction of the Universe*.

♦ **Boccioni** Umberto (Reggio Calabria 1882–Verona 1916). After various early moves, Boccioni went to Rome in 1899, meeting Balla and Severini. In 1906 he began a journey through Europe,

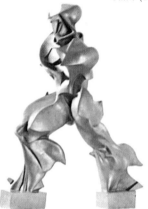

◀ Umberto Boccioni, Forme uniche nella continuità dello spazio *(Unique Forms of Continuity in Space)*, 1913, Museum of Contemporary Art, São Paulo (Brazil).

▼ Carlo Carrà, Funerali dell'anarchico Galli *(Funeral of the Anarchist Galli)*, 1911, Museum of Modern Art, New York. The painting clearly bears the mark of Carrà's previous Divisionist

experience, here directed at the interpretation of new social contents.

formal achievements of Picasso, Braque and Gris, and indeed of Cubism in general, were also particularly influential, although based on quite different premises, namely upon that static quality in theme and composition which the Futurists were always to oppose. Nonetheless, the formal synthesis attained by the Cubists through the decomposition of objects provides a partial key to the interpretation of Futurist paintings from 1911–12 onwards. The space–time identity is here interpreted in accordance with the new movement's emphasis on dynamic simultaneity of form and colour values, achieved with the use of complementary colours, which light up the palette expressionistically, and with the repeated fusion of object and setting. Boccioni in

the Futurist group by Balla, whose Roman studio was frequented between 1901 and 1904 by the young Boccioni and Severini. The Symbolist origins of Balla's painting influenced not only the initial formation of his two pupils, it also emerged as the central core of Futurism's development. The Futurist style was also clearly affected by contacts with the fevered climate of contemporary Paris, a contact that was made official in 1912 by one of the most important exhibitions in the history of Italian Futurism, at the Bernheim-Jeune gallery. The

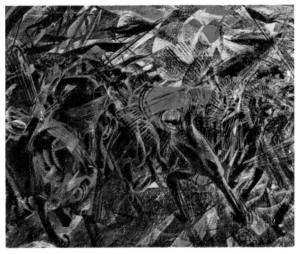

settling definitively in Milan in 1907. His early work bears the influence of his years in Rome, while his graphic work shows that of Art Nouveau and Beardsley. When, having joined the Futurist movement, he had a one-man exhibition at Ca' Pesaro in Venice, in 1910, he was in fact showing paintings that still had links with Symbolism and Divisionism. Among his first important works aiming at a

synthesis of the concepts of dynamism and simultaneity are the series of *Stati d'animo* (States of Mind) (1911). His later work was characterized by a plastic synthesis bearing the mark of a reinterpretation of Cézanne (*Ritratto del Maestro Busoni*, Portrait of the Composer Busoni).

♦ **Carrà** Carlo (Alessandria 1881– Milan 1966). Initially a mural decorator, he

studied at the Accademia di Brera, Milan, where he found new inspiration in Divisionism. His work as a Futurist, when his interest in the formal and constructional values of objective data was already emerging, also benefited from a relationship established with the Florentine artists of the review *Lacerba*. Around 1914, during a stay in Paris which consolidated his friendship with Apollinaire and

Picasso, Carrà became increasingly detached from Futurism, and shortly afterwards began to adhere to the theories of Metaphysical painting and "*Valori Plastici*."

♦ **Depero** Fortunato (Fondo di Trento 1892–Rovereto 1960). He met the Futurists in 1913. In 1915, with Balla, he signed the *Manifesto for the Futurist Reconstruction of the Universe*, embarking on a personal, magical and fairy-tale

165

▶ *Anton Giulio Bragaglia*, Il pittore futurista Giacomo Balla davanti al "Dinamismo di un cane al guinzaglio" *(The Futurist Painter Giacomo Balla in Front of "Dynamism of a Dog on a Leash"), detail, 1912. Photograph. From 1911 onwards Bragaglia began his own "photo-dynamic" experiments aimed at registering the speed of a body in motion.*

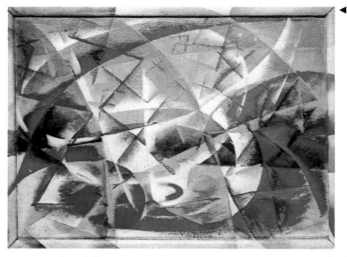

◀ *Giacomo Balla*, Velocità astratta + rumore *(Abstract Speed + Noise), 1913–14, Peggy Guggenheim Collection, Venice. The painting exemplifies Balla's particular interpretation of the concept of "dynamism," seen above all as a trajectory of colour and light, punctuated by moments of chiaroscuro whose succession gives movement to the whole composition. In reality, these movements are absolute, not relative to specific objects.*

particular based his artistic method upon these tenets, introducing the concept of lines of force (that is, the "directions of the forms and colour") as the fundamental principle of dynamism, which was applied and developed in his sculpture. Typical of such works is *Forme uniche nella continuità dello spazio* (Unique Forms of Continuity in Space) (1913), the plastic translation of a conceptually new dynamic tension, based on the decomposition and intersection of volumes.

However, the compositional results attained by the individual artists in the pursuit of these same concepts of simultaneity, mobility and interpenetration of planes differed widely.

The works of Balla, for instance, were totally abstract, starting with the *Compenetrazioni iridescenti* (Iridescent Interpenetrations) (1912–14): he was concerned with the objective and scientific analysis of the decomposition of light in relation to movement. Particularly important, at least in his first Futurist works, was the "photo-dynamic" research of Anton Giulio Bragaglia, an important experimenter in the field of photography and theater. Aiming to give a vi-

reinterpretation of Futurist interest in dynamism and the mechanical. After working in Rome as a set designer for Diaghilev, he opened his own design firm in Rovereto, designing furnishings and tapestries together with his wife Rosetta.

♦ **Marinetti** Filippo Tommaso (Alexandria 1876–Bellagio 1944). After graduating in Law at the University of Genoa and then in Literature in Paris, in 1905 he founded the international review *Poesia* in Milan, together with Sem Benelli and Vitaliano Ponti. As Futurism's first theoretician, he produced three different technical manifestos elaborating the concept of "*parole in libertà*" (words in freedom), inspired by the nineteenth-century French avant-garde. His most markedly "free-word" poetic compositions, *Battaglia Peso + Odore* (Battle Weight + Smell) (1912) and *Zang Tumb Tumb* (1914) are important literary documents, underestimated by academic criticism and only recently assessed their true value.

♦ **Prampolini** Enrico (Modena 1894–Rome 1956). Prampolini joined the Futurist movement in 1912, and was a frequent visitor to Balla's studio. His principal interest lay in the plastic rendering of the forms of objects: hence his particular relationship with the machine and the world of technology. In 1917 he founded the review *NOI*, through which he came into contact with Tzara and the Dadaists, and in 1923 (together with Panneggi and Paladini) he signed the manifesto *L'Arte meccanica* (Manifesto of Mechanical Art). In 1938 he returned to live in Rome, where he renewed his own "polymaterial" and "bioplastic" experiments.

▼ *Gino Severini,* Guerra *(War), 1915, Slifka Collection, New York. Severini executed several paintings inspired by the war during this same year, ranging from* Treno blindato *(Armoured* Train*), whose warlike subject is fairly explicit, despite the Cubist-inspired decomposition, to this work, which relies for its effect upon more symbolic references.*

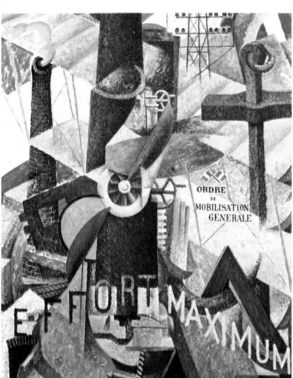

sual impression of the speed and trajectory of the movement of a body in space, along the lines of the earlier attempts made by Etienne-Jules Marey ("chrono-photography"), Bragaglia produced representations which dematerialized the object, representing it in all the luminosity and impalpable transparency of its dynamic course.

Severini took a quite different line in his interpretation of Futurist requirements with his lucid introduction of values typical of synthetic Cubism. A favourite motif – though he was always mindful of the movement's desire to glorify modernity – was the Parisian scene, whose elegance and joie de vivre is depicted for instance in the *Danse du Pan Pan à La Monico* (Pan Pan Dance at the Monico) (1910–12), called by the poet Apollinaire the most important work painted by a Futurist. Re-elaborating ideas suggested by reality, whether views of the Eiffel Tower or the boisterous whirl

♦ **Russolo** Luigi (Portogruaro 1885–Cerro di Laveno 1947). The son and brother of musicians, he began his career as an artist in 1909, with etchings of a Symbolist nature. In Milan he met Boccioni and took part in all the Futurist performances, as well as in the numerous exhibitions organized in Italy and abroad. In 1913 he drafted his manifesto *L'Arte dei rumori* (The Art of Noises) dedicated to the composer Balilla Pratella, in which he expounded a theory of the use of noises as musical events. A little later he abandoned painting to devote himself to research in the field of sound. Together with Ugo Piatti he created a series of *"intonarumori"* (noise organs), mechanical devices for the control of the intensity of noise, and in 1925 he patented the "enharmonic bow," enabling stringed instruments to obtain the same sound vibrations he had experimented with in some of his *intonarumori*.

♦ **Severini** Gino (Cortona 1883–Paris 1966). After practising a variety of professions in Rome, he turned to the study of art under Balla, through whom he became acquainted with French experiments in painting. He moved to France in 1906, and this new environment inspired some extremely original work, characterized above all by its elegance and formal rhythm, as well as by themes connected with Parisian life. When the Futurist group broke up, Severini became part of the Cubist circle of Léonce Rosenberg and, elaborating certain aspects of the work of Juan Gris and Georges Braque, by around 1920 he was painting works inspired by a modern classicism.

▼ *Enrico Prampolini,*
Béguinage
(Convent), 1914,
Private Collection,
Lugano. Foŕ the
Futurists, all the
elements of reality are
fed by the same vital
energy. Incorporating
them into a painting
means breaking all
barriers between the
work of art and reality
itself, endowing them
with a strongly
evocative and narrative
power.

of the boulevards, Severini achieved a vivid synthesis of forms in motion, through both the constructive use of primary colours and a very subtle geometrical decomposition. Severini was also one of the first to use the technique of collage, following the examples of Braque and Picasso, introducing fragments of paper of various

▼ *Giacomo Balla,* Insidie
di guerra *(Perils of*
War), 1915, Galleria
Nazionale d'Arte
Moderna, Rome. The
glorification of struggle
and interventionist
ideology are associated
in Futurist thinking by
an aesthetic rather than
a political nexus, linked
to the particular desire
to "regenerate" the
world according to the
new myths embodied by
machines. Confident of
technological and
scientific progress, the
Futurist vision of reality
is joyous and optimistic.
Like others dating from
this same year, this
work is characterized by
bright but basic tones
and the fluctuating
progress of the lines
through space.

kinds into his pictorial compositions, along with sequins and pieces of jewellery and cloth (as in some of his *Dancers*), so as to fuse the real with the pictorial. But it was Boccioni who introduced the concept of "polimaterismo" (polymaterial composition), with the aim of broadening the artist's visual and material range, and thereby intentionally narrowing the gap between the concerns of art and those of life. One of his most successful works in this field is *Cavallo + caseggiato* (Horse and Houses) of 1914.

Particular use of collage was also made around 1914–15 by Carrà, in his attempt to regain possession of "ordi-

nary things" through their formal and structural essence. Hence the choice of subject-matter such as the still life, which occupied an important place in his development. A position similar to that of Carrà, in its compositional aims and solutions, was that of Ardengo Soffici, the Florentine artist and intellectual who, through the pages of the journal "La Voce," was one of the first Italians to make French art known to the Italian public. Initially disappointed by Futurist painting, whose first exhibition he visited in Milan, Soffici subsequently drew closer to the Futurists, exhibiting with them in 1914 at the Sprovieri

Gallery in Rome and offering the review *Lacerba* (which he founded with Giovanni Papini in 1913) as a platform for the discussion, elaboration and publicizing of the movement's aims. *Lacerba* also published the plates of the plans for the *Città nuova* (New City) of Antonio Sant'Elia, a typical but possibly lone exponent of Futurist architecture, whose ideas concerning a new way of relating architecture and the urban context are symbolized by the vertical projection of his skyscrapers and by the myth of the industrial megalopolis.

The outbreak of the Great War, the deaths of Boccioni and Sant'Elia, together with

► *Antonio Sant'Elia, Città nuova: casa e gradinata su due piani stradali (New City: House and Staircase on Two Street Levels), 1914, Paride Accetti Collection, Milan. Architecture too was to be adapted to the changes imposed by the march of technological development. Futurist buildings displayed a completely new integration of the external environment.*

▼ *Ardengo Soffici, Frutta e liquori (Fruit and Liqueurs), 1915, Mattioli Collection, Milan. Soffici's compositions owe their specific character to his constant research into form and the objective fact. His reworking of the formal and conceptual problems deriving from French pictorial culture, particularly from Cubism, was a crucial aspect of his work.*

the growth of new areas of artistic interest among the various remaining members, marked a crisis within the movement. A new phase now began that was influenced by previous pictorial experiment, in particular the work by Balla on the dynamic synthesis of forms and colour, but characterized especially by the design and production of a wide range of objects and furniture, in accordance with the theories put forward in 1915 by Marinetti in the Manifesto for the Futurist Reconstruction of the Universe. Summing up the movement's interdisciplinary interests, signed by Balla and Fortunato Depero (an eclectic figure who acted as a link between the first and second generations of Futurists), the manifesto proposes the "reconstruction of the universe by making it more joyful, in other words by recreating it entirely. . . . We shall find abstract equivalents for all the forms and elements of the universe, then we shall combine them . . . to form plastic complexes which we shall set into motion." Thus the pervading vein of playfulness and inventiveness which had characterized Italian Futurism since its beginnings found expression in such artefacts as the "Futurist toy" and the "transformable garment" but above all in mechanical and noise-producing contrivances which reformulated the myth of the machine in a variety of different ways.

One distinguished interpreter of this phase was Enrico Prampolini, who signed the manifestos *L'Arte meccanica* (Mechanical Art) and *Scenografia futurista* (The Futurist Stage) among others. In this latter text Prampolini laid the basis of his own theories in the field of theater, and during the period between the two wars he emerged as one of the main figures in the revitalizing of international stagecraft. So-called mechanical art, on the other hand, was to play a part in Futurist concerns until the end of the 1920s, when

▼ *Liubov Popova,* Landscape, 1914–15, *Guggenheim Museum, New York. Between 1912 and 1913 Popova was living in Paris and studying under Le Fauconnier and Metzinger, whose very personal interpretation of Cubist theory she reflects. The landscape is broken down into numerous facets, plastically defined and revealed in the volumes by chiaroscuro.*

"aeropittura" (portraying the sensations of flight) was created with a 1929 manifesto. Together with the motor car, the aeroplane became the means of transport most acclaimed in Futurist pictorial and plastic experiments, dominating their creative imagination until the beginning of the forties, though not without a somewhat trivializing effect on their initial concern with dynamism and their exaltation of technological progress.

During the course of these three decades of activity, Futurist ideas became widely known in various countries, from Russia (where the Futurist movement was almost as important as it was in Italy) to Japan and Brazil, promoting a wide variety of experiments. In England, for instance, it became established under the name of Vorticism, a term derived from a definition by Ezra Pound in 1914. Initially the Vorticists were influenced by the Italian Futurists, who exhibited their work at the Sackville Gallery in London in 1912, but at a later stage the Vorticists distanced themselves from the Italian Futurists and elaborated a more abstract style. In Spain Futurism developed as Vibrationism, founded by Rafael Perez Barradas, who was to rework Marinetti's ideas in his own highly individual way. ∎

▶ *Fortunato Depero,* Balli plastici *(Plastic Dances), 1918, private collection, Milan. The fanciful demands for novelty proclaimed in the "Manifesto for the Futurist Reconstruction of the Universe" were developed in a highly original way in the sketches for scenery created by Depero between c.1916 and 1918 for the staging of* Balli plastici *(1918, with the collaboration of Gilbert Clavel), a projected theater where the actor is replaced by automatons, geometrically simplified manikins introduced into an artificial setting, highly coloured and almost metaphysical.*

Umberto Boccioni, Il lutto *(Mourning), 1910, Private Collection, Milan.*

Boccioni's pictorial research developed along two basic lines, the Divisionist and the Symbolist, blending with influences deriving from the secessions of Vienna, Munich and Berlin. This work reflects these, in the ''Expressionist'' treatment of the faces and in the contrast in colour between the dark clothes of the women, on the one hand, and the bright shading of their hairstyles and the heads of the flowers on the other. In fact, the figures represented are not six but two, seen simultaneously at different moments in their desperation, in accordance with the new Futurist principles.

Carlo Carrà, La Galleria di Milano *(The Galleria in Milan), 1912, Mattioli Collection, Milan.*

The bustle of the crowd in this celebrated center of city life was a favourite Futurist theme. Here Carrà's approach concentrates on balancing volume and depth, in a synthesis which is midway between Futurism and Cubism.

Giacomo Balla, Paravento *(Screen), 1917–18, Private Collection, Rome.*

In proposing a ''Futurist reconstruction of the universe,'' Balla and Depero intended to give form to ''every action which occurs in space,'' creating new objects defined as ''plastic complexes.'' Their range also included furniture, so as to put man and environment into a dynamic relationship with one another, particularly through optical effects created within a space saturated with colour.

Blériot flies across Channel	Death of Edward VII	Amundsen reaches South Pole	*Titanic* sinks on maiden voyage Proclamation of Chinese Republic	Balkan War Counter-revolution in China	Outbreak of First World War Opening of Panama Canal
Peary reaches North Pole	Curie: radium	Rutherford: theory of atomic structure	Freud: *Totem and Taboo*	Russell and Whitehead: *Principia Mathematica*	Broad: *Perception, Physics and Reality*
Strauss: *Elektra*	Stravinsky: *Firebird*	Schönberg: *Harmonielehre* Pratella: *Futurist Manifesto of Music*	Schönberg: *Pierrot Lunaire*	Stravinsky: *Rites of Spring*	Sibelius: *The Oceanides* Zandonai: *Francesca da Rimini*
Marinetti: *Manifesto del futurismo*	Marinetti: *Mafarka il futurista* Palazzeschi: *L'incendio*	D'Annunzio-Debussy: *Le martyre de Saint-Sébastien*	Claudel: *L'annonce faite à Marie* Shaw: *Pygmalion*	Cecil B. de Mille: *The Squaw Man* Apollinaire: *Alcools*	Gide: *Les Caves du Vatican*
Modigliani in Paris Diaghilev: *Ballets Russes*	Gaudí: Casa Milá (''La Pedrera'') Matisse: *La danse*	Fowler: *Concise Oxford Dictionary*	Kandinsky: *Concerning the Spiritual in Art* Delaunay: *Orphism*	Papini and Soffici's *Lacerba* Ford introduces assembly-line production	Kandinsky: *Impressions, Improvisations*
Boccioni: *Factories at Porta Romana (Suburbs of Milan)*	**Boccioni:** *The City Rises*	**Carrà:** *Funeral of the Anarchist Galli* **Larionov:** *Rayonism*	**Severini:** *Pan Pan Dance at the Monico* **Larionov:** *The Cockrel*	**Boccioni:** *Unique Forms of Continuity in Space* **Balla:** *Abstract Speed*	**Sant'Elia:** *The New City* **De Chirico:** *Sailors' Barracks*
1909	1910	1911	1912	1913	1914

Kasimir Malevich, Suprematism, *1915*, Russian Museum, St Petersburg. *The clear tendency towards abstraction during the second decade of the century is seen at its most radical with the "Suprematist" painting of Malevich. Here painting is reduced to its most minimal concrete components: a colour-laden surface, flat geometrical forms, the colour itself applied regularly and* homogeneously. *Each expressive element can thus be controlled, although the form lends itself to a symbolizing process that is close – at least with Malevich – to the tradition of the Byzantine icon.*

17 ABSTRACT ART

I t seemed inevitable that the avant-garde art of the beginning of the century should ultimately result in a painting devoid of any relationship with the external reality of objects, and hence an art no longer enslaved to visual experience. All the experiments carried out between 1900 and 1915 (from Symbolism onwards) converged upon that end, even if sometimes not in a completely clear and conscious way. With its interest in primitive styles and its search for a simplification of forms that would increase the work's powers of engagement, Expressionism was proceeding towards a notion of the painting as a "field of dynamic tensions," as a complex structure of forces and conflicts, freeing the pictorial result from any "banal" acceptance of the phenomena of the external world. Cubism too prepared the ground with a truly revolutionary conception of space, which – though starting from the claim of an effective fidelity to the date of perception – ended by destroying the most important of the accepted formal practises, perspectival representation. The work of the Fauves, too, which appeared to celebrate the lightness of a carefree world by plunging the onlooker into a euphoria of colour, actually tended to point to the possibility in art of an independent, fully self-sufficient language.

Here one should bear in mind the important part played by Henri Matisse, the leader of the Fauve movement. At the very moment of the group's official "chris-

▼ *Henri Matisse,* French Window at Collioure, *1914. The chosen theme of the French window open on to the night darkness leads Matisse* *to then dissolve any trace of the figurative image, while preserving his pretext of representation.*

tening" at the Salon d'Automne in 1905, he had an opportunity verbally to reveal the deeper aim of his painting: to a critic who had accused him of having used too many colours on a woman's face in the painting *La femme au chapeau* (Woman with a Hat), and who had laughed at the somewhat undignified appearance she had assumed as a result, Matisse replied: "*Monsieur, je ne crée pas une femme, je crée un tableau.*" (Monsieur, I am not creating a woman, I am creating a picture). And indeed during those years Matisse's painting was developing by becoming progressively distanced from the subjects which, nonetheless, continued to appear in it. In reality these were pure pretexts, useful, because of their novelty, in providing the constructive ideas on which

173

◀ *Henri Matisse, The Yellow Curtain, 1914–15, Hahn Collection, New York. In Matisse's work colour renders the surface dynamic, activating its internal tensions.*

▼ *Wassily Kandinsky, Painting with a Black Arch, 1912, Nina Kandinsky Collection, Paris. In this work, the title refers to a geometrical rather than a natural feature.*

to work. Matisse's method consisted of a continual intensification of the surface of the work by progressively reinforcing the impressions of colour. Colour, for Matisse, was not something external to human consciousness, but a feeling whose expressive power was used by the painter to give his work added solidity. Indeed, in the paintings of his most interesting period (*The Red Studio* of 1911, *The Blue Window* of 1912, *French Window at Col-*

lioure of 1914, *The Yellow Curtain* of 1914–15 and *The Piano Lesson* of 1916–17) he used reality as a sort of shadow of the painting, as something that served simply as a term of comparison, the better to make the main quality of its pictorial language stand out.

Abstraction was not really a movement, since it developed in widely scattered parts of Europe and, for the most part, with its main exponents working in mutual

independence. The first works where no imitative component was any longer recognizable were painted by Kandinsky from 1910–11 onwards. He was also the first painter explicitly to use the definition of "abstract art" for his own work, having taken it from an influential essay of 1907 by Wilhelm Worringer, *Abstractionism and Empathy*, in which the tendency to "sublimate" the data of reality was seen as having always been specific to paint-

BIOGRAPHIES

♦ **Balla** Giacomo (Turin 1871–Rome 1958). Around 1897 Balla was attracted by Divisionism, a style he was to abandon only in 1910, when he joined the Futurist movement of Filippo Tommaso Marinetti, together with the painters Carrà, Boccioni, Severini and Russolo. In 1912 he found an effective method for the representation of dynamism, and towards 1915 his art became virtually

abstract. In the same year, together with Depero, he published the manifesto for the *Futurist Reconstruction of the Universe*, which was to be fundamental for much of the Italian avant-garde during the twenties and thirties.

♦ **Kandinsky** Wassily (Moscow 1866–Neuilly-sur-Seine 1944). A graduate in law, Kandinsky began his career as a painter in his thirties and moved to Munich. Here he

came into contact with the European avant-garde and acted as intermediary between them and Russian Primitivism. In 1912 he published *Concerning the Spiritual in Art*, founded the *Blaue Reiter* group and painted his first abstract composition. At the outbreak of war he returned to Russia and, after the October Revolution, took an active part in the artistic projects of the new society. However, he soon found himself

in disagreement with the main exponents of Constructivism, and in 1921 he returned to Germany, where he was invited by Walter Gropius to teach at the Bauhaus. With the coming of Nazism he took refuge in Paris, where he remained until his death.

♦ **Magnelli** Alberto (Florence 1888–Meudon 1971). Between 1913 and 1914 Magnelli came into contact with the Italian and French

174

ing. But Kandinsky's first abstract phase reflected a very individual interpretation of the problem: before 1918 Kandinsky, a Russo-German artist (although born in Moscow, his general education and culture had been acquired almost entirely in Germany) had never practised any real pictorial structuralism. Indeed, geometrical forms are completely absent from his paintings. His detachment from the imitation of reality occurred rather through the progressive eroding of the image, becoming gradually more extreme before the demands of a "lyricism" based on the deep expressivity of colour. This was achieved by making liberal use of the model of music, the non-descriptive and non-narrative art par excellence.

Kandinsky's works from the first decade of the century, though still "figurative," are already characterized by this musical tendency. Using the methods of the Fauves and German

▼ *Wassily Kandinsky, Improvisation V, Nina Kandinsky Collection, Paris. The painting is a typical example of the balance achieved by the painter* *between the transfiguring force of lyrical emotion and reference to external reality.*

avant-gardes (Marinetti, Balla, Carrà, Apollinaire, Léger). In 1915 he painted his first abstract pictures, but later went through a neo-figurative phase, returning definitively to abstract art around 1933.

◆ **Malevich** Kasimir (Kiev 1878–Leningrad 1935). In 1904 Malevich threw in his lot with a young artists' commune in Moscow. He took part in all the major

movements of the Russian avant-garde, including Primitivism and Futurism. Between 1912 and 1914 he became widely known as the greatest representative of the new art, together with his colleague and rival Vladimir Tatlin. In 1915 he invented a style and a movement, Suprematism, which embraced a strictly geometrical and radical abstraction and whose works were at once material and spiritual,

rational and neo-mystical: so much so indeed that (despite his adherence to Constructivism in 1918–20) Malevich found himself accused of reactionary tendencies by the new exponents of Socialist culture. In 1928, after a quasi-triumphal trip to Germany, he fell definitively into disgrace, and was even imprisoned for several months. However, his funeral in 1935 was attended by a small parade of younger

followers. His coffin was decorated with a black square on a white ground.

◆ **Marc** Franz (Munich 1880–Verdun 1916). After studying theology he travelled to Italy, France and Greece. He soon became enthusiastic about the paintings of the Fauves, and in 1910 he came into contact with August Macke, then with Wassily Kandinsky. Together the three of them, and Arnold

Der Blaue Reiter

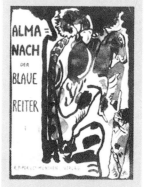

Expressionism, he abandoned the accepted colours of nature to use brilliant, intense tints, most of them cold and strident. The spots of colour, juxtaposed with a violence which was also extremely subtly gauged, ring out like notes in a strongly contrasting symphony. Kandinsky's was a world of counterpoint, not unlike that of the later scores of Gustav Mahler. Nor is it any coincidence that, from 1910 onwards, his works should mostly have been entitled "Improvisation," "Composition," "Impression," and that they were given opus numbers, like pieces of music.

In Kandinsky the transition from an increasingly ethereal and fluctuating figuration to true abstraction was so gradual and imperceptible that even when looking at the compositions of 1912–13, one is sometimes tempted to seek out some trace of landscape, some shape of a figure hidden in the free and fascinating span of colour, in the emotive tur-

The new abstract movement Der Blaue Reiter (The Blue Rider) was named after the almanac of 1912 (above), produced by Wassily Kandinsky and Franz Marc. It was Kandinsky who introduced the group to the idea of colour as an element capable independently of arousing powerful feelings ("inner resonances") in the observer. This theory, which descended more or less directly from Goethe's Farbenlehre, set out a vision of painting as a language of complex chromatic emotions, whose expression required neither the figurative image, through the mediation of phenomenal reality, nor a rigid geometrical construction. Alongside this more "rigorous" approach, and perhaps almost in contradiction to it, certain protagonists of the Blaue Reiter *cultivated a lyrical vision of the data of reality, transfigured and interpreted through the richness of the sensations it was able to arouse. This second pole, which Kandinsky was careful not to decry, was best exemplified in the work of Franz Marc and August Macke, whose paintings exhibited a tendency one might describe as "neo-Romantic."*

moil of harmonies and discords. In his study *Concerning the Spiritual in Art* (1912), after establishing the psychological values of the various basic tonalities and some of their combinations, Kandinsky claims that "in general, colour is a means of exerting a direct influence upon the soul. Colour is the keyboard. The eyes are the hammers. The soul is the piano with many strings." If it is true that "musical sound has direct access to the soul, and immediately finds an echo there, since man has music within him," who can deny that the same might be true for colour and painting? While artists like Marc and Macke were attempting something similar without totally excluding figuration from their paintings, for Kandinsky the descriptive element soon became a hindrance to the free construction of his colour references, which were to be regulated purely by their effect on the psyche. His painting is nonetheless

Schönberg, founded the *Blaue Reiter* (Blue Rider) in 1912. However, Marc's paintings retained a degree of naturalism and were thus distinguished from the abstract works of Kandinsky. He died in the First World War.

♦ **Matisse** Henri (Cateau-Cambresis 1869–Nice 1954). In 1891 Matisse went to Paris to study painting, entering the Académie Julian and working on the "classics," copying

and reworking. At the beginning of the twentieth century his painting still hovered between Seurat's

Divisionism and Gauguin's *à plat* technique, but by 1905 it was already a point of reference for the

young painters known as the Fauves. From then onwards his work became increasingly built around the theme of the power of colour and gradually, without ever really abandoning "figuration," it became the indispensable model for the future generations of abstract artists.

♦ **Mondrian** Piet (Amersfoort 1872– New York 1944). Mondrian began painting in a naturalistic style, but at

dependent upon an in-
stinctual gesture, which has
something of jazz music
about it, hence of improvisa-
tion, so that critics have
talked of "lyrical abstrac-
tion," in contrast with the
geometric art of Malevich
and Mondrian. During those
years Kandinsky was
strongly influenced by the
"a-tonal" research of his
friend Schönberg, whose aim
was to free musical compo-
sition from all established,
traditional formulae.

The situation of the
Russian Kasimir Malevich,
who was moving towards a
rigorously geometrical ab-
stract art around 1915, is
very different. In 1913, after
taking part in the experi-
ments of "Cubo-Futurism,"
which had helped him to
achieve a progressive com-
plete dismantling of repre-
sentational space (similar in
some ways to the efforts of
the French Cubists), he was
attracted by the literary theo-
ries of "trans-rationality." At
the time Velimir Khlebnikov
and Aleksei Krucenykh were

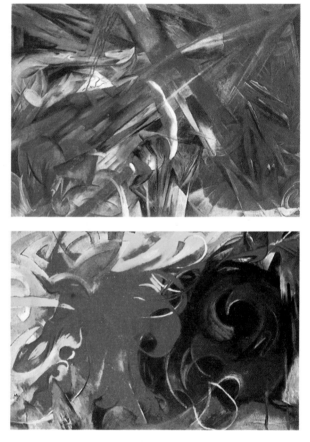

about the age of thirty
he became very
interested in
theosophy, to which
he remained faithful
throughout his life. He
regarded the Cubist
method as a means to
acquiring an
understanding of an
unequivocal rule: the
meeting of the vertical
with the horizontal, or
"cross." His abstraction
is a "philosophical"
painting, based on an
interpretation of the
image as a symbolic
and universal event.
Among other things,

this explains the
constancy with which,
between 1920 and
1940, he always in a
sense painted "the
same picture." Only in
New York, at the end
of his life, did he
abandon the scheme
elaborated twenty
years earlier and,
under the influence of
American culture,
embarked upon the
experiments entitled
Broadway Boogie-Woogie
and *Victory Boogie-
Woogie.*

♦ **Van Doesburg**
Theo (Utrecht
1883–Davos
1931). Initially linked
to the Fauves and
then to Kandinsky's
abstraction, around
1916–17 van Doesburg
began to develop his
mature manner, based
on the analysis of the
pictorial space as a
geometric–serial
structure made up of
elementary colour
masses. In the same
period he was involved
in the founding of the
review "De Stijl" and
with the group of the

same name
(Mondrian, Oud,
Rietveld). Until 1926
his ideas and
experiments were
linked to Neo-
plasticism, but in that
year he broke with
Mondrian for subtle
ideological reasons. In
1927 he published *The
Basic Concepts of the New
Figurative Art* in the
Bauhaus Book
collection, an
indispensable
document for the
theory of
Constructivist
abstraction.

◄ *Kasimir Malevich,*
Dynamic
Suprematism, 1916,
Museum Ludwig,
Cologne.

▼ *Kasimir Malevich,* Red
Square and Black
Square, *1916,*
Tretiakov Gallery,
Moscow.

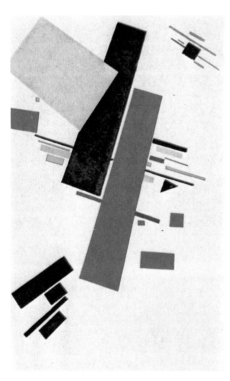

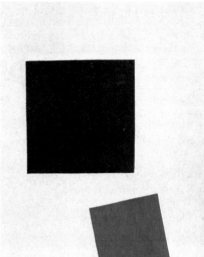

at the forefront of the poetic avant-garde, and were professing an almost blind faith in the independent powers of the word. According to these writers, language was not so much a means of communicating thoughts already in existence, as a system for the invention of thought, a machine which the artist must know how to use in the creation of "meaning." Thus, as the philosopher Martin Heidegger was later to say, it was a matter of "listening to language." To do this it was crucial, above all, to free the word from its traditional tasks, to stop considering it as a docile instrument which described reality and to make use of its evocative power, its irrational (a-logical) depth.

Malevich transferred these

principles to the field of painting: he put the single unit of iconic meaning – the "figure" – into an area without perspective or coherence, devoid of narrative co-ordinates, in which all parts fluctuated in a void, juxtaposed in an unrelated and chaotic way. The new format that resulted as for instance in *An Englishman in Moscow* of 1914, was one of internal balance within the picture: an order of "pictorial facts" in which, as in classical architecture, a vital part was played by numerical and formal relationships, by the balance of the parts and the harmony which could be expressed by the whole.

In 1915, at an exhibition which is regarded today as a turning point for the histor-

ical avant-garde, Malevich exhibited a painting of a black square on a white ground, with other paintings around it consisting of geometrical shapes in pure, brilliant colours, juxtaposed in corners of the canvas. This was the beginning of Suprematism, a pictorial movement, and above all a theory, which was soon to have many followers in Russia including Liubov Popova, Olga Rozanova and El Lissitsky. For its founder, the work of painting was unshackled by any subjection to the real world: indeed it was a real event in itself and for itself; it was as "concrete" as all the other objects that surrounded it. Thus the "object – painting" did not imitate reality: it existed, just as natural objects exist.

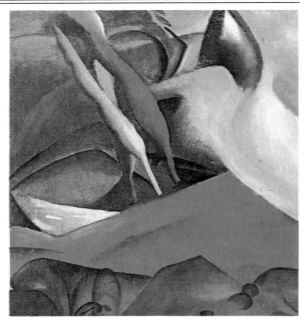

natural objects exist.

Painting is only a construction of colours on a two-dimensional plane. It is obvious that *Black Square on a White Ground* makes no claim to demonstrate the skill of its author: it is an idea made concrete, a sort of introduction to the new painting, but also the "last" word – uttered once and for all, according to Malevich's intentions – on imitation in art. If looked at with care, and without prejudice, the other works of the Suprematist period emerge not as mere acts of provocation intended to scandalize a conformist public: each work presents spatial problems (relationships between forms, the "weight" of the colour, internal movement) which are brilliantly resolved. Futurist dynamism, which Malevich had studied several years before, here found its mature outcome: not in the sense of a representational rendering of the dynamism of the external world, but in that of the transformation of the painting into a dynamic entity, one built around forces in equilibrium.

According to the principles of abstract art, each element of equilibrium, that is, of formal perfection, is quite simply the outcome of the control exerted over the active "pictorial forces": the norm by which they are governed is based upon the psychological effect of colour and its arrangement into shapes. It is obvious, then, that a construction of a geometrical type allows for greater control of the desired effects. This explains why, with the exception of

▼ *Liubov Popova,* Architectonics with Axis of Yellow Wood, *1916, Tretiakov Gallery, Moscow. Aware as she was of the problem of the relation between surface and spatial effect, Popova turned to the geometric language of Suprematist painting, superimposing "built" elements derived from the work of Tatlin.*

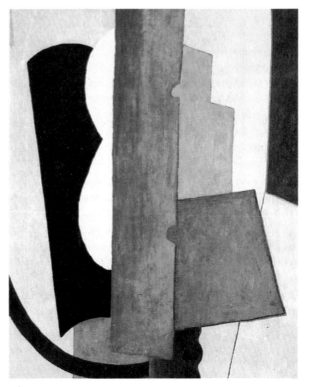

▼ *El Lissitsky,* Story of
Two Squares, *1920,
UNOVIS Eds., Vitebsk.
This picture is part of a
book designed and
made by Lissitsky:
using an invented
allegorical language
derived from*

*Suprematism, it gives a
concise and vivid
description of the
reconstruction of the
world achieved by the
proletarian revolution.*

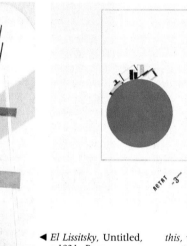

◀ *El Lissitsky,* Untitled,
*c.1921, Peggy
Guggenheim Collection,
Venice. Evidence of
Lissitsky's Suprematist
formation is not limited
to biographical fact,
which tells us that he
taught art at Vitebsk
(together with
Malevich) around
1920. It also emerges
from such paintings as*

*this, where the
construction is based on
geometrical units of
chromatic surface
arranged in dynamic
equilibrium.*

based primarily on Euclidean
geometry. The most ob-
vious example is that of Piet
Mondrian. His early paint-
ing, at the end of the
nineteenth century, was
naturalistic, but at the begin-
ning of the twentieth century
he drew closer to the Fauves
and came into contact with
Cubist painting in 1912.
From that moment onwards
he worked ceaselessly to-
wards the complete de-
composition of the image
through planes and linear
fragments, soon overlooking
the fact that Cubism's initial
aim had been to obtain a
more complete (and not
merely optical) representa-
tion of reality, so that be-
tween 1915 and 1920 his
painting became increasingly

cerebral and rarefied. With
Neo-plasticism he claimed
that he wanted to pursue an
art of "pure relationships,"
that is, according to his own
explanation, a painting that
expresses nothing other than
those formal relationships
that naturalism had been
concealing under its depic-
tion of objects for centuries.
In effect Mondrian's work
between 1920 and 1940
shows a radical reduction of
the painting into the funda-
mental elements of visual
perception: the vertical line,
the horizontal line, the pri-
mary colours – red, yellow
and blue – enclosed in square
or rectangular areas, plus
black and white used respec-
tively as background and line.
These elementary features

refer to the basic co-
ordinates of human experi-
ence – the horizontal plane
of the ground (or axis formed
by the eyes), the vertical line
of the upright position –
which in their turn are rich in
symbolic connotations: one
need think only of the in-
finite implications of the
above–below relationship on
a moral, religious or logical
level.

Basically, abstract painting
does away with the Renais-
sance norm of the "trans-
parency" of the painting and
replaces it with a conception
of the surface as dense and
opaque, by virtue of which
what "is seen" is only ever
the surface itself, treated in
various ways. Its language
thus includes the "concrete"

thus includes the "concrete" quality of the painting, its spatial proportions, stylistic assonances and dissonances, colour harmonies and clashes. All subsequent non-figurative painting kept to this principle, from the Dutchmen Vantongerloo and van Doesburg to the Germans Albers and Itten, the Russians Rodchenko and Puni, the Italians Magnelli and Prampolini.

Last, it should be stressed that the two most important artistic tendencies of the early twentieth-century avant-garde are closely inter-linked. It might seem surprising (at least at first sight) that the logical outcome of the various currents of abstract art – that is, of the theories of Malevich, Mondrian and Kandinsky – should become evident in so many of the developments of functionalism in the twenties. The main teaching experiments of the decade, like the main studios for the applied arts, made particular use of the contributions of abstract painting. Though purged of its neo-mystical elements, the "lesson" of Malevich was passed on through his pupil Lissitsky, an important exponent of Socialist Constructivism and something of an ambassador of Soviet art throughout Europe. Mondrian, for his part, was one of the protagonists (with van Doesburg, Rietveld and Oud) of the functionalist movement De Stijl, whose theories derived explicitly from the ideas of Neo-plasticism. Kandinsky later joined the German Bauhaus school as a teacher. There, along with a complex theory of "pictorial knowledge," he reshaped his own image as a restless and revolutionary artist, finding

▼ *Piet Mondrian,* Tree, *1912, Carnegie Museum of Art, Pittsburgh. This picture, painted shortly after the "Cubist turning point" of 1911, is a striking example of the gradual way in which Mondrian moved from naturalism to abstraction.*

that he could now work most creatively alongside architects such as Gropius and Mies van der Rohe, designers such as Moholy-Nagy, stage designers such as Schlemmer and painters such as Feininger and Klee. ■

▶ *Alberto Magnelli,* Lyrical Explosion, *1918, Beyeler Gallery, Basle. Aware of the importance of analyzing the structure of what is seen, an aim introduced at the beginning of the century by Paul Cézanne, Magnelli's painting reveals the search for the vital linear movements that determine the perception of the image.*

Wassily Kandinsky, First Abstract Watercolour, *detail, 1910, Musée National d'Art Moderne, Paris.*

Rightly regarded as the very first completely abstract painting, it anticipates the results of the Blaue Reiter phase by about two years. An isolated experiment, it was to bear fruit only much later. This explains the work's unexceptional quality and the choice of watercolour, which Kandinsky did not usually favour.

Kasimir Malevich, Black Square on White Ground, 1915. *Original lost.*

"I have become transformed into the zero of forms, and have dragged myself out of the junkyard of academic art" were the words with which Malevich celebrated his arrival at geometric abstraction. Considered as the most extreme example of the iconoclastic spirit of the historical avant-garde, this painting was Suprematism's opening shot: it proclaimed a painting that emphasized the importance of form as an independent intellectual entity.

Piet Mondrian, Composition, *1921, Musée National d'Art Moderne, Paris.*

The remarkable balance that characterizes all Mondrian's Neo-plastic compositions is created by an almost metaphysical arrangement of space, attained in an intuitive and spontaneous way; for this reason it contrasts with the apparent rational control with which the work appears to have been composed. The fact that the picture cannot be explained in mathematical terms contributes to its aesthetic power.

Revolution in Mexico Universal suffrage in Italy	Assassination of Archduke Ferdinand at Sarajevo Outbreak of First World War	Battle of Verdun Battle of the Somme Woodrow Wilson President of US	October Revolution in Russia Female suffrage in Britain	Treaty of Versailles Prohibition in US Weimar Republic	Washington Conference on disarmament New Economic Policy in Russia
Hess: cosmic radiation	Geiger: Geiger counter	Freud: *Introduction to Psychoanalysis*	New technology: tanks, machine guns	Keynes: *The Economic Consequences of the Peace*	Anti-tuberculosis vaccine
Strauss: *Der Rosenkavalier* Stravinsky: *Firebird*	Original Dixieland Jazz Band Scriabin: *The Poem of Fire (Prometheus)*	Debussy: *Etudes* Holst: *The Planets*	Satie: *Parade* Ravel: *Le Tombeau de Couperin*	Webern: *Lieder*	Berg: *Wozzeck*
Mann: *Death in Venice* Wells: *The History of Mr Polly*	Lawrence: *Sons and Lovers* Husserl: *Phenomenology*	Frazer: *The Golden Bough* Dewey: *Democracy and Education*	Strachey: *Eminent Victorians* Kafka: *Metamorphosis*	Pound: *Cantos* Woolf: *Jacob's Room*	Eliot: *The Wasteland* Joyce: *Ulysses*
Der Blaue Reiter in Munich Gaudí: Park Güell	Gilbert: Woolworth Building, New York Futurism in Italy	Duchamp exhibits "ready-mades" Griffith: *Birth of a Nation*	Tzara: *Manifeste Dada* De Stijl at Leyden	Piet Mondrian: Neo-plasticism Gropius founds the Bauhaus	Discovery of tomb of Tutankhamen *Neue Sachlichkeit* (New Objectivity) in Germany
Marc: *Blue Horses* **Picasso:** *Girl with Mandolin*	**Delaunay:** *Homage to Blériot* **Macke:** *Woman with a Green Jacket*	**Malevich:** *Dynamic Suprematism* **Mondrian:** *Composition No. 10*	**Modigliani:** *Portrait of Madam Anna Zborowska*	**Tatlin:** *Monument to the Third International*	**Mondrian:** *Composition in Blue* **Gris:** *Bottle, Glass and Fruit Bowl*
1910–12	1913–14	1915–16	1917–18	1919–20	1921–22

Paul Klee, Red-Green Gardens, 1921, Yale University Art Gallery, New Haven, Conn. This work is an important example of Paul Klee's purism. With the disappearance of traces of the "organic" as such, geometry and the constructive take on a main, even predominant, role. If some emotional matter is still at the root of the work, here it emerges through the filter of the intellect, conforming to a rule of its own, and to a deep intellectual detachment.

18 BAUHAUS AND CONSTRUCTIVISM

The dreams of progress and universal peace, generated by the rapid scientific developments of the first decade of the century, were shattered once and for all, around 1914, by the tragedy of the First World War. However, the lure of the new technological advances persisted, even after the end of the war, and continued to feed hopes of social and cultural growth. What is more, industrial development was now interpreted in Marxist terms as radical political change. If the dilemmas of the individual were not resolved, and both disenchantment and loss of identity sometimes led to irrational proposals, one current of artistic research drew positively from the present, making it an instrument of knowledge and drawing from it elements of a new faith in humanity which could fight the temptations of death and flight from reality.

Characterized by an interest in pictorial abstraction and an acceptance (at least in part) of Socialist thought, the parallel experiments of the Bauhaus in Germany, Constructivism in Russia and De Stijl in Holland emerged almost contemporaneously, between 1917 and 1920. Abstract art, rightly interpreted as a reduction of language to its objective data, seemed to express a need for the concrete which was (as Mondrian mentioned in the first number of the review "De Stijl") quite simply the mood of the moment. Art had to respond to the revolution in technology and the new social needs, but it also

◀ *Walter Gropius*, Fagus Factory, *1910–11, Alfeld-an-der Leine. The great stylistic novelty of the architecture – the idea of the glass and steel cube elevated to a system – looks forward to the atmosphere of Weimar.*

▼ *Lyonel Feininger, Mellingen, 1919, Philadelphia Museum of Art. Feininger's work gave a lyrical impetus to pictorial rationalism.*

had to remain faithful to itself, and thus resolve the clash between aesthetics and life. It did not avoid, indeed it sought, involvement in technological matters and the methods of industrial production, basing itself on the concept of the practical. This stance did not aim to ignore the problem of the mass use of the object: indeed, it was committed to making aesthetic values more prevalent in everyday life. So here modernity

meant a double normalization: the registering of the emergent realities (the proletarian metropolis, the very existence of the working-class and the need for the relevant appropriate services) but also the determining of a "norm" which would, in general, respect men's deeper needs. From small-scale craft activity to the large-scale planned works of engineering, design rejected all compromise with imitation, and pre-established creative categories.

The *Bauhaus Manifesto* declares: "Let us then create a new guild of craftsmen without the class-distinctions that raise an arrogant barrier between craftsman and artist. Together we shall conceive and create the new building of the future, which will embrace architecture, sculpture and painting in one unity and which will one day rise to heaven, as a crystalline symbol of a new, coming

▼ *Adolf Loos, Building on the Michaelerplatz, Vienna, 1910. In the Vienna of the beginning of the century the bank and the insurance company, temples of economic power and bourgeois life, inspired a whirl of avant-garde novelties. The dwelling house was fitted in among them in a fabric now drastically devoid of ornamentation.*

faith." The Bauhaus (literally, "Building House") was a school of arts and crafts founded by Walter Gropius in 1919 to tackle the problem of artistic working patterns in the realm of the industrial product and everyday article. Architects, painters, sculptors and technicians were invited to teach there: Oskar Schlemmer, Wassily Kandinsky, Paul Klee, László Moholy-Nagy, Lyonel Feininger, Johannes Itten, Adolf Meyer and later Josef Albers and Marcel Breuer, who had themselves been

▼ *Walter Gropius, Bauhaus, Dessau building, 1925. The powerhouse and temple of architectural and urbanistic experimentation, Bauhaus's own rudimentary structure reflected the rigour of the line which inspired the teaching of its collaborators. In both Weimar and Dessau, its second home, the project benefited from the work of artists who were to continue its traditions in the years of exile.*

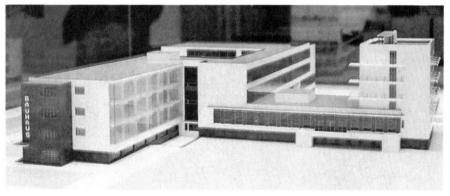

BIOGRAPHIES

◆ **Feininger** Lyonel (New York 1871–1956). The son of German musicians, in 1887 he went to Hamburg to study music and composition. In the first decade of the new century he became involved in the Expressionist movement and came into contact with Kandinsky. Later he became a friend of Paul Klee, and started to work with him on the Bauhaus experiment in 1919.

Here, together with Kandinsky, Klee and Jawlensky, he engaged in a degree of moderate internal confrontation, countering the rationalism of Gropius with a more lyrical conception of pictorial form.

◆ **Gropius** Walter (Berlin 1883–Boston 1969). Gropius collaborated with the Deutscher Werkbund as a designer, and was the architect of the *Fagus Factory* (1910–

11) and various other buildings and interiors. In 1919 he founded the Bauhaus at Weimar, and in 1925 designed a new building for it in Dessau. He took part in the reformist socialist movement and was involved in the planning of working-class districts. After the coming of Nazism he moved to Britain and then to the United States, where he was extremely productive in architecture and town planning.

◆ **Klee** Paul (Münchenbuchsee 1879–Muralto 1940). A Swiss painter, the author at first of etchings and watercolours and drawings of particular expressive intensity, he then exhibited with the *Blaue Reiter* group. During his period of involvement with the Bauhaus he elaborated the theses contained in the *Pedagogical Sketchbook* and in the *Theory of Art and Figuration* (published posthumously in

pupils at the school. Courses lasted three and a half years, with studies centering on the nature of the materials, the processes of production (from structuring to decorative aspects) and problems of representation and composition, in accordance with an "organic" approach that, as Giulio Carlo Argan observes, embodied a thorough synthesis of constructional knowledge. The students' work was exhibited and the teaching methods were made known through lectures, demonstrations and books. None of this, however, much pleased the citizens of the fragile Weimar Republic, and in 1925 the Bauhaus had to move from its capital (the city of Weimar itself) to Dessau, to a building designed by Gropius, in reinforced concrete and glass. In 1928 Hannes Meyer became its director. From 1932 the institute was housed in Berlin and directed by Mies van der Rohe. The repression of all forms of "degenerate art" finally entailed

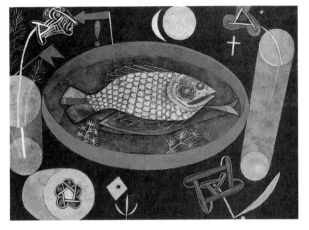

its definitive closure by the Nazis in 1933. However, the name did not disappear, because in 1937 Moholy-Nagy took up the directorship of the New Bauhaus, in Chicago, and the mass exodus of the protagonists of the European avant-garde to the United States ensured their continued creative influence.

Like the Russian Constructivists, the Bauhaus artists were influenced by the theories of Neo-plasticism and Suprematism. It was no coincidence that in 1927 the Bauhaus Book collection, edited by Moholy-Nagy, should have published Kasimir Malevich's *The Non-Objective World*, and that Mondrian's pamphlet *Neoplasticism*, already published in Paris in 1920, should have been republished in the same series with the title *Neue Gestaltung*, where the transition from form (*Gestalt*) to "formation" (*Gestaltung*) is explicit. This concept is similar to that of

1956). From 1931 to 1933 he taught at the Düsseldorf Academy, then was forced to leave Germany and return to Switzerland, to Berne, where he continued to work despite the serious illness which led to his death in 1940.

◆ **Lissitsky** Eliezer called El Lissitsky (Smolensk 1890– Moscow 1941). An architect, graphic artist and painter, involved initially in Cubo-Futurism, after the

1917 Revolution he saw the function of the artist as being that of the "builder of a new world of objects." He was a supporter of Malevich's Suprematism, collaborating with him on projects which reconciled abstraction and functionality. He was active in the field of propaganda and publishing. His close relations with Moholy-Nagy and the artists of De Stijl made him something of an ambassador for

Constructivism in Europe between 1920 and 1930. He returned definitively to the Soviet Union towards the end of the decade, to devote himself to architecture and the theater.

◆ **Moholy-Nagy** László (Bacsborsod 1895–Chicago 1946). A painter, photographer and graphic artist, influenced by the climate of Neo-plasticism and the early phase of

Constructivism, from 1922 he was invited to teach at the Bauhaus in the metalwork shop and was in charge of the Bauhaus Book series. He then went to Berlin as a set designer and collaborated with Erwin Piscator. With the coming of Nazism he left Germany for the United States, where he founded and directed the New Bauhaus in Chicago. Towards the end of his life he was involved in visual and kinetic art.

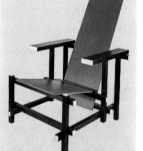

"construction," and expresses the need for the rational involvement of form in the vast field of practical articles — something that was subsequently to give rise to the field of industrial design. Even in the twenties the mood was decidedly international: the same ideas recurred from the Bauhaus in Germany to De Stijl in Holland and Constructivism in the Soviet Union, drawing upon the architectural works of their "predecessor" Adolf Loos in Vienna, those of Le Corbusier in France, Frank Lloyd Wright in the United States and, later, of Alvar Aalto in Finland.

However, it is interesting to note that the Bauhaus's structure did not exclude lyrical and emotional approaches, such as those of Kandinsky and, above all, of Klee. Invited in 1920 to teach painting (later with Kandinsky) Paul Klee made his first systematic commitment by producing about 3,000 manuscript pages and innumerable drawings, in which

Appearing as they did on the motley scene of twentieth-century tendencies, the two movements of Constructivism and the Bauhaus had in common the ideology of functionalism, which advocated close attention to the problems of society. The Bauhaus was more closely linked to social-democratic reformism, while Russian Constructivism inclined towards the revolutionary founding of a new world. However, the two movements shared a complete faith in mankind. Man can, and hence must, fuse reason and imagination, in order positively to plan his own future and create an order different from the existing one. The rejection of tradition was not limited here to the critical and destructive phase, but countered the rejected values with a "new" order which was seen as a product of rigorous technical and structural analysis, and which tended to see the commitment of each as coinciding with the overall growth of the community. Above: Gerrit Thomas Rietveld, Red and Blue Chair, 1918, Museum of Modern Art, New York. It is notable for its elementary form and reinstating of craft values.

he defined the essentials of a "science of art." For him, painting must develop in accordance with the organic laws of nature. The need for methodological clarity offered Klee's psychic universe, with its rich network of allusions nicely balanced between the ironic and the anxious, the possibility of a new ability to distance itself from what had previously rendered it somewhat enigmatic. In other words, the unconscious matrix of his art remained, but was now more controlled; the ferment of the natural world did not disappear, but was stripped of its emotional impurities. The rigorous premises he kept to during his period at the Bauhaus, and his professional position, imposed upon Klee a scrupulous discipline to which he remained faithful `throughout the period of his teaching, committing him to a more active and punctilious involvement than any other teacher.

The Constructivist movement in Russia was born in

♦ **Rietveld** Gerrit Thomas (Utrecht 1888–1964). One of the most important architects and designers of the century, after involvement in De Stijl he successfully applied the aesthetic principles of Mondrian and van Doesburg to the forms of the everyday object. In this way he helped to broaden the implications of Neoplasticism and of abstract art in general. His works include the famous *Red and Blue Chair* of 1918 and the *Schröder House* at Utrecht of 1924.

♦ **Rodchenko** Aleksandr (St Petersburg 1891–Moscow 1956). A versatile artist, a participant in the most important experiments of the Russian and Soviet avant-garde, at first he was drawn to Cubo-Futurism, then to "Non-Objective" Suprematist painting, and he then played an important part in the Constructivist movement as illustrator, painter, photographer, and stage, poster and graphic artist.

♦ **Schlemmer** Oskar (Stuttgart 1888–Baden Baden 1943). Initially

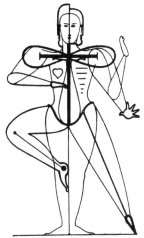

a period of active cultural debate and of great political upheaval. From 1907 at least, Moscow and St Petersburg staged a succession of eclectic exhibitions of an international nature. "Where are we going?" the publishing house Zarja asked Rus-

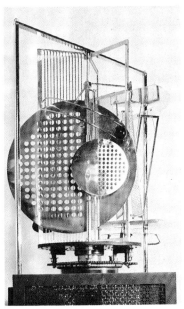

▶ *László Moholy-Nagy,* Light and Space Modulator, *c.1925– 30, Busch-Reisinger Museum, Harvard University. The sense of the constructive, of the synthesis of arts and techniques, but above all a brilliant prefiguration of kinetic art (the art of movement) can be clearly seen in this work, where research into the properties of the materials, chosen so that their compositional effects will also be varied, is further enriched by a wonderful transparency and marked dynamism.*

sian artists in 1910, and the replies indicated that at least some artists were going from Suprematism to Futurism and Cubism, with a strong tendency towards the revaluation of the autonomy of art and the specific nature of its language. Articles, essays and reviews of foreign publications were being written which paid almost obsessive attention to everything that came from France, Italy and Germany. Avant-garde art made use of something of the iconoclastic rage of the Futurists but also confronted the problem of the concrete work, for which it used the instruments of Cubism. Nor did any excessive creative daring intervene to disturb the relations established between the building and its correct function: everything was simple and based on the measure of man. One basic discovery was that of "texture," a notion used to refer to the objective form of the pictorial matter, and which was added to the basic concepts of point, line and plane

influenced by Cézanne and Seurat, he then became interested in Cubism and became involved with the Bauhaus in the early twenties, teaching mainly sculpture and stage design. He is best known for his broad and stimulating project of "total art," conceived as the interaction between the various plastic disciplines in the melting pot of theatrical performance.

◆ **Tatlin** Vladimir (Kharkov 1885– Moscow 1953). One of the founders of Cubo-Futurism, he was deeply influenced by Picasso. Critics have seen his *Counter-Reliefs* (1913–16) as the premises for Constructivism. From 1917 he became a supporter of the theory of the functionality of art in the service of the Revolution. In 1919– 20 he designed the *Monument to the Third International.* He was then involved in

industrial design, stage design and various branches of technology, including a Leonardoesque flying machine. His conception of art was characterized by extreme broad-mindedness, doing away with all demarcation lines, to become concerned with a wide range of technological applications and the most varied aims.

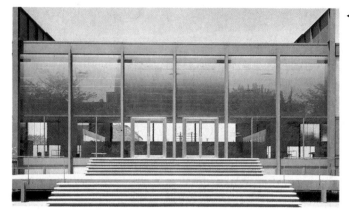

Ludwig Mies van der Rohe, School of Architecture and Design, detail, 1952, Illinois Institute of Technology, Chicago. As in Europe, in the United States too Mies van der Rohe's research was distinguished by a spirit of continuity. Solid and plastic at the same time, this work from the fifties seems to refer back to his creative achievements of the twenties.

(Kandinsky's treatise *Point and Line to Plane* was published in 1926, in the Bauhaus Books series). The word "Constructivism" was used for the first time by the critic Nikolai Punin in reference to Tatlin's *Counter-Reliefs* of 1913–14, sculptural assemblages which reflected a marked interest in mechanical techniques; Tatlin himself claimed that the Constructivist artistic revolution had begun in 1913, thus anticipating the political revolution of 1917 by more than four years. It should,

however, be noted that only in 1919–20 was the movement really coherent and active. Its birth was hastened jointly by the *Realistic Manifesto* (1920) of Naum Gabo and Anton Pevsner and the "productivist" theses of Aleksandr Rodchenko which appeared in the catalogue of the exhibition $5 \times 5 = 25$. These pinpointed Tatlin as a precursor, but they were quite clear about the new relationship established by the October Revolution between art and politics. The analogies with the more significant

tendencies of the period (Cubism, Dadaism, Futurism) were intensively discussed or polemically rejected. But one common denominator did exist: the repudiation of bourgeois art, and an intolerance of the standardized forms of cultural consumer goods, the need for the innovative, even if there was a clash of positions as to the methods of and recipients for this innovation. Although industrial technological means were welcomed, there was no desire for grandiloquent build-

Gerrit Thomas Rietveld, Schröder House, front façade, 1924, Utrecht. This house is a key example of architectural rationalism: all superfluous ornamentation has been rejected, the surface reduced to elementary forms; we see here clearly both an analogy with Rietveld's own red and blue chair, and a fertile interchange between a rigorous formalism and a sense of creative harmony.

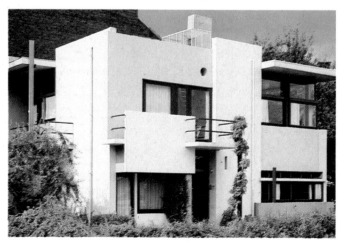

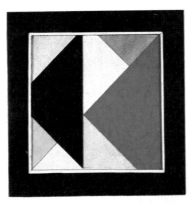

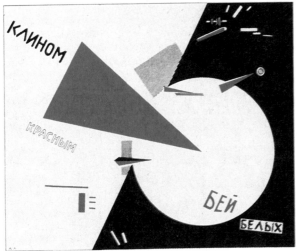

Schlemmer, Rietveld, Oud, van Doesburg and Kandinsky himself who, from 1921, was an exile at the Bauhaus after a historic quarrel with his Russian colleagues.

LEF (Journal of the Left Front of the Arts), with Eisenstein, Mayakovsky and Babel, proclaimed the need for a new, original art, characterized by novel procedures and unique expressive forms. While the "realism" of the Pevsner brothers (though the definition implies a meaning different and almost opposed to the usual sense of the word) saw art as being outside time, the expression of a free aesthetic calling, LEF maintained that "the collective art of the present is constructive life," and conceived of technology as the abolition of bourgeois traditions. Rodchenko, Varvara Stepanova and Tatlin replaced the term "work" with that of "thing," or *veshch* (object), to designate a combination of properties (light, space, plane, colour, volume) and human labour. El Lissitsky, who trained alongside Malevich, called his own paintings *Proun*, concrete projects, syntheses of form and material. Furthermore, these abstract paintings were only the preliminaries to the development of El Lissitsky's better-known works in propaganda graphics, publishing, architecture and design. His typographical achievements (*The Story of Two Squares, For the Voice*), for example, are positive miracles of technique and formal judgement, among the finest the art of our century has produced

ings for the glorification of power, but rather for new buildings for a new society, designed with man as their measure without sacrificing the idea of beauty to that of functionality.

The course of Russian abstract art mobilized by the Revolution may be gauged by considering the range of positions from Malevich and his increasingly radical Suprematism (the series of paintings *White on White* dates from 1917) to those of Vladimir Tatlin, Ivan Puni, Liubov Popova and Aleksandra Ekster. These same protagonists of earlier stages were to come together in the single current of Constructivism, and for a short time they managed to exist side by side while retaining their own peculiarities. They are all to be found again, after 1920, in the various schools of applied art, such as VKHUTEMAS and INKHUK, which were positive hotbeds of Soviet Functionalism. External contributions to their united aims were also made by various non-Russian protagonists: Moholy-Nagy,

191

▼ *Vladimir Tatlin, design for the* Monument to the Third International, *1919–20. This design and other Utopian projects in public architecture and propaganda were some of the artistic products in which the new spirit found expression. Technology offered art particular connections inspired by the idea of renewal, of which stylistic daring was an integral part.*

and inspired a whole generations of graphic artists. In the same way, Rodchenko was abandoning the paintbrush as early as 1919 and – after having elevated ruler and compasses to the level of an artist's chosen instruments – he devoted himself to all kinds of design, in photography, publishing and illustration.

The dream of art at the service of society was also translated into works of public architecture, such as the *Monument to the Third International* by Tatlin, of 1919, for which only the preparatory model was made. The finished work was to be higher than the Eiffel Tower: a steel spiral spinning up into the sky, intended to symbolize the Utopian impetus of the course undertaken by the Revolution; inside, three immense solids (a cylinder, a pyramid and a cube), rotating at different rates, were to mark the phases of the new era. In 1923–24 plans were drawn up by the Vesnin brothers for the *Palace of Labour* and the offices of *Pravda,* in Leningrad, and in 1925 Konstantin Melnikov's pavilion was put up at the Exposition des Arts Décoratifs. These same years also saw the development of the inspired town-planning of Ivan Leonidov, but also, unfortunately, the dictatorship of Stalin, which promptly began eroding all possibilities of free thought. Soon after 1930, Stalinism was to mark the end of the avant-garde in the Soviet Union – though one might also say of all artistic activity whatsoever. ■

▼ *Aleksandr Rodchenko,* Propaganda Manifesto, *1924. Here we have the poster used to put into practice the theoretical premises of the artistic avant-garde. A face shouting a message is incorporated into the usual sequence of geometrical elements. In this way not everything is sacrificed to pure abstract linearity, but the general layout of the image remains clearly decipherable as an overall key to its meaning.*

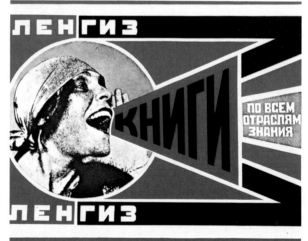

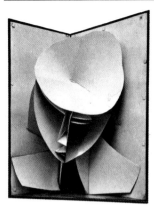

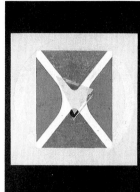

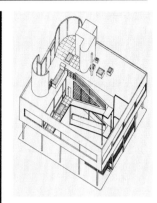

Naum Gabo, Woman's Head, *1917–20, Museum of Modern Art, New York.*

The position of Gabo (and his brother Anton Pevsner), that of so-called realism, went well beyond the usual meaning of the word. Realism was expressed through absolute values, that is, made up of forms reduced to their simplest, but basically concrete, elements.

El Lissitsky, Proun, *1924, Tretiakov Museum, Moscow.*

Once more, this Proun *demonstrates a fascination with the project and the principle of a synthesis in which form and matter complement each other; it is a work of stylistic rigour and scrupulous craft. The artist's skill is subjected to a disciplined concentration on the actual effects.*

Le Corbusier *and* **Pierre Jeanneret**, *Villa Savoye, 1929–30, Poissy. Axonometric drawing.*

Le Corbusier's work, although outside the framework of the Bauhaus and avant-garde constructivism, is nevertheless a mature example of the aesthetic functionalism which dominated twentieth-century architecture.

October Revolution in Russia First World War	Alcock and Brown fly across Atlantic Weimar Republic	Formation of USSR Fascist state in Italy First Labour government in Britain	Stalin becomes leader of USSR Lindbergh flies solo across Atlantic	Wall Street Crash	Hitler Chancellor of Germany New Deal in US
Langmuir: tungsten filament lamp	Rorschach Test	Wittgenstein: *Tractatus Logico-Philosophicus*	Fleming: penicillin	Eastman: first colour film	Marconi: microwaves
Delius: *Requiem*	Prokofiev: *The Love for Three Oranges*	Gershwin: *Rhapsody in Blue*	Armstrong leads the *Hot Five*	Brecht and Weill: *The Threepenny Opera*	Walton: *Balshazzar's Feast*
Apollinaire: *Calligrammes* Mayakovsky: *Mystery-Bouffe*	Proust: *A l'ombre des jeunes filles en fleurs* Machado: *Nuevas canciones*	Mauriac: *A Kiss for the Leper* Joyce: *Ulysses*	Kafka: *The Trial; The Castle* Cocteau: *Orphée*	Lawrence: *Lady Chatterley's Lover* Hemingway: *A Farewell to Arms*	Remarque: *All Quiet on the Western Front* Huxley: *Brave New World*
Maugham: *Of Human Bondage* Suprematist Manifesto	Morand: *Ouvert la nuit* Gropius founds the Bauhaus	Keynes: *Tract on Monetary Reform* Cassirer: *Philosophy of Symbolic Forms*	Hitler: *Mein Kampf* Fritz Lang: *Metropolis*	Heidegger: *Being and Time* Buñuel: *Un chien andalou*	Jung: *Modern Man in Search of a Soul* Eddington: *Expanding Universe*
Malevich: *Black Square on White Background* **Rietveld:** *Red and Blue Chair*	**Schlemmer:** *Abstrakte Rindplastik* **Rodchenko:** *Black on Black*	**Rietveld:** Schröder House **Man Ray:** *Rayograph*	**Van Doesburg:** *Against Composition XIII*	**Mies van der Rohe:** Tugendhat house **Miró:** *Dutch Interior*	**Aalto:** TB sanatorium at Paimio
1915–18	1919–21	1922–24	1925–27	1928–30	1931–33

193

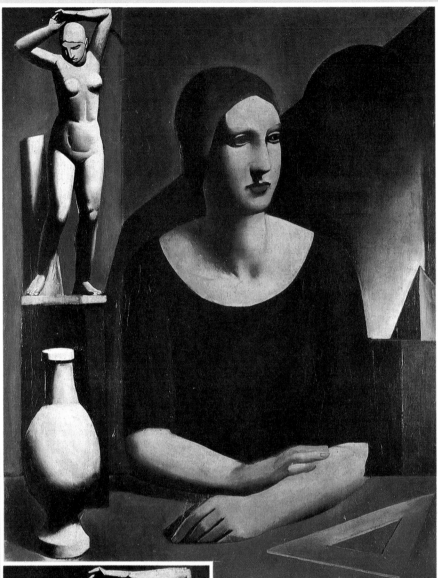

Mario Sironi, The Pupil, 1922–23, Private Collection, Venice. Painted in the post-avantgardist mood characterized by the return to formal values, this work is evidence of Sironi's adoption of the new aesthetic canons and at the same time of the persistence of certain features typical of the Metaphysical period, for instance, the enigmatic feeling of the whole composition. The rigid geometrical structure, the suspension of time, the careful construction, the references to the sister arts of architecture and sculpture, the grandeur and fixity of the figure, all come together to compose a complex image where the motifs borrowed from tradition are transposed into a language of unmistakable "modernity."

19 BEYOND THE AVANT-GARDE

In the years immediately following the First World War a need was increasingly felt – from various quarters and with a variety of implications – for a rethinking of artistic activity, to be directed mainly at revitalizing the pictorial language that had been so threatened by the avant-garde. It was at this moment of transition, with its strong cultural and political tensions, that the tendency to liberate art from the excessive experimentation and polemical engagement with the social and cultural system took hold, rooted as it was in a process that had already been under way before the war. In the general climate of a call to order, interest was growing in a representation of reality that would give precedence to formal values, such as balance and compositional rigour, and clarity and solidity in the figurative approach. The spectator, too, was to perceive the work in a different manner: his attitude was to be less emotionally involved, more lucid and detached. The goal, in short, was a "modernity" free of the shrill enthusiasm of the avant-garde, aiming rather at a reflection on the elements specific to painting as such: form, volume and colour viewed within an untroubled compositional system. The result was a reinstating of traditional cultural values and, together with them, of the figurative remembrance of the past. In reality, even during the war, the "museum art" so vilified by the avant-garde movements already dominated the thoughts of painters

▲ Giorgio De Chirico, The Enigma of the Oracle, 1910, Staatliche Museen, Berlin. This work is a prelude to the "tragic serenity" of the Metaphysical works.

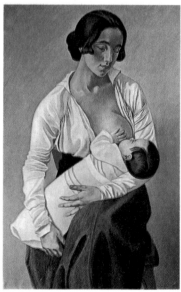

◀ Gino Severini, Maternity, 1916, Severini Collection, Paris. During these years Severini painted passionately felt works inspired by the tragedy of the war, but he also experimented with a reinterpretation of the classical world on which the formal thinking of Cubism was brought to bear.

such as Picasso, Derain and De Chirico, whose works staked out the basic lines of development for the artistic vicissitudes of those years. From 1911 Giorgio De Chirico elaborated a style of his own on inspiration drawn from Romantic and Decadent painting (by Böcklin in particular) and from the Classical world, evoked by architectural settings and

magical atmospheres which were a prelude to the "Metaphysical" period that was shortly to follow.

The type of relationship established by De Chirico and Carrà, when they developed *Pittura Metafisica* (Metaphysical Painting) in Ferrara during the war years, was to be reflected, albeit with different aims, in the programme put forward by the

Metaphysical Painting

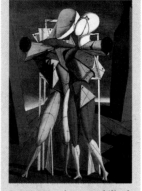

review "Valori Plastici" (Plastic Values), itself a rigorous and articulate summary of the artistic mood of the post-war period. Published in Rome between 1918 and 1922 (almost contemporaneously with another important periodical, "La Ronda"), "Valori Plastici" was edited by the painter and collector Mario Broglio with the collaboration of De Chirico, Carrà, Savinio and other young Italian artists: Melli, De Pisis, Morandi and Martini. The theoretical discussions that developed from the pages of this review concerned mainly contemporary art, understood as a language based on tradition but continually updating its own connection with classical art, since it alluded to a relationship between past and present based on continuity. It was indicative that Carrà should have devoted one of the review's first biographies to André Derain, whose interest in figuration had always gone hand in hand with

In 1917 Carrà was mobilized to Ferrara, where he met the brothers De Chirico and Alberto Savinio, who were also doing military service there. This chance friendship, which also included the young De Pisis, gave rise to a new art movement: Metaphysical Painting. Hints of it were already present in some works by De Chirico dating from 1910. But it was really during their time in Ferrara that they elaborated their aesthetic and theoretical values, based on an interpretation of reality which went beyond appearances to reveal the soul of things, in rarefied and timeless settings. While for Carrà the "Metaphysical" was a sort of abstraction that was arrived at by starting with the given object, for De Chirico (Hector and Andromache, 1918, Private Collection, Milan) it was a matter of juxtaposing disparate objects and images in ambiguous and ironic relationships, which freeze the meaning of the composition at its most magical and enigmatic stage.

an updating of the past, from Roman art to Caravaggio and Courbet. Equally significant was Carrà's critical scrutiny of his own earlier Futurist experiments, which he now repudiated, and from which he moved on to a reconsideration of nineteenth-century and then fourteenth- and fifteenth-century art from Giotto to Masaccio. Another signatory of the *Manifesto of Futurist Painting*, along with Carrà, was Gino Severini who, with the painting *Maternity*, embarked from 1916–17 onwards on a personal rediscovery of the Classical style, while at the same time making use of the formal contribution of Cubism. De Chirico's approach to the art of the past, however, took on a different form after the Metaphysical experiment. Around 1919 he did "copies" of famous paintings by Lotto, Michelangelo and Raphael, and subsequently developed a near-obsession with the painting of the seventeenth century.

BIOGRAPHIES

♦ **De Chirico** Giorgio (Vòlos 1888–Rome 1978). Leaving Greece after the death of his father, in 1909 he settled in Munich where his contact with German philosophical culture made a definitive mark. Equally important were the relationships he formed in Paris, where he had his first exhibition in 1912. The works he painted during those years were to lead him to his Metaphysical phase of 1917.

♦ **De Pisis** Filippo, pseudonym of Filippo Tibertelli (Ferrara 1896–Milan 1956). After beginning a career as a writer in 1916 with the volume *Canti della Croara*, De Pisis turned to painting. If his meeting

with De Chirico, Carrà and Savinio in 1917 was a turning point in his development, his work nonetheless remained marked by its fluid touch and lyrical use of colour.

♦ **Dix** Otto (Gera

1891–Singen 1969). Dix studied in Dresden and fought in the First World War, perpetuating his traumatic experiences in a series of drawings, which were the starting point for various paintings executed around 1920. After the war he joined the Berlin Dadaist group and then, with Grosz, the *Neue Sachlichkeit* movement, adding distinct touches of caricature to his typically minute rendering of detail.

Giorgio Morandi, Still Life, *1919, Private Collection, Milan. Morandi's depiction of real objects invites parallels with the "Metaphysical" manner of Carrà.*

▶ *Carlo Carrà,* The Pine on the Sea-shore, *1921, Private Collection, Rome. In its severity and simplification of space, this work shows Carrà's admiration for Giotto.*

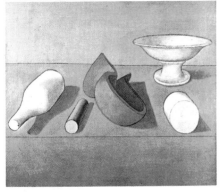

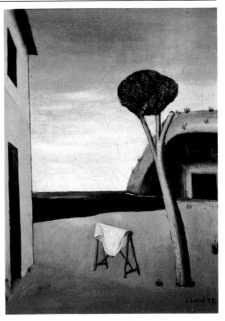

The pictorial and literary contributions of De Chirico, Carrà and Savinio theorized, through the pages of the "Valori Plastici" review, about the philosophical implications of Metaphysical thinking. Giorgio Morandi and Arturo Martini were also closely linked to this group. Morandi (who exhibited with the artists of *Valori Plastici* in Berlin in 1921 and in Florence in 1922) had for some time been engaged in a personal reappraisal of the work of Cézanne, Corot and Derain and was attracted by the Metaphysical experi-ment almost as a natural con-sequence of an interest he had always felt for geomet-rical composition and the resonance of colour. His manner of perceiving and in-terrelating the elements of reality, experienced basically as a pretext for an exclusively pictorial discourse, attracted him to the art of the primi-tives, in particular, Giotto and the masters of the early fifteenth century, as ex-emplified in the series of still lifes he painted around 1920. Arturo Martini, one of the major sculptors of this period, was presented to the public by Carrà on the occa-sion of his first one-man show at the Galleria Ipogei in Milan in 1920. He was par-ticularly interested in the search for a thorough defini-tion of form, drawing eclectic inspiration from both archaic sculpture and that of the fif-teenth century. Some of the views put forward by *Valori Plastici* were taken up again by the group "Sette pittori del Novecento" (Seven Painters of the Twentieth Century), formed in Milan in 1922 under the aegis of Margherita Sarfatti, and con-sisting of Anselmo Bucci,

◆ **Grosz** George (Berlin 1893–New York 1959). After dabbling with Cubism and Futurism, in 1917 Grosz published his first collection of bitterly humoristic drawings. He then joined the Berlin Dadaist group. With Heartfield he created the first politically satirical photomontages and collages and became interested in stage design. With the coming of Nazism he moved to the United States, where he exerted considerable influence on the social realism of the American painters, particularly Ben Shahn.

◆ **Magritte** René (Lessines 1898–Brussels 1967). Magritte studied at the Brussels Academy; in 1923 he became acquainted with the work of De Chirico and was drawn towards Surrealism. After spending time in Paris between 1927 and 1930, he returned definitively to Belgium, pursuing his own "modification of the everyday" through a more disquieting and illusionistic painting.

◆ **Martini** Arturo (Treviso 1889–Milan 1947). After apprenticeships in various ceramics factories, Martini studied at the studios of Carlini and Nono. Crucial to his development were the links he formed in 1909 with the members of the Munich scene, and his journey to Paris in 1912, during which he became interested in the sculpture of Maillol. In the twenties he intensified his own search for essential plastic values, amalgamating forms typical of popular tradition with those of archaic and fifteenth-century sculpture. He was also an accomplished graphic artist.

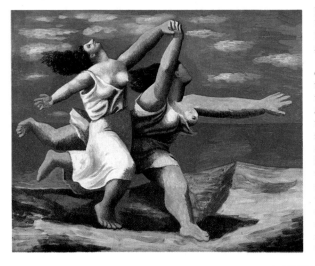

▼ *Pablo Picasso*, Two Women Running on the Beach (The Race), *1922, Picasso Museum, Paris. This explicitly figurative work indicates a return to classically based stylistic features and* themes. *This is also echoed by the clear outlining of the figures and the emphasis on their volume.*

Leonardo Dudreville, Achille Funi, Gian Emilio Malerba, Piero Marussig, Ubaldo Oppi and Mario Sironi. These artists had developed their work mainly within Symbolist or Futurist circles; but after the 1923 exhibition at the Galleria Pesaro in Milan, and its participation in the Venice Biennale of 1924, the group began to include artists of widely differing styles into its ranks, thus bowing to specific requirements of both publicity and the market. The group's energies, originally devoted to the control of form and volume within subtly balanced compositions, were now subverted in favour of the dictates of a taste that was basically in line with national tradition, rather than with mature considerations of style.

One figure worthy of mention for the coherence of his view is Mario Sironi. In works such as *The Pupil* and *The Architect*, he offers a marvellous synthesis of constructive values, reinforced by an extraordinary mastery of draughtsmanship and colour. Memories of a classical world recalled partly for its epic implications (as in the great frescoes of the thirties) were fused in Sironi with a personal interpretation of the Futurist themes to be found in the *Urban Landscapes* series.

This brief summary of the complex Italian scene after the First World War inevitably leads one to consider an equally complex international situation: this had some links with the experience of Metaphysical painting and "Valori Plastici," but was also partly connected to the contemporaneous reviewing of the artistic traditions particular to each country, as well as to internal developments within the work of the dominant figures

♦ **Morandi** Giorgio (Bologna 1890–1964). Though Morandi was in close contact with Italian literary and artistic movements, from Futurism to Metaphysical painting and "Valori Plastici," he was nonetheless only partly bound by their aims. He was in fact most influenced by the painting of Chardin, Cézanne and Corot, and his own interpretation of the Italian masters of the fifteenth century.

♦ **Savinio** Alberto, pseudonym of Andrea De Chirico (Athens 1891–Rome 1952). Brought up, like his brother Giorgio, in Greece, Munich and Paris, he devoted himself to music and literature as well as art, his painting being mainly reworkings of Surrealist inspiration.

♦ **Sironi** Mario (Sassari 1885–Milan 1961). Sironi frequented Balla's studio in Rome, and in 1914 he moved to Milan, where he was involved in the Futurist movement, though he continued to reinterpret Futurist themes even after joining the "Novecento" group in the early 1920s. He worked prolifically as an illustrator with the main Italian arts reviews. During the thirties he worked on murals for public buildings. After the Second World War he took up easel painting again, although retaining something of the compositional solidity of the mural.

◀ *Arturo Martini*, Water Drinker, *1926, Pinacoteca di Brera, Milan. This work clearly recalls the sculpture of the ancient world, particularly the Etruscan.*

▼ *Filippo De Pisis, Marine Still Life with Lobster and Feathers, 1924, Cacciabue Collection, Milan. The hasty execution gives an added lyricism to its sense of transience.*

▼ *George Grosz, White Slave Trader, 1918, Hessisches Landesmuseum, Darmstadt. Grosz's incisive style aimed at a* pitiless analysis of German society, an analysis that gradually became open political denouncement.

of those years. One need think only of Picasso's paintings of the early twenties, for instance, where the return to more explicitly recognizable figures, a renewed reference to the classical world and, in particular, the reinterpretation of Ingres, opened up new possibilities for a plastic definition of form. An important event on the French scene after the First World War, in parallel with the series of experiments of "Valori Plastici," was the founding of the review "L'Esprit Nouveau" by Amédée Ozenfant and Le Corbusier (pseudonym of Charles-Edouard Jeanneret), the supporters of the principles of a new movement, that of purism. In the manifesto entitled *Après le Cubisme*, published in "L'Esprit Nouveau" in 1918, the painter and the architect outlined the tenets of an artistic theory shorn of all psychological interpretation and concentrating rather "on the intrinsic qualities of the plastic elements," not "on their representational or narrative potentialities."

Any balanced reconstruc-

▼ René Magritte, Ceci
n'est pas une pipe
(This Is Not a Pipe),
1929, Los Angeles
County Museum of Art.
Typical of Magritte's
aims, this work
exemplifies the
uncoupling of the usual
interrelations between
the object, its image and
its verbal definition.

tion of the complex events of these years also requires consideration of the gradual emergence of the Surrealist movement, as evidence of a different way of conceiving relationships with reality, in the light also of certain implications of Metaphysical painting. In this context a particular importance is assumed by the art of René Magritte, which was close to but not completely identifiable with the theories of Surrealism. Magritte did indeed use the painting of De Chirico (greatly appreciated, incidentally, by Breton) as a starting point to investigate new potential relations between men and objects, between objects themselves, uncoupling the normal links between the object and its verbal definition, or (using a "Metaphysical" conception of space) unexpectedly juxtaposing the most familiar images, represented under the guise of a realism that was as incisive as it was mysterious and alienating.

Germany during this same period saw the development of the so-called new objectivity (Neue Sachlichkeit). Once again drawing on the basic features of German art, this current also grew from Expressionism, while at the same time reworking devices typical of Metaphysical painting. The result was a crude figuration, sunk in glassy atmospheres and frozen into disorientating visions of space, "objective" down to the rendering of the last details with an alienating sense of accurate caricature: thus the non-pictorial message was driven beyond the visual data in the direction of a crit-

◄ Edward Hopper,
Window at Night,
1928, Museum of
Modern Art, New York.
An important exponent
of American painting
between the wars,
Hopper painted
realistic, often
artificially lit, scenes
emblematic of life's
metaphysical private
spaces.

ical investigation into the moral and social situation of post-war Germany. George Grosz and Otto Dix occupied particularly important positions in the movement, their pictorial and graphic work being characterized by calculated political satire.

The United States too was pervaded by a mood of existential unease and tension, exacerbated by the isolation and nationalism into which the country withdrew at the end of the First World War. Indeed it was around the twenties that the conditions were created for the revival of a purely American realist tradition. Here an important

figure was Edward Hopper, whose strongly evocative and introspective painting, with its estranging light and compositional starkness, offers us an anonymous and desolate portrait of American life. ∎

Alberto Savinio, Objects in the Forest, *detail, 1927, Private Collection, Rome.*

Otto Dix, The Hall of Mirrors in Brussels, *1920, Poppe Collection, Hamburg.*

Otto Dix attacked the vices and immorality of Berlin society, taken as a metaphor for a more general existential malaise. The dramatic nature of his painting is fully rendered through the violence of the sign and the distortion to which bodies and settings are subjected.

Though he participated in the birth of the Metaphysical movement, Savinio was only involved with painting with any continuity from the second half of the twenties onwards. His work was characterized by an interpretation of reality filtered through irony, ''a very subtle but elementary and human reaction which one might call reserve'' and which underlies the particular quality of Savinio's unorthodox brand of Surrealism.

René Magritte, Duration Knifed, *detail, 1932, Art Institute of Chicago.*

Magritte's conception of space juxtaposes the most familiar images in unexpected ways, represented with a realism that is as incisive as it is mysterious and alienating. The immobility of the train is contrasted by the image of the clock and the steam emerging from it.

October Revolution in Russia League of Nations	Harding President of US Kemal Atatürk 1st President of Turkey	Pact of Locarno Fascist dictatorship in Italy	Stalin becomes leader of USSR Wall Street Crash	Dollfuss Chancellor of Austria Spanish Republic proclaimed	National Socialism in Germany Prohibition ends in US
First agricultural tractors First traffic lights	Discovery of insulin Anti-tuberculosis vaccine	Millikan: cosmic rays Baird: transmission of TV pictures	Fleming: penicillin	Ruska: electronic microscope	Discovery of polythene Isolation of influenza virus
Respighi: *Le fontane di Roma*	Vaughan Williams: *A Pastoral Symphony*	Puccini: *Turandot*	Ravel: *Bolero*	Pizzetti: *Rondo Veneziano*	Berg: *Lulu*
France: *Le petit Pierre* Mencken: *The American Language*	Lewis: *Babbitt* D'Annunzio: *Il notturno*	Fitzgerald: *The Great Gatsby* Mann: *The Magic Mountain*	Breton: *Nadja* Moravia: *Time of Indifference*	Auden: *Poems* Caldwell: *Tobacco Road*	Lorca: *Yerma* Miller: *Tropic of Cancer*
Wiene: *The Cabinet of Dr Caligari* Spengler: *The Decline of the West*	Discovery of tomb of Tutankhamen Simplon tunnel opened	Surrealist Manifesto Eisenstein: *Battleship Potemkin*	*The Jazz Singer* (first full-length talking film) Museum of Modern Art, New York	Berenson: *Italian Pictures of the Renaissance*	Breton: *Position politique du Surréalisme*
Grosz: *Homage to Edgar Allan Poe* **De Chirico:** *Hector and Andromache*	**Klee:** *Goldfish Wife* **Ernst:** *The Elephant Celebes*	**Dix:** *The Artist's Parents* **Picasso:** *Three Dancers*	**Magritte:** *Ceci n'est pas une pipe* **Wood:** *Woman with Plants*	**Wood:** *American Gothic* **Toorop:** *Friends at a Meal*	**Marini:** *Horse and Rider* **Arp:** *Shell and Head*
1917–20	1921–23	1924–26	1927–29	1930–32	1933–35

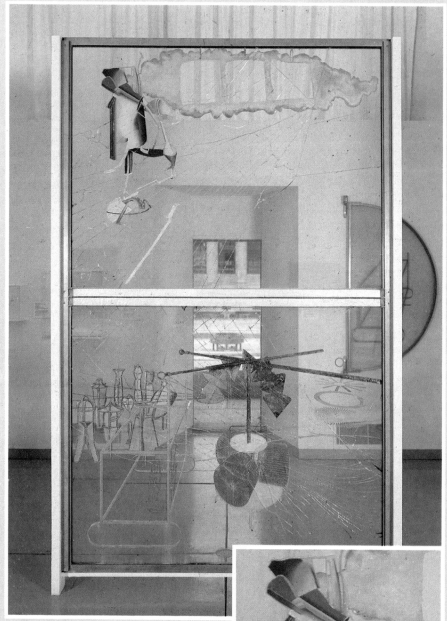

Marcel Duchamp, The
Bride Stripped Bare
by Her Bachelors *or*
The Large Glass,
*1915–23, Philadelphia
Museum of Art. A work
that took an extremely
long time in both its
conception and its
creation,* The Large
Glass *represents the
culmination of
Duchamp's
experiments.*

20 DADA AND SURREALISM

W hen examining Dada, rather than speaking in terms of an artistic trend, it would be more accurate to speak of certain groups or of a "spirit," a shared attitude towards the practise and theory of art. In fact, apart from its typically avant-garde type of external manifestations (which ranged from the publication of manifestos to attempts at shocking the artistic community), the main distinguishing features of Dada were the creative independence of the individuals involved in the venture and their willingness radically to alter their mental approach to the artistic product and, by extension, to all its integral elements: the essential figures of the artist and the "consumer," and the inevitable intermediaries of museums, the art market and the press.

It has often been stated that the driving force behind the activities and thinking of Dada was nihilistic, aimed at destroying all conventions and incapable of providing any constructive alternatives, able only to deny and never to affirm. In reality, the problem is much more complex. Although there is a basic element of truth to such assertions, it is equally correct to say that the provocative declarations of the Dadaists were also part of their deliberate use of outrage as a means of attracting the attention of a community already bombarded by countless other messages: their role was therefore propagandist, as well as artistic. Furthermore, according to

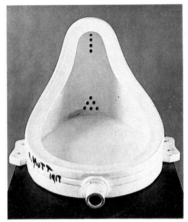

◀ *Marcel Duchamp, Fountain, 1964 (replica of the original), Galleria Schwarz, Milan. With Duchamp, the most common and mundane objects entered the world of art.*

▼ *Marcel Duchamp, Bicycle Wheel, third version, 1951, Museum of Modern Art, New York.*

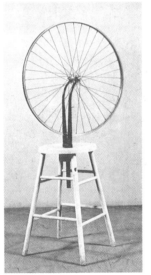

Dadaist thinking, it was no longer a question of modifying or altering the course of an aesthetic and artistic code that progressed along historically accepted and certified lines but of completely redirecting it, using procedures that gave the impression of being both destructive and self-destructive.

In order to illustrate this paradox we must examine

the subsequent developments in art history, most of which would be unimaginable without the Dadaist impulse. These range from such direct products as Surrealism, the so-called New Dada and Conceptual art, to such apparently unrelated experiences as Abstract Expressionism or the different manifestations of *Arte Povera* and Process Art during the 1970s.

As far as the actual birth of the movement is concerned, it was officially marked by the opening of the Cabaret Voltaire in Zürich in 1916, under the auspices of Tristan Tzara and Hugo Ball. However, it is generally agreed that the works created by Marcel Duchamp between 1913 and 1914, and Picabia's canvases from the same period, generated the beginnings of an art whose theories were destined to be made explicit in 1918 with the publication of the first Dadaist manifesto. By the same token, the conclusion of this shared experience has come to be identified with the explosive disagreement

Man Ray The Enigma of Isidore Ducasse, 1920. *The object, hidden and then made unrecognizable by the artist, has here been created solely as a function of photographic reproduction. The object thus disappears, while the image remains, capable of infinite reproduction with no addition to its meaning.*

between Tzara and André Breton in 1922, even though manifestations of Dada continued for some years afterward, albeit deprived of their original meaning and subversive role.

Like any other historical avant-garde grouping, Dada's roots lay in certain specific locations, hives of creative activity wielding vast, international influence and involving not only exhibitions and publications, but also theater and music. These places were Zürich,

the adoptive home of the Romanian exile Tzara and of Jean (Hans) Arp; Paris, the most important center during the period, a meeting point for artists from all over the world, as well as home to an avant-garde tradition, which, whether it involved Baudelaire or Apollinaire, the "scandalous" Impressionists or the Cubists, continued to be the focus of extraordinary cultural turmoil; Hanover, the hometown of Kurt Schwitters; Cologne, where Max Ernst

and Jean Arp founded a particularly active Dada group in 1919; Berlin, site of the Dada group most directly active in the political field, to which, unsurprisingly, George Grosz belonged; and New York, where Man Ray, following in the tracks left by Duchamp and Picabia, produced his first major works.

With the exception of Tzara, the people mentioned so far were involved in the area of the visual arts, but Dada also affected other aspects of artistic endeavour. The musician Erik Satie and the poets and writers André Breton, Louis Aragon, Philippe Soupault, Jean Cocteau and Robert Desnos were all active and influential members of the movement. In addition, visual research also achieved extremely high levels of expression in the fields of photography and the cinema, arts still in their infancy that had hitherto been regarded as minor, but which were exploited by Dada as instruments of great potential, suited to a

BIOGRAPHIES

♦ **Dalí** Salvador (Figueras 1904–89). A controversial figure who managed to surround himself with a not always justifiable aura of myth, Dalí became attracted to Surrealism at the end of the 1920s, when he concentrated on the themes of eroticism and visionary mysticism. As well as his painting, he is also particularly remembered for his work with the film maker Luis Buñuel on such masterpieces of

the Surrealist cinema as *Un Chien Andalou* and *L'Age d'Or*.

♦ **Duchamp** Marcel (Blainville 1887– Neuilly 1968). Initially a painter in the Cubo-Futurist mould, interested in the portrayal of movement on canvas, Duchamp became synonymous with the invention of "ready mades," works of art composed of objects taken directly from everyday life, with no intervention on the part of the

artist. Although he participated in the main Dadaist and Surrealist manifestations, he was always an isolated figure, who from 1928 onwards, on a public level at least, seemed more involved in his activities as a chess player than in his role as member of an artistic community whose development he had decisively influenced.

♦ **Ernst** Max (Brühl 1891–Paris 1976).

Founder of the Dada group in Cologne, Ernst was involved in the promotion of a great many Surrealist initiatives until his expulsion from the movement in 1954. As well as being a painter and sculptor, he expressed himself in a variety of other media, ranging from the first Dadaist collages to a reworking of the engraving technique. He was the first artist to exploit the effects obtainable from such unconventional

subtle mixture of irony and aesthetic irreverence, is the totally non-functional nature of all its components.

accorded the same status as a painting's traditional components. The surface thus also becomes the artist's field of action, the real reconstruction of a microcosm.

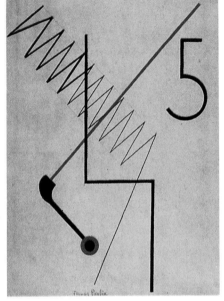

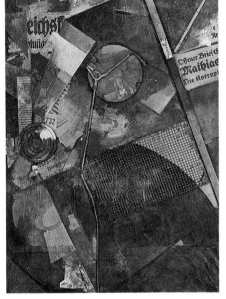

style whose central aims were the subversion of linguistic conventions and traditional artistic beliefs.

Finally, it should also be pointed out that Dada provided a vital staging point for many artists en route to other artistic experiences, most notably Surrealism, a movement whose founders included the protagonists of Dadaism. It represented a highly important point of transition from a state of absolute creative freedom to one of greater adherence to the aesthetic rules and regulations established by Breton.

The delegitimization of all traditional artistic language, a renewal of the relationship between objects and the words used to define them, an antiaesthetic view of works of art, a bitterly ironic attitude towards the laws governing the world (and not just the artistic world), the treatment of chance and

techniques as frottage, thus exemplifying once again the inexhaustible will to experiment, at every level, that inspired the best Surrealist artists.

♦ **Giacometti** Alberto (Stampo 1901–Chur 1966). Remembered all too often just for the sculptures that made him famous after the Second World War, Giacometti in fact made his artistic debut with Cubist-style works, later joining the Surrealist group in 1928. During his brief period of association with Breton and his colleagues, he used his work to throw doubt on the conventional techniques of sculpture, creating works that tread a fine line between being *objets trouvés* and expressions of the innermost impulses of the subconscious, while at the same time endowing them with a feeling of mysterious and often malicious playfulness.

♦ **Man Ray** (Philadelphia 1890–Paris 1976). A prominent member of the New York Dadaists, in 1921 Man Ray moved to Paris, where he remained, apart from one brief return to America, until his death. A painter, photographer and film maker, he was the embodiment of the avant-garde artist bent on breaking down the barriers between the different disciplines in order to assert the equal validity of all forms of artistic expression. Like his fellow artists, he took part in all the most important Dadaist and Surrealist shows, both before and after the war.

♦ **Masson** André (Balagny 1896–Paris 1987). After meeting Miró and Breton, in 1924 Masson joined the Surrealist group, with which he would always maintain links, even though he did not always approve of the ways in which the

Photography

the unconscious as prime movers of artistic creation, the adoption of combined techniques (collage, *assemblage* and photomontage), invented ones (the ready made) or even ones endowed with a new creative function (off-camera photography): all these were elements essential to the operation of Dada, which found its most fertile expression in the works of Duchamp, Man Ray, Schwitters, Ernst and Picabia.

Very famous examples of this process, and now raised to the status of "contemporary icons," are Duchamp's "ready mades," the *Bicycle Wheel* and *Bottle Rack* elevated to the level of sculpture, the urinal exhibited under the title *Fountain* and signed R. Mutt, and the glass ampoule of *Paris Air*. Beyond their deliberately provocative aims, these works form part of a research based on displacement, on the alienation of objects from their natural place and function, with a view to their inclusion in a representational and literary

For photography, a young art form that had previously been consigned to the limbo of the lesser arts, the Dadaist and Surrealist period was a time of great creative activity. Photography became an essential tool in the diffusion of new ideas. The factors that contributed to this phenomenon were, on the one hand, the growth of magazines and journals, not just political ones, which called for ever-increasing numbers of pictures and portrait photographs, and, on the other, an awareness on the part of artists that photography was not just a way of reproducing reality but rather a means of reinventing it, of providing a subjective vision of it and of giving shape and credibility to pure inventions of the mind. The ambiguous nature of photography was further accentuated by the adoption of such techniques as collage, photomontage, photograms and superimposition (above: a 1932 "rayograph" by Man Ray), which were no longer regarded as tricks or deviations from pure photography but instruments for the creative modification of perceived reality.

code, that of aesthetics, which in turn would be thrown into question by the entry of such items into its domain. Relationships with objects was a sort of *basso continuo* of the Dada experience, confirmed by the "ready mades" as well as by Man Ray's "rayographs" (photographs achieved without the use of a camera but through the contact of objects with sensitized paper whereby the object becomes a shadow, an ethereal mark) or Schwitters's *Merzbilden*. A *Merzbild*, the earliest example of which dates from 1919, is composed of a variety of the most disparate and random items, taken from everyday life and assembled on a panel on which the artist then works in paint. *Objets trouvés*, newspaper clippings and painting thus become part of the same world, sharing the same aims, in works that not only reveal the beauty of everyday objects whose aesthetic qualities are normally ignored, but also display their disdain for conventionally

group developed. His sand paintings of 1927 and his splendid automatic drawings make him one of the most important artists in this area, although his art betrayed a certain unevenness over the years.

◆ **Miró** Joan (Barcelona 1893– Palma de Mallorca 1983). A Catalan, Miró was particularly strongly influenced by researches in the Fauve area in his early art. During his first trip

to Paris in 1919 he came into contact with Dadaist circles and later, in 1924, took part in the first Surrealist shows. It was against this background that he developed his own very successful style and gained increasing acclaim amongst critics and public alike. After

moving to Majorca in 1944 he became increasingly interested in graphics, ceramics and sculpture, all fields in which he achieved notable successes.

◆ **Picabia** Francis (Paris 1879–1953). Picabia's artistic beginnings reflect a wide variety of

influences, ranging from early Impressionism to Cubism, to reworkings of Fauve and Orphic styles and subjects. A luminary of Dada in New York and later Paris, he was always known for his independence and for the provocative nature of his activities. Although never prepared to become a full member of any movement, he still enjoyed the respect of the Surrealist group, even when, during the

▼ *Max Ernst,* The Hat Makes the Man, *1920, Museum of Modern Art, New York. Images and phrases from every area of daily life provided Ernst with the focal point for his rejection of the accepted conventions of communication. His taste for cataloguing objects gave rise to an encyclopedia of nonsense that led to a collapse in the relationship between words and images.*

pleasing painting, created with an uncritical acceptance of academic rules.

An even more radical step was taken by Picabia, when, in 1921, he exhibited a work (*L'oeil cacodylate*) composed of his friends' signatures and phrases written by them on the canvas, with the only figurative element being a painted eye. The work was Picabia's because he had conceived and exhibited it, not because he had materially created it. This course was different from the one taken by Duchamp, although they converged in his conclusive statement that a work's artistic, and on a broader level, aesthetic merit is achieved and determined by the thinking that dominates its conception and by the different reactions that it is capable of arousing in the viewer. The collages of Max Ernst finally take us to the point where Dada and Surrealism meet. In fact, although antilogical content continued to be the hallmark of these works, Ernst showed a greater tendency to link series of incongruous images rather than random objects and to channel the subconscious in precise directions, though always respecting the principle of estrangement, which proved to be the mainstay of both movements. With his paintings *Une semaine de bonté* (1934) and *La femme 100 têtes* (1929), Ernst achieved unparalleled heights in transforming the popular language of illustration and the *feuilleton* in works exuding a sense of black humour and disquieting psychological violence, never explicit, but omnipresent nevertheless, threatening the collective imagination of the early twentieth-century public.

The same weapons were used by the Surrealists, led by Breton, in their search for a systematic form of rule

1930s, he reverted to an art that pushed bad taste to the limits and which is hard both to classify and to interpret.

♦ **Schwitters** Kurt (Hanover 1887–Ambleside 1948). An intellectual in the fullest meaning of the word, Schwitters participated as a writer on the magazine *Der Sturm* and later became associated with Dada, founding his own magazine *Merz* in 1923 and finally joining the *Abstraction-Création* group. As well as his *Merzbilden*, he also created a *Merzbau* (destroyed during the war), which took the form of a decorative environment within an apartment and which anticipated the many later environmental projects by other artists.

▼ *Max Ernst*, Two Children Are Threatened by a Nightingale, *1924, Museum of Modern Art, New York. The anxiety and disquiet stirred up by the intervention of the unexpected are never explicitly stated by Ernst, but, as in this case, are brought to the fore by minimal signals, by brief interruptions in the logic of reality.*

▼ *Joan Miró*, The Ploughed Field, *1923–24, Guggenheim Museum, New York. Miró has transformed a conventional genre of painting such as landscape into an invention of shapes and colours dictated by the subconscious. The composition is strangely complex and compact, filled with elements giving the whole surface a sense of disorientating movement.*

breaking, based on theories repeatedly expounded in the manifestos and programmatic declarations published in the different magazines that had accompanied the movement from its earliest beginnings. The Surrealists added to the keynotes of Dadaism two essential elements, or rather they adopted and reworked on a creative level two trains of thought, namely psychoanalysis and Marxism. These were to give the movement a precise and often dogmatic direction, as well as giving rise to the fre-

quent schisms, ruptures and expulsions to which the group was subject over the years.

Although the adherence to Marxism, which was motivated by deep convictions, continued to represent an adherence to principles that was theoretically valid, though dramatically rejected by Communist cultural orthodoxy, it was undoubtedly the influence of psychoanalytical research, most notably that of Freud, which had a decisive influence on

the theory and practise of the Surrealists. By the way in which it revealed the hidden forces of the subconscious, acknowledging and breaking down a whole series of taboos and conventions in the area of human sexuality, psychoanalysis acted as a source of both understanding and inspiration for Breton and his comrades (who included such extraordinary dissidents as Georges Bataille) in their plan to relay the foundations of every aspect of human existence.

This plan translated itself on an artistic level into the creation of works whose central component was overtly erotic and whose most successful technical novelty consisted of raising the concept of "Psychic Automatism" to the level of method. This term describes the process undertaken by an artist acting on the immediate interplay between the subconscious and the creation, whether pictorial or poetic, which occurs with no conscious control, in a sort of creative "blindness," with results depending totally on the individual. This process carried to the extreme limit certain postulates that had already been present within the Romantic and Symbolist styles. It was undoubtedly a key element in the long process of freeing artistic practise from the restrictions imposed by the traditional channels of communication and, above all, it also represents the greatest and most fruitful bequest made by the Surrealists to future artists (as is demonstrated, for example, by

▼ *André Masson,* Fish in the Sand, *1927, Kunstmuseum, Berne. This is one of Masson's famous sand paintings. His adoption of this medium allowed him to impart radically new colours and textures to* *the surface. The spatial arrangement of the elements reflects Masson's faithful adherence to Breton's theories of Psychic Automatism.*

▼ *Joan Miró,* Person Throwing a Stone at a Bird, *1926, Museum of Modern Art, New York. Miró moved between figuration and abstraction with no ideological preconceptions,* *capturing the narrative possibilities inherent in the liberal placing of shapes in space. His oeuvre is also characterized by an extraordinarily lyrical use of colour.*

the importance assumed by this technique in the birth and development of "action painting" in America).

Although the Surrealists strove to achieve a group style, sustained by the strong ideological ties represented by the theories of Breton, it is equally important to point out that the group exercised a strong influence on certain individuals and that the group was in turn also influenced by others. Clear traces of the movement can be seen in the work of artists such as Picasso and Klee, who, al-

though never members of the movement, undoubtedly derived considerable benefit from their familiarity with the paintings and personalities of Surrealist circles. Their paintings from the 1930s attest to the importance and widespread diffusion of stylistic theories linked to the exploration of the subconscious as a primary source of artistic intuition.

The influences on Surrealism, however, are much harder to unravel, even though the Surrealists made a comprehensive list of their own cultural and figurative models in the flood of theoretical statements that accompanied all their public appearances. In the field of literature, Arthur Rimbaud, particularly his *Illuminations* and the *"dérèglement de tous les sens,"* Le Comte de Lautréamont, the darker and more visionary face of the Romantic experience, and, in the figurative field, the hallucinatory art of Bosch, the distortions of the Mannerists, the different types of Sym-

▼ *Max Ernst, Oedipus,
collage from the fourth
book in the collection
entitled "Une Semaine
de Bonté," 1934. The
revival and elaboration
of popular means of
expression, which also
involved a return to*

*nineteenth-century types
of illustration, are
characteristic features of
this work by Ernst and
were also to influence
his later oeuvre.*

▶ *Constantin Brancusi,
Bird in Space, 1940,
Peggy Guggenheim
Collection, Venice.
Brancusi's sculptural
researches were based
on principles of absolute
formal purity, a belief
also reflected in the
material chosen for this
work. Like Giacometti,
Brancusi treated the
base as an integral part
of his works.*

bolism represented by Odilon Redon and Gustave Moreau, and the metaphysics of Giorgio De Chirico: these were all links in the chain that bound the Surrealists to a sometimes distant past. In addition to these models, there were other figures and other points of reference that entered into the stylistic vocabulary of the Surrealist language. An example of this is provided by Constantin Brancusi, the Romanian-born sculptor who moved to Paris at the beginning of the century. A friend of Marcel Duchamp and Erik Satie, Brancusi took part in none of the movements that sprang up in Paris during the first part of the twentieth century, but his style, characterized by a rigorous and constant adherence to its own highly individualistic code, had a subtle influence on the works of certain members of the Surrealist movement.

The elements of Brancusi's style that were of greatest interest to a significant number of Surrealist artists, particularly Jean Arp in his search for sculptural specifics, were: the way in which he reinterpreted primitive sculpture in a mystically evocative key and plunged into the heart of a primitivism derived not only from non-Western cultures but also from sources much nearer home, and his technique of transforming the figurative image into a purely plastic form, divorced from all temporal or phenomenal contingencies. Brancusi's style also represented a sort of return to basics,

to a state of as yet uncontaminated awareness, but, unlike the Surrealists (or any other artistic movement of the day), he disassociated his sculpture from all ideological connotations or exemplary functions, in order to create works that would be an extension of material in space, enclosed in a shape whose very nature, whose cold definition and lyrical resonances, provides its own

reason for existence.

Of all the many elements that go to make up the complex language of Surrealism, a particularly important role is played, as has already been mentioned, by the reappraisal of so-called primitivism. From Alberto Giacometti to Man Ray and from Victor Brauner to Max Ernst, almost all the movement's protagonists tackled this theme in different ways and

◀ *Alberto Giacometti,
Suspended Square,
1930, Kunstmuseum,
Basle. Certainly one of
the most disquieting
works ever made by
Giacometti or any other
member of the
Surrealist movement,
this sculpture negates
all the traditional
attributes of the plastic
experience. It seems to
take an almost perverse
pleasure in the contrast
between the round and
sharp-edged shapes and
between the apparent
immobility of the
composition and the
underlying suggestion of
movement.*

with different results. What they had in common, however, was a desire to capture the magical, mysteriously primeval character of the objects arriving from Africa and Oceania, which had none of that quality of rationalization that typifies Western culture. It was not the shapes that attracted the attention of the Surrealists so much as the evocation of the "fetish," the re-emergence of a magical universe, the puzzle of forms

and meanings, the basic rules of "common sense."

Of all the figures in the Surrealist movement, special mention should be made of Joan Miró, who, through a technique based on psychic automatism, conjured up a series of images from the depths of the subconscious, creating works in which the proliferation of signs and organic forms on the canvas resolves itself in the creation of a magical and extraordinarily

lyrical universe. Other first-rate Surrealist artists include André Masson and Alberto Giacometti, who translated the dark areas of the mind into pictures, uniquely manipulating form and matter and bearing witness to the infinite possibilities offered the artist by a non-dogmatic interpretation of the basic principles of Surrealism. And yet, apart from these artists and the ones already mentioned (Ernst, Man Ray and

▼ *Salvador Dalí,*
Persistence of
Memory, *1931.*
Museum of Modern
Art, New York. The
melting watches,
emptied of all material
substance, combined
with the precise

definition of every
detail, give this work a
feeling of dream-like
unreality.

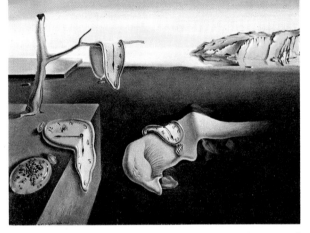

Picabia), who achieved the smooth transposition of their clearly defined theories within a Surrealist context, there were many occasions when Surrealist painting resorted to the creation of dream images and surprising figurative associations, tainted by an element of didacticism and symbolic narrative that degenerated into a banal and conventional breaking of rules.

The most famous Surrealists, ranging from Salvador Dalí to Paul Delvaux and Yves Tanguy, substantially rejected all the innovations and upheavals that had occurred during the early decades of the century, as well as the very premises of automatism, and opted for a return to traditional painting, to virtuoso skills and the consequent revival of pictorial values that had been overturned during the contextual evolution of art. Salvador Dalí, whose early career was marked by works that reveal

a fascinating, visionary transformation of the world, gradually became more and more involved in a stale and repetitive, pompous and rhetorical style concerned purely with effect. But it is certainly not these images, nor the many other similar ones scattered throughout the world, which justify the importance of Surrealism within the context of twentieth-century art. Rather it would be frames from the early films of Luis Buñuel and René Clair, photographs taken by Man Ray or Brassaï, the disquieting sculpture—objects of Giacometti, the prose of Bataille and the verses of Paul Eluard or the paintings of Miró and Masson, all of them works that now form a part of the collective imagination of contemporary man. ∎

▶ *Yves Tanguy,* Mama, Papa is Wounded!, *1927, Museum of Modern Art, New York. Tanguy's work reflected a balance between the different components of Surrealist art. Many elements come together in this work: an emphasis on the subconscious, a taste for literary titles, a feeling of technical refinement and a sense of space that is both real and metaphysical.*

Raoul Haussman, Dada
linocut print, 1918.

It was characteristic of the
exponents of the Dada experience
to use magazines, pamphlets and
posters to spread their artistic
message. The same aims are
reflected in a new approach to
graphic layout, which also was a
feature of the contemporary
Constructivist and Futurist
movements. At every cultural
level, from the highest to the
lowest, there was a constant
interchange of ideas.

Luis Buñuel and Salvador
Dalí, frame from Un Chien
Andalou, 1928.

Cutting the eye became, over the
years, a sort of trademark of
Surrealism, as it did for all
Buñuel's films. The cruelty of the
act is naturally not an end in
itself but is part of the total
revision of visual conventions,
materializing in the idea of black
humour that lay at the basis of
Surrealist aesthetics. Buñuel was
assisted by Salvador Dalí in this
film, demonstrating how the
different artistic disciplines were
seen as part of a single
panorama.

Paul Delvaux, The Break of
Day, detail, 1937, Peggy
Guggenheim Collection, Venice.

Delvaux was one of the greatest
representatives of that brand of
Surrealism that preferred the
recreation of dream-like images
painted using traditional
techniques and formal layouts
rather than the conceptual and
technical innovations contained
within the aesthetics of Breton
and his colleagues. This feature
partly accounts for the
uniqueness and success of his
works.

October Revolution in Russia Treaty of Versailles	Weimar Republic, Germany Harding President of US	General Strike in Britain Kellog-Briand Pact	Wall Street Crash Start of Depression	Spanish Civil War Rome–Berlin Axis	Invasion of Poland 2nd World War
Rutherford: Proton	De Broglie: wave nature of electron	Birdseye: frozen food process Schick: electric shaver	Whittle: jet engine	Fermi: fission of uranium	Lumière: three-dimensional cinematography
Poulenc: *Mouvements perpétuels*	Satie: *Relâche; Mercure*	Webern: *Symphony*	Stravinsky: *Symphonie de Psaumes*	Shostakovich: *A Lady Macbeth of Mtensk*	Rodrigo: *Concierto de Aranjuez*
Breton: *Les champs magnétiques* Aragon: *Feu de joie*	Cocteau: *Poésies*	Aragon: *Mouvement perpétuel* Dos Passos: *Manhattan Transfer*	Cocteau: *Les Enfants terribles*	García Lorca: *Bodas de sangre* Priestley: *English Journey*	Steinbeck: *The Grapes of Wrath* Isherwood: *Goodbye to Berlin*
Cabaret Voltaire, Zurich Dada group, Cologne	Surrealist Manifesto Mencken: the *American Mercury*	Breton: *Le Surréalisme et la Peinture*	2nd Surrealist Manifesto Marx Brothers: *Monkey Business*	International Surrealist Exhibition	Disney: *Fantasia* Chaplin: *The Great Dictator*
Duchamp: *Bicycle Wheel* **Man Ray:** *First Object Aerated*	**Ernst:** *The Elephant Celebes* **Picasso:** *The Three Musicians*	**Masson:** *Dead Horses* **Buñuel–Dalí:** *Un chien andalou*	**Dalí:** *Persistence of Memory* **Giacometti:** *Suspended Square*	**Ernst:** *Une semaine de bonté*	**Brancusi:** *Bird in Space* **Picasso:** *Guernica*
1916–20	1921–24	1925–28	1929–32	1933–36	1937–40

Jean Fautrier, Head of a Hostage No. 1, *1948, G. Panza di Biumo Collection, Varese. The* Hostages *series, a definite forerunner of the informal style, was born of an experience in Fautrier's own life, but it also marked the culmination of a process of artistic research begun during the previous decade. He transformed the memory of the bodies of the partisans shot by the Nazis against the wall surrounding his house into a vibrant material image of unexpected chromatic luminosity, into tragic masks of a cruelly naked truth. The materials used in painting are no longer technical means but the very essence of the work.*

21 AFTER THE SECOND WORLD WAR

Although it can often be controversial to relate historical and artistic events too rigidly to each other, there can be no doubt that the Second World War marked a watershed in the history of twentieth-century art. There are many, perhaps rather obvious, reasons for this. First and foremost, the war broke out within a cultural environment that had already witnessed the emigration of many European intellectuals to the United States during the 1930s, a process that had broadened the horizons of American culture by the introduction of new stimuli. This was followed, after the end of hostilities, by a substantial shift in the art market and in artistic expertise away from the capitals of Europe to the great urban communities of America, most notably New York.

The length and geographical extent of the conflict, as well as its social and economic consequences, means that the postwar period may be regarded as encompassing the entire decade of the 1940s and, perhaps for the first time ever, it was not just the artistic output of Europe that was involved, but also that of all the most advanced non-European countries.

The tragic dimension of the conflict in all its different manifestations is also significant, not least the dropping of the atom bomb, an event which was destined to have a lasting effect that went far beyond its role of signalling the end of the conflict in that it suggested the possibility of the destruction of the entire planet.

▲ *Jean Dubuffet,* Noeud au Chapeau, *1946, Moderna Museet, Stockholm. Dubuffet destroyed traditional painting from within, adopting some of its basic elements and turning its meaning upside down.*

By linking these factors to the natural difficulties in the marketplace created by the war and bearing in mind the postwar enthusiasm for new ideas and new knowledge that was made possible by the reopening of cultural as well as political frontiers, one observes the emergence of a varied artistic panorama. This combined continuity with innovation, an acceptance of international influences with a defense of local traditions, and contemporary upheaval with projections of a future to be both imagined and built.

Thus, in the area of the figurative arts, the procedures and innovatory work carried out by certain masters of the historic avant-garde, including Picasso, Matisse, Ernst, Miró and Giacometti, to mention but a few, were matched by the radically new artistic language of Fautrier, Wols and Dubuffet. The rebirth of an abstract style that recalled the great prewar tradition was balanced by the appearance of an uncompromising realism tinged with political undertones; the progressive decline of European cultural

hegemony coincided with the first stirrings of the highly successful "New York School," still in its formative stages at the time.

Having identified the overall characteristics of the period, we should now turn to the most representative figures, movements, events, places and works. In 1945, at the René Drouin Gallery in Paris, Jean Fautrier exhibited his latest pictures in a show entitled *Otages* ("Hostages"): numbers of small pieces of paper backed on to canvas and arranged along the walls in distressing, apparent monotony. Each work reveals a lump of thick material, which stands out against a background bereft of all spatial references and which, although of indeterminate origin, creates a very striking effect, both in its colouring and in the way that it catches the light. In their presentation as fragments of reality, and more explicitly fragments of body, these works have a strongly dramatic quality, but, above all, they

Like still photography, the cinema forced painters and sculptors to question their own roles and also their technical and visual repertoire by showing that, for example, painting could not possibly compete with the "seventh art" in the objective representation of reality and in the production of images for a public as varied as it was numerous. It is no coincidence that the best and most famous expression of the dreams, hopes, trials and tribulations of postwar Europe is undoubtedly to be found in the Italian neo-Realist cinema, in images from the films of Vittorio De Sica (above, a frame from The Bicycle Thieves, *1948), Rossellini and Visconti. These directors succeeded, in an apparently objective way (but also exploiting an extraordinary narrative ability that contains echoes of the nineteenth-century novel), in telling stories with an immediate, mass appeal through the creation of exemplary figures with whom a whole generation of cinema goers was able to identify.*

are anti-rhetorical, containing no attempt at narrative, no unambiguous message.

Fautrier did not relate historical dramas; he revealed an eternal human condition, in this case personified by the hostages massacred by the Nazis, through a validation of the prime instruments of painting, material, colour and image. These are no longer used to portray reality, but to reveal the "embodiment of painting," which, in its despairing beauty, represents the final possible justification of human behaviour.

The same year also saw a one-man show at the same gallery by Wols (Alfred Otto Wolfgang Schulze), a Berliner who had moved to Paris many years earlier and, after starting life as a photographer, had become a painter specializing in watercolours. The few visitors to the gallery found themselves confronted by an uninterrupted flow of brush strokes applied in accordance with the Surrealist-inspired doc-

BIOGRAPHIES

♦ **Calder** Alexander (Philadelphia 1898–New York 1976). From 1926 he lived and worked in Paris where he came into contact with Surrealism. In 1931 he joined in the "Abstraction-Creation" movement and produced his first abstract sculptures. During the postwar period he created a number of fragile metallic mobiles.

♦ **Dubuffet** Jean (Le Havre 1901–Paris 1985). Dubuffet

became an artist relatively late in life, his earliest practical experience being at the first Parisian shows held during the immediate postwar period. His work developed through

cycles, among the most famous of which are *Microbolus, Macadam, Corps de Dames, Texturologies* and *Matériologies*, all of which evolved between the mid 1940s and the early 1960s.

Active, albeit with less qualitative success, up until the 1980s, Dubuffet's name became associated with *art brut*, a name that he himself invented to define all artistic expressions that were not officially recognized (from the work of the mentally ill to that of clairvoyants, children and primitives).

♦ **Fautrier** Jean (Paris 1898–Chatenay Malabry 1964). An artist who always lived

216

▼ Wols, Composition V, 1946, Musée National d'Art Moderne, Paris. The prevailing feeling of an image derived from the subconscious and the way in which the artist has vindicated the beauty to be found in

an exhausted chromatic lyricism makes this one of Wols' greatest works, as well as illustrating his affinities with, and divergences from, the world of his artistic contemporaries.

▼ Arshile Gorky, Waterfall, c.1943, M. Philipps Collection, London. This work shows signs of Gorky's early Surrealism, but also reveals how he progressed beyond it in order to create a language of his own, characterized by an organic style and the dissolution of colour into shape.

of works entitled *Hautes pâtes*. Although, in concept, these might appear similar to Fautrier's work, the artists' techniques were motivated by different causes and different aims. As a painter, Dubuffet operated beyond the rules of convention, beyond traditional values and beyond the expression of painting in a cultured, historically authenticated language. He sought to conduct a dialogue with the world in all its aspects and to constantly acknowledge the primary role of art, or the caricature of art, as an agent working on reality. This is evident in his drawing of children and lunatics, his use of every sort of technical instrument, including ordinary everyday utensils which he made no attempt to vindicate aesthetically, but which he adopted in order to affirm his own character as an outcast, in a constant critical and sarcastic reference to the reality around him.

United during these years by coincidences that were

trine of "psychic automatism." They represented the artist's immersion in the depths of his own being, the extreme expression of a drifting consciousness, in which he attempted, with extraordinary success, to communicate his message by giving shape to inner reality through the lyrical resonances of colour and form.

The following year, again at the Drouin Gallery, Jean Dubuffet presented a series

and worked in isolation, Fautrier was inspired by a realism similar to that achieved by the German *Neue Sachlichkeit* movement, before later developing a more markedly Expressionist style. Alternating between life in Paris and periods in which he divorced himself almost totally from the world of contemporary art, he developed a technique of his own that led to his becoming one of the forerunners of the

"informal" style aimed specifically at investigating the expressive possibilities of material.

◆ **Fontana** Lucio (Rosario di Santa Fe 1899−Cernobbio 1968). The son of Italian emigrants to Argentina, he worked initially in the area of abstract painting and also in the creation of neo-baroque ceramics. After the war he created an extraordinary sequence of *Ambienti*

("Environments"), using neon lights, *Concetti spaziali* ("Spatial concepts"), the name given to his whole series of torn and pierced canvases and to his later *teatrini* (toy theaters), and terra cotta *Nature* ("Natures").

◆ **Gorky** Arshile (Hajotz Dzore 1904−Sherman 1948). An Armenian by birth, Gorky emigrated to the United States in 1920, where he began teaching and made his

first contacts with the art world, meeting Stuart Davis and Willem de Kooning, among others, during the 1930s. His earliest works are characterized by his own personal interpretation of Cubism, later overlaid by a strong Surrealist element, which played a decisive part in the works of his latter years. Although his importance as an artist was recognized in the immediate postwar period, a series of

◀ *Hans Hofmann,*
Cataclysm, 1945,
Private Collection. One
of the first uses of the
dripping technique,
based on the principle
of pure randomness, in
which the action of the
painter and the growth

of shapes achieve perfect
synchronism.

not pure chance, by dates and by the places in which they exhibited, Fautrier, Wols and Dubuffet traced the course that would later be taken by informal art. Above all, they achieved extraordinary results in the three careers they had already pursued for some years and which, with the exception of Wols, who died in 1951, they were destined to continue in the decades to come.

Their counterparts in the United States were Arshile Gorky and Hans Hofmann, the fathers (and not merely on a spiritual level) of the later generation of "action painters." For Gorky, an Armenian refugee, 1945 was the year of an equally important exhibition, held at the Julian Levy Gallery in New York. The paintings shown on this occasion revealed how he had shaken off the Picassoesque influences that had formed part of

his figurative baggage since the early 1940s, as well as displaying his new and highly personal revocation of Surrealist "automatism," geared towards portraying the process of seeing reality as a process of organic transmutation of the shapes assembled by the subconscious. Hofmann, the elder of the two, played a crucial role both as teacher in an art school that he himself had founded and also as one

personal misfortunes drove him to suicide in 1948.

♦ **Hofmann** Hans (Munich 1880–New York 1966). A German who had worked in Paris during the early years of the century, Hofmann emigrated to the United States in 1932. He became a central point of reference for young American artists, both as a teacher with firsthand experience of the European abstract scene and also as a

figure prepared to renew his language in the light of the new stimuli of "action painting," whose technique of dripping he anticipated.

♦ **Tobey** Mark (Centerville 1890–Basle 1976). As early as 1917 Tobey held his first one-man show at Knoedler's in New York, but it was during the years that followed, after repeated contacts with Oriental culture, that he developed an

independent style of his own. After learning the basics of the Baha'i religion, in 1922 he met the Chinese painter Teng Kuei in Seattle and in 1926 he embarked on a series of journeys to Europe and the Orient; in 1934 he travelled to China and Japan, where he spent a month in a Zen monastery at Kyoto. His calligraphic style had a profound influence on European and American art of the 1950s, a period

during which the seal was set on his own recognition. He moved to Switzerland in 1960.

♦ **Wols** pseudonym of Alfred Otto Wolfgang Schulze (Berlin 1915–Paris 1951). Cutting the typical figure of the intellectual outcast, Wols moved to Paris in 1932 where he moved in Surrealist circles. He began his career as a photographer and subsequently took up painting, specializing in watercolours.

▼ *Mark Tobey,* Eskimo
Language, *1946,
Seattle Art Museum.
Travels through non-
European cultures have
here led Tobey to create
an alphabet of signs
that completely fills the
surface.*

▼ *Lucio Fontana,* Spatial
▼ Environment with
Black Light, *1949,
Archivio Fontana,
Milan. The action
springs out of the
canvas in order to
become a movement of
flight in space, radically*

*altering perceptive
conventions. Fontana
has here anticipated the
later ''environmental''
quality that was to play
such a decisive part in
the art of the 1970s.*

◄ *Renato Guttuso,*
Crucifixion, *1941–42,
Galleria Nazionale
d'Arte Moderna, Rome.
This is one of the most
significant works by
Guttuso in its attempt at
linking social
involvement with an
artistic language
balanced between
innovation and
tradition. In this case
his realism possesses a
strongly symbolic
quality.*

of the first artists to methodi-
cally adopt the technique of
Drip Painting, an extreme de-
velopment of the ''seeds''
contained within the expres-
sive revolution initiated by
Surrealism.

The same years saw the
artistic coming-of-age of
Mark Tobey, whose sprawl-
ing compositions, with their
Oriental echoes, opened up
yet another area of pictorial
experimentation, this time
centered on the expressive
independence of shape and
line.

Europe, in the meantime,
was still in a state of artistic
flux, with the first stirrings
of Spanish informal art
emerging in the form of the
''Dau al Set'' group, led by
the young Antonio Tapies
(1947), and the extreme
neo-Expressionism of the
Northern European ''CoBrA
Group'' (1949). In Italy the
mood was characterized to
a much greater extent by
great debates and important
moral decisions than by any
effective creative achieve-
ments. An example of this
is provided by the Roman
''Forma'' group, established
in 1947 by artists who were to
come to the fore during the
1950s, ranging from Accardi
to Dorazio and Turcato, who
at this period definitely made
greater progress with their
theoretical formulations than
with their works, most of
which were still character-
ized by a historically derived
form of abstractism.

It was, in fact, the polemical
disputes between sup-
porters of abstract and fig-
urative art that came to an
explosive head in 1947 with
Togliatti's famous break with
everything that did not

219

▼ *O. Licini,* Amalasunta on a Cinnabar Ground, *1949, Private Collection, Milan. Here reality is reinvented in a magically lyrical key, the ancient colour of the ground recalling an age-old tradition.*

▼ *Henri Matisse,* Girl
▼ Swimming in the Aquarium *(plate from* Jazz), *1944, Private Collection. Matisse's synthesis of form and colour gave rise to extraordinarily decorative effects.*

tana. During the period immediately after the war, Fontana, who was protagonist of one of the century's most complex and intriguing artistic episodes, perfected the spatialist experiments that he had already conducted and which he himself had theorized in the "Manifesto Blanco" of 1946.

The environment with neon lights created by Fontana at the Naviglio gallery in Milan in 1949 transformed the gallery's space, both visually and psychologically, into a radical breaking-down of the traditional interdisciplinary barriers between sculpture and painting, with the intention of treating artistic practise as a pure conceptual and physical extension of space. Similar intentions are reflected in the *Concetti spaziali* (Spatial concepts), the famous torn canvases that Fontana began to create during this period, thus contributing, from what would appear to be the sidelines, towards Italian culture's attainment of a prominent position within the panorama of contemporary art. ■

respond to the dictates of the realism embodied by the work of Renato Guttuso, that were to block Italian art in a diatribe, as interminable as it was unproductive, concerned mainly with the ideological and formal premises of works rather than their substance.

These years were ones of transition for many Italian artists, ranging from the young members of "Forma" to the protagonists of the "Scuola Romana" (which included Guttuso himself), who were bent on bringing

their language up to date on the basis of a recently discovered neo-Cubism, and the abstract artists of the "Movimento Arte Concreta" (1948). As far as the works created in Italy during these years are concerned, the most important ones were still being produced by artists who had already been active before the war and were now prepared to branch out in new directions, based firmly on a familiar linguistic and structural repertoire, as exemplified by De Pisis, Licini, Morandi and, above all, Fon-

Wols, Composition, 1947–48, Didsheim Collection, Lausanne.

Matta, The Dryads, *detail, 1941, Peggy Guggenheim Collection, Venice.*

For the Chilean artist Matta (Roberto Sebastiano Matta Echaurren) the figurative nucleus, translated into a dream-like vision, is of Surrealist inspiration. The artist's contribution to later styles takes the form of a narrative quality composed of pure, free-flowing symbols.

Wols has captured the image in painted form at the moment when it becomes a physical reality. It presents itself as a fragment, complete in itself, of a much vaster lyrical questioning of the world. The development of the shape coincides with the development of the line and with the series of operations, however small, by the artist on the surface, which becomes a sort of emotional seismograph. It is no coincidence that one of the artist's best-known works is entitled Le Bâteau Ivre, in homage to the poet Arthur Rimbaud.

Giorgio Morandi, Still Life, *1950, Galleria Civica d'Arte Moderna, Turin.*

Morandi's tireless soundings in the area of shape found a focus in the theme of "bottles," to which he returned at different times. The fusion of shape and background and the minimal variations of shade in the subject are both characteristics of this period in Morandi's career.

2nd World War Japanese attack on Pearl Harbor	Fall of Fascism in Italy Normandy Landings	Yalta Conference Partition of Germany	Marshall Plan First British nuclear reactor	Council of Europe established North Atlantic Treaty	Coronation of Queen Elizabeth II US explodes first hydrogen bomb
Gamow: Big Bang theory Von Braun: V2 rockets	Waksman and Schatz: streptomycin Quinine	First atom bomb Eckert and Mauchly: electronic computer	Reflecting telescope at Mount Palomar Observatory Bardeau, Brattam and Shockley: transistor	Einstein: unified field theory	Fermi: *Nuclear Physics* Parsons: *The Social System*
Copland: *Appalachian Spring*	Poulenc: *La Figure Humaine*	Honegger: *Sinfonie liturgique*	Stravinsky: *Orpheus*	Hindemith: *Harmony of the World*	Britten: *Billy Budd*
Literary works by Koestler, Hemingway, Camus, Faulkner, Colette	Literary works by Brecht, Sartre, Borges . . .	Literary works by Simenon, Orwell, Anouilh, Prévert, Pound . . .	Literary works by Bellow, Moravia, Mann, de Beauvoir . . .	Literary works by Miller, Ionesco, Greene, Neruda, Dürrenmatt . . .	Literary works by Beckett, Steinbeck, Miller, Rattigan . . .
Fromm: *Escape from Freedom* Jung: *The Interpretation of Personality*	Saint-Exupéry: *The Little Prince*	Auerbach: *Mimesis* Founding of UNESCO Dubuffet: *art autre*	Kinsey Report Dead Sea Scrolls discovered	Lévi-Strauss: structuralism The Beat Generation	Sartre: *The Psychology of Imagination* Le Corbusier: *Unité d'habitation,* Marseilles
Guttuso: *Crucifixion*	Still: *Jamais*	Léger: *Composition with Branch* Calder: *Yellow Bottle*	Gorky: *Agony*	McIver: *Venice* Morandi: *Still Life*	Pollock: *Convergence* Still: *Painting*
1940–42	1943–44	1945–46	1947–48	1949–50	1951–52

Willem de Kooning, Woman 1, 1950–52, Museum of Modern Art, New York. American ''action painting'' was the cutting edge of that vast international movement that was later to be defined as ''informal art.'' De Kooning's painting, with its fiercely iconoclastic quality, represents a fundamental chapter in the history of American art. Most of his paintings contain vague outlines of figures, almost dream-like signs, uncontrolled impulses from the subconscious, distorted by the expressionist violence of the dripping technique with which the artist has attacked them.

22 ABSTRACT EXPRESSIONISM

I n the period immediately following the Second World War the avant-garde spirit took over New York, affecting every aspect of artistic endeavour. There had already been important precedents during the first half of the century, between 1910 and 1945, when the immigration of European intellectuals (ranging from Duchamp to Masson, Kandinsky to Mondrian, and Albers to Moholy-Nagy) had sown the seeds in a soil which, given the country's contemporary economic and social development, was more than ready to accept the rationale of modernism. As a result, many American artists (Man Ray, Alfred Stieglitz, Mark Tobey and Arshile Gorky) had reacted very positively to the proposals made by Dada, Surrealism and abstract art, each making their own contribution to the establishment of a flourishing American avant-garde. The latter did not come into being until after the end of the war, when the label Abstract Expressionism was applied to two important trends in New York art. It is not easy, however, to differentiate between these two trends since the boundary between them was not clear and many works lie in a hazy area between the two.

One of the styles concerned was certainly more open to the principles of historical abstraction. Its models were, to be specific, the works of Malevich, Matisse, Mondrian and Kandinsky. But it should also be remembered that artists such as Barnett Newman, Ad Reinhardt, Mark Rothko and

◀ *Mark Rothko,* Number 10, *1950, Museum of Modern Art, New York. American Expressionism of the 1950s also contained a more overtly abstract element, far removed from the violence of informal dripping, but based equally on the idea of a sort of "action painting" capable of giving vent to the hidden realities of the psyche.*

▼ *Barnett Newman,* Vir Heroicus Sublimis, *1950–51, Museum of Modern Art, New York.*

Clyfford Still, in their own way, followed pictorial ideals with no historical precedents and appeared to be animated by a totally radical reaction to the pragmatic nature of their country's culture. In their paintings the image becomes a ritual, magical, sacred event and, by reviving esoteric parameters, aims at achieving its psychological effect through the use of the same prerogatives that inspire, for example, the art of Asian mythology. We therefore find ourselves face to face with the paradoxical, contradictory phenomenon of an art that assumes a metaphysical role, that tries to become a pure concept, an absolute idea, and yet in so doing succeeds in making the picture more of an "object" than ever before, reducing it of necessity to the essential elements of its structure: the canvas, the frame, the rectangular or in any case geometrical shape of its border and the simplified colours of its background. In comparison with the Suprematism of Malevich and the Neoplasticism of the Dutch, the very idea of "shape" proves to be missing, or at

Automatism

Jackson Pollock, Number 12, 1952.

least is reduced so much that it becomes a chance meeting of two or three colours that stretch over large areas of the surface without any real spatial definition.

The second trend was represented by "action painting," whose protagonists (Pollock, Kline, Motherwell, De Kooning, Guston, Francis and Gottlieb), although often biographically close to, and sometimes very supportive of, the contemporaries we have already mentioned, were completely indifferent towards European abstractism, thus blurring once and for all the ingenuous distinction between "figurative" and "abstract" art. Action painting was, in fact, a highly successful reassertion of the essential concept of Surrealist theory, namely the definition of "automatism" formulated by Breton between 1924 and 1929. Using the discoveries made by psychoanalysis, psychic automatism succeeded in establishing a direct link between the subconscious and

Informal art, in its role as the immediate expression of the innermost recesses of the ego, is a response to the need to abolish the rational control exercised by the artist on his or her hand during the creation of a picture. It is also motivated by a belief in the intimate psychological capacity of as yet "unformed" material. At the root of these requirements lies the concept of automatic writing, which Breton had theorized during the 1920s, but which the Surrealists had only partly, and unsatisfactorily, succeeded in applying. According to Breton, the basis of art should be pure psychic automatism, whereby one aims to express the true creative unconscious, whether verbally, in writing or in any other manner in the absence of any control exercised by reason and beyond all aesthetic or moral concerns. The idea that thought could dictate its own truth, provided the subject avoids submission to any socio-cultural censorship, explains the state of trance required during the creation of informal art.

the act of the "gesture" of creation, promoting the free flow of linguistic material with no ethical and aesthetic controls, or, in other words, the artistic activation of latent impulses unaffected by any cultural filter.

In "informal" painting, and especially "action painting," it is the pictorial material per se, in its sense as a non rational element, as matter yet to be transformed into language, that becomes the vehicle for the artist's inner content, which, similarly, is not yet, and never can be, arranged in logical, discursive structures, since any sort of precise delineation that gave it a conscious quality would destroy it. This explains the increased presence of chance and accident in works such as those of Jackson Pollock. They were created in psychological conditions of unrestrained vitality, with the result that the hand, the arm, the whole body of the artist "forgot" to depend on the mind and the will and were liberated in a

BIOGRAPHIES

◆ **Bacon** Francis (Dublin 1909). He settled in London in 1925, starting out as an illustrator. It was not until 1945 that his work began showing signs of the social criticism, sustained by a strongly polemic spirit, that led to his violently spontaneous distortions of the figurative image, especially in portraits.

◆ **Burri** Alberto (Città di Castello 1915). After graduation and early years of professional practise, he abandoned his medical career in order to devote himself entirely to painting. In 1952 his works attracted the attention of the public because of the expressive force of their styles, and the use of heterogeneous and unusual materials. Despite the decidedly revolutionary character of his experiments, he remained firmly linked to the values of Italian popular culture.

◆ **De Kooning** Willem (Rotterdam 1904). Dutch by birth, he moved to New York in 1926. During the 1930s he created abstract and figurative works, with no particular concern for stylistic coherence. When, after the war,

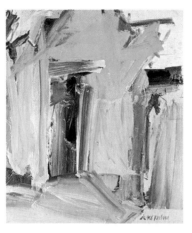

Willem de Kooning, Door to the River, 1960, Whitney Museum of American Art, New York. This work displays an amazing degree of emotional intensity and formal precision. It seems almost as though the artist has successfully synthesized these two conflicting requirements, so demonstrating the extraordinary technical and linguistic heights achieved by his art.

Jackson Pollock, Lucifer, detail, 1947, Hazen Collection, New York. Pollock was the most assiduous and skilful exploiter of the dripping technique, which consisted of letting paint fall on the canvas in an uncontrolled, almost random way, or through an unusual system of checks and balances.

sort of sacred frenzy, mindless of all decorum, all rules of composition and all aesthetic device. The measured style of the results achieved in this way in no way diminishes this unique revelation of chaos. During his most daring phase (from 1947 to 1952) Pollock treated painting as a sort of hand-to-hand encounter with the surface to be painted: the technique known as "Drip Painting" (derived from certain experiments by Max Ernst) offered him an opportunity to violate the canvas and exploit the effects of drips and randomly created splashes. The canvas was first laid on the floor and then, after being covered in liquid paint, was placed in a vertical position to allow gravity to create unpredictable non-shapes, or, alternatively, the colour was allowed to drip on to the canvas from a specially pierced container. It represented a modern rethinking of the romantic idea of inspiration, since the work could be obtained solely by starting

his Expressionism evolved into action painting and became one of the linchpins of informal art, his earlier stylistic oscillations did not disappear, but rather contributed to the originality of his work.

♦ **De Staël** Nicolas (St Petersburg 1914–Antibes 1955). In 1932 he began studying at the Brussels Academy and in 1938 he settled in France. His painting, based on broad expanses of colour,

displays links with the nineteenth-century French tradition, ranging from Courbet to Cézanne, as well as with German and Belgian Expressionism.

♦ **Hartung** Hans (Leipzig 1904). From a very early age he expressed interest in the more anarchic and unruly versions of Expressionist painting (Nolde, Kirchner). In 1935 he moved to Paris and began working on the notions of gestural

freedom and the language of the subconscious. During the 1950s, contact with the new international mood resulted in his art achieving the equilibrium of full maturity.

♦ **Kline** Franz (Wilkes-Barre 1910–New York 1962). After studying at the universities of Boston and London, he exhibited his first gestural works in New York in 1950. Their

broad and rapid, black brush strokes on a white ground reveal two main influences: Oriental calligraphy and Surrealist automatism.

♦ **Leoncillo** pseudonym of Leoncillo Leonardi (Spoleto 1915–Rome 1968). From 1939 until 1942 he ran a majolica factory in Umbria. Meanwhile he perfected his technique as a sculptor and ceramist, creating his first major works

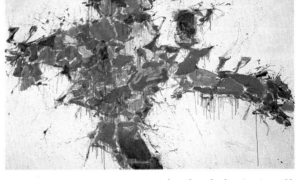

from a sort of "state of grace"
(*Surprise and Inspiration* is
the title of a painting by
Robert Motherwell from
1943). We also now have a
new concept of authenticity,
which invokes the artist's to-
tal participation in the act
that he is performing: an
unbridled form of expres-
sionism, capable of evok-
ing primitive, violent actions
that involve all muscles and
nerves, body and spirit, heart
and soul, discovering a per-
son's deepest being on a tor-
mented canvas of vibrant
tangles and splashes, becom-
ing nothing more than a
screen on which the incur-
able wounds of the contem-
porary ego are projected.

In a sense, the informal
art of the 1950s embraced
the heritage of much of
twentieth-century avant-
garde art, combining ele-
ments derived from the
German *Die Brücke* (The
Bridge) group, the primitivist
movements from the begin-
ning of the century, Dada
and Surrealism, the *Der Blaue
Reiter* and Fauvism. On the

other hand, despite its self-
proclaimed "abstractism,"
this style of painting is by no
means without images of
the "real" world (albeit
distorted), as is illustrated
by certain of Willem de
Kooning's works, in which
the spontaneous element
seems to require a figurative
substratum on which to sup-
port itself: at most a human
body, a nude, female or
otherwise, able to conduct
a dialogue, so to speak,
with the spirit of the person
who has created it on the
canvas and to fire the sub-
conscious impulses that will
create its distortion. In the art

between 1944 and
1950. During the mid
1960s he opted for the
informal style and was
soon achieving results
of great stylistic
quality.

◆ **Motherwell**
Robert (Aberdeen,
Washington, 1915–
New York 1991). In
1948 he founded the
Subjects of the Artist
school, which attracted
many members of the
young New York
avant-garde (Newman,
Rothko, Baziotes).
Although an

essentially abstract
artist, he sometimes
also made use of
ambiguous dream
forms, with a palpably
structural quality,
which seem to recall
the Surrealist images
of Masson and Miró.

◆ **Newman** Barnett
(New York 1905–
1970). Together with
Ad Reinhardt, he
represented the most
rigorously abstract
tendency of American
Expressionism. At the
beginning of the 1940s
he formulated a

neomystical concept of
the painted surface
that he treated as a
receptacle for
psychological and
linguistic imperatives
that could not be
expressed in any other
way.

◆ **Pollock** Jackson
(Cody, Wyoming,
1912–Long Island,
New York, 1956). In
1929 he moved from
the West to New York
where he came under
the influence of, first,
Mexican painting and
then Surrealism and

Cubism. In around
1940 he began to
devote a great deal of
space in his works to
irrational impulses,
soon arriving at that
gesturally spontaneous
style that gave rise to
the "dripping"
technique of his
post-1946 works. He
died in 1956 in a car
accident.

◆ **Riopelle** Jean Paul
(Montreal 1923). In
1940 he founded the
Automatisme group,
inspired by Breton's
theories. In 1947 he

▼ Franz Kline, Figure Eight, 1952, Rubin Collection, New York. In the monochrome brush strokes of Kline's work, the artist reveals his search for the essence of gestural painting understood as

a mystical moment of introspective awareness. In this sense his art shares similarities with certain Oriental experiences of philosophical self-analysis.

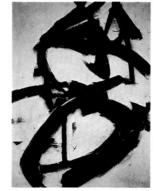

of Franz Kline, on the other hand, the automatic gestures are always broad, open and expansive, almost schematic in their monochrome quality of black lines on a white ground, and, yet, confined within a quivering precision, they exude a feeling of intensity and tragedy, a quality similar to that encountered in the harsh, caustic brushwork of the European Hans Hartung.

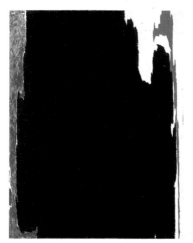

▶ Clyfford Still, Painting, 1951, Museum of Modern Art, New York. Still's Abstract Expressionism exploits a gestural technique with a great sense of space and solemnity, usually on very large canvases. An almost "religious" approach to the picture acts as a counterpoint to the uneven shapes of colour, subtly arranged with a full awareness of the effect he is trying to achieve.

From 1950 on the relationship between Europe and America seems to reverse, with American painters starting to influence French, Italian, Spanish, German and Belgian painting. The rule of America leading and Europe following was not a firm one, however: around 1930, for example, Jean Fautrier can be seen to be working along the same lines that would, quite rightly, make him one of the masters of Abstract Expressionism. His position at the time was, and always would be, that of an artist in isolation, dedicated entirely to an exhaustive study of his own personal obsession with perceptual associations and language. In Europe, the technique of "gestural painting" tended to display a more moderate and reflective character than that found in American "action painting." The paintings of Wols (Alfred Otto Wolfgang Schülze) and Hartung, two of the spiritual fathers of European art at the time, often possess a carefully balanced

moved to Paris, where he was attracted to *Tachisme* (painting in spots), which he interpreted in a very personal way, creating strongly structured works composed of coloured spots or blobs applied using a palette knife.

♦ **Rothko** Mark (Dangavpils, Latvia, 1903–New York 1970). He moved from Latvia to New York in 1913. During the 1920s he came into contact with the

painting of Matisse (examples of which were already in American museums) and the theories of the Surrealists. After 1945 his Abstractism reconciled the chromatic preferences of the great European painters with the expressive demands of the American "action painters."

♦ **Vedova** Emilio (Venice 1919). Initially influenced by the neo-Cubist style and by cultural groups

involved in the conflicts between figurative and abstract art, in 1952 he formulated a style of his own, which maintained a balance between the German experiences of Hartung and Wols and the dripping technique of Pollock and Kline, creating works with a strongly dramatic quality. Vedova also deserves credit for the way in which he brought innovation into his work during the 1960s by involving

the dimension of space in his gestural work (the so-called *Plurimi*), while remaining faithful to the principles of informal art.

▼ *Hans Hartung,* Painting, *1958, Private Collection.* Tachisme *was the main way in which French artists interpreted informal art. It was a painting that relied on* taches *(spots or blobs), much more than on gesture or subject, to illustrate the spontaneous creative flow.* Taches *were a negation of form, which was seen as an impossible, rational control of the psyche.*

quality, even though Wols, who arrived at Abstract Expressionism after the trauma of imprisonment in a concentration camp, displays a scratchy and sometimes violent style. The broad, essential "writing" of Hartung, on the other hand, echoes the Oriental tradition of calligraphic art, which, after its rediscovery during the period, exercised a strong influence on European avantgarde experiments, with signs of it appearing in the works of such artists as Pierre Soulages and Georges Mathieu. In Italy, gestural art achieved very successful results with Emilio Vedova,

▼ *Emilo Vedova,* Image of Time (Barrier), *1951, Peggy Guggenheim Collection, Venice. The concept of "spazio inquieto" (restless space), on which this painting is based, was formulated by Vedova in his search to find the true dimension of inner experience, as opposed to the rational space of everyday reality. The gestural impetus in his work has produced sharp corners, with abrupt changes of direction in the rapid, nervous brushwork.*

whose work reflects an idea of spiritual involvement similar, in many respects, to that expressed by the Americans, and subsequently with certain "spatialists," such as Crippa and Peverelli, and also, to an extent, with some of the works by Scanavino and Santomaso. In the majority of cases, the expression or the gesture matches the nature of the subject, as in the work of Afro, Moreni, Birolli, Scialoja and Bendini. Gestural paintings also found applications within the realm of representations that do not shun the figurative image, as, for example, in the paintings of the Irishman Francis Bacon, the highly original interpreter of a style that mediates between Expressionism and Pop Art and which, in certain aspects, anticipates the "informal photography" of the Austrian Arnulf Reiner.

Apart from Fautrier (the founder of pictorial Existentialism with works based on thick blobs of matter), France saw the rise of artists of great expressive force: figures such as Georges Sécan, whose works closely echo American models, or Jean Paul Riopelle, a Canadian by birth, who works in mosaics composed of countless dashes of thick paint, or Nicolas de Staël, who makes use of densely coloured blocks in patterns and, while maintaining a difficult balancing act between the figurative image and its negation, almost always achieves a surprising degree of expressive intensity. Mention should also be made of the Spaniard Antoni Tàpies. His paintings bring about a sort of trompe l'oeil effect in the material, which is carried to such a degree that it becomes a paradoxical "imitation" of itself. In Italy,

▼ Jean Paul Riopelle, Untitled, 1956, Wallraf-Richartz Museum, Cologne. The decorative value of Riopelle's paintings lies in his use of thick layers of colour on the canvas: a sort of rhythmical, geometric wall, composed of an intriguing arrangement of small, thick patches of paint applied with a palette knife.

▼ Nicolas de Staël, Agrigento, 1953, Henie Collection, Oslo. European informal art achieved an unusual balance of figuration and abstraction in the works of artists such as the Russo-French

Nicolas de Staël, who invented colourful compositions that are reflections equally of reality, memory and soul.

some very convincing work was produced by Ennio Morlotti, the main exponent of a naturalistic-informal trend that the critic Francesco Arcangeli has used as the basis for his theory that recognizes a continuation between the Romantic style and the painting of the post-war period. Other members of this group, which lasted for only a few years, include Pompilio Mandelli, Sergio Vacchi and Vasco Bendini.

A rare example of an informal sculptor is provided by Leoncillo (Leonardi), who in

▼ Antoni Tàpies, Large Painting, 1958, Guggenheim Museum, New York. The manipulation of the paint in the work of Antoni Tàpies gave rise to a style of painting that relied for its expressive capacity on the effect of multiple layers, on an almost sculptural thickness.

his ceramic and terra-cotta works showed uncompromising dedication to the mysterious qualities of the raw material. Sometimes completely bereft of any conceptual content, the "shape" of his sculptures is that of an ancient lava flow, whose dead, two-tone colours seem to be the chemical product of natural agents rather than the result of artifice. On other occasions he revived certain classical motifs of religious iconography, but transposed them into a direct, solid representation of pure corporeal presence, often achieving dramatic levels comparable to those found in the painting of Soutine.

The most outstanding figures in what could be called the "heretical component" of informal art are those artists who, basing themselves on different premises at different times, paved the way for the experiments of the 1960s: Yves Klein, Lucio Fontana, Alberto Burri, Pinot Gallizio and the protagonists of the international CoBrA group (a group of painters from Copenhagen, Brussels and Amsterdam). What they shared was a need for their

▶ *Francis Bacon,* Studio of Velázquez: Portrait of Pope Innocent X, *1953, Burden Collection, New York. Bacon pursued his own ideal of art as a means of philosophical, existential reflection and social denunciation. Although stylistically very different, his oeuvre may be compared, in terms of processes used, to that of Willem de Kooning.*

▶ *Alberto Burri,* Iron D, *1958, Palazzo Citterio, Milan. Less well known than his* Sacks *and* Plastics *series, Burri's* Irons *are among the most remarkable inventions of informal experimentalism, which was based on a belief in the intrinsic expressive qualities of the materials themselves.*

works to be unconfined within the space of reality, a rejection of the painting as an independent and enclosed place, as an "alien" dimension, divorced from the real-life experiences of society and the individual. Burri's work, for example, reflects the firm belief that a genuine interest in the expressive abilities of material must involve experimentation with various new types of materials, that are not a part of the painter's and sculptor's traditional source of inspiration. Even before being put to work, these materials already possess a rich existential, cultural and psychological content of their own: crude metaphors of their earthly existence, they convey the grief, the passion and the misery that they have experienced, unstintingly pouring them back into the space in which the artist places them. There they are modified and given new meaning, reacting to their contact with the emotive language provided by the artist's sensibility. And so it becomes objects made of iron, plastic and wood, sacks and used, dirty, torn, burned and patched sheets, mended with string, arrayed (like a solemn statement of the real-life experiences that have created them) within the confines of the frame. The picture becomes a secular and deeply human "shroud," a place of remembrance, a ritual theater in which the artist celebrates the constantly repeated sacrifice of life, and the shreds and tatters on which it feeds and by which it recognizes its own truth. ∎

Arshile Gorky, The
Betrothal II, *1947, Whitney
Museum of American Art, New
York.*

*The founding members of the
American postwar avant-garde
included painters such as Mark
Tobey and Arshile Gorky, whose
works clearly betray a link with
Surrealist painting. Rather than
''automatic writing'' (later to
appear in Pollock and Kline), the
artist has here exploited the
dream-like quality of the
paintings by, for example, Miró
and Matta.*

Pierre Soulages, Painting,
1953, Private Collection.

*One characteristic feature of
European informal art is its
cultivated spontaneity. The idea
of an action expressing the
artist's innermost thoughts in the
most direct way is matched by an
awareness of aesthetic
imperatives (''natural'' to
European artists), of which
American culture, given the
absence of any classicist heritage,
was far less aware.*

Leoncillo, St Sebastian, *1961,
Sargentini Collection, Rome.*

*This work by Leoncillo is
classified as an example of
''informal sculpture'' by virtue
of its revolutionary interpretation
of terra cotta, transformed into a
dramatic metaphor of the raw
material itself.*

Yalta Conference	Marshall Plan	Council of Europe	Atlantic Pact	Hungarian uprising	US–Soviet Summit at Camp David
Partition of Germany	Start of Cold War	Korean War	Eisenhower President of US	Suez Crisis	
Fermi: first controlled nuclear chain reaction Biro: ballpoint pen	First TV transmission in US	Breaking of sound barrier Cortisone	Crick, Watson, Wilkins: DNA Cockerell: hovercraft	Salk: anti-polio vaccine Soviet Sputnik	2nd Soviet Sputnik Optical micro-wave lasers
Shostakovich: *''Leningrad'' Symphony*	Cage: *Sonatas and Interludes*	Robbins-Bernstein: *Age of Anxiety*	Boulez: *Le Marteau sans maître*	Bernstein: *West Side Story*	Britten: *Noye's Fludde*
Literary works by Sartre, Mann, Levi, Gide, Buck . . .	Literary works by De Beauvoir, Pasternak, Priestley, Calvino . . .	Literary works by Orwell, Borges, Dürrenmatt, Nabokov, Dylan Thomas . . .	Literary works by Salinger, Sagan, Steinbeck, Robbe-Grillet, Dylan Thomas . . .	Literary works by Tolkien, Nabokov, Osborne, Kerouac, Greene . . .	Literary works by Grass, Yevtushenko, Mishima, Tennessee Williams . . .
Jung: *Psychology and Religion*	Lukács: *Studies in European Realism* CoBrA group	*Beat Generation* in US Brecht: *Berliner Ensemble*	Le Corbusier: *Unité d'habitation,* Marseilles	Hoyle: *Man and Materialism* Ayer: *The Problem of Knowledge*	Wright: Guggenheim Museum, NY
Pollock: *Composition No 1* **Motherwell:** *Surprise and Inspiration*	**Vlaminck:** *A Bunch of Flowers* **Pollock:** *Lucifer*	**Newman:** *Vir Heroicus Sublimis* **Chagall:** *King David*	**De Kooning:** *Woman and Bicycle* **Bacon:** *Portrait of Pope Innocent X*	**Rothko:** *Black on Brown* **Hepworth:** *Orpheus*	**Noguchi:** *Integral* **Miró:** murals for UNESCO building, Paris
1942–45	1946–48	1949–51	1952–54	1955–57	1958–60

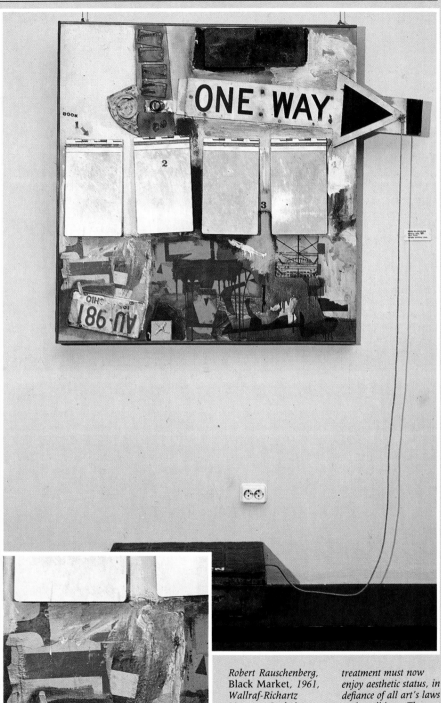

Robert Rauschenberg, Black Market, 1961, Wallraf-Richartz Museum, Ludwig Collection, Cologne. By including rubbish and waste elements in his paintings, Rauschenberg aims to underline how everything that was once considered unworthy of artistic treatment must now enjoy aesthetic status, in defiance of all art's laws and traditions. The content of his works is therefore decidedly subversive; by glorifying what is valueless, he deliberately questions the hierarchic distinctions between art and non-art objects.

23 POP ART

op Art emerged after a period lasting almost twenty years that was wholly dominated by abstract art. At a time when Abstract Expressionism was internationally established, this striking art movement was founded in England and then independently in New York.

The strong belief in the art form as a means of protesting against the stultifying, oppressive life style of the metropolis that had constituted the backbone of "action painting" meant nothing to Pop artists. They were sufficiently disillusioned with these experiments not to harbour any faith in art as a release, and they no longer believed that the individual could act as a free, autonomous agent in the creative process. In fact, any interest in the human as subject to be found in Pop Art is very different — on a desensitized, alien level. Yet, although this movement represented a reaction against former beliefs, it is clearly the heir of the abstract rather than the figurative tradition.

Pop Art did not find fertile ground everywhere; and, as we shall see, its diffusion in Europe and America assumed quite different guises. America proved a far more propitious setting for its development since the public was highly responsive to the message it proclaimed. The new trend was introduced to New York during the 1960s. However, already in 1956–7 certain works, legacies of the New York school and full of gestural traits, had already appeared featuring inanimate objects of everyday use,

▲ *James Rosenquist, F-111, (detail), 1965, Robert C. Scull, New York. This detail of the mural shows how the artist unites natural and artificial subjects to produce obsessive science-fiction visions.*

◀ *Jasper Johns, Numbers in Color, 1958–59. Albright-Knox Art Gallery, Buffalo. Johns aims to confer artistic dignity on banal, everyday images. The result is a fresh appraisal of a visual cliché that apparently lacks content by reason of excessive familiarity.*

either painted or simply attached to the work. Artists such as Larry Rivers, Jasper Johns and Robert Rauschenberg, who included in their highly expressive work iconic elements of a decidedly anti-expressive character, were forming a bridge between the abstractionists and the later exponents of mature Pop Art. And while initially these early activities appear consonant with *assemblage*, from 1961 onwards, through the works of Dine, Oldenburg, Lichtenstein and Rosenquist, they display decidedly anti-abstract charac-

teristics, adopting to symbols and techniques which are more obviously derived from the language of advertising.

Even if all historical influences on Pop Art cannot be directly traced, its prototypes are certainly Surrealism and Neo-Dadaism, especially as epitomized by Duchamp. From Duchamp comes the mode of handling the object, which is removed from its natural surroundings and transplanted into a completely different context. In front of other, often foreign connotations, the object is

presented as a poetic absolute. While Pop Art adopted the process of removing objects from their normal contexts, its way of re-portraying them differed. Pop artists reinstated objects as items of waste, discarded trash of the society which produced it.

In order to understand Pop Art properly, to justify its techniques, to grasp its contents, it is necessary, above all, to bear in mind that this is a movement which was very much a part of the contemporary scene, characterized by an impulse and a style that are indissolubly linked to the rhythms of modern city life. Unrestrained by limitations or conditions, this new art sets out to equate its field of action on the canvas with the events of the world; to take in whole moods and issues and to match them in their art. Its sources of inspiration, therefore, are the more cloying and provocative aspects of contemporary culture, society in the mass, and the images evoked by the jargon of commerce, exerting ex-

▶ *Claes Oldenburg,* Giant Soft Swedish Light Switch, *1966, Wallraf-Richartz Museum, Ludwig Collection, Cologne. Here we see how the artist takes inspiration from the familiarity of everyday life. His subjects are in daily use but are treated with mocking irony. Made to look unfamiliar and unnatural by being heavily disguised or deformed, they are assigned artistic validity.*

ceptional pressure on the consumer.

Pop Art was launched in two phases. Initially, as the result of a general mood of exasperation and disorientation, a group of artists became very sceptical about the ability of spontaneity in art to lead them to freedom. Fearing the power that the image was capable of exerting while art became a tool of the industrial age, Rauschenberg, Johns, Dine, Lichtenstein,

Rosenquist and Segal went through a short-lived time of total pessimism. This was succeeded by a basically cynical stage, in which they yielded completely to the banality of life. The barriers between art and life crumbled, as art came to identify itself not only with the world but with its subculture; the language of the mass media was provocatively raised to aesthetic level, disregarding any of the already-established

BIOGRAPHIES

◆ **Adami** Valerio (Bologna 1935). He draws with thick black strokes, typical of the strip cartoon, creating silhouettes in subtle picture stories.

◆ **Angeli** Franco (Rome 1935–88). A period artist who died prematurely, Angeli chose to illustrate in a provocative way consumer symbols such as dollar signs and eagles repeated obsessively on canvases and sometimes partially hidden from the gaze by thin veils.

◆ **Dine** Jim (Cincinnati, Ohio, 1935). The artist's attention is concentrated on personal objects, mostly related to his work, rather than consumer objects. However, it is not so much the subject that interests him, but the way of presenting it, which he achieves in lively and complex works.

◆ **Hamilton** Richard (London 1922). He sees the phenomenon of twentieth-century consumer culture as the source of evocative material, endowed with such imaginative potential as to be perfectly adaptable to artistic ends. He uses photography not only to explore technological themes but also to realize lively fantasies of human reality.

◆ **Hockney** David (Bradford, West Yorkshire, 1937). An artist of considerable talent, he captures moments of contemporary life with great precision through an extremely pure and simplified pictorial style.

◆ **Indiana** Robert (Newcastle, Indiana, 1928). His works place emphasis on letters, numbers and sign systems which, when combined and repeated, produce verbal and visual creations.

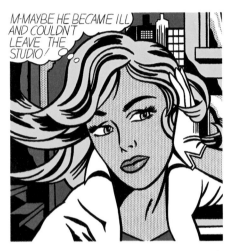

principles of art. The life style of the capitalist metropolis with its pressures of conformity and its subjection to deceit and exaggeration thus became the source of material from which artists such as Warhol, Wesselmann, Oldenburg and Indiana, derived their stereotyped and inert images.

However, the process by which they consecrated the most commonplace objects, raising them to artistic status,

♦ **Johns** Jasper (Allendale, South Carolina, 1930). In his attempt to depart from fixed meanings, the result of visual familiarity, Johns expresses the representational possibilities of banal and commonplace images such as banners, targets, series of numbers, etc., raising them to artistic level.

♦ **Jones** Allen (Southampton 1937). Probably the most typically English Pop artist, he uses lively erotic images from the world of advertising combined freely with other ideas, for mainly decorative purposes.

♦ **Kaprow** Allan (Atlantic City 1927). Inventor of the concept of Environment, he founded a new theatrical form, the so-called Happening, based on this notion, representing places, objects and actions of everyday life.

♦ **Lichtenstein** Roy (New York 1923). His comic strips, stylistic elements and decorative forms are done in boldly drawn outline and *pointillism* derived from print enlargement. This allows him to lay stress on the technique as against the content, achieving a sarcastically detached style that, ironically, does not leave room for the emotive aspect.

♦ **Oldenburg** Claes (Stockholm 1929). His art takes the familiar forms of everyday life and creates disproportionate surrogates endowed with their own life. Enlarged to grotesque proportions and bearing unnatural shape and consistency they are a clear allusion to the perishability and temporary nature of consumer objects.

♦ **Rauschenberg** Robert (Port Arthur, Texas, 1925). Starting in the 1950s when his

Happenings

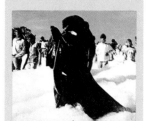

was not based on a critical, challenging stance but on acceptance of the system as it existed. Thanks to the mass media, such images were understood by everyone in the same way. Pop artists, rather than rebelling against this ideological conditioning, substantiated it by making use of it in their art. They did not seek to banish reality but to embrace and enhance it. Mesmerized by the idea of industrial productivity as the means to wealth and happiness, the individual is subjected to stereotyped images, the instruments of hidden persuasion that are daily administered. Unable to avoid the onslaught of such symbols, they become the victim of consumerism. The proliferation of such icons inevitably renders society incapable of rational discernment and individual thought. Confronted by this standardization of behaviour, people do nothing, accepting it simply because it is the norm.

The Pop artists, aware of

Inherent in the Pop movement was an involvement of art in life, in the everyday life of people and objects. The search for an understanding of modern culture and environment led to a reciprocal identification with objects so that people were mass-produced articles and objects were individuals: this proved an enticing theme for the theater. Realizing the barriers between art and the language of representation could be resolved, Pop artists leapt at the opportunity offered by the stage. The Happening became the expressive form that interpreted many of the points of interest of the contemporary art movement. Happenings dramatized very ordinary events but concentrated, rather than on human behaviour, on the human environment, on stage settings of common, everyday reality. The theorist and originator of the Happening was Allan Kaprow in the late 1950s. (In the photograph: Allan Kaprow, Going to the Dump, *part of the Happening,* Gas, 1966, *Springs, Long Island, New York.) Others particularly fascinated by the theater were Oldenburg, Dine and Rauschenberg.*

this process, took the most prominent examples of this visual reality and reoffered them in as impersonal a manner as possible. The expressive techniques they adopted owe much to commercial art, poster design, photography, silk-screen printing and comic strips. While the repetition of inanimate, unadorned figures, slavishly reproduced from the world of commerce meant the artist's identity was in danger of being lost in favour of his art, the standardization of the images revealed at the same time the artist's contempt for artistic tradition and for the consumer world. Pop Art is in fact a movement whose success relied on the wealth and success of capitalist society.

In Europe, the whole matter was considerably more complex, given the wide spectrum of political beliefs represented and the pluralistic cultures that such diversity produces. The cultural climate was dominated on the one hand by Abstract Ex-

pictorial style was marked by abstractionism, his painting has moved on to representing consumer and waste objects. These "combine-paintings," using a collage technique, negate the distinction between art and non-art objects.

♦ **Rosenquist** James (Grand Forks, North Dakota, 1933). Concerned by the bombardment of mass media and unrestrained

consumerism, he originated science-fiction landscapes in comic-strip style, elaborated through paint and photography.

♦ **Schifano** Mario (Homs, Libya, 1934). He reduces iconography to a few repeated symbols, often centered in squares evoking television screens, or

painted in brilliant or varnished colours on wrapping paper.

♦ **Segal** George (New York 1925). He creates life-size figures from life, in plaster casts and places them in familiar settings with real objects. The immobilization of the gesture and the construction of the mould notably increase the sense of discomfort and solitude that these anonymous and spectral forms transmit.

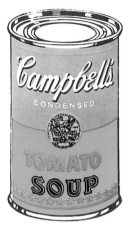

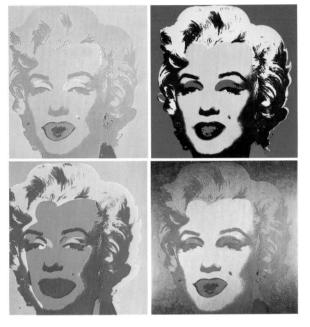

pressionism, on the other by the formalistic tradition of the avant-garde movements. Where the latter trend was especially deeply rooted, the influence of American Pop Art had great difficulty in becoming established. Its impact varied greatly in degree from country to country, and perhaps for the large majority of artists, the Pop experience was no more than a transitional phase.

England, however, constituted a case apart. Here the movement developed more or less independently, with its own body of theory and its own history. The term "pop" (popular) was first used in 1955 by Fiedler and Banham to denote expressions drawn from the language of the mass media, from comic strips and glossy magazines, from cinema and television. Other social observers had simply applied the label of *kitsch* to images derived from the commercial culture as opposed to the more aristocratic, elitist tradition.

In 1955 a group of intellectuals belonging to London's Institute of Contemporary Art came together, all similarly attracted by the culture

◆ **Smith** Richard (Letchworth, Hertfordshire, 1931). Smith is able to evoke memories of objects through techniques other than figurative, stimulating association and recall in the spectator.

◆ **Tadini** Emilio (Milan 1927). Emphasizing his figures with stiff, heavy brush strokes, he elaborates a story around familiar objects dispersed in a disorderly way.

◆ **Warhol** Andy (Pittsburgh, Pennsylvania, 1928– New York 1987). The subjects of his works are familiar images and events, ranging from stars of the cinema screen to car accidents, from canned-goods advertisements to the electric chair, from flowers to items of news. These are presented in a sequence of repeated and often provocative images, in dazzling, daring colours.

◆ **Wesselman** Tom (Cincinnati, Ohio, 1931). Departing from traditional techniques of collage and *assemblage*, the artist paints in clear and vivid tones; his works are ironic and sentimental in content and include real and life-size figures and objects.

▼ Richard Hamilton, Just
What Is It that Makes
Today's Homes So
Different, So
Appealing?, 1956,
Private Collection,
Thousand Oaks. For
Hamilton, photography
became an excellent

creative means of
stressing art's
association with daily
life.

▼ Allen Jones, Bare Me,
Konstmuseet, Göteborg.
The work of this
English artist was often
inspired by the glitter of
the stage, its lights and
colours.

▼ Tom Wesselman,
Bathtub Collection
No. 3, 1963, Wallraf-
Richartz Museum,
Ludwig Collection,
Cologne. This work
recreates, on a life-size
scale, the atmosphere of
a bathroom. The
extreme simplicity of the
treatment and the
detachment of the whole
scene reveals the artist's
wish to illustrate a
superficial appearance.

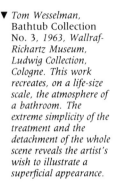

symbols of the most disparate provenance. The techniques included straightforward drawing and painting through to the use of transfers and strip cartoons. So the special aspect of English Pop Art was the total absence of homogeneity, both in respect of styles and groups.

As for the rest of Europe, the area most obviously influenced by America was the urban arts associated with "new realism." Although Pop Art and New Realism share several features they are actually two very distinct movements. By and large, artists in Europe found it extremely difficult to take a commercial image and pro-

of urban civilization. Their meetings dealt mainly with techniques, in particular photography. The method, already employed by Bacon, became for other English artists of the first Pop wave – Hamilton, Cordell, McHale and Paolozzi – an ideal creative aid that could evoke at the same time images from reality and hypothetical ones from the imagination. This first phase was, therefore, concerned with questions of technique, while the second

was to be by nature abstract. Loyal to the examples of their predecessors, the second group (Smith, Coleman, Blake, Green, Denny) cast an eye on their surroundings. Familiar and recurrent symbols now occupied mental spaces verging on the illusory, recalling the great American abstract paintings.

The third phase posited a return to figurative art. Kitaj, Jones, Phillips, Tilson, Boshier, Caulfield, Hockney, Bates and Toynton mingled

Ronald B. Kitaj, An Urban Old Man, *1964, Reeves Collection, New York.*
Characterized by sharp irony, Kitaj's painting exemplifies English Pop Art culture at its most sophisticated. It blends *sociological and literary allusions and draws themes from advertising, strip cartoons and magazines.*

▼ *Mario Schifano,* Propaganda, *1965, Studio Marconi, Milan. This painting is from about the time when the Roman artist began to employ stereotypical images of blown-up lettering from widely* *diffused consumer products such as Coca-Cola, Esso gasoline and the like. These images are often painted with great elegance, in bright, bold colours.*

▼ *George Segal,* Rock'n Roll Combo, *1964, Hessisches Landesmuseum, Darmstadt. This sculpture exemplifies the procedure adopted by Segal, reproducing* *human figures in plaster casts. Very ordinary actions are frozen in time, accentuating the climate of solitude in which they are set.*

ject it without manipulating it, or to give it aesthetic value without any kind of personal touch. Individuals such as Klein, Villeglé, Arman, César, Rotella, Deschamps, Christo, Niki de Saint-Phalle, Dufrêne, Hains, Tinguely, Raysse and Spoerri concentrated their art on the multiple facets of everyday objects but they were not going to portray the trash and trivia of urban society just as a matter of course.

Italy, for its part, was somewhat late in responding to the solicitations of Pop Art, which, in all of Europe, was evolving in all sorts of ways. Only from 1963–64 onward would an Italian trend develop, taking two particular directions.

In the north (Milan, Turin and Bologna) it was the influence of European Pop Art that was most felt. Adami, Tadini and Modino adopted the technique of the hard

outlines of comic strip design. Heavy black outlines form the shapes of both common and obscure objects in frenetic, fragmentary pictures. Enrico Baj, one of the Milanese circle, on the other hand, created grotesque

characters, using a method similar to *assemblage;* and in Bologna, Concetto Pozzati elevated advertising images of fruit to an aesthetic level, with an attractively stimulating pictorial style.

The area around Rome, by

▼ *Peter Blake,* Drum Majorette, *1957, Private Collection. Blake's figures are often derived from the cinema, television and advertising, but also draw inspiration from British folklore and the* magic and legend of the Victorian age. The images are formed by a process combining painting and photographic montage.

▼ *Mario Ceroli,* Cassa Sistina, *1966. Outlines of individuals obsessively repeated are assembled within a space. The dimension of space is in fact the central motif of this work. By adopting untreated, poor-quality wood as an expressive medium, Ceroli signals his desire to recover ancient values and also to popularize craftsmanship. Advertising symbols are thus given distinction by the material used, while museum exhibits acquire a new level of accessibility.*

contrast, exhibited stronger American influence. Although they never accepted the notion of simply exhibiting objects, Schifano, Festa and Angeli made use of a particular group of objects, highlighting their recurrent, emblematic and allusive sides with techniques such as portraying them in television screens, hidden behind closed windows or half-concealed by veils. Fioroni and Tacchi touched up photographic images with dazzling, violent colours. Ceroli adopted a sculptural approach in his treatment of human figures, animals or letters of the alphabet, cut out in wood.

From this overview it is clear that the Pop Art style in Italy, often confined to a fleeting experience, was not marked by any firm sense of direction. ∎

Jasper Johns, Flag above White with Collage, *1955, Artist's Collection.*

The flag is one of those bare objects and standardized stereotypes that recur in Johns's work during this period. He is intent on conferring artistic validity to things that are not normally art objects because of over-familiarity.

Claes Oldenburg,
Hamburger, Popsicle, Price, *1962, Carpenter Collection, New Canaan, Connecticut.*

This soft sculpture, a gigantic structure deprived of any support, full of folds and wrinkles, forms part of a fetishistic repertory of foods and household objects in large dimensions and grotesque shapes. The intention is to denounce and criticize the consumerism to which man is subjected.

Robert Indiana, Numbers (from 0–9), *detail, 1968, Powers Collection, Aspen.*

Alphabetical and numerical characters are the principal elements of Indiana's work. Regularly constructed symbols, and thus conventional, aseptic images, become artistic subjects. These figures are capable not only of attracting attention through their flat, lurid colours but also of asserting their validity as verbal and visual compositions.

Hawaii becomes 50th State OPEC established	Bay of Pigs John F. Kennedy president of US	Assassination of John F. Kennedy Civil Rights Act, USA	Assassination of Malcolm X Cultural Revolution in China	Military junta in Greece Six-Day War Assassination of Robert Kennedy	Nuclear Non-Proliferation Treaty
Stereophonic records Optical microwave lasers	Gagarin in space Telstar satellite	Valentina Tereshkova in space	BASIC programming language Music synthesizers	Barnard: first heart transplant	First flight by Concorde
Boulez: *Portrait of Mallarmé*	Britten: *War Requiem*	Cage: *Atlas Elipticales with Winter Music*	Bussotti: *La passion selon Sade*	Stockhausen: *Anthems*	Stockhausen: *Spiral*
Literary works by Calvino, Behan, Grass, Burroughs, Amis, Sagan . . .	Literary works by Amis, Osborne, Ginsberg, Solzhenitsyn . . .	Literary works by Baldwin, McCarthy, Mailer, Bellow . . .	Literary works by Updike, Albee, Pinter, Malamud . . .	Literary works by Capote, Garcia Marques, Singer, Kundera . . .	Literary works by Snow, Roth, Segal, Borges . . .
Niemeyer: inauguration of Brasilia Galbraith: *The Affluent Society*	Carson: *Silent Spring* Ionesco: Theater of the Absurd	Koestler: *The Act of Creation* Miller: *After the Fall*	Photo-Realism Saarinen: Gateway Arch, St Louis	Westin: *Privacy and Freedom* Malraux: *Antimémoires*	Monod: *Chance and Necessity* Woodstock
Johns: *Numbers in Color* **Warhol:** *Dick Tracy*	**Vasarely:** *Supernovae* **Rauschenberg:** *Reservoir*	**Lichtenstein:** *Hopeless* **Dine:** *The White Suit*	**Wesselman:** *Great American Nude* **Oldenburg:** *Giant Soft Swedish Light Switch*	**Warhol:** *Marilyn Monroe* **Indiana:** *Numbers (from 0–9)*	**Jones:** *Hatstand, Table, Chair* **Laing:** *The Loner*
1958–60	1961–62	1963–64	1965–66	1967–68	1969–70

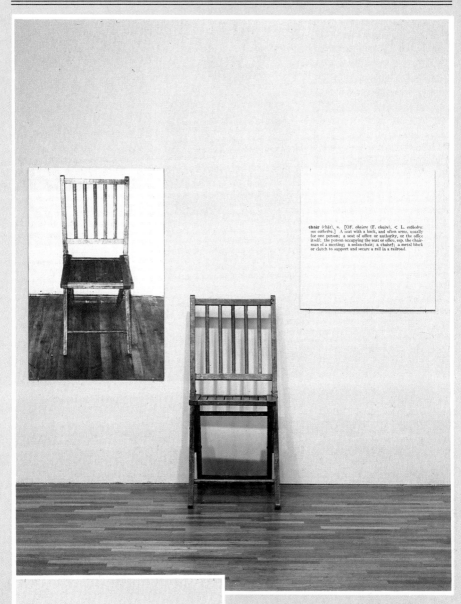

chair (chār), *n.* [OF. *chaiere* (F. *chaire*), < L. *cathedra*: see *cathedra*.] A seat with a back, and often arms, usually for one person; a seat of office or authority, or the office itself; the person occupying the seat or office, esp. the chairman of a meeting; a sedan-chair; a chaise†; a metal block or clutch to support and secure a rail in a railroad.

Joseph Kosuth, One and Three Chairs, 1965, Museum of Modern Art, New York. Wholly free of aesthetic connotations, lacking any real expressiveness, this work is a kind of manifesto of Conceptual Art; it exemplifies very effectively the aims of an artistic ideology that tends to exclude anything that is not a pure phenomenon of communication, or an abstract example of "language," assimilating the creative act in philosophical reflection or a mathematical exercise.

24 CONCEPTUAL ART

From 1965 onwards, in both the United States and Europe, a new interpretation of art came strongly to the fore. It had no precedents in the history of aesthetics, apart from occasional rudimentary ideas issuing from the avant-garde movements. At first glance, the theory behind Conceptual Art seemed to involve a very idealistic stance. It claimed that what is really important in the work is not so much its physical embodiment, the mode of production or the fact of its physical presence, but rather the idea (the concept, the decision and the plan) that lies behind the work, that precedes it and that determines it. As this notion became more popular, there was virtually a total rejection of the idea of "degrading" the artistic project by realizing it and reducing it to a mere, real object. Rather the artists opted to retain all its vitality (its openness to possibilities) by presenting it in its abstractness, as a pure philosophical consideration or reflection, with no practical applications whatsoever. According to this position, the individual artist, the coming into being or the actual finished object — everything that is single, in other words — represents a sketchy and partial reflection of the concept that produces it. If art is a linguistic action, a form of communication and expression of thought, it can make use of the power that is peculiar to language: to go beyond the single example (the phenomenon) and contain the whole notion in a way that permits us to possess it culturally.

▲ *Yves Klein,* Suaire ANT SU 2, *Moderna Museet, Stockholm. The body of the "model" is here an instrument that generates its own image.*

When the American Joseph Kosuth exhibited his *One and Three Chairs* in 1965, or rather when he confronted the spectator with three manifestations of the entity "chair" (including an ordinary folding chair without any stylistic connotations, a photograph of the same chair, and the definition of the word "chair" taken from a dictionary and reproduced on a panel), his intention was to present three different ways of acquiring reality: verbal (in the form of writing), which is the most assimilated; iconic (as a neutral, photographic image), which is the closest to the method of the plastic arts; and finally, the least assimilated way, involving the physical presence of the chair, which can illustrate the notion by exemplifying

▼ *Sol LeWitt,* 3 Part Set 789 (B), *1968, Ludwig Collection, Cologne. This work brings into play concepts of modularity and geometric development, as well as themes of fullness and emptiness.*

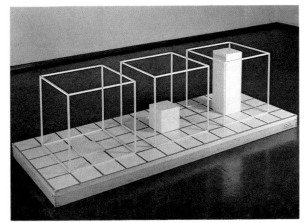

Tautology

paint'ing, n. 1. the act or occupation of covering surfaces with paint.
2. the act, art, or occupation of picturing scenes, objects, persons, etc. in paint.
3. a picture in paint, as an oil, water color, etc.
4. colors laid on. [Obs.]
5. delineation that raises a vivid image in the mind; as, word-painting. [Obs.]

it. None of the three methods really reaches the object. They are all just linguistic propositions. The "real" chair, in fact, can only indicate, via one of the infinite number of possible concrete examples, the *concept* of chair. The photograph, not unlike the verbal description, responds to a linguistic code that, by its very nature, in referring to the object excludes it by making an abstraction of it. Kosuth's work is thus situated in the wake of the semiological research undertaken by Magritte, although the latter's work was focused on the problem of comparing different systems of representing reality. (In the case of the French painter this process started with the famous "pipe calligramme" of 1929.) Kosuth took Magritte's process to an extreme, streamlining it until it was nothing more than a laboratory analysis of language and how language functions. In England, under the same umbrella, the Art & Language group was to limit its

Joseph Kosuth. Art as Idea. *Mounted photostat. Dorothy and Roy Lichtenstein Collection, New York. According to Kosuth, each work of art can be defined as a definition of Art: "What is the function of art, or the nature of art? If we continue our analogy of the forms art takes as being art's language one can realize then that a work of art is a kind of proposition* presented within the context of art as a comment on art." *The work entitled* Art as Idea *above exemplifies the potential tautological value of a work. Perhaps for the first time in the history of language, the* what is meant *by an art proposition coincides perfectly with the objective and empirical product of its meaning. The work is enclosed in its own sphere: it is no more than what it claims it is. It does not pretend to explain the world, but – in a coherent manner with the philosophical premises from which it springs – it affirms its own pure presence with the same gesture that founded it. We find ourselves before an art stripped of narrative ambitions, absolved of any presumed link with external reality, and whose statements, for that very reason, are wholly ascertainable.*

own activity to theoretical statements, avoiding the need to "dirty their hands" (or minds) with brush and colour, declaring that the artists of a multi-media society and of the era of information should occupy themselves exclusively with philosophical problems.

As is evident from the works of Robert Barry, Jan Dibbets, Lawrence Weiner, On Kawara, Vincenzo Agnetti, Bernard Venet and Kosuth himself, the theoretical aspect of "conceptual art" takes precedence over concrete demonstration. The work of art coincides with the idea or concept of the work. Poetics replace poetry once and for all. Artists cease to produce objects – not least because they feel themselves displaced by the triumph of the mass media – and restrict themselves instead to analyzing language in its functional and scientific aspects.

All this takes up the rejection of traditional artistic criteria as formulated by Marcel Duchamp towards the end

BIOGRAPHIES

♦ **Art & Language.** English group formed by Terry Atkinson, Michael Baldwin, Daniel Bainbridge, Harold Hurrel and others. It represents the most extreme position within Conceptual Art. Its varied operations are centered on theoretical possibilities of objects which, by definition, remain absent.

♦ **Flavin** Dan (New York 1933). His works are always related to the space in which

they are located: the use of neon light permits him to modify the surroundings by creating expressive moments within the

space that are simultaneously pictorial, sculptural and architectonic.

♦ **Judd** Donald

(Excelsior Spring, Missouri, 1929). His version of Minimalist sculpture is characterized by the obsessive repetition of identical geometric shapes that take over the entire space they occupy, and impose on it their own inner mathematical logic.

♦ **Klein** Yves (Nice 1928–Paris 1962). With Marcel Duchamp, Piero Manzoni and Lucio Fontana, he was one of the founding fathers of

of the second decade of the twentieth century and echoes many of the general questions concerning the role, the *raison d'être* and the very survival of art that have arisen in the century. It raises, for example, the problem of the artist's public recognition, and the extent to which this might affect the value attributed to the work. It raises the matter of the siting of the work itself (in a gallery, museum or marketplace) as a vital element in the process of its legitimization. Finally, it raises the global and extremely central problem of the function of art within society, a society which concentrates on much more effective means of establishing political consensus and therefore sees art as "useless."

Beyond the almost obsessive rigour present in the above-mentioned artists, in whom it is quite hard to pinpoint operations that are not purely theoretical and constructed with verbal material, an interesting aspect was the intense usage made by certain conceptual artists of photography (for example, Douglas Huebler) which was adopted as a cold, linguistic medium in opposition to painting. There also developed a large number of

Conceptualism. His output, radical and subversive, culminated around 1958–62 in a series of important works, including sponges, fires and air sculptures. Worth mentioning, too, are his theoretical work (conference at the Sorbonne in 1959 on *The Evolution of Art and Architecture towards Immateriality*) and his musical compositions (*Monotone Symphony*).

♦ **Kosuth** Joseph (Toledo, Ohio, 1945).

As a very young man, he made his mark on the avant-garde world with a work destined to arouse general bewilderment (*One and Three Chairs*, 1965). He subsequently pursued his research into the philosophical and scientific implications of art language with works that utilized verbal definitions and other innovations pertinent to his theories. His prolific output of essays has contributed impressively to the debate surrounding the role of the artist in contemporary society.

♦ **LeWitt** Sol (Hartford, Connecticut, 1928). Author of various writings devoted to the problem of the disembodiment of the work of art. His Minimalist works illustrate the structural quality of space as brought out by human systems of measurement and awareness.

♦ **Morris** Robert (Kansas City, Missouri, 1931). His earliest works were large geometrical sculptures. By 1964, he had moved into a Minimalist phase. Later, after 1968, he veered towards experiments in Anti-Form and Land Art.

♦ **Nannucci** Maurizio (Florence 1939). Adopting a position midway between visual research and poetic practise, his work is notable for a very

▼ *Claudio Parmiggiani, Sineddoche, 1976, installation of 1988 at the Kunsthistorisches Museum, Vienna. The painting on the left is an original by Dosso Dossi (c.1530). Parmiggiani extracts a*

part of it, a synecdoche, which lends the scene theatricality and invites the viewer to replace the protagonist.

parallel trends of moderate conceptualism that surrounded the more radical movement. The different areas covered between those sharing the same precepts (as in the case of American Minimalism) and those with formulas that are simply less intransigent, in which the work, while still intended to illustrate a concept, to represent an idea, still exists as a concrete object. This is the direction taken by Giulio Paolini, who has categorically transformed the work of art into a means of investigating the function of art itself, devoting himself essentially to the "preliminaries" and to the "fundamentals" (geometry, perspective and colour) of pictorial representation. It is equally true of Claudio Parmiggiani, whose works may be interpreted as reflections on the history of painting or on the history of language in general, and of the Czech Jiři Kolař, who has for decades veered between poetry and the plastic arts.

Another branch of Conceptualism is represented by the international movement, Fluxus, whose members ranged from the founding fathers, George Brecht and George Maciunas, to many (albeit sometimes occasional) adherents. They professed the total precariousness, impermanence, randomness and even humdrum everyday nature of the artistic/creative act, whereby any medium can be transformed into art, and mini-

mal ideas turned immediately into works of art. It is questionable whether there is still some sense in using this term for the activities of Ben Vautier, Robert Filliou and Brecht himself, for the small marvels and miraculous manifestations of the intellect that we find in particular "moments" by Maurizio Nannucci or in certain magical and dreamlike "excerpts" by artists like Ian Hamilton Finlay, Dick Higgins and Emmett

liberal but extremely precise use of all modern technological media (photography, film, sound recording, book, radio, cinema, etc.), conceived as the material deposits of a much wider scope of mental activity.

♦ **Paolini** Giulio (Turin 1940). His early work is characterized by monochrome canvases on which were marked only the preliminary lines of a hypothetical, unrealized spatial

construction. Paolini's research constitutes an enquiry into the concept of art, from inside, or rather through the art, itself; in some cases the results are didactic, in others decidedly mysterious and suggestive, but always quite intriguing.

♦ **Parmiggiani** Claudio (Luzzara 1943). He belongs to the mature phase of the Conceptual movement. Between 1968 and 1977 his

sculptures examine historical categories of subject matter that are at the origin of creative activity. For this reason they utilize direct references to painting from the past, from the Renaissance to Suprematism.

♦ **Reinhardt** Ad (Buffalo 1913–New York 1967). His abstractionism, initially close to that of Barnett Newman, evolved in the 1950s towards the annulment of perceptive data within

the painting with the objective of achieving an analysis of painting itself, with no other content. Absolute monochromes or, at most, geometrical dialogues involving a few colours dependent on the slightest variations of tone, are the constants of his painting, which in this way anticipates both pictorial and sculptural Minimalism.

♦ **Stella** Frank (Malden, Massachusetts, 1936).

▼ *Ad Reinhardt,*
Number 119, 1958,
Black, 1958,
Hirshhorn Museum,
Washington, D.C.
Reinhardt's "quasi-
monochromes" play
with slight,
imperceptible nuances
of light. With their
constructive rigour and
mental density, they
pave the way for
Minimalism – both
pictorial and sculptural
– and anticipate true
conceptual art.

▼ *Antonio Dias,*
Niranjanirakhar,
1977, Private
Collection. There are
many examples of the
links between the
avant-garde and
Oriental philosophy.
This work, with a title
which in some Nepalese
communities means
"the unpronounceable
name of God," borrows
the magical-
representational
typology of Indian
mandalas.

Williams . . . Nor is it easy to track down the notion of "work of art" in the strange and intriguing, idea-rich sequences of Daniel Spoerri and Marcel Broodthaers. Here, and in all the activities of Fluxus, what we do find are the idea of an incessant flow of things evolving, nourished by the uncertainty of the intention of art, and the precariousness of the creative act as a movement of wonder in the uncontrollable and ever-changing passing of existence.

This attitude is not far from the theoretical basis underpinning the practise of Performance Art, which is so widespread in the period we are describing. Performance Art manifests itself as the dramatization of the discovery of the body in Body Art, as an extreme consequence of informal gesturalism, or as an integration of the expressive systems of theater and dance in the context of the plastic arts. Alternatively, it may be defined as aesthetic "action," narrated and re-

Protagonist of the last phase of pictorial abstractionism, he attempts to translate on canvas the formal motifs of Minimalism, leading to stylistically original works, from which decorative, Oriental-like elements sometimes emerge.

◆ **Weiner** Lawrence (New York 1940). Outstanding exponent of strict Conceptualism (also known as "tautology"). His writing encompasses analytical theorems on the work of art and on art in general. His work is close to that of Robert Barry, Douglas Huebler and Bernard Venet.

corded by the new media techniques (video, record and tape for Nam June Paik, Wolf Vostell, Keith Sonnier, Joseph Beuys, and for the composers Philip Glass, Terry Riley, Steve Reich, La Monte Young and Giuseppe Chiari). It repudiates logic in art, taken as the production of physical, formal and concrete objects. It refuses to see a work of art as a durable, definitive product, and replaces it instead with a principle of happening, of existential *hic et nunc*.

In order to unravel the philosophical basis of Conceptual Art, alongside the apparently improvised and provocative example of Duchamp or of the more recent "radicals" like Piero Manzoni and Yves Klein, it is worth considering Maurice Merleau-Ponty's definition of existentialism, as well as the wealth of ideas emanating from that inexhaustible mine of contemporary thinking, Antonin Artaud. In fact, there is no clearly defined boundary to separate Con-

Frank Stella, New Madrid, *1961, Kasmin Gallery, London. To some extent, much of the experimental work of the new conceptual avant-garde was anticipated by the American abstract painters of the 1950s and 1960s, notably by Stella, Kelly, Noland, Newman, Albers and Reinhardt.*

ceptual Art from the other avant-garde movements of the 1960s and 1970s, such as Body Art, Land Art and *Arte Povera*. On the one hand we have the drastic positions adopted by the radical conceptualists, on the other the various kinds of "dematerialization" of the work, which may be transformed, as these tendencies suggest, into physical gesture, into landscape or into a form of creativity freed from the traditional ideology of the art object. The work of Fontana, Klein and Manzoni has prepared the ground for the

emancipation of the artist from the servitude of the object, permitting him to enlarge his own field of endeavour towards the open frontiers of mental activity and indeterminate action. From now on, the thought of the artist is his exclusive product.

Closely related in many ways to Conceptual Art, but nonetheless still attached to the concrete nature of art, are the painters and sculptors associated with American Minimalism. In the sculptures of Robert Morris, Carl Andre, Donald Judd, Dan

Donald Judd, Eight Modular Unit V — Channel Piece, *1966, Museum of Modern Art, Frankfurt. Minimalism emphasizes the idea of serial and mathematical regularity, which was already present in the abstract work of the 1920–30s. In fact, a creative work is not offered as a reflection of emotive, epic or lyrical data, but appears as a cold analysis of the linguistic structures which are bought into play.*

▼ Robert Smithson,
Spiral Jetty, 1970,
Great Salt Lake, Utah.
Although very different,
Minimalism and Land
Art share a unifying
abstract-geometrical
mould.

◄ Carl Andre, Cedar
Piece, 1964,
Kunstmuseum, Basle.
One of the earliest
examples of the
construction of a
sculptural object based
on an abstract motif of
serial development.

▼ Robert Morris,
Untitled, 1966, Private
Collection, Colorado.
Morris's minimalism
involves a stubborn
paring down of the
sculpted object to its
essential geometric
outline, to the
"primary structure" of
form. By this term
Morris denotes the very
basis of visual
perception, the
psychological
foundation of all
aesthetic experience.

Flavin and Sol LeWitt, we find the analysis of elementary geometrical form as the basis of the aesthetic object and as the fundamental principle of its relationship to its surroundings. On the one hand, therefore, this movement is linked with the historical tradition of abstract art, constituting its last important episode; on the other, it displays a strong element of Platonic idealism, which connects it with Conceptual Art, insofar as the works are intended to show the "primary structures" of knowledge, as indicated by the title of a group exhibition in 1966.

In relation to the many precedents of abstract sculpture, the works of Morris are presented as an extreme reduction of the object to its own mathematical soul. The form, in the accepted sense of the term, is done away with, and the work is dematerialized at the very moment in which it becomes concrete. It is the mere manifestation of an idea. Whether

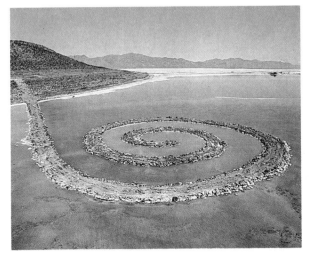

it is a prism with a triangular base, or the right-angled conjunction of two parallelepipeds, or a circular ring, in every case the material forming the work is a neutral prerequisite to its existence and nothing more. Its surfaces have no eye-catching features (no optic, aesthetic or sensual qualities). Its substance is a silent revelation of the calculation from which it is produced. Judd's works add the term "series," and those of LeWitt and Andre the term "modular," to this vocabulary. So it is no coincidence that LeWitt is also one

▼ *Dan Flavin*, The Nominal Three, *1963, Panza di Biumo Collection, Varese. The effect of this installation – the theme of which is inspired by the philosopher William of Okkam – is almost theological.*

▼ *Walter de Maria*, Mile-long Design, *detail, 1968, Mohave Desert. Minimalist geometrical art also draws on the boundless design of Land Art works.*

of the major theoreticians of Conceptual Art, even if in practise he has always been alongside the Minimalists. The notions of module and series are used by these artists in relation to post-Euclidean physics – that is, the sum of knowledge of modern man. They are also employed by Dan Flavin, who has a somewhat special place in this movement, being the only artist who has attempted to produce light sculptures using straight neon tubes, distributed in the exhibition area on the basis of precise metrical and serial rhythms. Robert Grosvenor, Philip King and Tony Smith occupy more moderate positions which reconcile the rigour of Minimalism with the various traditions of avant-garde sculpture.

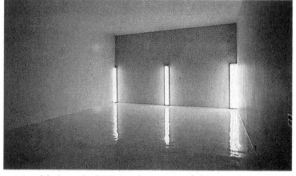

Finally, it is worth mentioning that there is a Minimalist form of painting, the spiritual father of which is Ad Reinhardt. During the 1960s, the paintings of Frank Stella, Kenneth Noland and Ellsworth Kelly kept alive the experimental phase that, in the immediate post-war years, launched Newman and Rothko. But it was Reinhardt who, in painting, carried to the extreme the negation of the aspect of perception in favour of the revelation of the concept sustaining it. Among the exponents of this trend are Agnes Martin, Robert Ryman, Brice Marden, Richard Tuttle and Robert Mangold, who came together for a crucial exhibition of 1966, entitled Systematic Painting. It was organized by Lawrence Alloway and held at the Guggenheim Museum in New York. These artists represent the American counterpart of the burgeoning movement of Analytical Art in Europe, which brought to the fore the Support-Surface group in France and which found followers, too, in Italy, Germany and Spain. ∎

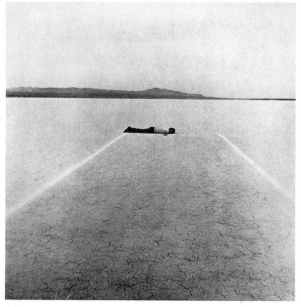

Piero Manzoni, Achrome, *1958, Museum of Modern Art, Frankfurt.*

In the white paintings that Manzoni created at the beginning of his career (achromes, *devoid of colour*), the pictorial data are conveyed by tactile *"suggestions"* of cotton, gauze, etc. The artist aims to eliminate from the work any motive of representation and to take it to the limits of his expressive capacity: in that sense, before even the Performance Art of 1960–3, he was a fully fledged Conceptual artist.

Giulio Paolini, Giovane che guarda Lorenzo Lotto, *1967, Private Collection.*

Typical of the middle phase of Conceptual Art, this work is simply a photographic reproduction of a famous painting of 1505 and its technical quality has nothing to do with the meaning of the work. The title, which hinges on the sixteenth-century work, means that the wheels of time have turned on themselves here, overturning the normal categories of time and subject.

Nam June Paik, Violoncello TV *(Charlotte Moorman playing the instrument, 1971), Performance held in New York.*

The artistic-theatrical activities of Performance Art, derived from the reductive experiments of Conceptualism, reached the peak of their development in the 1960s, both in the West and elsewhere. The Korean artist Nam June Paik was motivated by the idea of exhibiting the body of the artist in works (Body Art).

Bay of Pigs Sharpeville Massacre, South Africa	Assassination of John F. Kennedy Escalation of Vietnam War	Assassination of Malcolm X Cultural Revolution in China	Assassination of Martin Luther King	Nuclear Non-Proliferation Treaty Invasion of Cambodia	Massacre at Munich Olympics Watergate scandal
First men in space Telstar satellite	First woman in space	Gabor: holography First moon probe	Barnard: first heart transplant	Man sets foot on the moon First supersonic civil aircraft	Venus probe First heart and lung transplant
Britten: *War Requiem*		Bussotti: *La passion selon Sade*	Dallapiccola: *Ulisse*	Stockhausen: *Spiral*	
Literary works by Solzhenitsyn, Heller, Pinter . . .	Literary works by Osborne, Hochhuth, McCarthy, Bellow . . .	Literary works by Siniavsky, Solzhenitsyn, Weiss . . .	Literary works by Capote, Garcia Marquez, Kundera . . .	Literary works by Roth, Vonnegut, Segal, Borges . . .	Literary works by Moravia, Böll . . .
Foucault: *Madness and Civilization* Lévi-Strauss: *La pensée sauvage*	Barthes: *Elements of Semiology* Pop Art at Venice Biennale	Rauschenburg and Cage: EAT (Experiments in Art and Technology)	Op art at Museum of Modern Art, NY McLuhan: *The Medium is the Message*	Douglas: *Natural Symbols*	Mutilation of Michelangelo's *Pietà* Death of Stravinsky
Stella: *New Madrid*	**Flavin:** *The Nominal Three*	**Kosuth:** *One and Three Chairs*	**Bacon:** *Pope No 2*	**Haacke:** *Chickens Hatching*	**Paik:** *Violoncello TV*
Klein: *Monogold: MG 18*	**Beuys:** *Stuhl mit Fett (Chair with Fat)*	**Opalka:** *I to Infinity*	**Kaltenbach:** *Art Works*	**Walter de Maria:** *Las Vegas Piece*	**Gilbert & George:** *Singing Sculpture*
1960–62	1963–64	1965–66	1967–68	1969–70	1971–72

Pino Pascali, Vedova blu, *1968. During the four years when he attained full artistic maturity, Pascali produced cycles of work that included walls, weapons, white sculptures, anatomical fragments of women and natural elements. Although each was apparently a complete and independent entity, all were linked by a common basic idea and a sense of explosive fantasy. Fantasy is expressed in the representation of new figures inhabiting an improbable, dream-like world; the irony is variously displayed, sometimes with coarseness and cruelty, sometimes with playfulness and mockery; and the quest for form is spatial research pursued beyond the fleeting creative gesture or the uncertain image. The same intentions can be discerned in the relationship with the materials used by the artist who, contrary to the beliefs of the exponents of* Arte Povera, *does not intend to labour any effect in a ''tautological'' sense but to achieve precise solidity of a formal type.*

25 THE LAST AVANT-GARDES

The transition from the 1950s to the 1960s was dominated by a climate of particular impatience, dissatisfaction and an eventual rejection of problems presented by existentialism and non-representational art. The artistic experiments of this period are therefore founded on an uncontainable desire for innovation and, above all, on a decisive opposition to all forms of discipline and rules of authority in art. Artists were powerfully animated not only by spirit of rebellion against current ideology but also by opposition to traditional means of expression. What they sought was complete freedom in their attempt to enliven art. And to achieve this, they resorted to a much broader range of expressive instruments, aided and abetted, to some extent, by industrial progress. Art was understood as a "process of knowledge," and experimentation implied continually, extending the frontiers of art into new fields of action. However, this introduced yet another question into the discussion: just how long was one form of experimentation to last if progress is to be the fundamental motivator.

Art therefore affirmed its independence, conceived not so much in terms of the autonomy of the painting as of *centrality of experience*, because not only was the notion of the artist as an individual altered but also those of the artistic gesture and space. Such an act of liberation would hardly have been possible without Alberto Burri and Lucio Fontana, or

without the modification of relationship between the environment and the spectator introduced by Yves Klein; yet Piero Manzoni, Francesco Lo Savio and Enrico Castellani emerged as crucial figures who would reawaken the revolutionary rigour possessed by the avant-gardes but also anticipate future movements of fundamental importance. The *achrome* permitted Manzoni to confront the problem of space. To assert his gesture of freedom, the artist covered the canvas with a single colour. Thanks to the absence of

image, he achieved a "reduction" of the painting, which could then establish a relationship with the surrounding space using only the luminous properties of the colour. Subsequently, Manzoni was to create works that were clearly intended to demystify art, as exemplified by the powerfully provocative *Linee*, *Sculture viventi* and *Merda d'artista*.

Enrico Castellani attempted to explore the relation between colour and space by stretching the canvas over a frame to pro-

▲ *Piero Manzoni,* Consacrazione dell'uovo sodo, *1960, Private Collection. By elevating consumer products to an artistic level, Manzoni made his own satirical comment on the reverence accorded to the fine arts.*

◄ *Yves Klein,* Relief Eponge Bleu: RE 19, *1958, Wallraf-Richartz Museum, Cologne.*

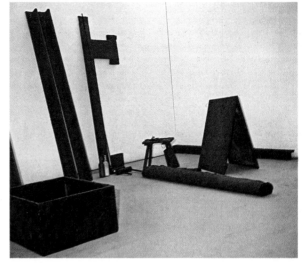

Joseph Beuys, Raumplastik (Room Sculpture), 1968, Hessisches Landesmuseum, Darmstadt. The German artist was not so much concerned with single objects as with their relationship to the other objects involved in the sculpture. Every part takes on a powerful allegorical connotation within the context of a theme on the protection of nature from human abuse.

duce a grid pattern. These absolutely pure and immaculate canvases are endowed with an intrinsic mobility that tempts the spectator to look for irregularities and protrusions. This shifts the attention away from the picture as a screen and induces the impression of an active work in space.

Lo Savio, too, produces monochromes, but his experiments are directed toward the poetic quality of light. Light becomes the protagonist, and the artist explores its relationships with space and colour.

But the prelude to later experiments in avant-garde, and initially to *Arte Povera*, is to be found in the work of an artist with a very marked talent: Joseph Beuys. Already during the 1950s he was refusing the "ready made" in an attempt to return to the primordial state of every living thing, to a point where the differences between man, animal and vegetable are barely perceptible. The German artist based his work on the fusion of art and experience, convinced of the capacity of the one to include the other. This is exhibited in a rapid and reductive style, using liquid and earthy colours, which does not entail a planning stage. During the 1960s he made performance pieces in which he interacted with external space, filling it with basic materials of strong physical impact. Such operations aimed not only to underline the collapsing barriers between the various arts but, first and foremost, to display the involvement of the artist, as a human being, in the political and economic life which envelops him and in the recovery of a harmonious relationship with nature.

The principle of artistic endeavour in those years was

BIOGRAPHIES

♦ **Anselmo** Giovanni (Borgofranco di Ivrea 1934). His work owes much to a study of physics, phenomenology and logic, centered upon crucial concepts such as stasis, equilibrium, gravitational force, entrophy, etc. For Anselmo, language, before even being broken down into words (or relegated to "form"), already contains all the components of sense for which it is a vehicle.

♦ **Beuys** Joseph (Kleve 1921–Düsseldorf 1986). Throughout his life Beuys pursued his dream of the total interpenetration of everyday existence and artistic experience. The concept of the body and the mark it leaves (whether in terms of physical work, writing, spatial symbols, pictorial hieroglyphics or technological images) was central to his activity, consisting of many live public performances.

♦ **Castellani** Enrico (Rovigo 1930). Founder with Piero Manzoni of the review "Azimuth," he created monochrome outlined or stitched surfaces intended to be mirrors of thought and movement. The canvases, imbued with dynamism and feeling, are stretched over frames and exposed to the light which penetrates and modifies them.

♦ **Fabro** Luciano (Turin 1936).

Proclaimer of "space imposed by matter itself," Fabro founds his work on the conviction that art should be understood as an experience, before which the spectator must abandon any preconceptions. Among his most famous works are *Italia, Attaccapanni, Piedi*.

♦ **Hesse** Eva (Hamburg 1936–New York 1970). Because of her short life, this artist

▼ *Richard Long, Wiltshire, 12–15 October, 1969, Panza di Biumo Collection, Varese. Immediately identifiable, Long's work consists of extended sculptures, organized on a strict geometrical scheme, both in the open and in traditional enclosed surroundings. His thinking was clearly part of the foundation for Minimalism and also Land Art.*

▼ *Enrico Castellani, Superficie bianca, 1968, Marconi Collection, Milan. From the early 1960s to this day, Castellani has firmly pursued the strict ideal of the tabula rasa, the uncompromising purity of an absolutely monochrome surface, animated by modulations scarcely perceptible to the eye. The canvas is enlivened by low-relief projections where it is stretched over nails.*

therefore the search for "absolute reality," giving preference to the concept, the idea, rather than the object. At the same time as these experiments, certain artists explicitly directed their thinking towards perceptive and "kinetic" phenomena. The desire to give structure to their ideas led them to create works aided by the dimension of movement. The apparent visual and psychological sophistication of these works contrasted with the extreme simplicity (if not

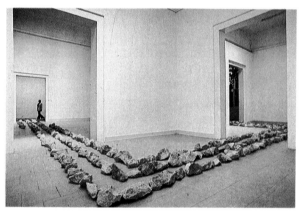

downright vulgarity) of the means employed, the will being more important than the technology available. This current, according to the form it took, was called Kinetic or Op Art. The artists involved were often organized into groups: Zero Group in Germany, Kalte Kunst in Switzerland, Group de Recherche d'Art Visuel in France, Nove Tendencije in Yugoslavia, Gruppo N and Gruppo T in Italy.

Although the emphasis of

left few works, but they include some of the finest examples of Neo-Avant-Garde. Her tangles of artificial and insubstantial fibers reveal her deep awareness of the difficult boundary between the world of objects and the transparent immateriality of thought.

◆ **Kounellis** Jannis (Piraeus 1936). He constructs his poetics on the interplay of two opposing but inseparable perspectives: everyday life and history. His work develops around these issues, with the emphasis on social comment rather than aesthetic effect, avoiding both the weight of European tradition and the pressures of contemporary reality.

◆ **Lo Savio** Francesco (Rome 1935–Marseilles 1963). He initially created monochrome canvases in order to study the effect of light on surfaces. Very soon he became convinced that only by pursuing the phenomenon of luminosity could he achieve a complete visual structure. By stretching veils over his pictures, he studied the relationship between light penetration and image formation. His last works were made up of curved metal surfaces, conceived along the same lines of research.

◆ **Long** Richard (Bristol 1945). The major representative of English Land Art, his very individual approach is founded on ideas of length and route. He sees a work of art as the acquiring of an existential space through geometrical models of rationality.

◆ **Manzoni** Piero (Soncino 1933–Milan 1963). From 1959 he was the leading spirit, together with Enrico Castellani, of the review (and later the

The Theater of the Neo-Avant-Garde

Op Art was focused on technology, the movement was at the same time engaged in the search for natural archetypal forms adopted by the devotees of Anti-form. This did not mean it was a tendency toward the total abolition of form as much as a desire to create structures that evoked nature with the aid of technological instruments and procedures. The images that resulted had no iconographic pretensions, but, with the ideas that created them and the materials that formed them, they were able to make specific impacts. Artists like Eva Hesse, Bob Morris, Bruce Nauman, Ger van Elk and Keith Sonnier produced works, for instance, that placed an emphasis on sensory experience. Numerous points of contact with Anti-form were advanced by Funk Art, which borrowed its name from jazz music. This current, which developed in the San Francisco area, was strongly rooted in contemporary life, from which it drew

It is indisputable that the figurative arts played an enormous part in the formation of contemporary theater. But the opposite phenomenon is equally evident: the osmotic, reciprocally influential relationship between visual art and the stage reflects the corrosion of historical barriers which separate art from reality. A major figure in theatrical work of the 1960s was Jerzy Grotowsky, who reduced the process of stage-acting to an ensemble of corporeal statements derived from actual life. The ''recitation'' is based on a plain, sparse gesture, capable of involving the spectator in the most direct manner (thanks in part to the abolition of the seating area). As had already happened with Antonin Artaud's ''theater of cruelty,'' the text is considered an obstacle to the immediacy and authenticity of the spectacle. The ultimate effect of this spectacle is that it becomes confused with real life.
Above: *Living Theater presents* **Antigone.**

its images. Its style, however, was very provocative. It produced works with a strongly allusive and ironic character, disrespectful of public morality, certainly closer to Dada objects than to traditionally accepted sculpture.

In order to map the artistic boundaries of the 1960s and part of the successive decade, we need to focus on movements such as Land Art and Body Art, which presented revealing and incontestable links with Conceptual Art. Land Art certainly showed many affinities, too, with Minimalism. As the experiments grew in size, Land Art came to require ever-wider spaces in which to operate. The expansion in size of artistic works to often extraordinary dimensions meant the hallowed institutions such as galleries and museums had to be abandoned in favour of enormous outdoor environments. Art was therefore conquering space.

The need for such large amounts of space understandably meant this movement

gallery) "Azimuth." Experimenting with materials such as wax, oil and glue, he aimed to confer original meanings to art, which he conceived as a cerebral rather than physical undertaking. Paradoxically, with works like *Linee, Consacrzione all'arte dell'uovo sodo* and *Merda d'artista*, he made use of a physical side, but they gave him the opportunity to launch an attack on the commercial art market and to achieve

renown as a troublemaker. He died in mysterious circumstances at the age of only thirty.

◆ **Merz** Mario (Milan 1925). He began in the field of informal art. But in the 1960s he was one of the founders of *Arte Povera*

and his work was directed toward the notion of rescuing art from the authority of art history. His environmental installations are composed of heterogeneous materials, mostly possessed of biological energy and presented as significant in themselves. One recurrent element in such works is the form of the igloo, a spiral shape that symbolizes the evolution of life and art.

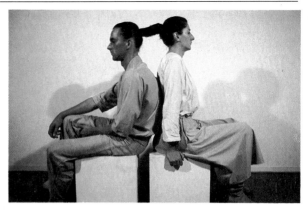

became established more
easily in America than in
Europe, for here immense
zones were readily available,
often desert regions with
scarcely a sign of human
presence. From the vast scale
on which the Land artists
worked, it is obvious that the
preparation of the operation
was long and arduous, both
in regard to the choice of site
and the assembly of the ma-
terial. Considering the length
and complexity of the pre-

paratory phase, the lifespan
of the work was often short,
due to the natural decay of
the material and changing
atmospheric conditions.

For these reasons, as well
as the gigantic size that often
prevented the work from
being perceived in its en-

tirety, attempts were made to
provide a thoroughly infor-
mative document with the
aid of still and cinemato-
graphic photography. The
Land artists' technique was
to modify the environment
with schemes derived from
minimalist experiences, such
as straight lines, curves and
circles – elements in some in-
stances detrimental to the
environment. Giacomo De
Maria, Richard Long, Dennis
Oppenheim, Michael Heizer
and Christo laid out their
scenarios with lines made by
digging or piling earth. This
could cause considerable dis-
turbance to the natural fea-
tures that were compelled to
accommodate them.

Body Art, on the other
hand, centers attention on
the human body and its ex-
pressive capacity, in contrast
to the traditional custom of
conceiving a work of art as an

◆ **Pascali** Pino (Bari
1935–Rome 1968). His
work was directed
toward the search for
"primary values," in
an attempt to free art
from commercialism
and restore its real
essence. Among
Pascalli's works, often
with strong theatrical
associations, are the
series of *Armi* and
Animali, and the
environmental
installations entitled *Il*
mare.

◆ **Smithson** Robert
(Rutherford, New

Jersey, 1938–Amarillo,
Texas, 1973). With
Walter de Maria,
Michael Heizer and
Dennis Oppenheim, he
was one of the major
exponents of American
Land Art. His
masterpiece is the
Spiral Jetty of Great Salt
Lake (1970), an
enormous spiral
pattern of earth on the
coloured surface of the
lake in Utah, achieved
by means of an
artificial embankment.

◆ **Zorio** Gilberto
(Andorno Micca,

Turin, 1944). He is one
of the protagonists of
Arte Provera. His works
play on the continuous
changes of natural
forces and can be seen
as processes gathered
in the split second of
their creation. Stars,
javelins, canoes are
constant symbolic
figures in his
productions,
metaphors of energy
solidified or about to
erupt.

▼ *Michelangelo Pistoletto,*
Venere degli stracci,
1968, Di Bennardo
Collection, Naples.
Repudiating any system
of techniques and
materials, the artist
brings his awareness of
the past to bear on his
contemplation of
everyday reality.
Pistoletto devotes much
thought to the artistic
process and mingles
historical allusions
with references to
contemporary urban
culture.

▼ *Yvonne Rainer,* Face-
Farces, *1968–75. The*
two indicated dates that
apply to this work
represent two distinct
phases in Rainer's
artistic output,
chronologically some
way apart yet
conceptually close to
each other. Whereas the
photographic medium
relates to the period
associated with Body
Art, the painting
process is more
characteristic of the
artist's recent activity.

nents of the Viennese group, and especially Hermann Nitsch, author and theorist of a scandalous proposition called *Orgien Mysterien Theater* (*The Orgiastic and Mysterious Theater*), based on the updating of the principal characters of Greek tragedy.

The end of the 1960s saw in Italy the growth of an independent movement, not dominated by American culture, introduced by the critic Germano Celant under the name of *Arte Povera*. It was born from the revolt against "pop" ideology, still powerful in Italy, and from the re-introduction of the human subject (as a combination of culture and nature) as the central issue of artistic expression. What is absolutely new about this tendency is, however, that it surpasses "representation," in the sense that the creative gesture and the natural fact are deliberately intermingled in an artifice which is continually self-denying. Above all, the artists exploit the climate of high tension which dominated society after 1965, and assign a pre-eminently ideological, if not outright revolutionary, role to art. The aesthetic act thus becomes an instrument of collective emancipation: it permits that "coming to terms" that frees the individual and his psyche from all the influences used by power (at a conscious and unconscious level) to obtain consensus and preservation of the status quo.

Arte Povera proposes a full involvement with the present, a global integration between poetic and everyday experience, a closer dialogue

object. The body affirms its presence by focusing attention on its intrinsic sensuous and tactile attributes. Within this one movement there are various subgroups, each linked to other forms of visual expression. One kind of Body Art has clear connections with dance, yoga and various initiation ceremonials or apotropaic rites. The body itself thus becomes a work of art, functioning as the link between man and nature. A further artistic form to which this trend is connected is the theater. On the basis of the work of Artaud, Grotowski and the Living Theater, the body becomes a protagonist of both script and staging.

Another orientation with-

in Body Art encourages a sado-masochistic tendency. Many of the actions represented are distinguished by aggressiveness, derived from the concept of physical and mental torture. Often it takes on a ritual character, intended to underline the need to establish an interactive rapport between artist and public. As happens in Land Art, artists such as Gina Pane, Arnulf Rainer, Urs Luthi, Marina Abramović and Vito Acconci, adherents of the "body" movement, arrange for their Performances to be transmitted by videotape and photography, even if this is sometimes to the detriment of the spectacular content of their works. It is particularly worth mentioning the expo-

▼ *Richard Serra, Untitled, 1969, Jasper Johns Collection, New York. Serra's art may be defined as a synthesis of radical thought and spatial command. The materials themselves are significant for their presence. The precarious balance between the pieces of metal is outweighed by the various effects the volumes, devoid of any aesthetic effect, have on the spectator.*

▶ *Alighiero Boetti, La natura, una faccenda ottusa, 1980, Minini Gallery, Brescia. In his work Boetti takes a specific concept as his departure point, and then often emphasizes it by using rhythmic repetition. The basic motivation of this technique should not be mistaken for mechanical repetition but should be identified as a calculated and ironic form of serialism.*

◀ *Mario Merz, 610 function of 15, 1971, John Weber Gallery, New York. The works of Merz are notable for their apparent simplicity, with natural elements possessing the same value as artificial products. It is, in fact, disturbing to note how Fibonacci's progressive numerical series, adopted for the purpose of observing growth in nature, assumes alarming proportions when applied to man-made objects.*

between social and artistic life. Against the static quality of representational art, it seeks the dynamism of the artistic gesture: an important exhibition in 1967 was entitled *Con/temp/l'azione*; the work as a contemplative object is replaced by the idea of action which evolves in time. Artists like Pino Pascali, Giovanni Anselmo, Luciano Fabro, Jannis Kounellis and Michelangelo Pistoletto refuse to accept the role of isolated creators uninvolved in social processes, content to simply contemplate the past.

Consequently, art sheds the aura of nobility and mysticism which surrounds it to become a method of research and testimony of being. The image – as the result of representation – crumbles under the blows of an operative process which insists on combining and transforming heterogeneous materials. Often the end product appears as mere evidence of the action carried out. The preference is for materials of organic origin or, at any rate, elements with their own energy. And among elements capable of alluding to events are "residual" forms such as the star of Gilberto Zorio, the spiral of Mario Merz and the tree of Giuseppe Penone. Of the technological materials chosen, the principal ones are objects and substances of an energetic-luminous character (neon lights, incandescent metals), and sometimes phenomena that are as a rule totally unconnected with the artistic scene, like the fire used by Kounellis, the synthetic ice of Calzolari and the animal skins used by Zorio.

259

▼ *Luciano Fabro,* Italia
vota, *1983, Herbert
Collection, Ghent. The
shape of Italy is a
recurrent theme in
Fabro's work, though
realized in different
materials such as iron,
crystal and copper. The*
*anecdotal motif,
however, is not
intended to dominate,
so the artist uses
common materials
which have no poetic
values.*

Alongside those working
in Turin and Rome, the true
centers of *Arte Povera*, one
should note the contribution
of artists who, though not
strictly of this movement,
gravitated towards the area:
Piero Gilardi, Gianni Piacen-
tino, Claudio Parmiggiani,
Eliseo Mattiacci, Emilio Prini,
Paolo Icaro and Vasco Ben-
dini. Giulio Paolini and Ali-
ghiero Boetti are, in a sense,
separate cases, always "in-
volved" in the activities of
the Turin group but whose
works are more closely asso-
ciated with the poetic
qualities of Conceptual Art.
The activities of Maurizio
Nannucci also come into this
category.

The transfusions of one
form of avant-garde to the
other are typical of this phase
of modern aesthetic inquiry,
and Celant himself, in his
texts, seeks to demonstrate
the international dimensions
of the movement, referring
to a precursor such as Joseph
Beuys or to parallel experi-
ences like those of Richard
Serra, Ger van Elk, Jan Dib-
betts, Bruce Nauman, Hans
Haacke, Keith Sonnier,
Robert Barry and Eva Hesse.
■

▼ *Michael Heizer,*
Displaced, Replaced
Mass, *1969, Silver
Springs, Nevada.
Robert C. Scull
Collection, New York.
A macroscopic erosion of
an untouched desert
environment, in which
the artist creates regular
furrows of Minimalist
stamp. The artificiality
of the construction
conflicts with the
natural corrosive action
that has occurred
around it.*

Joseph Beuys, Stuhl mit Fett (Chair with Fat), 1964, Hessisches Landesmuseum, Darmstadt.

Representing the liberation of the work of art from the shackles of tradition, the sculptural installations of the German artist made use of a variety of elements ranging from manufactured household articles to animals, from vegetable to organic materials such as wax and fat.

Bruce Nauman, Bound to Fail, 1967–70, Leo Castelli Gallery, New York.

A protagonist of so-called Anti-form, Nauman resorted to highly technological methods to create structures inspired by natural forms, his materials ranging from PVC to latex rubber and fiberglass. He made much use, too, of neon tubes. These transparent filaments, conductors of light, no longer possess their traditional rodlike form but appear as capillaries that, as they twist and coil, enclose life forms or simulate writing. The result is a combination, an open dialogue between artificial instruments and natural elements.

Gilberto Zorio, Evviva di giavellotti e lampade, 1974, Artist's Collection, Turin.

Sculpture, for this artist, is intended to be an intersection point of tensions, a node of energy. It is not, however, the configuration of the work that achieves this; it is the completeness and compactness of the structure itself which conveys the image of powerful tensions. Designed to collect the flow of energy, it employs technological means such as electrical resistances and laser beams or resorts to archaic symbols such as javelins and stars.

Escalation of Vietnam War Cultural Revolution in China	United Nations' sanctions on Rhodesia Six-Day War Death of Che Guevara	Prague Spring Student riots in Paris	Nuclear Non-Proliferation Treaty China admitted to UN	End of Vietnam War Coup in Chile Oil crisis	Nixon resigns Restoration of monarchy in Spain
BASIC programming language Music synthesizers	Barnard: first heart transplant	First men on the moon	Hoff: microprocessor First heart and lung transplant	Venus probe Carson: hybrids	Space rendezvous between USA and USSR
Stravinsky: *Abraham and Isaac, Elegy for J.F.K.*	Stockhausen: *Anthems*	Stockhausen: *Spiral*	Babbitt: String Quartet No 4	Birtwhistle: *Triumph of Time*	Shostakovich: Viola Sonata
Literary works by Yevtushenko, Plath . . .	Literary works by Capote, Garcia Marquez, Greene, Kundera . . .	Literary works by Roth, Murdoch, Bukowski . . . Grotowski: *Towards a Poor Theater*	Nobel literature prize: Solzhenitsyn	Nobel literature prize: Böll	Literary works by Solzhenitsyn, Snyder . . .
Schumacher: *Small Is Beautiful* Marcuse: *One-Dimensional Man* National Theater, London	Galbraith: *The New Industrial State*	Marcuse: *Negations* Woodstock	Monod: *Chance and Necessity* Body Art in US Anselmo: *Entrare nell'opera*	Pocket calculators Death of Picasso	Sartre: *Between Existentialism and Marxism* Hauser: *Social History of Art*
Appel: *Horses and Man*	**Nauman:** *Bound to Fail*	**Castellani:** *Superficie bianca* **Beuys:** *Raumplastik (Room Sculpture)*	**Merz:** *610 function of 15*	**Bernhard and Hilde Becher:** *Pitheads*	**De Andrea:** *Woman on Bed*
1963–65	1966–67	1968–69	1970–71	1972–73	1974–75

Anish Kapoor, Mother as a Mountain, *1985, Walker Art Center Collection, Minneapolis. A return to primeval forms is a significant feature of the sculpture by this Indian-born artist. Kapoor's works derive their power from the fundamental relationships of form, volume and space. They are not solemn, they do not pretend to be effigies, yet can be perceived as an expression of a meditative culture. These images evoke mysterious and contradictory feelings.* *Whereas the impalpable colour imbues them with a sense of uncertainty and ephemerality, by contrast, the surrounding circles of powdery dust on the ground that hem them in bring out their shapes by defining their boundaries.*

26 CURRENT TRENDS

Although the 1970s were marked by a succession of artistic languages and techniques of the most disparate origins and implications, towards the end of the decade there were strong attempts in various quarters in America and Europe to rehabilitate painting as the principal medium of expression. Breaking free from the notion that artistic endeavour should be indissolubly linked to political conscience or social commitment, the visual arts threw off the chains of the exponents of the triumphant avant-garde. A partial return to the traditional concepts had already been signalled by the activities, after 1968, of the artists representing a new painting movement. The guiding principle of this movement was the critical analysis of the process whereby artists directed their attention to the painting itself as a surface of colour and as an articulation of signs, endeavouring to dismantle its system of language. In the United States these developments were pioneered by a group composed of Ryman, Marden and Mangold who exhibited together in 1966 under the banner *Systematic Painting*. The European counterparts, of "analytical" painting, were represented in France by the Support/Surface group and the quartet of Mosset, Buren, Toroni and Parmentier; in Germany by Girke, Gaul and Grubner; in England by Leverett, Green and Charlton; and in Italy by Verna, Gastini, Griffa and Olivieri. This widely diffused movement, although doubtless

▲ *Anselm Kiefer, Sulamith, 1983, Saatchi Collection, London. The subject of Kiefer's works often consists of somber pieces of architecture that appear to be sinister portents of impending disasters.*

◄ *Mimmo Paladino, Musica al buio, 1984, Waddington Galleries, London. An example of the archaic symbology so characteristic of this artist's work.*

derived from the scientific rigour of Conceptual Art, paved the way for certain aspects of the artistic sensibility that came to dominate during the 1980s.

The return to painting, as witnessed over the 1980s was therefore rich in trends and aspects characterized by a multiplicity of themes and expressive vocabularies. The cultural situation of recent times has been a breeding ground for a wide number of individual stances. They all essentially concentrate on

the subjectivity of the creative act, without, however, excluding historical reference or the revival of traditional modes and techniques. In support of this position, the Italian critic Achille Bonito Oliva, in 1979, introduced to the public a figurative trend known as trans-avant-garde, which advocated a total repudiation of the tenets of Conceptual Art. Trans-avant-garde artists such as Mimmo Paladino, Enzo Cucchi, Sandro Chia, Francesco Clemente and Ni-

cola De Maria did not confine themselves to any particular school but drew inspiration from many directions, from Expressionism, metaphysics and informal art, and also from minor cultural forms, including the crafts. For this reason their work reflects no unequivocal style but rather a diverse mixture of vocabularies. What emerged was an art full of life and emotive impulses, deeply expressive despite its structural anarchy.

The trans-avant-garde movement enjoyed great success, rapidly spreading its message abroad. It found particularly fertile ground in Germany where for some time a number of artists have shown keen interest in figurative work. Kiefer, Richter, Polke, Baselitz and Penck have been engaged in trying to heal the wounds of recent history and reaffirm a sense of national identity. They have paved the way for a second wave of German artists, the so-called *neue Wilden*, who are primarily concerned with the formal violence of

In the course of the 1980s, sculpture, too, was reinstated as a specific discipline and a fundamental sector of artistic endeavour. But in contrast to practises of the past, attitudes to technique changed, particularly with regard to the materials used. The most interesting sculptural work today is founded on a strong awareness of plan and design often determined by rigid stylistic controls. The work is deeply researched at the intellectual level, and the finished product represents the concrete application of such thinking. This is the inspiration for artists such as Bill Woodrow, Tony Cragg (above: Evensong, 1984), Anish Kapoor, Hidetoshi Nagasawa, Tony Grand, Albert Hien, Nunzio, Fabrizio Corneli, Antonio Violetta, Pino Spagnulo and Pietro Coletta. Their works propose a notion of sculpture as a dynamic act which opens out into complex dialectics, often revolving around the association of surface and space.

the image, achieved by means of an impulsive and exuberant manner and a lively, strongly contrasted chromaticism.

The revival of figurative art produced some strange phenomena and singular deviations: Neo-Classical and Neo-Baroque Mannerism, for example, attracted many followers in Italy and France between 1980 and 1985. In America it resulted in a more than ever ambiguous style, that of the "graffitists," who succeeded in finding the perfect compromise between the spirit of suburban revolt and the demands of the international marketplace. Such works, which might be presumed to have originated outdoors – as on the walls of the subway – are transposed to the prepared, framed canvas, and finally placed on sale in the art galleries frequented by New York's high society.

Yet alongside these statements, associated more or less with Expressionism, a trend developed during these

BIOGRAPHIES

♦ **Buren** Daniel (Boulogne-Billancourt 1938). A distinctive feature of his work is the programmed repetition of identical bands of colour, painted on a variety of supports, from wood to canvas, from wall to fiberglass.

♦ **Chia** Sandro (Florence 1946). Initially he was strongly influenced by the climate of *Arte Povera*, but from 1977 onwards he initiated a return to the figurative

image, which culminated in his adherence to the trans-avant-garde group. His compositions, blending both irony and innocence, are peopled

by figures of Mannerist inspiration, moving about against busy backgrounds.

♦ **Cucchi** Enzo (Morro d'Alba 1949).

His Conceptual beginnings were followed by a return to a pictorial style evoking ancient architecture, animal forms, naturalistic elements and figures inspired by paganism and Christianity. A richness of subject matter and an accentuated chiaroscuro achieve the dramatic feeling that pervades all his works.

♦ **Förg** Günther (Füssen 1952). He is

▼ *Thomas Schütte,* But But Butter Brain, *1988, Tucci Russo Gallery, Turin. The artist, aware of the sterility of the contemporary art market, founds his work on utopian visions realized in temporary forms such as sketches and models. Because everything harks back to the realm of the imagination, the basic theme is the gap between reality and copy.*

▼ *Günther Förg, Untitled, 1989, Private Collection, Switzerland. The artist uses physical space as a vacuum in which he allows free play to his expressive means, which include painting, architecture and photography.*

The work of Günther Förg, based on order and equilibrium, in fact combines lyricism with geometric-constructivist spatial concepts. Ranging from early monochromes, realized on various types of support, to representative painting, murals and photographic works, Förg shows great versatility in assimilating the linguistic aspects of space and in originating a network of relationships in which objects, images and architectonic and public components are all involved. Gerhard Merz also works in the field of architecture, and with a range of classical structures in colours of an antique style he reduces architectural environments to an artistic representation.

In this context, the catalyst of the artistic process is the meeting point of image and reality; and the focal points of attention are the bonds and relationships between things that are apparently incompatible. Thomas Schütte and Reinhard Mucha both operate within this spectrum.

same years towards a form of geometrical abstraction, in some respects faithful to the premises of Conceptual Art. The artists who represented it assumed an introverted, reflective attitude and adopted a new way of working with architecture, writing and sculptural installation.

one of the most representative German artists of the last decade. The fulcrum of his work is the analysis of form in its role of interpreting meanings. From this stems a multiplicity of techniques adopted for operations that simultaneously involve surroundings, objects, images and spectators.

♦ **Gastini** Marco (Turin 1938). Initially Gastini was preoccupied with problems of a linguistic character. Subsequently he introduced the idea of the picture as a repository of high tensions, in which the painter can express his impulses, his psychic forces and his emotions, giving surfaces depth and life.

♦ **Girke** Raimund (Heinzendorf 1930). He belongs to the first phase of German "analytical" painting and bases his work on bright colour as a physical entity. He investigates colour in its transparency and thickness, concentrating on a range that extends from warm ochers to the coldest blues.

♦ **Kiefer** Anselm (Donaueschingen 1945). The work of this painter is directed towards the contemplation of history, its disasters, its memories and its detritus. Such an attitude, however, does not imply remorse and regret, but stimulates the imagination with thoughts of regeneration and new life.

♦ **Kruger** Barbara (Newark, New Jersey, 1945). By manipulating mass-media techniques, she has revealed how a strong image can still create ideologies in an established capitalist society. A markedly ironic component emerges from the narrative plane and the material surface of

▼ *Cindy Sherman,*
Untitled 92, 1981,
Private Collection.
Goddesses of the cinema
and paranoiac women
are the central subjects
of her works. In her
deliberately flat images,
where the photographic
technique becomes a
vehicle for criticism,
Sherman always brings
out some imperfection
or feature that serves to
underline her ironic
approach.

The former transfers his own utopian notions (linked to architectonic schemes) to models that have no prospect of practical application. Thus they assume the validity of sculpture but are contradicted by an unreal language. Mucha, too, concentrates on the ambiguities of the sculpture's relationship with its surroundings. His structures are born of the need to combine materials of many different sources and to organize them in such a way as to create a new system of formality. The object, decontextualized and converted to assume a new function, is no longer merely a sculptural volume. Inasmuch as it constitutes a different reality, it acquires unexpected formal value. "Forms become form," claims Bertrand Lavier, who applies thick impasto to everyday objects, conferring on them the ambiguous appearance of works of art and, at the same time, of anonymous articles, endowed with implicit aesthetic signifi-

◀ *Georg Jiri Dokoupil,*
Papel igienico, 1989,
Minini Gallery,
Brescia. The debt to
Expressionism is very
evident in Dokoupil's
work. After an initial
phase of employing
violent colour, his
painting became more
tranquil and
disciplined.

cance. The aim is not to rob the object of its own specific identity but to permit the creation of new symbolic overtones.

This also happens in the work of Wolfgang Lab, where the intrinsic ritual quality of the substances employed brings about a kind of slowing down of the perceptive process. The act of perception is fundamental, too, to the installations of

the image, while the political message is reduced to a mere spectacle.

♦ **Paladino** Mimmo (Paduli 1948). Interest in figurative painting is at the heart of the work of this very individual painter who has a preference for mythological subjects. He draws from various archaic sources (Egyptian, Etruscan, Greco-Roman art) and juxtaposes sculptural elements with pictorial surfaces.

♦ **Richter** Gerhard (Dresden 1932). His painting revolves around a central nucleus: illusion and make-believe, the fading of images, the contradictions of the visible. He produces landscapes with hazy, nuanced outlines, out-of-focus photographs and compositions that sometimes rely upon an abstract pictorial quality.

♦ **Ryman** Robert (Nashville 1930). The work of this American artist consists of defining monochrome surfaces through the calibration of the brush stroke, from which he calculates extent, duration and scope of colour.

♦ **Sherman** Cindy (Glen Ridge, New Jersey, 1954). Since 1978 she has used photography as her main tool. Her early works investigate the narcissistic component of femininity; later efforts explore obsessive facets of the "myth" of women in modern society.

the Swiss Markus Raetz, concerned with establishing strange short-circuits between spatial illusion and actual space, as are the "sculptures" of Franz Erhard Walther and Imi Knoebel. The work of Knoebel demands intense concentration, for in it precise geometrical forms follow one another, are superimposed and cross to produce complex stratifications. The synthesis of order and disorder that is derived from them mirrors at once the imaginary and the real.

The American artistic scene of the 1980s was enlivened by a variety of trends and hypotheses, including a revival of minimalist, geometrical and conceptual approaches. Contrasting with this is the overtly expressionistic style of Julian Schnabel's painting, which rather than evincing a return to figuration and the recognition of a mimetic image, encourages the manipulation of recycled objects and of used materials. Photography and "objectivism" are both logical mediums for Schnabel's art. Representation constitutes the guiding force for a group of artists who, beginning in the late 1970s, adopted photography as a critical means of questioning the role of art. They use images that, through clear references to social settings and everyday occurrences, aim to reveal myths of oppression and dominion. The objectification of women is in fact the subject of Cindy Sherman's photographs. Louise Lawler, Sherrie Levine and Richard Prince prefer, however, to underline the extreme vulnerability of the artist in the context of a system that commercializes the work, dominated by collectors and political institutions. Barbara Kruger, too, is accusing in tone. Her photographic works are based on the decomposition and reconstruction of images that evoke consumer objects, which are placed alongside apparently unrelated texts, as in advertising language. Her work is in more than one sense "political," but the irony resides in the fact that all is reduced to a representation, to pure spectacle.

▲ *Peter Halley*, Two Cells with Circulating Conduit, *1988, B. Bischofberger Gallery, Zurich. A feeling of ironic detachment characterizes these colour surfaces, which are designed to overcome the instability of abstract art.*

▶ *Bertrand Lavier,* Incudine, 30 kg, *1990, Minini Gallery, Brescia. The object, although not robbed of its original function, assumes a new formal identity with a dense application of colour.*

▼ *Richard Artschwager,
High Backed Chair,
1988 Rivendell
Collection, New York.
A combination of Pop
Art, Conceptual Art
and Minimalism,
Artschwager's works
hover between the
functional and the
indeterminate. Each
one may be seen as an
object of everyday use
but also as a purely
aesthetic product.*

Criticism of the social conscience is also at the root of the theory of simulation, of the pictorial simulacrum. In this context, it is worth stressing the importance of Richard Artschwager, whose works, based on a combination of Pop, Conceptual and Minimal art, show his awareness that an object can be viewed in the light of its function, yet at the same time be considered as an aesthetic product without function. Younger artists who have modelled themselves on his thinking include Jeff Koons and Peter Halley. Koons, emphasizing the aesthetic content of both new and used objects, focuses on the question of artistic rules. Halley's chromatic surfaces aim to reflect nothing other than the prisoner-like ordering of our civilization, which he criticizes by employing a geometrical treatment that is both detached and ironic, removing from his historic models all reference to elements of transcendence or religion. ■

▼ *Barbara Kruger,
Untitled (In space no
one can hear you
scream), 1987, Fredrik
Roos Collection,
Stockholm. Analysis of
manipulation by the
media is at the root of
this work. Space in this
picture is confined to
pure surface, while the
text, fulfilling a didactic
function, is used to give
the images meaning
that they do not
themselves possess.*

David Leverett, Interspaces in Sequence, *1973–74, Private Collection.*

The artist's attention is centered on the work itself, on traditional means of expression and hence on strictly pictorial elements such as symbol and colour. The analytical component is intended to be strong and his attitude is powerfully conditioned by the idea behind the work. As a result, nothing is left to chance and great emphasis is placed on procedure. This English painter is especially motivated by the need to focus on the primary elements of the medium: canvas, colour and their interactions with light.

Marco Gastini, Il peso della pelle, *1981.*

Space is the dominant subject of Gastini's work. The fundamental consideration of his pictorial process is therefore the way in which he arranges the subjects in the area of the work. In organizing his spaces the artist uses a variety of objects chosen for their particular formal function.

Daniel Buren, Del colore della materia, *1989, Minini Gallery, Brescia.*

A primary feature of Buren's work is his insistence on discipline, exactitude and essence. The artist has remained consistent in his approach and method for some twenty years, his work being marked by an intelligent and simple use of alternating bands of colour that always match the nature of the places where they are situated. Time, too, is a parameter that contributes to the definition of the work.

End of Vietnam War Death of Franco	Death of Mao Karol Wojtyla elected Pope	Shah of Iran replaced by Ayatollah Khomeini Iran–Iraq War	Falklands War Israel invades Lebanon	Gorbachev President of USSR US–Soviet Summit	Democracy in Eastern Europe Gulf Crisis
Space rendezvous between USA and USSR "Terra-cotta army" excavated in China	Application of fiber optics Genetic engineering	Compact disc Introduction of ECU	Isolation of AIDS virus	Liquid-crystal TV screen Chernobyl disaster	Channel Tunnel started
Britten: *Death in Venice*	Bernstein: *Songfest*	Rochberg: "Concorde" Quartets Boulez: *Réponse*	Stockhausen: *Samstag aus Licht* Berio: *Un re in ascolto*	Birtwhistle: *The Mask of Orpheus*	
Literary works by Solzhenitsyn, Powell, Snyder . . .	Literary works by Satre, Greene, Gordimer . . .	Literary works by Golding, Grass, Burgess, Garcia Marquez . . .	Literary works by Amis, Kundera . . .	Literary works by Gordimer, Golding, Leavitt . . .	Rushdie: *The Satanic Verses*
World oil crisis Death of Picasso		Lévi-Strauss: *The Naked Man*	McQuail:	Opening of Musée d'Orsay Van Gogh's *Sunflowers* sold at auction for $36.3 million	Hockney Retrospective at Tate Gallery Picasso's *Acrobat and Young Harlequin* sold at auction for $34.9 million
Leverett: *Interspaces in Sequence* **Lüpertz:** *Babylon Dithyrambic I*	**Riley:** *Green Dominance* **Christo:** *Running Fence*	**Schnabel:** *For the one who comes out to know fear*	**Kiefer:** *Sulamith*	**Kapoor:** *Mother as a Mountain* **Kruger:** *Untitled*	**Artschwager:** *High Backed Chair* **Buren:** *Del colore della materia*
1972–75	1976–78	1979–81	1982–84	1985–87	1988–90

THE WORLD'S GREAT MUSEUMS

ALTE PINAKOTHEK MUNICH

The various collections that make up the nucleus of the present museum, from the substantial one of the House of Wittelsbach to the smaller ones such as those of the Mannheim and Zweibrücken palatinates, were assembled here from 1836 onwards; in the early nineteenth century the exhibits were supplemented by treasures confiscated from religious orders. German artists on exhibit in the museum include Pacher, Grünewald and Altdorfer (*Battle of Darius at Issus*); Dürer, represented by such superb works as a *Self-Portrait* and *Lamentation on the Dead Christ*; and Cranach the Elder with a *Crucifixion*. There are rich collections, too, of Dutch (Rembrandt, Steen and Cuyp) and Flemish art (Rubens and Van Dyck). Among the many fine examples of Italian art are the *Pietàs* of Fra Angelico and Botticelli and works by Titian and Tintoretto. Also worthy of particular mention are works by Ribera and Zurbarán and the Classical French school paintings of Poussin and Claude Lorrain.

THYSSEN-BORNEMISZA FOUNDATION LUGANO

Begun in the 1920s by Heinrich Thyssen-Bornemisza and continued by his son Hans Heinrich, this is one of the richest of recent private collections. The nucleus of the collection was transferred from Hungary to the Villa Favorita di Castagnola at Lugano, Switzerland, a gallery specifically built to house it in 1937. About ten years later it was opened to the public by the founder's son, who is the present owner. His father's collection, which ranges from fourteenth- to eighteenth-century European art, is especially notable for its fifteenth-century German and seventeenth-century Dutch paintings, and for a number of important Italian works such as *Young Knight in a Landscape* by Carpaccio, *Madonna Enthroned* by Lorenzo Costa, *St John* by Tura and *Three Beggars* by Ceruti. Also of great interest are the French paintings of Watteau and Boucher, and those of the Spanish school, notably works by Zurbarán, and Goya's fine portrait of Ferdinand VII. Hans Heinrich Thyssen-Bornemisza's own interests extend to nineteenth- and twentieth-century European and American art, and he has added important contemporary works from the French Impressionists onwards.

◀ *View of inside of Musée d'Orsay, Paris.*

HERMITAGE ST PETERSBURG

This is the largest museum in the world, situated in a series of eighteenth-century palaces, including the Winter Palace, residence of the tsars until the 1917 Revolution. The other palaces were built successively to house the art collections begun by Catherine the Great and continuously enlarged thereafter. Opened to the public in 1852, the museum was expanded after the Revolution, incorporating treasures from other imperial residences and property belonging to the great princely and noble families. Some works have been sold by the Soviet State.

The Hermitage gallery presents an exceptional panorama of Western art. Spanish masterpieces include *The Drinkers* by Velázquez and works by Murillo, Zurbarán and Goya. In the Flemish section there are paintings by Van der Goes and Van Dyck and many Rubens, among them his *Deposition*. Italy is represented by Leonardo's *Madonna Benois* and *Madonna Litta*, Raphael's *Conestabile Madonna* and *Holy Family*, Giorgione's *Judith*, and many paintings by Titian and Veronese. German and English art are well represented, as is eighteenth-century French art with Chardin, Watteau and Boucher. There are also many nineteenth- and twentieth-century French works, including the most important collection of works by Matisse.

UFFIZI GALLERY FLORENCE

Vasari's Uffizi Palace was first used as a museum by Francesco I de' Medici, who, after 1584, housed his private collections in the Loggia and his most valuable treasures in the octagonal Tribune, both built by Buontalenti. Steady growth was subsequently ensured by the Medici and Lorena families, who donated their collections to the city.

Notwithstanding the presence of works by important foreign artists such as Van der Weyden, Van der Goes, Memlinc, Rubens and Rembrandt, the Uffizi is essentially a collection of Italian masterpieces. The thirteenth- and fourteenth-century Florentine and Sienese schools are represented by Cimabue (*Madonna Enthroned*), Duccio and Giotto, and by Simone Martini's *Annunciation*. Tuscan fifteenth-century art includes the *Adoration of the Magi* by Gentile da Fabriano, the *Madonna and Child with St Anne* by Masaccio and Masolino, Uccello's *Rout of San Romano*, works by Piero della Francesca, Botticelli (*Birth of Venus* and *Primavera*), Leonardo and Pollaiuolo. Sixteenth-century works include Michelangelo's *Tondo Doni*, Raphael's portraits and *Madonnas* and paintings by the Mannerists Pontormo and Bronzino. Outside the Tuscan school notable works include Parmigianino's *Madonna with the Long Neck* and Barocci's *Madonna of the People*.

GALLERIA NAZIONALE D'ARTE MODERNA ROME

Founded in 1883 as a national museum devoted to contemporary art, it was moved in 1915 into the present building, which commemorates the fiftieth anniversary of Italian unification. Many of the works in the collection were acquired at international exhibitions and at the Venice Biennale, while others come from artists and private donations.

The gallery contains the largest collection of nineteenth- and twentieth-century Italian painting, with ample documentation on the various movements concerned. There is also a modest selection of international paintings. The nineteenth-century section includes works by Canova, Hayez and the Tuscan Macchiaioli painters. The twentieth-century opens with the works of Modigliani, the Futurists Boccioni, Balla and Severini, the Metaphysical artists De Chirico and Carrà, the Roman school and principal contemporary Italian artists up to the present.

GALLERIE DELL'ACCADEMIA VENICE

Founded in 1807 originally as a picture gallery of the Academy of Fine Arts, the building was expanded to accommodate Venetian paintings recovered from the French after the Restoration and to house various private collections. In 1878 it became independent of the Academy.

The gallery's works are devoted almost exclusively to a comprehensive range of Venetian painting. Among the early works are those by Paolo Veneziano, Lorenzo Veneziano and Jacobello del Fiore. Fifteenth-century artists represented include Giovanni Bellini (*San Giobbe Altarpiece, Madonna with Baptist and Another Saint, Pietà*) and Carpaccio (*Stories of St Ursula*). The sixteenth century is represented by works such as *Tempest* by Giorgione, Lotto's *Portrait of a Young Man*, Titian's *Pietà* and *Presentation of the Virgin in the Temple*, Tintoretto's *Miracles of St Mark* and Veronese's *Feast in the House of Levi*. The vast eighteenth-century collection contains views by Canaletto, pastel portraits by Carriera and sketches by Tiepolo.

GEMÄLDEGALERIE DRESDEN

The gallery was founded in 1831 to house the collections of the Electors of Saxony, primarily based on the eighteenth-century acquisitions of August II and, particularly, August III. The latter obtained for the gallery, among other things, a hundred or so selected pieces from the Este collection, sold by Francesco III in 1745. The gallery was rebuilt after its destruction in the Second World War, and, after the establishment of the new museum, the large original collection was reorganized and subsequent acquisitions were directed at examples of contemporary art.

Among the gallery's treasures are the altarpieces by Correggio (*Adoration of the Shepherds, Madonna of St Francis, Madonna of St Sebastian*), paintings from the Bologna school (Carracci, Reni and Guercino), and works by Titian, Tintoretto, Velázquez and Rubens. Additionally there is Giorgione's *Dresden Venus*, Raphael's *Sistine Madonna* and Rembrandt's *Self-Portrait with Saskia*. Other Dutch artists include Hals and Vermeer, while the Flemish school is represented by Van Dyck, Teniers and Van Coninxloo. The French contribution ranges from Valentin, Vouet and Poussin to a splendid collection of Impressionist works.

GUGGENHEIM MUSEUM NEW YORK

Founded in 1937 by Solomon R. Guggenheim with the intention both of collecting and promoting contemporary art, the image of the museum is inseparable from the building in which it is housed, an architectural masterpiece built between 1943 and 1959 to the design of Frank Lloyd Wright. This rich collection can be roughly divided into three basic sections. The first contains the Impressionist and Post-Impressionist works of Manet, Renoir, Pissarro, Degas, Gauguin and Van Gogh. The second is made up of the twentieth-century avant-garde movements, notably the Cubists – Picasso (*The Accordion Player*), Braque (*Piano and Lute*) and Delaunay (*Eiffel Tower*) – the Italian and Russian Futurists, and the Abstractionists, represented by Kandinsky, Klee, Feininger and Mondrian. Important twentieth-century sculptures include those by Brancusi, Calder, Moore and Archipenko. The third part of the collection represents twentieth-century American artists.

KUNST-HISTORISCHES MUSEUM VIENNA

The museum was established in 1781 when the Empress Maria Theresa decided to bring together under one roof the wealth of art treasures from collections belonging to the Hapsburg rulers in their various centers of power. The Empress herself contributed to the growth of the collection with acquisitions following the suppression of the Jesuit order. In 1891 the museum moved to its present site, and it now also accommodates archaeological and decorative arts collections. Among the most important works in the Kunsthistorisches Museum are the *Madonna of the Meadow* by Raphael and *Adoration of the Trinity* by Dürer, *Massacre of the Innocents* and *Peasant Wedding* by Pieter Bruegel the Elder, and *Isabella d'Este* and *The Gypsy Madonna* by Titian. Flemish artists are represented by Van der Goes, Van der Weyden, Van Eyck, Rubens and Van Dyck; and there is a series of portraits by Velázquez. Italian masterpieces include Giorgione's *Three Philosophers,* Correggio's *Jupiter and Io* and Caravaggio's *Madonna of the Rosary*. One of the most celebrated treasures is the gold *Salt Cellar of Francis I* by Benvenuto Cellini.

KUNSTMUSEUM BASLE

The city and university of Basle acquired the Amerbach collection in 1662 and it has been on public display ever since. Subsequently enlarged by donations and purchases, it moved to its present site in 1936.
The Amerbach collection comprises many drawings and engravings of the German school and some interesting paintings, including Altdorfer's *Resurrection,* Baldung Grien's *Allegories of Death* and Hans Holbein the Younger's *Portrait of Erasmus of Rotterdam*. Later acquisitions include Impressionist and Post-Impressionist works by Monet, Pissarro, Cézanne, Sisley, Van Gogh and Gauguin, and a group of paintings by the Swiss artists Böcklin and Hodler. The Expressionist avant-garde is splendidly represented by Kirchner, Nolde, Barlach, Beckmann, Dix, Kokoschka and Marc; many of these works, which constitute an important survey of German art of the 1920s, were bought at a Nazi sale of "degenerate art." The Cubist movement is illustrated in excellent works by Picasso, Braque, Gris and Léger. The museum's policy of continuous acquisition has extended to contemporary art of the past few decades.

METROPOLITAN MUSEUM NEW YORK

Founded in 1872 and housed at its present site in 1880, the museum has since been enlarged thanks to many private bequests and donations (Lorillard, Pierpont Morgan, Vanderbilt, Havemeyer and others) and the astute management of vast sums of money used to finance important acquisitions for the art gallery and the archaeological and Oriental departments.
There are many splendid examples of seventeenth-century Dutch art, with works by Hals, Rembrandt (*Self-Portrait, Flora*) and Vermeer (*A Girl Asleep*), and of the Flemish school, notably Van Eyck and Van Dyck. Italian painting is represented by the works of Botticelli, Filippo Lippi, Crivelli, Raphael (*Madonna and Child Enthroned with Saints*) and Veronese (*Mars and Venus United by Love*). Also worthy of special attention are paintings by Georges de La Tour (*The Fortune Teller*), Chardin, Watteau, Boucher, Velázquez, Goya, Reynolds and Constable, as well as nineteenth-century American artists. Additionally there is a particularly rich and comprehensive collection of nineteenth-century French painting, ranging from Corot, Courbet and Daumier to Manet, Monet (*La Grenouillère*), Renoir, Gauguin, Van Gogh and Seurat.

MUSÉE CONDÉ
CHANTILLY

The museum is associated with the Duc d'Aumale who, in 1886, bequeathed his art collection and the château in which it was housed to the Institut de France. The sixteenth-century castle built for Anne de Montmorency passed into the Condé family and was later rebuilt by the Duc d'Aumale after its destruction during the Revolution. It stands in a beautiful landscape setting and is the site of numerous dramatic events in French history. The library contains many precious illuminated manuscripts, including the celebrated *Très riches heures du duc de Berry*, illustrated with miniatures by the Limbourg brothers. The art collection, which comprises paintings, drawings, tapestries, bronzes, jewels and enamels, includes forty miniatures by Fouquet and works by Raphael (*Orléans Madonna* and *The Three Graces*). In the tribune, alongside Sassetta's *Mystic Marriage of St Francis* and Piero di Cosimo's *Simonetta Vespucci*, are paintings by Botticelli, Perugino, Memlinc and Van Dyck. French art is represented by Jean and François Cluet and their school, by Poussin and, from the eighteenth century, by Greuze, Boucher and Watteau. The museum also provides an excellent overview of European art from the fourteenth to the nineteenth century.

MUSÉE D'ORSAY
PARIS

Since 1986, the readapted Gare d'Orsay, originally built to receive visitors to the 1900 exhibition, has accommodated sculpture, painting, applied arts and photography from approximately 1848 to 1914. The central core of Impressionist paintings is from the Jeu de Paume museum while other works come from the Louvre, the Musée National d'Art Moderne and museums in other parts of France.
The fields of nineteenth-century sculpture, historical painting, art of the Third Republic and Art Nouveau have benefited particularly from this new treatment, but, equally, other far more famous works have been revealed in a new light. Among the latter are masterpieces of the Realist school, represented by Daumier, Courbet and Millet; the finest examples of Impressionism, ranging from Manet's *Déjeuner sur l'Herbe* to Degas's *Absinthe Drinker*, Renoir's *Le Moulin de la Galette* and Monet's *Rouen Cathedral* series; works by Van Gogh, Cézanne and Toulouse-Lautrec; the Neo-Impressionism of Seurat and Signac; the Symbolism of Moreau, Puvis de Chavannes and Redon; the Pont Aven school of Gauguin, Bernard and Serusier; and the Nabis.

MUSÉE DU LOUVRE
PARIS

The Musée du Louvre, formerly a royal residence, was established in 1791 with a collection of works requisitioned during the Revolution including the priceless treasures of the French kings, initiated by François I and enlarged under his successors, plus important private collections, like those of Richelieu and Mazarin. The policies of large-scale acquisition by Louis XV and Louis XVI enriched the collection, and additions continued throughout the nineteenth century, particularly under Napoleon I (despite treasures returned during the Restoration period) and Napoleon III. In the twentieth century acquisitions were mainly intended to bridge gaps not filled in the past. Leonardo's *Mona Lisa* and *The Virgin of the Rocks*, and Raphael's *La Belle Jardinière* formed part of the original collections, as did various works of the Fontainebleau school. Later acquisitions included important works such as Michelangelo's *Slave* sculptures, paintings by Correggio, Titian, Veronese and Tintoretto, Caravaggio's *Death of the Virgin*, and classical French masterpieces by Poussin, Claude Lorrain and Georges de la Tour. Of particular interest are French works of the eighteenth century (Chardin, Watteau, Boucher and Fragonard) and early nineteenth century: David's *Oath of the Horatii*, Géricault's *Raft of the Medusa* and paintings by Delacroix.

MUSÉE NATIONAL D'ART MODERNE PARIS

Since 1977 many of the contemporary art works that were accommodated after 1939 in the Tokyo Palace and before that in the Luxembourg Palace, have been housed in the Centre Pompidou, better known as the Beaubourg. Conceived by Louis XVIII in 1818, the collection devoted to living artists has been kept continuously up to date. Acquisitions since 1977 have been the responsibility of the International Center of Contemporary Art.
All the principal art movements of the twentieth century are represented, with an emphasis on the Ecole de Paris from Post-Impressionism to the present day. A remarkably rich collection of Cubist works includes Picasso, Braque, Léger, Gris, Metzinger and Delaunay. Among the Fauves, Matisse is given ample space, as is Nouveau Réalisme in more recent times. The international art scene, from avant-garde to post-war developments, is represented with works by Mondrian, Van Doesburg, Kandinsky, Klee, Kupka, Chagall, Severini, Prampolini, Gontcharova, Tzara, Grosz, Rothko, Tobey, Gorky and Wols, to mention only a few. There are also frequent temporary exhibitions held for the latest generation of artists.

MUSEO DEL PRADO MADRID

The museum was established in 1819 in the Prado Palace. Works confiscated from private individuals and religious orders and already in a museum collection thanks to the work of Joseph Bonaparte were united with the immense royal collections. These dated from the reign of Catholic Queen Isabella and were continually supplemented by the patronage of her successors.
Titian, official court painter to Charles V and Philip II, is represented by his portraits of both monarchs, by his *Danaë*, *Entombment of Christ* and *Venus and Adonis*. Equally important are the works by Bosch, including *The Garden of Earthly Delights*, El Greco (*Baptism*, *Pentecost* and *Resurrection*) and Velázquez, painter to Philip IV, represented by his masterpiece, *Las Meninas*, by *The Surrender of Breda* and others. There are notable paintings by Botticelli, *The Death of the Virgin* by Mantegna, *The Triumph of Death* by Bruegel the Elder, *The Three Graces* and *The Garden of Love* by Rubens, and works by Spanish artists such as Zurbarán, Ribera, Murillo and Goya. Goya is represented by many of his major paintings such as the court portraits, including the *Nude Maja* and *Clothed Maja*, *The Second of May 1808*, *The Execution of the Rebels on 3rd May 1808*, and the *Quinta del Sordo* series.

MUSEUM OF MODERN ART NEW YORK

Founded in 1929, the museum was transferred in 1939 to its present site to allow for expansion. Continuous acquisitions and frequent donations have made this the largest modern art museum in the world. The Impressionists are represented by Monet (*Water Lilies*) and Cézanne (*The Bathers*) and the Post-Impressionists by Rousseau (*The Sleeping Gypsy*), Van Gogh (*The Night Café*), Gauguin (*The Moon and the Earth*), Bonnard and Toulouse-Lautrec. The comprehensive survey of twentieth-century art includes *Les Demoiselles d'Avignon* by Picasso and works by Braque, Gris and Léger; Expressionism finds a place with Kirchner (*Woman in the Street*), Heckel and Barlach; Fauvism with Matisse; Futurism with Boccioni (*States of Mind. Farewells*), Carrà (*Funeral of the Anarchist Galli*) and Severini. Abstract art is amply represented by Kandinsky, Mondrian, Malevich and Klee, and Surrealism and Dada by Ernst, Miró, Dalí and Duchamp. There are important works representing Latin America (Orozco, Rivera and Lam) and the Abstract Expressionism of De Kooning (*Woman 1*), Motherwell and Pollock (*Number 1*). Finally, there is a wide-ranging review of all the later movements on the international scene, from Pop Art to Conceptualism and the most recent trends.

NATIONAL GALLERY LONDON

The present gallery was established in 1938 to accommodate several private collections donated to the nation over the years, beginning with the Angerstein legacy of 1823 and expanded continuously thanks to a policy of direct and privately funded acquisitions. Italian art of the fifteenth century is well represented with works such as Masaccio's *Madonna*, *Agony in the Garden* by both Mantegna and Giovanni Bellini, Tura's *Madonna Enthroned* and *Primavera*, Filippo Lippi's *Annunciation*, Piero della Francesca's *Baptism of Christ* and Botticelli's *Nativity*. Other periods of Italian art are splendidly documented, too, with masterpieces by Correggio, Raphael, Michelangelo, Sebastiano del Piombo, Bronzino, Titian, Caravaggio and Canaletto. In addition to Van Eyck's *Arnolfini Wedding Portrait* are other important works by Cranach, Altdorfer, Dürer, Holbein, Rembrandt, Rubens and Vermeer, and the Lane donation of Impressionist paintings. The important collection of English eighteenth- and nineteenth-century art includes works by Hogarth (*Marriage à la Mode*), portraits by Reynolds and Gainsborough, and paintings by Constable (*The Haywain*) and Turner. In July 1991 the Sainsbury Wing was opened to house the Early Renaissance Collection and create more exhibition space.

NATIONAL GALLERY OF ART WASHINGTON, D.C.

The gallery was founded in 1937 on the initiative of Andrew Mellon. The existing holdings were later supplemented by the acquisition of several important European collections of ancient art. The original nucleus comprised paintings from the Leningrad Hermitage sold by the Soviet government to Mellon himself, and additions came from the Anhalt-Dessau, Hannover, Widener and Kress collections. The American philanthropist Samuel Kress not only donated his own collection, containing important works by Duccio, Sassetta, Fra Angelico, Guardi and Longhi, but also financed subsequent acquisitions. Other important Italian paintings are Raphael's *Madonna*s (including the *Cowper Madonna*) and Giovanni Bellini's *Bacchanale*. There are many worthy examples of Flemish and Dutch art, notably by Hals, Rembrandt, Vermeer, Van der Weyden, Van Dyck and Rubens; of German art (Grünewald and Dürer); and of eighteenth-century French painting. In the field of nineteenth- and twentieth-century art, there are excellent specimens of French Impressionism and contemporary sculpture, the latter housed in the recently constructed East Wing, used for temporary exhibitions as well.

MUSEUM OF ART PHILADELPHIA

Founded in 1875, the museum has housed various collections over the years, including those devoted to Oriental and Pre-Columbian art, and others ranging from ancient European to contemporary international painting. Among the most important are the Arensberg, Johnson, Ingersoll and Steiglitz collections.
The European collection includes works by Pietro Lorenzetti, Masolino, Botticelli, Giovanni Bellini, Antonello da Messina (*Portrait of a Man*), Bosch, Bruegel and Van Eyck. French art is represented by examples of religious architecture from the twelfth to the eighteenth century, and works by Poussin (*Triumph of Neptune*) and by the Impressionists. As for the twentieth century, the museum's collection faithfully reflects the situation in America during the 1920s, when private collectors acquired contemporary European works and supported the endeavours of young American artists.

PINACOTECA DI BRERA MILAN

PINACOTECA VATICANA ROME

RIJKSMUSEUM AMSTERDAM

The museum began as a picture gallery of the Academy of Fine Arts, inaugurated in 1776 by Maria Theresa of Austria on the site of the suppressed Jesuit order. After initial expansion with confiscated religious property, there was further growth during the Napoleonic era when works from all parts of the kingdom flowed in to enhance the prestige of the capital. Subsequent additions were in the more conventional form of acquisitions and donations, especially after the separation from the Academy in 1882. Lombard and Venetian painting are amply represented. Among the greatest treasures of the gallery are the frescoes of Bramante, including the *Armed Men*, Ercole de' Roberti's *Santa Maria in Porto Altarpiece*, Mantegna's *Dead Christ*, Giovanni Bellini's *Pietà*, Piero della Francesca's *Brera Madonna,* Raphael's *Marriage of the Virgin* and Caravaggio's *Supper at Emmaus.* There is an interesting section devoted to nineteenth-century Italian painting. Among twentieth-century art works in the Jesi collection are Boccioni's *Riot in the Galleria,* Carrà's *Metaphysical Muse,* and paintings by Morandi, De Pisis, the artists of *Valori Plastici* and the Roman school.

The foundation of the picture gallery dates back to the pontificate of Pius VI in the late eighteenth century. It was moved in 1932 to its present site, which was built after a decision to distance the collection from the papal apartments. It forms part of the huge complex of Vatican museums, which also includes those sections of the palace open to the public by reason of their artistic value: the Borgia apartments frescoed by Pinturicchio, the Loggia and Stanze of Raphael, and the Sistine Chapel with frescoes by Michelangelo and fifteenth-century artists such as Perugino, Pinturicchio and Botticelli. Among the most important works in the Pinacoteca are the *Stefaneschi Triptych* by Giotto, the *Madonna of the Frari* by Titian, *Deposition of Christ* by Caravaggio, the altarpieces by Perugino, and works by Giovanni di Paolo, Nicolò Alunno and Benozzo Gozzoli. Among treasures by Raphael are his *Madonna of Foligno, Coronation of the Virgin, Transfiguration* and ten tapestry cartoons. Special mention should also be made of Barocci's *Rest During the Flight into Egypt,* and a large number of seventeenth-century paintings, including Caravaggio's *Deposition,* Reni's *Crucifixion of St Peter* and Domenichino's *Last Communion of St Jerome.*

The museum is situated in a palace built between 1875 and 1885 to house the collections of the National Gallery founded in The Hague in 1800 and then transferred by Louis Napoleon to Amsterdam, where it was significantly enlarged by donations and acquisitions. Since then the museum has further expanded its collections beyond its original focus on seventeenth-century Dutch painting.
Among the more interesting works in the museum are those by Hals (*Portrait of a Married Couple* and *Merry Drinkers*) and Rembrandt (*Syndics of the Cloth Drapers' Guild, The Jewish Bride* and *The Night Watch*). Among many other fine examples of Dutch art are landscapes by Cuyp, Van Goyen, Van Ruysdael and a notable group of paintings by Vermeer (*Young Woman Reading a Letter, The Letter* and *The Kitchen Maid*). The museum also possesses a large section devoted to decorative arts, especially Delft ceramics.

STEDELIJK MUSEUM AMSTERDAM

The foundation of this municipal museum was based on the De Bruin donation of furniture and objects from the old houses of the city; the palace, built in 1892 and subsequently enlarged as a result of vast acquisitions, now contains an extremely important collection of works from the mid nineteenth century to the present.

This collection, housed in the most modern wing of the building, begins with a good representation of the French Realist painters and, of particular interest, the artists of The Hague school, including early works by Mondrian. The section on twentieth-century Dutch art naturally contains many examples of the De Stijl group, with more abstract works by Mondrian and Van Doesburg. There are also a number of abstract paintings by Malevich. Another important display is devoted to Chagall, notable for quality as well as quantity, including *Self-Portrait with Seven Fingers*. Further collections focus on the CoBrA group as well as the principal modern art movements from avant-garde to the most recent trends.

TATE GALLERY LONDON

The gallery, opened in 1897 to house the Henry Tate collection, has grown enormously over the years and now comprises two main sections, one devoted to a comprehensive survey of British painting from the seventeenth century on, the other to world contemporary art. The former is dominated by the paintings of Hogarth, Reynolds and Gainsborough, the Neo-Classicists Hamilton and West, the Pre-Romantics Wright of Derby, Stubbs and Fuseli, Constable and Blake, the Pre-Raphaelites, and Turner. Almost all of Turner's oils (from *Calais Pier* to *Fall of an Avalanche in the Grisons* and *Norham Castle*) and a large number of his watercolours are exhibited in a separate wing, the Clore Gallery, opened in 1987. Twentieth-century movements are represented by the Vorticists; Bacon, Nicholson and Sutherland; Pop Art; the sculptors Gaudier-Breszka, Moore, Hepworth, Chadwick, Paolozzi and Caro. The Tate also boasts a fine European and American collection, including Impressionists and Post-Impressionists (Pissarro, Manet, Degas, Renoir, Cézanne, Van Gogh and Gauguin), significant examples of the avant-garde, and important works by post-Second World War American and European artists. Periodic exhibitions are dedicated to post-war art and contemporary British art.

WALLRAF-RICHARTZ MUSEUM COLOGNE

The museum was founded in 1824 with the donation of the Wallraf collection and the Richartz palace in which it was accommodated to the city. The collection was enlarged by other acquisitions such as the Haubich and the Strecker bequests. Since 1975 it has occupied a new site, built to house it together with the Ludwig Museum, which is devoted to contemporary art.

The original collection concentrated on German art, especially local fourteenth- and fifteenth-century painting, including Lochner's *Saints* and *Madonna of the Rose Bower*. Later acquisitions have been the romantic and naturalistic works of Friedrich (*Isolated House in a Pine Forest*), Menzel and Leibl. Representative painters from abroad include Rembrandt, Rubens and Murillo. The contemporary section was rebuilt after wartime destruction with the acquisition of works by Picasso, Braque, Dufy, Vlaminck, Ensor, Kollwitz and Kokoschka. The Ludwig collection presents a large selection of contemporary international art, including Abstract Expressionism and Pop Art.

GLOSSARY

Abstract Image Painting
A form of Abstract Expressionism, with brushwork subordinated to colour and form.

Action Painting A modern American artistic style that flourished between 1945 and 1960. The theory of Action Painting is based on the idea of immediate and psychologically intense expressiveness, achieved by applying colour freely and rapidly on to the canvas. The spontaneity and violence of the "gesture" is seen to be directly related to the artist's state of mind at the very moment of creation.

Allegory Understood in antiquity as a rhetorical figure of speech concealing the real sense (from the Greek *állos agoréuin*, "to speak otherwise"), allegory was readopted as an ideal method of artistic expression by the Florentine Neo-Platonic movement during the second half of the fifteenth century. It was based on the notion that the ultimate, divine significance of the universe could only be explained by representing subjects in terms of symbolic images.

Anamorphosis From the Greek *anamórphosis*, or "reformation." A technique of constructing the image in distorted perspective, usually based on a viewpoint well off normal center. This distortion is utilized not to imitate reality but to confuse the observer, allowing the object to be recognized only after the correct viewpoint has been discovered.

Assemblage A French word that means an unusual or haphazard combination of disparate objects and materials. Typical of avant-garde sculpture and painting, the first *assemblages* appeared in the context of Futurism and Dada.

Avant-garde Art historians use this term to describe a fairly precise form of artistic activity, both in conception and practise. Typical of much twentieth-century art, it favours an innovative, revolutionary approach, rejecting tradition as an obligatory point of reference. From the chronological point of view, it is possible to distinguish between historical avant-garde, which developed in the first three decades of the century (and which is represented by Expressionism, Cubism, Futurism, Abstractionism and Dada) and recent avant-garde, which after the Second World War adopted similar attitudes, attempting to revive comparable methods and techniques (Conceptual Art, Minimalism, Body Art, *Arte Povera*, etc.).

Catharsis From the Greek *katharsis*, or "purification." In Attic tragedy it denoted the capacity of the theatrical representation to purge the spectator of evil feelings and desires. In the twentieth century, theoretical aesthetics rediscovered the ideology of catharsis on the basis of psychoanalysis, making it a qualifying factor in the social function of art.

Chromaticism From the Greek *chrômatikos*, "colour."

In scientific usage, employed adjectivally or as a suffix, it relates to the tonality of colour. In painting, it defines a style whereby colour is given a particularly important role.

Drip Painting Technique characterized by the application of paint on to the canvas in drops, very common in the informal art of the Second World War. See also Action Painting.

Environmental Art Derived from French *environs*, or "surroundings." In contemporary art it describes a three-dimensional, sometimes temporary work of art, with which the artist seeks to expand the creative act through the surrounding space, or to promote a reciprocal penetration of work and reality.

Esoteric According to the Greek philosophers, the term was applied to knowledge reserved exclusively for initiates (adepts). During the Middle Ages and the Renaissance it indicated a series of "superior" philosophic disciplines, and so unsuitable for the rank and file. Such esoteric sciences included alchemy, astrology, geomancy, Kabbala, Pythagoreanism, etc. The adjective is often used as a synonym for occult, secret or mysterious.

Gestalt From the German for "form" or "configuration." The term acquired special scientific significance in the first half of the twentieth century, initially in psychology and subsequently in the figurative arts. The Bauhaus theoreticians, for example,

attributed great importance to the psychological problems of perception, with reference to the relationships between the physical structures of the image and the psychic faculty of individual reception.

Gesturalism One of the two predominant aspects of Informal Art, whereby the artist's marks on the canvas are indicative of his state of mind and subconscious. See also Action Painting and Drip Painting.

Icon, Iconic In Russo-Byzantine art, the icon is a ritualistic religious image painted on wood by means of somewhat complex techniques designed to guarantee durability and bring out the splendour of the colours. The high symbolic value of the icon in Byzantine tradition led to the word acquiring a special significance other than its literal meaning as the equivalent of "image" (Russian *ikona*, Byzantine Greek *eikóna*, classical Greek *eikónos*). Thus a representation is termed iconic when it tends to stray from the naturalism to which it originally refers and to take on more generalized aspects. Iconic is applied to a sign or symbol of easy identification and communication that stands for a particular image and is distinct from other forms of language.

Iconography, Iconology Iconography is the study of subject matter, in terms of its conventional representation, e.g., Christian iconography, the iconography of St George, St Catherine of Alexandria or St Paul. Iconology is the historical interpretation of the symbols and images of a work in relation to their context.

Kitsch German for "work in bad taste," "shoddy work" or "junk." In the language of contemporary art criticism it usually has a negative connotation but may sometimes denote a deliberate choice of style or manner and therefore often assumes ambivalent or even positive significance.

Koinè Also *coinè*. Spiritual and cultural community or social gathering of individuals who share a culture, an ideology or a tradition. The term derives from the name given by the Greeks to a common language, based on Attic, which they chose at the end of the fourth century B.C. to eliminate local dialects.

Mimesis From the Greek *mimesis*, "to imitate." It is specifically associated with the philosophy of Plato, who considered art to be an imitation of reality, and reality, in turn, a pale imitation of the divine world of ideas. Today mimesis describes the tendency of art to appear as a copy or description of the real (extra-linguistic) universe.

Performance Art Term applied to works of art that straddled the visual and performing arts, dominating the field of European and American artistic experiment from 1965 to 1980.

Poetics The sum total of ideas that an artist has concerning his or her own art. In

a wider sense it can mean what the Germans call *Weltanschauung*, a conception of the world.

Psychic Automatism See box on page 224.

Structure, Structuralism A structure, in physics and mathematics, is an entity consisting of interrelated inner components. In a structure each part is definable only in relation to another and to the totality of the parts. A typical twentieth-century tendency is to conceive the phenomena of reality, nature and language as being made up of structures (and hence capable of being interpreted as an orderly complex of mutual relationships). Structuralism is a philosophical movement with methods based on the identification and study of structures.

Tautology Derived from the Greek *tautós*, "identical," and *lógos*, "talk." In ancient rhetoric the term was used to define the repetition of a concept. Today it indicates an expression that is logically true per se but that demonstrates in an unnecessarily graphic way the truth and proof of the individual propositions that comprise it. For the use and meaning of tautology in Conceptual Art, see box on page 244.

Texture Translation of the Russian concept *faktura*, a notion introduced by David Burliuk in the context of Futurism (1912) and revived (for use by the Constructivists) by Nikolaj Tarabukin in 1916–17. The word, in strictly technical use, de-

scribes the characteristics of a work of art over and above its pure aspects of "figuration." Texture is the concrete conformation of the material used in a work of art.

Theophany Sensible manifestation (revelation) of the divine. Byzantine icon painting is a prime example of theophany. After Giotto, European art abandoned its theophanic intentions.

Theosophy A recent tradition of religious character associated with esoteric (q.v.) thinking, which believes that knowledge can directly attain the divine through the symbolic interpretation of nature. The first Theosophical Society was founded in Russia in 1875. Some of the protagonists of Historic Abstractionism have important links with theosophy: Mondrian was influenced by Schoenmakers and Malevich was a friend of Uspensky and Florensky.

Tonalism Pictorial tendency to highlight tonal values and harmonious relationships between colours. The tone of a colour depends on its level of intensity, luminosity or saturation. Tonalism in European painting was principally developed by Titian in Venice after 1510, based on the examples of Giovanni Bellini and Giorgione.

INDEX OF ARTISTS

Page references in roman refer to main text, in *italics* to captions and boxes, and in **bold** to illustrations; numbers preceded by an asterisk refer to an artist's biography.

Picture sources

C. Abate: 252. – A.F.E. P.Servo: 251. – Alberto Giacometti Foundation, Basle: 210b. – Archivio Sansoni: 240b, 251c. – Artephot J.P. Ziolo, Paris: 124. – Artephot J.P. Ziolo/A. Held, Paris: 134. – Artephot J.P. Ziolo/Varga, Paris: 98. – Bibliothèque Nationale, Paris: 116. – J. Blauel, Munich: 111b. – Brompton Studio, London: 217b. – Bulloz, Paris: 115a. – L. Carrà: 197r. – Certro per l'arte contemporanea Luigi Pecci, Prato: 265a. – Chomon-Perino-Spanger: 74b. – Coll. Eli and Edithe L. Broad: 266a. – G. Colombo, Milan, 258, 269c. – Courtauld Institute Galleries: 132b. – Desire Daniel, Liège: 211b. – G. Fall, Paris: 182b, 231c. – Musée des Beaux Arts, Dijon: 35b. – Fondazione Lucio Fontana: 219b. – Foto Flammarion, Paris: 220b. – Foto Freeman: 91. – Foto Marzari: 99b. – Foto Mori: 104ar. – Foto Secky, Brno: 60b. – M. Garanger: 159b. – Giraudon/Alinari, Florence: 22b, 38ar, 39a, 40b, 74a, 120b, 125a, 137b, 140b, 152b, 200a. – P. Grünert, Zurich: 181. – G. Guadagno, Venice: 158, 160, 166, 175a, 211l, 211r, 213r, 221l, 226b, 228b. – Hamburger Kunsthalle, Hamburg: 106, 107b. Hammel, Paris, 145b, 148l. – Robert Hausser, Mannheim/Ursula Seitz-Gray, Frankfurt: 248b, 251l. – A. Held, Lausanne: 117a, 149, 182a, 221c, 229a. – D. Heald: 191a, 208b. – Henning Rogge, Berlin: 156. – Hessisches Landesmuseum, Darmstadt: 199b. – E. James: 201. – Kaiser Wilhelm Museum, Kreferd: 153r, Kleinhempel, Hamburg: 121a. – Kodansha, Tokyo: 29b, 30a, 35a, 48a, 52l, 62al, 62b, 77b, 83b, 108, 112b, 143c, 203a, 214, 217a, 226a, 227a, 229br, 235, 236, 237, 238c, 239b, 240a, 241r,. 243a, 249c, 249b, 251r, 259al, 259b, 260b, 261r, 261c, 263a. – Kunsthistorisches Museum, Vienna: 68. – Lewis Brown Associates: 113c. – Lisson Gallery, London/Gareth Winters: 262. – Lufin, Abano Terme: 18a. – Manso David, Madrid: 75r. – J. Mathews, N.Y.: 203b. – Museum of Modern Art, N.Y. Larry Aldrich Foundation Fund: 242. – Mussat Sartor, Turin: 261l. – M. Nannucci, Florence: 245b. – National Gallery, London: 30b, 51alr. – T. Nicolini: 11b, 49br. – T. Nicolini/M. Jodice: 95. – Philadelphia Museum of Art/Bequest of Katherine S. Dreier: 202. – Photo Meyer: 79. – Photoservice, Milan. 135a, 146, 168a, 179b, 180l, 183c, 186a, 190, 193c, 231r, 234, 245a, 249a, 250a, 253a, 255b, 269l. – Preiss and Co.: 78. – M. Pucciarelli: 26, 47, 97c. – F. Quilici, Rome: 49a. – Rampazzi: 176. Rheinisches Bildarchiv Köln/Museum Ludwig, Cologne: 232. – L. Ricciarini, Milan: 32, 66, 86, 256, 270. – L. Ricciarini/Bevilacqua, Milan: 22a, 53c. – F.R. Roland, Paris: 103a. – Rotalfoto: 571 – Sandak, Inc. N.Y.: 212, 223. – Scala, Florence: 10, 11a, 14, 16ar, 17, 18b, 19, 21, 23, 25r, 27, 28b, 29a, 31r, 37lr, 38ar, 39b, 40a, 41c, 42, 45r, 50b, 52a, 54, 55, 57r, 60a, 61, 62ar, 64ar, 64a, 70l, 71, 72ab, 76, 77a, 80, 81a, 83ar, 84a, 87a, 90, 92, 93a, 102, 115b, 118a, 125b, 135b, 142b, 151b, 154, 194. – Scode: 238b. – Segalat, Paris: 153c. – V. Sergio, Verona: 12. – Service Photographique de La Réunion des Musées Nationaux, Paris: 117b, 118b, 120a, 126, 127a, 129, 130, 131b, 133r, 143, 198. – Shogakukan: 50a, 93b. – Soichi Sunami, N.Y.: 192a. – Stedelijk Museum, Amsterdam: 172. – Studio G 7, Bologna: 257a; Thames and Hudson Archives: 89b, 241l, 241c, 244. – Top, Paris: 175b. – Malcolm Varon, N.Y.: 227b. – Von der Heydt-Museum, Wuppertal: 162. – By courtesy of: André Emmerich Gallery, N.Y.: 218r; Coll. G. Marconi, Milan: 239ar, 255a; Galleria Massimo Minini, Brescia: 259ar, 260a, 266b, 267b, 269r; Los Angeles County Museum of Art: 238a; Marlborough Gerson Gallery, N.Y.: 239ar; Olivetti/Antonio Quattrone: 20; The Art Institute of Chicago: 128.

© Walter De Maria, 1968: 250.
© Carl Andre, Richard Artschwager, Robert Barry, Emile Bernard, Joseph Beuys, Constantin Brancusi, Georges Braque, Carlo Carrà, Marc Chagall, Giorgio De Chirico, Filippo Luigi De Pisis, Nicolas De Staël, Robert Delaunay, Sonia Delaunay, Paul Delvaux, Maurice Denis, Fortunato Depero, Jean Dubuffet, Marcel Duchamp, James Ensor, Max Ernst, Jean Fautrier, Dan Flavin, Alberto Giacometti, Arshile Gorky, Juan Gris, George Grosz, Hans Hartung, Hans Hofmann, Jasper Johns, Donald Judd, Wassily Kandinsky, Yves Klein, Michel Larionov, Henri Laurens, Charles-Edouard Le Corbusier, Fernand Léger, Roy Lichtenstein, Adolf Loos, Alberto Magnelli, René Magritte, André Masson, Henri Matisse, Sebastian Matta, Juan Miró, Piet Mondrian, Claude Monet, Giorgio Morandi, Robert Morris, Robert Motherwell, Bruce Nauman, Claes Oldenburg, Max Pechstein, Constant Permeke, Francis Picabia, Pablo Picasso, Arnulf Rainer, Robert Rauschenberg, Man Ray, Gerrit Rietveld, Jean-Paul Riopelle, James Rosenquist, Georges Rouault, Alberto Savinio, Gino Severini, Pierre Soulages, Chaim-itche Soutine, Yves Tanguy, Antoni Tápies, Otto Wols – by S.I.A.E., 1991.
© Jean Arp, Lyonel Feininger, Ernest L. Kirchner, Paul Klee, Oskar Kokoschka, Kurt Schwitters; Mark Tobey – by Cosmopress, Genève, 1991.
© Succession Henri Matisse, Les héritiers Henri Matisse. Monsieur Claude Duthuit 61m, quai de la Tournelle, Paris: 2, 173.

Illustrations not listed are from the Mondadori Archives, Milan.
Where reproductions are controlled by the individual museums, details are given in the relevant illustration captions.
The publishers apologize for any errors or omissions in the picture sources.